MEDIA/QUEERED

PETER LANG
New York • Washington, D.C./Baltimore • Bern
Frankfurt am Main • Berlin • Brussels • Vienna • Oxford

Advance praise for

MEDIA / QUEERED

"This volume contains valuable historical information about how queer original thinkers, who did not have institutional status or support, were able to influence media representation. And even more interesting is how their bravery made it possible for gays who could not think out of the box to advance in the media/representation business. This book explores how these phenomena resulted in problematic television and marketing representations that may not advance our best interests. An interesting snapshot of what queer academics are thinking about community based rebellion and its subsequent containment."

Sarah Schulman, New York historian, playwright, and author whose novels include Delores

"In this 'all gay, all the time' era when queers are too often the hip accessories for a still-dominant hetero paradigm, this anthology couldn't be more welcome. A smart, accessible, broad-ranging take on how queers both use and are used by the ever-expanding media machine. From flashy gay TV stations to homos in cyberspace, these chapters provoke needed debate on the vexing problem of visibility in an unremittingly consumerist culture."

Suzanna Walters, Chair of Gender Studies, Indiana University, Author of All the Rage: The Story of Gay Visibility in America, *among other studies*

"I've reported news for some 350 gay publications since 1985. I lost the ability to keep up with the flow of gay news in 1992 when Bill Clinton tried to lift the ban on gays in the military. These days, I could easily sit in front of my computer and read gay news 24/7. *Media Queered* feels my pain and gives it a context."

R⸻ W⸻⸬ ⸬ ⸬ ⸬ ⸬v reporter (wockner.com)

MEDIA/QUEERED

Visibility and its Discontents

Edited by Kevin G. Barnhurst

PETER LANG
New York • Washington, D.C./Baltimore • Bern
Frankfurt am Main • Berlin • Brussels • Vienna • Oxford

Library of Congress Cataloging-in-Publication Data

Media queered: visibility and its discontents / edited by Kevin G. Barnhurst.
p. cm.
Includes bibliographical references and index.
1. Mass media and gays. I. Barnhurst, Kevin G.
P94.5.G38M43 302.23086'64—dc22 2006101082
ISBN 978-0-8204-9533-0 (hardcover)
ISBN 978-0-8204-9532-3 (paperback)

Bibliographic information published by **Die Deutsche Bibliothek**.
Die Deutsche Bibliothek lists this publication in the "Deutsche
Nationalbibliografie"; detailed bibliographic data is available
on the Internet at http://dnb.ddb.de/.

Media/Queered logo by Kevin G. Barnhurst
Cover design by Lisa Barfield

© 2007 Peter Lang Publishing, Inc., New York
29 Broadway, 18th floor, New York, NY 10006
www.peterlang.com

Printed in the United States of America

For Richard, so much more than a gay lover,
who has stuck by me for more than fifteen years

Table of Contents

Part II. Flaming and Fashioning

Part III. Radical Decoder Rings

Part IV. Queers in Cyberspace

Preface

Gays and lesbians became a prominent fixture in the media during the first years of the twenty-first century. The news grew full of stories about marriage between same-sex couples, and gay and lesbian main characters populated sitcom, drama, talk, and reality shows. Marketing targeted queer consumers, and professional leaders of queer political and research groups played a role in public discussions. In the spring of 2003, I began to plan a course for advanced undergraduate and graduate students on the growing media visibility, hoping to draw on recent research and thinking, but, to my surprise, I could find no current collection on the topic. In correspondence, many leading scholars of media studies and queer studies urged me to develop what grew into this book.

Support for the project was immediate and widespread. Grants to develop original research came from a dozen sources within my university, spanning three colleges, and from several external funders. The project developed around a seminar I taught during the spring 2004 semester. More than two dozen scholars met with the seminar to present, comment on, and discuss new work. Research presentations, discussant remarks, and audience questions and answers all appeared through on-line streaming video.

The resulting book has several features unique among edited collections. First, it has been road tested. It is not a proceedings of the series; rather, all of the papers went through two rounds of review. Students in the seminar, who were queer and

straight, male and female, white and persons of color, young and old, gave their input on which articles were most enlightening and readable from their perspective. Authors revised their manuscripts with the benefit of comments from panel discussants. Finally, prominent scholars then reviewed the manuscripts and made recommendations about which papers to include. The book now includes roughly half of the research papers presented in the series, organized topically.

Second, the collection includes a mix of well-established contributors and bright new scholars. Top names in the field of queer media studies include Larry Gross, Ed Alwood, Lisa Henderson, and Meg Moritz. The new scholars come from important centers such as the University of Pennsylvania, New School University, and the University of Leicester, United Kingdom. Each section of the book includes a brief introduction by a leading scholar who participated in the series, including John D'Emilio and Deirdre McCloskey.

An important feature of the project is a series of interludes containing responses from media practitioners, including journalists working in the gay and mainstream press. The first of them is by Studs Terkel, who interviewed and knew personally the founders of and others involved in the early U.S. homophile movement.

The book comes with a web supplement. The authors of the research each gave brief remarks before a live audience, which are available for viewing on streaming video, along with comments, questions, and answers. The internet video stream also includes clips from films and television shows, along with charts, facsimiles, and other visual aids from the research. These on-line resources are available through the generous hosting of the University of Illinois at Chicago (http://www.uic.edu/~kgbcomm/mq).

READERS

Media Queered is written for scholars, students, and an interested lay public and should be useful to instructors of media studies and gender studies. Their advanced undergraduate and graduate courses are found in the communication curricula in larger, research-oriented universities and in the women's studies curricula of a wide variety of colleges. The anthology is also accessible for students and for general readers who have an interest in the topic.

No other book has the focus of this collection. Several older volumes provide a general overview of queer theory (Abelove, Barale & Halperin 1993; Medhurst & Munt 1997) or of queer communication theory (Yep, Lovaas & Elia 2003), but they mention the media only in passing. This is the first anthology available at the nexus of media studies and queer studies. James Chesebro's (1981) and R. Jeffrey Ringer's (1994) collections focus on interpersonal communication and are out of print. *The Columbia Reader* (1999), edited by Larry Gross and James Woods, is partly concerned

with the media and makes a valuable resource but is now hard to find. The only other similar work, an edited collection (Wolk & Kielwasser 1991), places psychology rather than media studies in the spotlight (and is also out of print).

There are three monographs on the topic of the media and queer visibility. The books by Gross (2001) and by Walters (2001) came out half a dozen years before this one, and the book by Capsuto (2000), a useful popular rendition, appeared even earlier. These books could not anticipate developments such as marriage debates, niche marketing, and so forth.

ACKNOWLEDGMENTS

The Center for the Study of Media and Society of the Gay and Lesbian Alliance against Defamation provided general support for the entire Media Queered series of events. The Skornia Lectureship Fund supported the appearances of Studs Terkel and Todd Mundt, who delivered talks on how the public service media related to the themes of the series.

At the University of Illinois at Chicago (UIC), the Chancellor's Committee on the Status of Lesbian, Gay, Bisexual, and Transgender Issues provided generous funding for the events, as well as moral support and getting the word out. The Humanities Laboratory funded the videotaping and placing of streaming video on line. The Institute for the Humanities gave financial support and acted as host, carrying a logistical burden of publicizing and staging events in Stevenson Hall. Staff from the Department of Communication became a key support during the series. Dace Kezbers and Mamie Gray handled arrangements and budgeting, and Richard Doherty took charge of the video-to-web process. Stanley Fish, then dean of the College of Liberal Arts and Sciences, gave moral and financial assistance, and the College of Urban Planning and Public Affairs provided a grant as well. Other important contributions from departments at UIC include the following: John D'Emilio, then director of the Gender and Women's Studies Program, contributed financially and as a participant. The Chancellor's Committee on the Status of Women, the Office of Women's Affairs, the Chancellor's Committee on the Status of Asian Americans, and the Departments of Psychiatry, Psychology, Political Science, Art History, and English all helped fund speakers.

At Peter Lang, Damon Zucca was an early fan of Media Queered whose enthusiasm was infectious and whose persistence paid off. Mary Savigar guided the project with grace and lent invaluable input and support. Sophie Appel was meticulous in supervising the production and patient and long suffering with an academic who has just enough knowledge of publishing to be dangerous.

Projects such as this one disguise the biographies of those who contribute. My own health took at least two turns for the worse, delaying work on bringing the collection

to print. Individual authors faced job changes, tenure decisions, foreign sojourns, and dissertation throes, sticking with the project to its conclusion. I'm indebted to them all, to my students, to my long-suffering partner Richard, and to my sons, Joel, Andrew, and Matthew. The spring semester of 2004 was a stimulating experience for me, and, through the on-line videos and now through this volume, that experience lives on, shared with viewers and readers anywhere now and in the future.

—*Kevin G. Barnhurst, Uptown, Chicago, Illinois*

REFERENCES

Abelove, Henry, Michele Aina Barale, and David Halperin, eds. 1993. *The Lesbian and Gay Studies Reader*. New York: Routledge.

Capsuto, Steven. 2000. *Alternate Channels: The Uncensored Story of Gay & Lesbian Images on Radio and Television*. New York: Ballantine Books.

Chesebro, James, ed. 1981. *Gay Speak: Gay Male/Lesbian Communication*. New York: Pilgrim Press.

Gross, Larry. 2001. *Up from Invisibility: Lesbians, Gay Men, and the Media in America*. New York: Columbia University Press.

Gross, Larry, and James D. Woods, eds. 1999. *The Columbia Reader on Lesbians & Gay Men in Media, Society & Politics*. New York: Columbia University Press.

Medhurst, Andy, and Sally Munt, eds. 1997. *Lesbian and Gay Studies: A Critical Introduction*. London: Cassell.

Ringer, R. Jeffrey, ed. 1994. *Queer Words, Queer Images: Communication and the Construction of Homosexuality*. New York: New York University Press.

Walters, Suzanna Danuta. 2001. *All the Rage: The Story of Gay Visibility in America*. Chicago: University of Chicago Press.

Wolf, Michelle A., and Alfred P. Kielwasser, eds. 1991. *Gay People, Sex, and the Media*. New York: Harrington Park Press.

Yep, Gust, Karen Lovaas, and John Elia, eds. 2003. *Queer Theory and Communication: From Disciplining Queers to Queering the Discipline(s)*. New York: Harrington Park Press.

Visibility as Paradox

Representation
and Simultaneous Contrast

KEVIN G. BARNHURST

Since the 1960s, queers have become increasingly visible in the media. Queer identities in community life and politics may rely in the twenty-first century on the prevailing media landscape. And yet visibility, like other semantic and semiotic forms, contains its own contradictions. The paradoxes of visibility are many: spurring tolerance through harmful stereotyping, diminishing isolation at the cost of activism, trading assimilation for equality, and converting radicalism into a market niche. Signaling the existence of queer persons may aim for inclusion in public discourse, but, through simultaneous contrast, the assertion contains its inevitable opposition: Queers are different and cannot go unremarked.

Ethnic, racial, and religious minorities within a given society usually raise up most of the heirs who will join their cultural heritage. Sexual minorities are unusual for not necessarily following that pattern. The youth who finds an identity as lesbian, gay, bisexual, or transgender while growing up with LGBT parents or guardians is the exception, not the rule. Initially, those with few or no connections to others like themselves rely heavily on the media to find out about what eventually will become their chosen communities. As a result, an understanding of queer identity, community, or political life, especially at the beginning of a millennium rich in new technology, depends to some degree on understanding queer visibility in the media.

That same visibility, however, seems incoherent on first inspection, revealing a welter of incompatible expectations and outcomes. Coming out is supposed to reap

benefits but often destroys personal relationships and may lead to social death in some circles or physical harm in others. Creating a queer marketplace provides employment for so-called professional homosexuals—reporters, travel agents, and the like—but may also create a ghetto. A sense of group or personal invisibility may persist even in the face of widespread popularity for queer characters in the media. And new technology promises to free everyone, but especially queer youths, from the shackles of geography, especially in rural and prejudiced places, but may end up endangering users. These four paradoxes form the topics for each section of this volume: history, the professional, the popular, and technology.

The topics are paradoxes because they begin from assertions accepted as true about a positive good—progress, financial means, acceptance, and digital prowess—but the value in each case turns out to be at least partly negative, contrary to expectation. The assertions are at the same time true and false, although their main incongruity is not necessarily at the level of logic.

To explore the four topics, this essay describes each one and then turns to a disparate but overlapping set of theories for explanation. Scholars from a variety of disciplines have struggled with the paradoxes in the human condition of visibility and have arrived at similar concepts: *identification* in rhetoric, *contrast* in visual studies, *interpellation* in cultural studies, and *simultaneous contrast* in psychology. The dualities these terms encompass are less like a binary opposition, such as black-white, which Ferdinand de Saussure found in all language (where "there are only differences" [quoted in Derrida 1982]), and more like the deconstructive black–not-black of Jacques Derrida (1982).

Despite the variety of terms, all have the same aim: to describe what appears to be a central conundrum in experience. The simultaneity of being self and other, part of and distinct from community and society, is identifiable in language, appearance, and understanding but only through the existence of opposites. It is fashionable to argue in favor of multiplicity and to consider dualities merely linguistic, but they extend beyond language into human physiology. The experience of queer visibility presents a special case but illuminates a universal aspect of human life, the simultaneous contrast, conceptual and physical, of either-or and both-and conditions. Although there is no escape from that universal condition, it is possible to choose which contrasts to embrace and which to ignore.

THE PARADOX OF COMING OUT

Coming out has been one of the key narratives of queer identity for several decades. The coming out story imagines change as a progression, in a tale of progress, as

John D'Emilio suggests (see Part I, Introduction, pp. 23–26). Coming out proposes a before state (closeted), a liminal state (the threshold or passage for coming out), and an after state (out). As individuals progress from the interior of the self to the exterior of the social and political worlds, clear improvements take place. For individuals, coming out moves the self from self-consciousness to selflessness, from duplicity to candor, and from isolation to inclusion. Through coming out, representations of the community move from the marginal to the mainstream. In other words, when few queers are out, the only ones visible are those whose showy behavior makes them un-closet-able, but those unusual (or even extreme) images yield to others more like the mainstream, as the less exotic queers emerge, confirming the familiar assertion: We are everywhere. In the larger polity, coming out stories move the nation and globe from ignorance (not knowing queers exist) to enlightenment (tolerance or even acceptance). In the face of these acts in human contexts, all institutional and legal barriers crumble. Coming out stories are like religious conversion narratives, with all the attendant emotions associated with epiphany, along with structural change in society.

The media play a central role in coming out. The history of coming out in the media documents the typical shift (see Chapter 2, pp. 27–44), in which the queer community moves from closeted object to *out* subject, a process that begins with experts and moral judges talking *about* queers and ends with queers allowed to talk for themselves. The media also supply archetypes, whose stories are variants of the mythic pattern: the comedienne who risks her career (Ellen DeGeneres), the ingénue-as-hostess who turns activist (Rosie O'Donnell), the athlete who stands against the world (Martina Navratilova), among other lesbians.

And there are examples from ordinary life, in venues such as the reality series, *Coming Out*, on the Logo Channel. Each episode enacts the coming out process before the camera: It begins with the protagonist living an interior life, considering little more than the closet walls that surround her, and facing a decision of whether to break out by telling that person most dear or least able to receive the news. The emplotment dwells in the liminal state, showing the protagonist in scenes of everyday activity, with voice-overs that build faux suspense: Will she do it? Does she have enough courage? The viewing audience becomes the chorus calling (or thinking), "Come out, come out!" And in the end, she does come out, yielding a rush of tears to the accompanying flood of community feeling in the viewing audience. The antagonists in this drama—those key dear or weak ones—play their roles on cue, saying the right things before the camera: Coming out is acceptance, coming out is honesty, coming out is closeness. Only later, in the falling action of the plot, do these secondary characters sometimes falter. They decide (off camera) that being queer is not okay after all, that their acceptance is less than boundless, that they cannot continue the relationship as before. These encounters with the non-queer *other*, rather

than raising doubts about coming out–as–liberation, teach indelible lessons: Coming out, for all its liberating force, is still hard. Coming out requires periodic reenactment. Behind these lessons, one element persists: coming out.

On another level, the series makes clear that even the ignorant and homophobic backwaters of American society know the script and will say their lines for the camera. Coming out has become a common trope, an easy, tacit reference to queer culture that has a million uses. A young man in the office where I work creates his own coming out extravaganza, arranging for many unsuspecting friends and acquaintances to gather at several sites where they can witness him exposed on television for what he is, not gay or transsexual or the like but another variety of queer: a straight man who does ballroom dancing. On television, celebrities talk of coming out about almost anything, sometimes kinky but usually not: fetishes, addictions, surgeries. Coming out is the hip term for telling secrets of all kinds.

Some skeletons appear to remain in the cupboard, such as sexuality between generations (see Chapter 3, pp. 45–56). Sex in childhood is a forbidden subject that has a history not only of discussion spanning decades but of overt representation in books and film. The existence of a taboo is always an open secret. To ban anything, a culture must identify and classify the activity through discourse. Even when a taboo extends to the *discussion* of its object, discursive patterns of euphemism supply ample means for the society to represent the banned.

The Logo Channel itself illustrates the pattern of silence and speaking. The channel declares that "the word Logo is about identity, about being comfortable in your own skin" (http://www.logoonline.com/about/). MTV Networks, a division of Viacom, launched the digital station in 2005 ostensibly to serve LGBT audiences, with the tag line, "Programming that reflects our lives. Programming that tells our stories." However, selling advertising to corporations is what gives the channel economic viability, and its stated goal is to be "a sponsor-friendly cable channel." To deliver the queer audience to mainstream advertisers over cable and satellite networks, the Logo Channel bleeps out expletives and expurgates scenes to avoid giving offense to non-queer viewers, especially potential advertising clients. Those silences disguise queer experience, despite the channel declaring itself not just gay friendly but one with the LGBT communities.

Such seeming contradictions are part of what rhetoricians call *identification* (Burke 1969). Rhetorical identification occurs when any entity or person relates closely with another. In the case of two life partners, each individual in the close relationship is like two entities, one joined to the partner and the other separated as the self, but both existing at the same time. A particular queer person is also, for example, one with a broader circle of queer friends. Such dual existences always involve erasures and ambiguity like those of the Logo Channel.

The term *representation* also refers more broadly to the opposites contained in any assertion. To say anything involves asserting its opposite. There are countless

instances: One cannot refer to oneself without implying the existence of another. Being queer sexually may involve finding oneself in the place expected of the opposite sex and, as a result, feeling in a sense both male or female at once. Queers not only experience an LGBT identity but may also operate in, and feel part of, a straight family and a heteronormative society. All these instances are "appeals to the common ground (sub-stance)" (Killingsworth 2005, 3), which underlies all communication. Making things visible by speaking is teeming with oppositions.

In the rhetoric of representation, both aspects of an assertion (black and white, for instance, or the self and other) exist inside, integrally, and all at once. The literary and performing arts develop characters by separating out and embodying the opposing sides separately: antagonist to protagonist in literature, straight man to comedian in vaudeville, or leading character to foil in theatre. In the melodrama of coming out, a female friend can play the foil to a gay man, for instance. Like the typical foil, she is the opposite of the protagonist, female to his male, straight to his gay, and fertile to his supposed sterility (see Chapter 4, pp. 57–72). When stories of gay men and straight women succeed, they expand the range of relationship possibilities, as does the (less often depicted) lesbian–straight-male friend story.

Coming out is an assertion that, through rhetorical representation, entails its opposite: going in. The experience can make sense only under conditions of hiding, and thinking in terms of coming out collapses a wide array of states—confusion, doubt, fear, silence, ignorance, or simple indifference—into one: the closet. One consequence of several decades of queer visibility has been the revelation that these other states are not all the same. Those who find a queer identity later in life—the generation that most relied on coming out to formulate a life narrative—illustrate the contrast. "I hate coming out stories," writes a longtime feminist, coming to terms with her own life. "No matter how I try to squash this collection of conflicting, disjunctive, contradictory experiences into a single clear-cut narrative, they just won't fit" (Stempel 1998, 1). For those who once lived lives as straight persons, becoming queer seems to force a choice between a complex story of unstable identity and a simple one, in which our earlier lives were a lie that coming out has finally put right. One way out of the quandary is to stop "revising away" one's own past and denying one's "period of heterosexual life" (Barnhurst 2001, 57) or, in other words, to reject coming out.

There have existed examples of queer citizens and activists who lived their lives without organizing it around such a ready-made story (see Interlude A, pp. 73–80). Viewed from within the closet narrative, these persons would seem to take enormous risks and persevere, despite hardship, just to be *out*. But being out was not always everyone's aim. Some queers live without regard to *out* or *in*. They don't buy into the dramatic emplotment that coming out provides. For them, the coming out story defines

things not from inside their lives but from the outside. Viewed without reference to coming out, they instead appear to lead ordinary lives, confronting a range of challenges and obstacles not unlike what others face. They avoid that particular form of rhetorical representation.

Living from day to day without the closet as reference is unusual, these days, because families, office-mates, and others expect the closet to be the main thread of the narrative one tells about queer life. In other words, the closet is now a story that straight folks have learned to expect. The closet narrative has become commercially convenient and so comfortable in the mainstream. It is a script that a non-queer perspective makes available, and queer folks play their part in growing numbers (Deb Price, "Gay Closet Doors Open Wide, Research Finds," *Detroit News*, 16 October 2006, http://www.detnews.com/). The closet has turned into a heteronormative plot device.

THE PARADOX OF THE PROFESSIONAL QUEER

One outcome of gay and lesbian liberation has been the rise of the full-time homosexual, who works at the crossroads of queer and straight communities, at another of the boundaries of visibility. Professional groups establish a position in the marketplace by erecting barriers to entry, which prevent others from working in the same field. Limits on competition increase the cost of their services, which the groups justify by asserting a public service mission. Homosexuals cannot control entrance into the ranks of professionals; that power resides with the legal, medical, psychological, and other such associations, not with queers. But they do generally hold credentials, primarily in the form of education but also, in some cases, government licenses.

The rise of queer organizations, especially after the AIDS crisis began in the 1980s, expanded a niche in economic life. An array of organizations emerged to serve or cater to queers themselves and, more importantly, to represent queers to each other and to mainstream legal, social, and economic interests. Political groups, advertising agencies, research firms, and non-profit services joined the gay and lesbian press, and, together, they established or enlarged the need for lobbyists, fundraisers, marketers, pollsters, human services and health workers, executives, and the like. That is the demand side.

On the supply side, being queer itself is the barrier to entry. To fill all the new jobs, holding a lifetime membership in the club—being queer—is important. Sexual minorities have always populated the professions, but this new brand of queer has turned being visible into an asset. Membership in queer communities gave them

insider knowledge that added value to their professional qualifications. The value added depended in part on the existence of the closet.

A barrier surrounds career queers because of the prejudice against queers generally. Only a small subset manages to be out in the professions, and non-queer professionals are hesitant, under conditions of prejudice, to focus on queer clients. In short, the queer professional can operate as a specialized subgroup of a profession, but only because others either remain in the closet or are straight but avoid serving queers. Professional homosexuals can then claim, again because of discrimination, to provide a unique public service.

The so-called *homocrats* are especially valuable in an increasingly bureaucratic culture, that is, one where the scale and patterns of organizational life depend upon expertise. Mainstream bureaucracies, populated with members of the professions, have need of counterparts and peers in the queer world. Or, stated the other way round, the new queer organizations could not speak effectively to the mainstream except through professional discourse. Take the example of the news media. My case study of the reports that National Public Radio (NPR) broadcast during U.S. presidential campaigns found that, from the 1990s to the 2000s, attention shifted away from ordinary queer citizens as sources (Barnhurst 2003). The bland pronouncements of professionals from queer organizations replaced the pointed arguments of nonprofessional queers, whose voices diminished to the occasional slogan or outburst.

How did this happen? After Bill Clinton openly courted the gay vote in 1992, major news organizations began covering queer political issues regularly. The professional routines of journalism produced a gay and lesbian beat, making the coverage more frequent, more standard in length, and more predictable in structure (with such forms as the follow-up story, the sidebar to the main story, and the like). Ordinary citizens lack the accoutrements of professionals: the offices and regular hours, with multichannel access (phone, fax, and e-mail) that make homocrats reachable, as well as the job titles, expertise, and credentials that make them authoritative. For journalists working on deadline, the queer on the street is hard to find, and a peer-to-peer source, one with a sound bite at the ready, is better.

As NPR journalists became more comfortable reporting on queer politics, the tone of the reporting became more positive. In a process I call *normalization*, the use of professional sources in standardized coverage yielded a feel-good veneer, an accommodation between journalists and their fluent, skilled (usually upper-middle class and white) homocrat sources. At the same time, the process accomplished a *pacification* of the queer audience, which yearns for any visibility at all, especially for such a safe and middling one. The representations matched the images emerging from homo-marketing, where queers look just like the mainstream (see Chapter 5, pp. 89–106). However, the growth in coverage was a mixed blessing, because journalists

also applied the professional standard of balance, in which queer sources occupied one side in an uneven face-off with rivals from the extreme right wing. As with other news, queer political reports took part in widespread *polarization*. In accomplishing this balancing act, journalists come off as centrists, and LGBT demands for equal rights appear radical.

The professionalization of queer visibility had two other important aspects. Disagreements over representation always involve resistance to negative depictions, but the emergence of experts as activists changed the character of those arguments. Queer expertise seemed capable of making the face-off more professional (see Chapter 6, pp. 107–124), with better organization and discipline more likely to exert control over the queer image in mainstream media. But gay and lesbian newspapers and magazines have become less activist as the U.S. market for queer media has become more professional and organized along industrial lines, with chain consolidation and conservative ownership (Ingall 2003). In other places, where a queer press is still emerging and continually struggling to survive, the potential for unsettling the status quo still exists (see Chapter 7, pp. 125–142). Queer media put homosexuals in control of the means of cultural production, but the dangers include the pursuit of mainstream production values, the superficial polish that serves up celebrity and sensationalism but excludes unglamorous queers leading ordinary lives.

Queer journalists face all the problems of mainstream society: sexism, market pressures, the slide into entertainment, and the like (see Interlude B, pp. 143–158). There remain zones away from urban centers where conservative audiences consider the mere statement that queers exist a form of promoting the so-called gay lifestyle. But even mainstream news organizations have room for queer journalists to be transgressive, reporting on a wide range of topics while challenging conventional ideas. One strategy is co-optation, winning others over by joining them, making their issues into queer issues. Another is to be sensitive to the forms of mainstream discourse.

In the ideological process called *interpellation* (Althusser 2000), the larger hegemonic structures of society and culture hail to the individual. The concept is closely related to rhetorical representation but specifies one set of oppositions that assertions contain: the relation between the individual and the dominant culture. That culture, through interpellation, calls to the self, and, through the identifying act, the self enters into a network of associations that reinforce the existing relations of power.

An advertising supplement, Leading with Diversity, in the pages of the *New York Times Magazine* (25 September 2005, sec. 6, 101–144), illustrates one case of interpellation. The section ran more than three dozen pages of brief articles, concluding with one on "Domestic-Partnership Benefits." The texts hold together a score of ads

from the likes of Bayer, Chevron, Dell, Hilton, Johnson & Johnson, Kodak, Mattel, McGraw-Hill, Merck, the NCAA, Starbucks, and UPS, along with lesser-known enterprises. An article titled "Out & Equal" claims that "diversity is more than black and white, male and female." It has come to "embrace a wide spectrum of diverse groups," LGBT persons among them, along with distinct ethnic and national-origin groups, "the physically challenged, new hires, employees over 40, military veterans, religious minorities, and a host of other grass roots" groups (142). Another brief piece, "Making Diversity Work," proposes expanding diversity, so that "all employees feel they benefit" (141). Diversity no longer depends on legal protections or on a history of discrimination. It is a matter of individualism, open to any American. As a human resources senior vice president for Pitney Bowes remarks,

> In the end, our belief is if you feel able as an individual to really give your talents without feeling that you have to fit into some predetermined mold, then we will get the best results. (143)

Such a view of diversity may seem incoherent or inarticulate but amounts to a demand for covering, so that persons with real differences blend in (Yoshino 2006). Diversity is then a feel-good slogan that exalts individuals, not groups, and does so to feed the corporate bottom line. From the *Times Magazine* supplement (2005): "I matter because I am part of a team of talented professionals," says the smiling black man in shirt and tie, next to the headline, "What I do matters." The ad for Sanofi Aventis, the third largest pharmaceutical company in the world, uses the tag line, "Because health matters." It concludes, "At the heart of all that matters are people, connected in purpose by career" and so forth (143). Professional identity becomes a containment system for individual difference, so that the dominant culture can interpellate or call to *individuals* without acknowledging a history of devaluing collective identities: their class, race, ethnicity, gender, or sexuality, that is, their *kind*.

THE PARADOX OF POPULARITY

Visibility benefits and suffers from its Oedipal relationship with the popular, with style, and with the market (see Part II, Introduction, pp. 83–88). In the *History of Sexuality*, Foucault (1978) argues that a discourse of regulation exists when two conditions hold: first, when greater talk is taking place (about sexuality, for instance), and, second, when that talk occurs in the presence of widespread belief that instead silence prevails. The clamor and quiet are verbal forms of visibility and invisibility.

One of the least visible among queer groups is the aged. The West worships youth, and so, the logic goes, aging involves a gradual disappearance from the public eye.

A film by Johnny Symons, *Beauty before Age* (New Day Films 1997), for example, asserts the power of youth in American culture, along with the lack of older role models, as its rationale. And yet the film itself helps fill that gap, undoing its own logic. It is one of many texts in the discourse of aging queerdom, going back to before the 1982 volume *Gay and Gray* (Berger 1996). A bibliography of the Affirm Network at SUNY Stony Brook lists more than 150 works on aging among queers from 1975 through 2001, and the rate of publishing has accelerated, with nineteen appearing in the first decade, fifty-two in the second, and seventy-five in the final seven years. So there is increasing talk, a popularity in at least some quarters, but the belief that graying queers are invisible persists.

Queers have reached the same sort of invisible visibility throughout the life cycle, beginning with youth culture not only in fictional series such as *Queer as Folk*, but also in mainstream journalism. A *Time* magazine cover story, "The Battle over Gay Teens" (John Cloud, 10 October 2005, 43–51), uses a fundraiser for the Point Foundation, which supports scholarships for queer youths, to describe a movement widespread enough to spawn national attitude surveys, books from publishers including Harvard University Press, and secondary school gay-straight alliances so common that they go by their initials, GSAs, and have an organized political opposition. "At many schools around the country it is profoundly uncool to be seen as anti-gay," a bold pull-quotation proclaims, and the article concludes that the change occurred "with shocking speed" (51).

After youth comes the highly visible ritual of marriage (see Chapter 9, pp. 181–196). The marriage debate has grabbed repeated attention and sparked heated controversy even within the liberal *New York Times*, which published a kind of ideological self-cleansing in its ombudsman column for having played cheerleader on the issue of marriage for same-sex couples (25 July 2004, Week in Review, sec. 4, 2). In the *Times Magazine*, the next phase of the queer life course, fledging the young, appeared just months later. The cover blurb announced an article, "Got a Problem with My Mothers? Coming of Age with Same-Sex Parents," a marketing version of the title for an article inside, "Growing up with Mom & Mom" (Susan Dominus, 24 October 2004, sec. 6, 69–75, 84, 143–144). In it, four women appear, two lesbian mothers and their two daughters, one lesbian, one straight. Of course, the article focuses on the straight one, Ry, and all the lesbians play the chorus. Ry uses "the drama of her family story" as an art project, a mixed-media piece that incorporates images of the family along with footage from television news, taped after a judge announced a decision concerning her parents' custody. Ry's experience illustrates her dual state: Homesick on semester abroad in Dublin, she goes with her boyfriend to a gay bar for a little home comfort, only to get turned away at the door for being straight.

Queer middle age has its own documentation, in Alan Ellis's (2001) collection and elsewhere, and, to bring the life course full circle, there is now coverage of the

transition from mid-life into retirement. A June 11, 2006, Associated Press article, "Aging Gay Population Fuels New Housing Market: Nearly a Dozen Specialized Developments up and Running Nationwide," contains the usual combination of visibility and erasure. After an initial vignette gives the story a human hook, the anonymous journalist then parades out experts ("specialists in gay aging issues") and a set of predictable controversies: aging and reentering the closet, independence from blood families, assimilation and self-segregation. Following standard journalistic practice, the article presents two sides to each aspect of the story: the boosters of second-chance proms and other senior events versus a psychologist citing clients who say the idea sounds awful. Along the way, the article trots out the inevitable stereotypes of queers: the stigma and isolation, the estrangement from family, the trend setting in the arts, and the like. Readers get to meet all the queers they know already: the lonely and childless, those suffering under discrimination, and the comic-relief characters, oh so precise about everything.

It is hard to imagine that, amid such detailed coverage of the entire life cycle, some queers remain invisible, and yet male sex workers are one such group (see Chapter 8, pp. 165–180). An examination of the reporting and research among support organizations in the United Kingdom illustrates the doubtful value of increased visibility. The paradox is that sex acts between men are an object of silence, rarely mentioned themselves, but that same silence contributes to the regulation of those sex acts. Another region at the edges of queer visibility is social class (see Chapter 10, pp. 197–216). A nuanced understanding suggests that the discussion must move away from persons and toward material conditions of work and class structures.

Even in the pre-AIDS era, codes existed to make queers visible. In one project, *Gay Semiotics*, Hal Fischer (1977) catalogued the signs, archetypes, and fashions gay men used in San Francisco of the 1970s. The codes of queer communication give the lie to complaints about invisibility. Fisher's exhibition, which led to the book, came at the end of an era, when the knowledge of queer subcultural signs spilled out into public. The use of colored bandanas, for example, was a topic of straight conversation when I was a young adult deep in the American hinterland.

When marginal group codes move into the mainstream, they maintain a visible-invisible state. Cult films, for example, are at once well known and obscure. There seem always to be more of them joining the canon, and none ever leaves for under- or overexposure. Queer films, which may have a cult quality at least among LGBT audiences, demonstrate the trend. The University of North Carolina Libraries maintain a filmography of queer titles, which begins with the 1963 Jack Smith film, *Flaming Creatures*, and the 1970 release, *The Boys in the Band*, by William Friedkin. In the next decade, a handful of films emerged, including Edouard Molinaro's *La Cage aux Folles* of 1978. These older movies retain an obscurity desirable for cult status. But

the intervals between new releases have grown shorter, and two dozen films joined the UNC collection in each decade to follow (see http://www.lib.unc.edu/house/mrc/films and use the Filmfinder to search under the genre, Queer Cinema). The UNC collection is not exhaustive but illustrates what a serious mainstream collector might have considered worthy of preserving.

By the time a counter- or subcultural expression enters the mainstream, it may no longer exist or have the same currency and force for those who participated in it. Stuart Hall (1996) has described the process that occurs for indigenous cultures once their images and artifacts enter world capitalist commodity markets. Mass Western culture becomes fascinated with the paraphernalia of subcultures once their practical function has disappeared. For example, although labor has declined in U.S. America over the past century, "men's work finds continued expression in the culture as costume—jeans, undershirts, and work boots flourish in the absence of the laborer" (Barnhurst 1996, 101). Queers now wear invisibility as a fetish, not recognizing the evidence it provides that queer invisibility itself has vanished. But the *story* of invisibility persists, like a folk tale the older generation continues recounting to chasten the young.

The waxing and waning of popularity seem the outcome of collective whim, but haphazard changes are no longer the rule. Styles become obsolescent throughout the fashion world, not in response to shifting public tastes but in service to the fashion industry. The idea of *planned* obsolescence is relatively new, having emerged only in the 1920s. Facing a saturated market and slowing purchases, Alfred Sloan, Jr., the head of General Motors, is said to have begun pushing for the automobile industry to begin changing the style of products to spur sales (Rothenberg 1999). The new form of obsolescence depended on superficial style, turning consumption into a symbolic act rather than a response to human wants. Consumption for the leisure classes may always have been *conspicuous* (Veblen 1899), but the new form expanded flashy consumption to the working and middle classes. The Great Depression of the 1930s spurred American business to expand style obsolescence to a broad range of products, as a method of *Consumer Engineering*, the title of a cheerleading book published in 1932 (Sheldon & Arens). Culture industries have continued the practice since then.

Recent political history demonstrates how an engineered visibility is useful for the enemies of queer communities. In elections of the 2000s, the political handlers of then Texas Governor George W. Bush encouraged widespread discussion, debate, and fear by making queer relationships a planned element of campaigning in specific states and localities. If public relations experts are correct, even negative exposure is good for any group or client, but that argument relies on this assumption: that visibility operates like a mechanical ratchet, so that each increase sets a new bottom limit. In this sense, visibility is like a financial instrument, a liquid commodity that tends, as

economists say, to be price inflexible in the downward direction. Visibility of the sort the Republican Party has engineered transforms queer culture and identity into a fearful beast that looms but is easy to vanquish. Queers want an end to that sort of visibility, want to strike down the right-wingers who fathered it.

Each aspect of popularity—the invisible visibility of queers throughout the life course, the circulation of well-known secret codes, the residue of artifacts that persist after their users have faded away, and the grassroots enthusiasm that political and culture industries engineer—each one contains the paradox. Popularity is heightened visibility that implies its opposite: the fall from grace, the loss *and* the public adulation. Visual theory suggests a simple concept, *contrast*, to understand the quandary.

In its simplest sense, contrast is inherent in every form. Placing a dot on a field (a canvas in painting, but also a page in the media or a screen on line) sets up a contrast. The spot asserts its shape, darkness, scale, location, and so forth by implying the opposite. A dot brings the field into the viewer's awareness, in a relationship between *figure* and *ground*. Every figure must inescapably sit on a background, and the existence of one implies the existence of the other. A similar phenomenon occurs in every aspect of popularity.

Seen without its inherent contrast, popularity is an illusion that gets in the way of understanding. The phasing in and out of style of different identity groups in Western capitalism is one-dimensional, because no commodity is ever far from commercial reach. Each is just as visible in times of invisibility. During the gloomy period of queer suppression, in mid-twentieth-century America, every family seemed to know about a cousin who ran off to the big city on the coast. "Uncle Hub moved to New York City," went the line in one family I knew. The intonation told the rest of the tale. Knowledge that queer folks exist is a constant. When media popularity wanes, interpersonal innuendo waxes. The hearers love these fill-in-the-blank stories more than any episode of *Will & Grace*. Through contrast, visible and invisible are coexistent states, always present because one implies and depends upon the other.

THE PARADOX OF TECHNOLOGY

Millennial notions about new technology have colonized conceptions of future queer visibility. Millennialism, of course, grew from religious expectations (Christian, Islamic, Buddhist, and indigenous) for a paradise on earth, a golden age when the ills of society vanish as a result of historical processes. Because the term *millennial* refers to a thousand years, ends of centuries can usher in a period of millennial thinking, but specific developments can do the same. In the mid- to late 1990s, the rise of the internet promised to foster freedom and independence for individuals and to advance democratic and economic equality for societies.

Millennialism holds out hope of a better earthly life for the downtrodden, from persecuted religionists in the ancient world to oppressed minorities today. Such hopes seem especially apt for queer communities. By 1999, in China, for example, the low cost of on-line publishing and even lower cost of internet access made it possible to circumvent state controls. According to one account, gay men—

> now have a web site listing gay bars. One gay man in Beijing downloads interesting articles on homosexuality from the internet, translates them into Chinese, and distributes them to friends. And they can now talk to one another through such e-mail addresses as *chinagay@ hotmail.com*. (Jan Wong, "Comrades on the Net," *Australian*, 30 September 1999, Features sec., M-14)

Internet radio soon followed, and, in 2000, queers had eight stations broadcasting from Hong Kong to the mainland and elsewhere on RadioRepublic.com (Carolyn Ong, "HK Service Boasts 105 Channels in English and Cantonese; Entrepreneur Runs with a Revolutionary Radio Plan," *South China Morning Post*, 15 February 2000, Technology Post sec., 3). Shortly thereafter, press agencies reported "growing acceptance of sexual diversity" in China (Rachel Morarjee, "For China's Gay Community, a Quiet Liberation Is Afoot," *Agence France Presse*, Dateline Shanghai, 15 January 2001, International News sec.).

Similar reports emerged from the Middle East, Africa, and elsewhere. Computer technology made it easier for queers to find each other in South Africa (Naomi Wolf, "New Sex Revolution," *Johannesburg Sunday Times*, 26 January 2003, Arts, Culture & Entertainment sec., 12). Al-Bawaba, a news service headquartered in Amman, Jordan, and Dubai, United Arab Emirates, reported, "With the growth of the use of the internet, it seems Arab gays, lesbians as well as bisexuals and transgenders [*sic*] have found new places they can call home" ("Summer Lovin': Arab Gays, Lesbians Coming Out of the Closet . . . ?" *Al-Bawaba*, 7 August 2003, http://www.albawaba.com).

For those facing discrimination because of sexual difference, the availability of new communication media seemed to allow users to set aside the visibility quandary. Queer folks are unlike the women or persons of color whose outward traits make them readily visible. The internet changes the stakes for these users, who can operate without revealing their identifying traits upon first encounter. The internet is supposedly the great leveler, so that even white men cannot assume others on line recognize their physical strength or whiteness. At the same time, queers may assume total openness on line with minimal risk. In cyberspace, everyone is potentially queer, and so the internet *queers* just about every aspect of life, such as race on gay dating sites and elsewhere (see Chapter 12, pp. 243–260). Exposing one's identity in a zone away from the physical body also seems perfectly safe.

Millennial thinking has a dark side in the fears of apocalypse that accompany hopes for renewal. The most extreme example of the destructive tendencies accompanying

the millennial urge is Nazism (Fenn 2003), which had a direct impact on queer persons. In recent history, the arrival of the year 2000 (Y2K) coupled a thousand-year date (however arbitrary in origin) with forecasts of technical doom, and not without consequences for queers. The so-called *millennial bug*, resulting from the failure of programmers to plan for dates longer than two digits (as in 99 for 1999), raised fears in societies reliant on computers for activities from banking to utilities. In the general climate of anxiety, gays and lesbians specifically became a target for extremist groups. The Federal Bureau of Investigation (FBI) issued a report in late 1999 "warning police chiefs across the country" about "groups preparing for violence as New Year's Eve approaches," which listed gay men and lesbians, along with African Americans, Jews, and others, among potential targets of the radical right (David A. Vise & Lorraine Adams, "FBI Warns of Millennial Violence Risk; Police Vigilance Urged as New Year Approaches," *Washington Post*, 31 October 1999, Final Edition, A-1).

The end-of-time jitters seem to have calmed since then, but the dual promise of freedom and risks of exposure—identity theft being the most disturbing, besides physical vulnerability to stalking and the like—have not subsided (see Chapter 11, pp. 231–242). The existence of two opposites together, and their interaction with each other, is a puzzle called *simultaneous contrast*, which has troubled thinkers from ancient philosophers to recent psychologists.

Simultaneous contrast occurs because any element changes noticeably when in the presence of other elements, compared to its appearance in isolation. The concept appears in the writings of thinkers from Aristotle to Sir Isaac Newton, with the Arab natural philosopher of the Middle Ages Ibn Al Haytham in between them (Kingdom 1997). It emerged in commercial discourse among dye makers of France, who matched a color as instructed, only to fall under royal censure because the threads (identical in isolation) no longer matched when woven next to other colors in tapestry (one of the tropes of multiculturalism today). The chemist Michel Eugène Chevreul documented the fact that contiguous colors "appear as dissimilar as possible" (1887, 11), and, later, the German-born American abstract painter and designer Josef Albers (1975) asserted that the effect is deceptive, that is, a pathology. More recent critiques raised questions about whether simultaneous contrast results from physiology or judgment (Lee 1981). These ideas may seem far afield, but they correspond at many points with identity issues familiar to scholars of queer studies, such as controversies surrounding the idea of *normal*, the so-called gay gene, and nature versus nurture.

Millennial thinking is one instance of simultaneous contrast because the existence of hope and fear at the same time has an impact on each. The hope is more poignant, and the fear is more pointed. The palpable changes seem rooted in the mind. For instance, a straight man may experience simultaneous contrast in his sense of self upon discovering the presence of queers around him. Psychology has had

a long history of examining the phenomenon. It emerged in the 1866 work of Hermann von Helmholtz (1962), and, decades later, William James (1981) weighed in on the debate over whether simultaneous contrast is psychological or physiological. Gestalt theorists, of course, viewed both aspects as inherent in holistic experience (Behrens 1998). Recent work in perception includes many studies on the simultaneously contrasting judgments of self and others (see Biernat, Manis & Kobrynowicz 1997, for an overview).

Around the turn of the millennium, the gay press stirred up the air of anxiety and hope by calling attention to the link between visibility and bashing. The murder of Matthew Shepard in 1998 brought gays to the forefront of national attention, and then, during early 2000, California passed Proposition 22, banning same-sex couples from marrying, and the *Advocate* magazine reported increases in attacks on queers. That pattern of coverage has continued since then. On April 27, 2004, a special section on marriage included a piece on "Marriage's Bloody Backlash" (Christopher Healy, *Advocate*, 38–40). It reported National Coalition of Anti-Violence Programs data: In the six months following the 2003 U.S. Supreme Court ruling that overturned sodomy laws, hate incidents based on sexual orientation increased 24 percent nationally (43 percent in New York City alone) and almost doubled in Colorado. A sidebar in the *Advocate* issue pulled out an earlier example: an article on Anita Bryant's campaign to repeal nondiscrimination based on sexual orientation in Miami, with the title, "Ever since Dade County, Gay People Are Being Beaten and Murdered in Increasing Numbers." The sidebar shows the front cover of the April 2, 1981, magazine, then published on tabloid-size newsprint, with a graphic illustration of bashing (2004, 25). The exhilaration of visibility and the agitation of attendant hate crimes play off and change each other.

Of all queers, the young seem the most vulnerable (see Chapter 13, pp. 261–278), in spite (or because) of the freedom that new technology provides. Facts on the ground do not seem to support the image of technological liberation. The *New York Times* reported during pride celebrations of 2004 that "the identity-affirming pitch of gay rights advocates" combines with media portrayals, especially "the feel-good wit of television shows like *Queer Eye for the Straight Guy*," to "encourage adolescents to declare their sexuality" (Andrew Jacobs, "For Young Gays on Streets, Survival Comes before Pride," 27 June, New York Report, A-21). Thousands of them ended up homeless, exposed to "drugs, hustling, violence, and the virus that causes AIDS," and one of the few shelters that works to get them off the street had a waiting list of more than one hundred.

The sad statistics reassert the fate of physical bodies in the digital age. The rise of new communication technologies at the end of the millennium may have raised hope for queers, especially the young under the control of heteronormative families and communities but also those under repressive national regimes around the world. The paradox, of course, is that the same persons expecting digital freedom

experience physical attacks and discrimination. The existence of high expectations changes the tenor of the dangers, so that both states exist in simultaneous contrast to each other. These two states are one, incorporated into the mindset of a millennial age.

RESISTING PARADOX

Eve Kosofsky Sedgwick described the impossible contradictions of queer identity in *Epistemology of the Closet* (1990). In one memorable example, she recounts the quandary of an eighth-grade science teacher in Maryland, who lost his post after revealing he was gay. By *choosing to speak* to the media about losing his teaching post, he brought what the Board of Education considered (and the federal court ruled to be) improper attention to his sexuality. Upon appeal, the Fourth Circuit Court upheld the verdict but disagreed with its logic. Instead, the justices argued that he had acted improperly by *failing to speak* of his sexuality when completing the original job application. In each ruling, the teacher's sexuality itself was not, ostensibly, at issue. It was his *visibility* that mattered. The "management of information," about queer identity, says Sedgwick, is so vulnerable "that the space for simply existing as a gay person who is a teacher is in fact bayoneted through and through, from both sides, by the vectors of a disclosure at once compulsory and forbidden" (70).

When legal systems do address sexuality itself, a similar paradox emerges, because queerness appears at once innate and acquired. German advocates for decriminalization in the nineteenth century asserted that homosexuality is naturally occurring. The argument, after some initial success, led the Prussian state to stop treating queers as criminals subject to fixed-term imprisonment and instead to incarcerate them for life as members of a degenerate species (Halperin 1995). In twentieth-century America, U.S. courts have ruled in some cases that homosexuals deserve no civil protections, because homosexuality is not an innate characteristic, but held in other cases that homosexuals are "criminals *as a class*" (34). Therefore, "if homosexuality *is* an immutable characteristic, we lose our civil rights, and if homosexuality is *not* an immutable characteristic, we lose our civil rights," concludes David M. Halperin, who then asks, "Anyone for rational argument on these terms?" (34).

The difficulty with these paradoxes is that they seem to present impossible binds from which queers cannot ever find escape. Paradoxes usually yield to analysis, which can unmask the conflicts, haziness, and lies within the original premises, but some paradoxes are more obdurate. Queer visibility seems to be of the latter sort, a true contradiction, which asserts its opposite within itself and has no resolution. The way to understanding, as in so many other cases for queer folk, is through literature and the arts. "In reality opposites are one; art shows this," says the aesthetic realist Eli Siegel (1967).

The principal tools for understanding are words and images, seeing and saying. From language come the notions of rhetorical representation and of cultural interpellation. One observes the broad and inescapable existence of oppositions within any utterance, and the other observes the narrower operation of dominant power on subordinate selfhood and identity. From images come the notions of contrast in art and simultaneous contrast in psychology. One observes the same broad and inescapable existence of oppositions but this time in vision, and the other observes that those contrasts always operate on and change each other. These related notions contribute to a general concept: the difference at the root of all human vision and expression. The concept does not resolve contradictions but heightens awareness of their relationships. A simple acknowledgement that difference is inescapable is the first step toward understanding what is at stake in queer visibility.

That acknowledgement is also the first step toward knowing what to do about queer visibility. The necessary action is to reject the question of visibility, to set it aside, and to choose something other than focusing on queer difference. This path is something like *différance* in post-structuralism (Derrida 1982), a call to defer, delay, and temporize rather than engage in the available stories about queer difference.

In August 2006, the *Advocate College Guide for LGBT Students* listed the University of Illinois at Chicago (UIC) among the most gay-friendly campuses in the United States (Bruce C. Steele & Neal Broverman, "College Made Easy," 29 August 2006, http://www.advocate.com). UIC trumpeted the ranking on its web site and in the campus newspaper, the *UIC News* (6 September 2006, 3). Having experienced harassment at my previous university (Barnhurst 2001), I know how good it is at UIC. But the most recent Campus Climate Assessment found that almost a quarter of LGBT respondents at UIC said they had experienced harassment, almost 19 percent of the men, 29 percent of the women, fully half of the bisexuals, and 100 percent of those in the closet (http://www.uic.edu/depts/quic/oglbc/campus_survey.html). The results reported a significant correlation between harassment and negative assessments of the campus. These two survey results, one national, the other on campus, contradict each other, and they illustrate the trap of difference. Being a gay-friendly campus is good and bad at the same time. It makes the climate intolerable and cause for celebration, each quality heightening the other. But, for me, living in the incongruity of (a) a gay-friendly campus where (b) undergraduates drop my courses upon learning I am gay, the best strategy is to defer, to put to one side this particular difference and move on to other things.

"There is no binary division" that permeates discourse, according to Michel Foucault (1978, 27). Here is a hopeful idea: that somewhere in discourse it is possible to avoid a given paradox. He goes on: "We must try to determine the different ways of not saying these things" (27). Following that advice, queers must find

different ways of not saying such things as these: organizing our stories around the closet, ministering professionally to our invisibility, celebrating our popularity, and hoping for a technological, queer utopia.

REFERENCES

Albers, Josef. 1975. *Interaction of Color*. New Haven: Yale University Press. (Orig. pub. 1963.)

Althusser, Louis. 2000. "Ideology Interpellates Individuals as Subjects." In *Identity, a Reader*, 31–43. Ed. Paul du Gay, Jessica Evans & Peter Redman. London: Sage.

Barnhurst, Kevin G. 1996. "The Alternative Vision: Lewis Hine's Men at Work and the Dominant Culture." In *Photo- Textualities: Reading Photographs and Literature*, 85–107. Ed. Marsha Bryant. London: Associated University Presses.

Barnhurst, Kevin G. 2001. "Waking Up on the Other Side." In *Gay Men at Mid-life: Age before Beauty*, 45–58. Ed. Alan Ellis. New York: Harrington Park Press.

Barnhurst, Kevin G. 2003. "Queer Political News: Election-Year Coverage of the Lesbian, Gay, Bisexual, and Transgendered Communities on National Public Radio, 1992–2000." *Journalism 4*.1 (February): 5–28.

Behrens, Roy R. 1998. "Art, Design, and Gestalt Theory." *Leonardo 31*.4 (Autumn): 299–303.

Berger, Raymond M., ed. 1996. *Gay and Gray: The Older Homosexual Man*. 2nd ed. New York: Harrington Park Press.

Biernat, Monica, Melvin Manis, and Diane Kobrynowicz. 1997. "Simultaneous Assimilation and Contrast Effects in Judgments of Self and Others." *Journal of Personality & Social Psychology 73*.2: 254–269.

Burckell, Lisa A. 2002. *Bibliography on Gay, Lesbian, and Bisexual Issues*. SUNY Stonybrook: Affirm Network. Available at http://naples.cc.sunysb.edu/CAS/affirm.nsf/pages/bib7.

Burke, Kenneth. 1969. *A Rhetoric of Motives*. Berkeley: University of California Press. (Orig. pub. 1950.)

Chevreul, Michel Eugène. 1887. *The Principles of Harmony and Contrast of Colours and their Applications to the Arts*. Covent Garden, UK: George Bell & Sons. (Orig. pub. 1839.)

Derrida, Jacques. 1982. "Excerpt from Différance." In *Margins of Philosophy*, 3–27. Trans. Alan Bass. Chicago: University of Chicago Press. Available at http://www.hydra.umn.edu/derrida/dif.html.

Ellis, Alan, ed. 2001. *Gay Men at Mid-life: Age before Beauty*. New York: Harrington Park Press.

Fenn, Richard. 2003. "Apocalypse and the End of Time." *Daedalus 132*.2 (Spring): 108–112.

Fischer, Hal. 1977. *Gay Semiotics: A Photographic Study of Visual Coding among Homosexual Men*. San Francisco: NSF Press. Available at http://www.queerculturalcenter.org/Pages/HalPages/Gaysemi_1.html.

Foucault, Michel. 1978. *The History of Sexuality: Volume 1: An Introduction*. Trans. R. Hurley. New York: Pantheon.

Hall, Stuart. 1996. "The Question of Cultural Identity." *Modernity: An Introduction to Modern Societies*. Ed. David Held, Don Hubert, Kenneth Thompson & Stuart Hall. London: Blackwell.

Halperin, David M. 1995. *Saint Foucault: Towards a Gay Hagiography*. New York: Oxford.

Helmholtz, Hermann von. 1962. *Treatise on Physiological Optics*, Vol. 2. Trans. & Ed. James P. C. Southall. New York: Dover. (Orig. pub. 1866.)

Ingall, Andrew. 2003. "Media, Message, and Meaning." *CLAGS News 13*.1 (Winter): 15, 20.

James, William. 1981. *The Principles of Psychology*. New York: Dover. (Orig. pub. 1890.)

Killingsworth, M. Jimmie. 2005. *Appeals in Modern Rhetoric, an Ordinary Language Approach.* Carbondale: Southern Illinois University Press.

Kingdom, Fred. 1997. "Simultaneous Contrast: The Legacies of Hering and Helmholtz." *Perception 26*.6 (June). Available at http://perceptionweb.com/perc0697/editorial.html.

Lee, Alan. 1981. "A Critical Account of Some of Josef Albers' Concepts of Color." *Leonardo 14*.2 (Spring): 99–105.

Rothenberg, Randall. 1999. "The Advertising Century." AdAge.com. Available at http://adage.com/century/rothenberg.html.

Sedgwick, Eve Kosofsky. 1990. *Epistemology of the Closet.* Berkeley: University of California Press.

Sheldon, Roy, and Egmont Arens. 1932. *Consumer Engineering: A New Technique for Prosperity.* New York: Harper.

Siegel, Eli. 1967. "Is Beauty the Making One of Opposites?" *Afternoon Regard for Photography*, New York: Aesthetic Realism Foundation. Available at http://www.terraingallery.org/IsBeauty.html.

Stempel, Laura. 1998. "Str8grls." Paper delivered at the Sex on the Edge conference, Concordia University, Montreal, October.

Veblen, Thorstein. 1899. *The Theory of the Leisure Class.* New York: Macmillan. Available at http://www.gutenberg.org/etext/833.

Yoshino, Kenji. 2006. *Covering: The Hidden Assault on Our Civil Rights.* New York: Random House.

Part I
Monsters No More

Progress and Representation

JOHN D'EMILIO

At first glance, the essays in this section could not be more different from one another. Edward Alwood investigates how independent radio and television contributed to a gay and lesbian public presence in the media in the two decades before Stonewall. Not subject to the same corporate pressures as network affiliates, stations in big cities provided homophile activists with the opportunity to broadcast a message of self-acceptance. James Allan looks at movies across four decades. He analyzes the complex messages that filmmakers communicated through the representation of friendships between gay men and straight women. In a semiautobiographical piece, Bruce Henderson examines a work of young adult fiction from the immediate post-Stonewall period. He then traces its metamorphosis two decades later into a movie made by an international superstar.

Different as they are in their subject matter and modes of analysis, the three essays together provoked extended reflection on issues of cultural representation and social change, on how the media and popular culture create and constrain public identities. In particular, they pushed me toward thinking about two issues. One is the idea of progress. It hovers in the background of all three pieces, never named, yet somehow inescapable. Have queer communities witnessed progress or not? Do we believe in it or not? How do we measure progress or determine its achievement? The second issue is the assumption that cultural representation—the images and discourses of homosexuality that flow from and through media and popular culture—vitally shapes

how we understand ourselves and the world around us. Indeed, might cultural representation, the amount and the kind, be somehow determinative of progress?

The idea of progress has a long history in the West. Capitalism is deeply wedded to the notion of progress. It is almost impossible to imagine American capitalism without the notion of progress attached to it. Every time new figures on the gross domestic product emanate from Washington, they serve to mark whether the nation made progress in the last quarter or not. At the same time, the Western idea of progress has not fared well in the twentieth century. Two world wars, the Holocaust, the Soviet gulag, the killing fields of Cambodia, and ethnic cleansing in Bosnia and Rwanda shake one's belief in progress. And yet the idea of progress retains its hold as a way of understanding the world.

As hard a time as a reader might have with the notion of progress, it nonetheless infiltrates these chapters. They are grouped together under the heading, Monsters No More. What is that phrase but a statement of progress? Isn't it nice not to be a monster any longer? Each essay engages this notion in one way or another. I think one would have to say that Alwood's essay is firmly on the side of progress. The effects of those television and radio appearances accumulate, he seems to be suggesting; over time, they take viewers to a better place. Allan's essay is more ambiguous. On the one hand, seeing Rupert Everett portraying a gay man on the screen makes one think, "Gay men have come a long way, baby!" But, when one sees him as part of the longer-running narrative that Allan describes, perhaps these kind-hearted nurturing characters are just another form of containment, locking gay men into a desexualized persona as a way of making them sympathetic. Henderson's chapter is filled with a longing for progress, with a barely hidden desire to have the transformation of a novel from his adolescence into a film of his adulthood replicate the trajectory of his own evolution as an openly gay man. That desire is frustrated as the Mel Gibson film, according to Henderson, remains stuck in a "necrological approach to gay male representation."

For myself, and to my surprise, I came away from these essays wanting to cast my vote firmly on the side of progress: "Yes, there has been some since the 1950s, and don't tell me there hasn't been." But progress is a complicated notion rather than a simple one. It is filled with ambiguities and reversals. Progress can be bittersweet. It can come tinged with regret and longing as much as with jubilation. It can be halting as well as decisive.

The second issue that occupied my attention is the importance of cultural representation. How does it matter, and how much does it matter? Alwood uses the term *breakthrough* in his analysis. This is a powerful descriptor to attach to a two-hour program. It asserts without ambiguity that cultural representation is vitally important. The notion that representation carries great significance is implicit in the structure of Allan's argument. After all, there are not that many gay-man–straight-woman pairings in the forty years of film he surveys, and yet he communicates the sense

that something crucially valuable is at stake in this recurring representation of gay male lives. Henderson lets one know without question that literary representation has immense power. His encounter with a novel has stayed with him for more than a generation; it brought him to the film version of the story with a set of expectations in which he has invested deeply.

It seems no accident that these two issues, the notion of progress and the importance of cultural representation, popped out of these essays. The two topics, separately and entwined, have not only been present in, but have also been central to, the rhetoric of gay and lesbian activists for more than half a century. Peruse the contents of homophile publications like *ONE, The Ladder*, and *Mattachine Review* in the 1950s, and you will encounter, over and over, activists decrying what they called a conspiracy of silence. Ending the silence and shedding invisibility have been goals from the beginning of an organized movement; pre-Stonewall activists used progress in these directions as their measuring rods for success or failure.

Concerns about cultural representation continued in the post-Stonewall era. Again and again, demonstrations against media institutions served as key mobilizing tools. In the wake of Stonewall, gay liberationists in New York staged disruptive actions against the *Village Voice* and *Harper's Magazine*, and, in San Francisco, they targeted the Examiner. In Chicago, lesbians and gay men held noisy demonstrations to protest the homophobic newspaper columns of Ann Landers and Mike Royko. As researchers delve into the histories of other cities, they will surely find additional important instances of activism directed at media. One of the first national mobilizations came in the mid-1970s in the form of coordinated protests against an episode of *Marcus Welby, M.D.*, a popular ABC television series. Larry Kramer's play, *The Normal Heart*, revolves around the silence of the *New York Times* in the early years of the AIDS epidemic and how destructive its refusal to cover the epidemic proved to be. More recently, recall the attention that focused on the coming out of Ellen, a television character of the 1990s, or the plaudits that gay and lesbian organizations have heaped upon *Will & Grace*.

Of course, the goals of shedding invisibility and breaking silence are not as uncomplicated as they sound. The goal has never, in fact, simply been visibility, but rather a particular kind of visibility. Activists did not like headlines about sex deviates and perverts. Nor was it ever simply a matter of ending silence. Instead, who spoke and what they said mattered at least as much. In this regard, one can understand why the activists in Alwood's essay, and Alwood himself, attach so much importance to the programs of independent broadcasters in the 1950s and 1960s. Such affirming programs were so unusual that gays who happened upon them at the time describe viewing the show as a life-changing event.

Yet, is it simply the poles of positive or negative that make cultural representation vital or transformative? Can one ever imagine testimony to the effect that an

episode of *Queer Eye for the Straight Guy* or *Will & Grace* transformed a life? In recent years, both shows are on too frequently, and they compete for attention with too much other queer-friendly programming, to make any one of the episodes particularly significant in an individual's life.

Reflecting on Alwood's characterization, I wonder how significant these early broadcasts were. They are vital to the individuals who encounter them. The moment the program is over, however, the break in the wall of silence repairs itself, rendering the cumulative impact of one particular show negligible. By contrast, *Will & Grace* and *Queer Eye* might thoroughly bore me, but their persistent presence on the air endows them with significance and allows me to think that progress has occurred, that I would rather be in this time and place than in the 1950s.

Just as I am about to rest happy in the conviction that progress, in the form of continuing positive media representation, has materialized over the last half century, Allan comes along to shake my certainties. He asks one to rethink the notion that visibility equals progress or that benign images in and of themselves are good. Transforming gay men into parents might render them sympathetic to a heterosexual audience, but at the price of desexualizing them. Suddenly, what I considered an unreserved good becomes more complicated, even perhaps a bit sinister.

At the same time, one needs to recognize that much more is going on in these films than a simple process of cultural containment, of desexualizing gay men. These films also perform the work of resistance to oppression. Does it matter that gay men are among the creators and shapers of these particular films and screenplays? Does it shift one's perspective to recall that the narratives of gay-as-parent coexist alongside *Sunday Bloody Sunday* (1971) or *In & Out* (1997) or *My Beautiful Laundrette* (1985) or *Midnight Cowboy* (1969)? Is it important to consider whether these gay-man–straight-woman tales might be forms of resistance to the kind of necrological approach that Henderson identifies and that is exemplified by films like *Advise & Consent* (1962) or *The Detective* (1968) or *Cruising* (1980)?

Finally, as I mull over the question of progress and the issue of evaluating the importance of cultural representation, I wonder whether one can ever isolate these matters from particular viewers, from the actual consumers of culture. Is the transformation of *The Man without a Face* from novel to film indicative of broader cultural shifts, conflicts, or continuities? Or is its importance ineluctably tied to particular readers for whom the book participated in their coming of age?

A Gift of Gab

How Independent Broadcasters Gave Gay Rights Pioneers a Chance to Be Heard

EDWARD ALWOOD

During the 1950s and 1960s, an era that considered homosexuality unapproachable for public discussion, several independent broadcast stations risked allowing gay and lesbian activists to appear on radio and television talk shows. These few opportunities allowed gay men and lesbians to discuss homosexuality and the discrimination directed at them in their own words before a mass audience. The broadcasts played an unusual role, beginning to pierce the unofficial veil of media silence that obscured the identity of the fledgling gay movement before the Gay Liberation Movement arose in 1969.

The 1950s in America was a dangerous time to be openly gay. Gay men and lesbians who dared to acknowledge their homosexuality did so at considerable risk. Not only did they face social ostracism if their sexual desires became known, but they also felt the threat of restrictive laws. In many states, homosexual behavior was a felony (D'Emilio 1983). Conviction in New York, for example, carried a maximum sentence of twenty years in jail. Some jurisdictions barred homosexuals from purchasing alcoholic beverages. Pioneering gay activist Don Slater (1995) reports cases of persons arrested and jailed for merely raising the subject in a suggestive manner.

The media did not create oppressive social and political conditions, but their depiction of gays and lesbians as a menace legitimized and perpetuated the image of homosexual as criminal. The mention of homosexuals in the media during the 1940s and 1950s typically involved men arrested in compromising situations at public parks or men who engaged in homosexual activities in the military and received

a dishonorable discharge (Berube 1991, 21). Newspapers and magazines routinely characterized homosexuals as abnormal, corrupt, and evil and as degenerates, dirty pansies, and deviants, to name a few (Bennett 1998, 3). A 1950 *New York Times* headline, for example, said "Perverts Called Government Peril" (19 April, 25). An *Atlanta Constitution* headline in 1954 read, "1,500 Sex Deviates Roam Streets Here" (11 October, 2) The negative depictions generated suggestions for drastic remedies, such as a 1954 headline in the *Miami Herald*: "Just Execute Them All" (13 July, 3-F). At the same time, editors and publishers scrupulously avoided any positive portrayal of homosexuality for fear of offending their audiences (Alwood 1996, 29).

Broadcasters followed a similar approach. A program, "Something Ought to Be Done," on New York radio station WMCA in 1948, for example, aired interviews with the chief city magistrate and an eminent psychiatrist who called homosexuality a serious problem facing the entire city (Duberman 1981). Whenever broadcast and print media broached the topic, they relied exclusively on so-called experts from law enforcement, psychiatry, religion, and public health who could deflect criticism of broadcast by describing homosexuality in the dreariest terms.

Recognizing the influence of the media, pioneering gay and lesbian activists began efforts to counter the trend (Gross 2001, xiv; Streitmatter 1995, 20). A daring few recognized that radio and television offered their best chance to be heard. In the print media, their comments, if included at all, were subject to the whims of reporters and editors, who would select and arrange their comments as the journalists saw fit.

This chapter examines radio and television interviews with gays and lesbians before the 1969 Stonewall riots in New York City, the historical marker of the beginning of the gay liberation movement, to answer three questions: What promoted gay and lesbian activists to discuss their sexuality openly during this era? How did these activists use their appearances to counter prevailing stereotypes? And why did broadcasters risk offending their audiences by including homosexual guests? Articles about the broadcast appearances appeared in pioneering gay and lesbian publications, including *ONE, Mattachine Review,* and *The Ladder,* and several transcripts of appearances also survive. Interviews with gay and lesbian activists of the 1950s supplement the record.

For the growing research on the gay movement before the Stonewall riots (Chauncey 1994), this chapter unearths documents and recollections, adding to research on the role of media play in constructing gay and lesbian visibility (Capsuto 2000), especially television talk shows (Gamson 1998). It also contributes to an understanding of how talk show producers exploit guests to build ratings (Grindstaff 1997, 167) and how gays and lesbians turned guest appearances to their own advantage.

PUTTING A FACE ON HOMOSEXUALITY

In April 1954, Los Angeles station KTTV-TV gave viewers a unique opportunity to learn what it was like to be gay in Southern California. The guests included a policeman, a psychiatrist, and an openly gay man. Producers of *Confidential File* found a willing gay guest by approaching the Mattachine Society, the pioneering gay rights organization Harry Hay and four other gay men in Los Angeles established in 1950 (D'Emilio 1983, 67). Although conservative members recoiled from the invitation, fearing that any contact with television "was like handling nitroglycerine" (Legg 1993, n.p.), more adventuresome members, undaunted by the possible dangers, encouraged the organization's young secretary to accept. Twenty-two-year-old Dale Olson agreed to appear under the pseudonym Curtis White, to protect his identity. His appearance on television may have been the first for any representative of the nascent gay rights movement and the first for any homosexual (Kepner 1998).

The segment, entitled "The Sex Variant in Southern California," began with a brief film clip showing twenty unassuming men and women in a homey living room drinking coffee and eating cookies (*Newsletter* 1954). The host of the show, Paul Coates, began the interviews with the psychiatrist who predictably described homosexuality as a mental illness. He insisted that no one is born homosexual. When Coates asked about any success in treating homosexuals, the psychiatrist said, "It depends on the length of time the problem has existed, the desire of the individual to understand his problem, the availability of psychiatric help" (KTTV-TV 1954, n.p.).

The police detective next expressed concern over "notorious homosexual hangouts" that gave young men an opportunity to meet homosexuals without realizing the risks of developing homosexual tendencies themselves. "Without a doubt there are many young men who have latent tendencies of homosexuality and if they are exposed to the type of person found in these hangouts the chances are that their potentialities will be developed," said the detective.

Coates then turned to a pleasant young man dressed in a coat and tie, his hair slicked back in the 1950s style, introducing him as an "acknowledged homosexual." Speaking unapologetically, Olson told viewers that, unlike the previous guests, he never considered homosexuality a mental illness. He confronted one of the prevailing stereotypes by telling viewers he had never faced arrest. The discussion then turned to another stereotype, mental illness. "If it were possible," Coates asked, "either through psychotherapy or through some physical treatment, for you to be transformed into a heterosexual person, would you desire that treatment?" Olson replied, "I'm speaking only for myself, but the answer is no."

Perhaps the most startling moment came when Coates asked whether Olson's family knew he was homosexual. "Well," he responded, "they didn't up until tonight. . . . I think it's almost certain that they will. I think I may very possibly lose my job too." Startled by the response, Coates asked why his guest would appear on television under such troubling circumstances. "I think that this way I can be a little useful to someone besides myself," Olson said.

KTTV received accolades the next day from many quarters. "Without sensationalism, Coates and his cohorts managed to present this delicate subject in an adult and informative way," a columnist wrote in the *Daily Mirror*. "Coates handled the difficult subject with taste and dignity, pinpointing the social problems raised by the presence in this area of some 200,000 sex variants," said the entertainment industry newspaper *Daily Variety* (*Confidential File*). The praise was especially ironic because the press was celebrating a development that newspapers themselves had failed to anticipate, that is, affording gay men or lesbians access to a public platform where they could speak for themselves.

Olson's appearance said as much about a subtle shift in media access as it did about the willingness of gays to express themselves more openly. *Confidential File* was a locally produced public affairs program on KTTV-TV, a station owned by the publishers of the *Los Angeles Times* and the *Daily Mirror*. It was one of several programs the station developed after station executives dropped its affiliation with the short-lived DuMont Television Network in 1954. The station hired Coates, a popular Los Angeles *Mirror* columnist, who had already an established reputation for tackling taboo subjects in print. "I'll take people where they ordinarily couldn't and wouldn't go," he said when he made his television debut. "It'll be 'Off-Beat Journalism' on TV. It won't be nice, but I believe it will be effective and will make for a better city and community" (Hilgenstuhler 1953, 40). Although Federal Communications Commission (FCC) licensing standards encouraged broadcasters to delve into local issues under the rubric of public affairs programming, few were willing to tackle the controversial subject of homosexuality as Coates approached it in the spring of 1954.

Olson's appearance came not without sacrifice. When he arrived for work the next day, he collided with the harsh reality of the 1950s. His boss had watched the interview and immediately fired him. Two months later, Olson wrote a letter to the editor of *ONE* to reassure gay and lesbian readers. He not only had survived the ordeal but had found another job, and at a higher salary. *ONE* commented in an editorial, "May his courage serve as the example for more and more of us to stand up and be counted. The day will come when thousands and thousands of our people will rise proudly to demand social equality and civil rights" (Freeman 1954, 27).

OPPORTUNITY KNOCKS AT INDEPENDENT TELEVISION

When the gay movement was beginning to form in the United States during the early 1950s, the broadcasting industry was also undergoing a shift brought on by increased competition for viewers and listeners. The 1950s witnessed a rapid growth in the number of U.S. television stations after the federal government lifted its freeze on broadcast licenses following World War II. The expansion of stations and sales of television sets translated into greater competition among broadcasters and a heightened influence of fledgling television networks. NBC and CBS created television programs imitating comedies and dramas that became the heart of programming on radio during the 1930s and 1940s. In response, radio networks branched into other programming, including a surge in talk programs.

Independent television stations, unaffiliated with the two major networks—NBC and CBS—or the fledgling DuMont Television Network, began to search for alternative programming that would allow them to compete with the increasingly influential majors. As a result, independent stations became more accessible to marginalized groups traditionally shunned by major broadcast outlets and the print media. Independent and alternative stations began to experiment with a greater number of programs that tackled unusual topics and featured unusual guests, including gays and lesbians (Head & Sterling 1987).

To be sure, radio and television stations faced pressure from the FCC to carry public affairs programming, which encouraged talk shows. But there was no assurance that the stations would delve into homosexuality; moreover, none of them had any obligation to include gay and lesbian guests. In fact, the National Association of Radio and Television Broadcasters may have discouraged such discussions. Industry standards discouraged broadcasters from showing "illicit sex relations" as "commendable" or as acceptable program material (Capsuto 2000, 22).

In 1958, four years after Olson's television appearance in Los Angeles, producers at New York television station WABD got in touch with the New York Mattachine Society and invited a gay guest to appear on the lunchtime program *Showcase*. DuMont Television, the owner of WABD, was quickly establishing itself as the most progressive of the early television broadcasters. It was a forerunner in featuring black performers when it began airing a fifteen-minute show starring singer Nat King Cole. At a time when many broadcasters and advertising agencies shunned Jews, Allen DuMont took the bold step of appointing a Jewish head of the broadcasting division and managing director of the network. When the man questioned him about the risk involved, DuMont responded, "If somebody doesn't want to give us business because you're Jewish, I don't want their business" (Kisseloff 1995, 63, 218;

see also Jeff Kisseloff, "Battling the Bottom Line in TV's Early Days," *New York Times*, 20 October 2002, IV-27).

The March 10, 1958, segment of *Showcase* examined the increasingly visible homosexual community in New York. Its guests included New York psychologist Albert Ellis, the author of *How to Live with a Neurotic*; Gerald Sykes, an author who had written a *Harper's* article on Freud and Jung; and Gonzolo "Tony" Segura, a gay man identified as "Mr. Grau." A chemist by profession, the Cuba-born Segura was one of the more courageous and outspoken members of the New York group, but he wore a hood to camouflage his face, perhaps aware of the repercussions Olson had faced in Los Angeles (Talbot 1958).

Ellis began by laying out the prevailing medical model that characterized homosexuality as "an unfortunate disease that was more to be pitied than censored." But, among psychiatrists, Ellis represented a notably enlightened perspective on homosexuality and had spoken at meetings of the Mattachine Society. He told television viewers that "many homosexuals lead respectable and productive lives." Segura shifted the conversation to discrimination faced by homosexuals, calling it "a problem affecting every American." He explained that the aim of the Mattachine Society was to achieve acceptance through educational programs for homosexuals and the public. Asked why homosexuals had become increasingly visible since World War II, he attributed it to the public's increased interest in homosexuals. "The friends, relatives, acquaintances, and associates of every American, whether he knows it or not, probably numbers several people who are homosexual," he said ("Mattachine Speaks" 1958, 3).

Gay and lesbian activists hailed the broadcast as "the first daylight telecast on the East Coast devoted to the subject of homosexuality" (Kepner 1998, 240). Again, events dampened the triumph a week later, when the producers canceled a similar broadcast on lesbianism only minutes before air time. Show host Fannie Hurst told viewers that the planned program had "undergone severe censorship" and then introduced a panel of experts to discuss handwriting analysis (Talbot 1958, 10).

A WELCOME AT LISTENER-SUPPORTED RADIO

The late 1950s brought additional opportunities for gays to penetrate the unofficial media veil of silence surrounding homosexuality. Radio station KPFA in Berkeley aired the program, "The Homosexual in Our Society," which ran interviews with the mother of a gay man, a psychiatrist, a criminologist, an attorney, and Mattachine Society President Harold Call (Lasar 2000). Established in 1946 by the Pacifica Foundation, KPFA served as a haven for alternative voices and unpopular

beliefs during the late 1940s and 1950s by encouraging dialogue among persons of diverse backgrounds and beliefs. Along with several other stations owned by Pacifica, KPFA became a refuge that encouraged those with unpopular ideas to speak out.

In early 1958, Elsa Thompson Knight approached the Mattachine Society in nearby San Francisco about a program on homosexuality. A native of Idaho and the daughter of a liberal magazine editor, Knight had grown up in the libertarian atmosphere of Los Angeles during the 1920s. In the late 1930s, she and her British husband moved to Eastern Europe where she taught at the University of Romania. She later joined the BBC, initially as an editor and then as a staff journalist, where she reported on World War II and filed one of the first broadcast reports of the Nazi Holocaust. After the war, she returned to the United States to pursue a broadcasting career (Lasar 2000).

From an early age, Knight had expressed concern about the social stigma associated with homosexuality, having witnessed it firsthand. Although she admired her aunt and uncle, she had found something disturbing about their relationship. Later, she realized that the two had maintained a largely platonic relationship because her uncle was a closeted gay man. In November 1958, the fifty-two-year-old Thompson became the director of public affairs at KPFA and, soon after that, scheduled "The Homosexual in Our Society," for broadcast in two one-hour segments.

Unlike Olson in Los Angeles and Segura in New York, Call used his true identity. He projected a nonconfrontational tone and used the broadcast to emphasize the Mattachine Society mission to promote a better understanding between homosexuals and heterosexuals. He noted that the "problem of homosexuality" was often much closer than most realized, noting that family members, neighbors, co-workers, and friends could be homosexual. "It isn't one of those scourges that is visited on someone here and there, it is quite general in our culture and it spreads throughout our entire population with no respect to economic or intellectual standing," he said (Martin 1959, 7).

Each guest in turn criticized oppressive laws against homosexuals and questioned the belief that homosexuality was a mental illness. Rather than condemn homosexuality, psychiatrist Blanche Baker told the listeners, "I do not look upon homosexuality as a neurotic problem, but more a basic personality pattern reaction. Just as some people prefer blondes and others prefer brunettes, I think that the fact that a given person may prefer the love of the same sex is their personal business." The parent took a similar approach, saying her first reaction to her son's homosexuality was shock, but she quickly added, "I wasn't about to put him out of the family circle just because he happened to have a different sexual attitude." She said her son's disclosure prompted her to try to understand. "You know, the big part of fear is the unknown" (KPFA 1959, 7).

Gays could hardly have found a more understanding or more positive depiction. Enthralled Mattachine Society members arranged to have a complete transcript of the program published in the *Mattachine Review*. Pacifica re-aired the program on its stations in New York, Washington, and Los Angeles. By the end of the decade, homosexuality became accepted as a more legitimate talk show topic, although the programs focused almost exclusively on gay men.

Lesbians began to gain greater visibility by the late 1950s. A 1959 New York radio broadcast, "Should Homosexuals Marry?" included lesbian guests. Because marriage of a same-sex couple was an unimaginable prospect in the 1950s, the discussion revolved around whether closeted gay men should marry women and whether a lesbian should marry a man. "My observation is that marriage of many homosexuals to heterosexuals ends only in chaos," one of the lesbians told the listeners (Brown 1959, 21). In September 1961, the program, *University of the Air*, on New York radio station WEVD, invited a representative of the Daughters of Bilitis, the lesbian organization established in 1955, to discuss the topic, "How Normal Are Lesbians?" ("DOB on New York Radio" 1961).

Like the Pacifica stations, WEVD was a listener-supported station funded through donations. It established its liberal leanings when founded in the 1930s, dedicated to Socialist labor leader Eugene V. Debs, for whom the station adopted its call letters (Glaser 2001). *The Ladder* said only that it "ranged over a wide field of topics related to Lesbianism" ("Some Facts" 1959, 4). The discussion most likely revolved around demographic data collected by Daughters of Bilitis in the late 1950s, in the first statistical studies of lesbians in the United States. Broadcasts on KTTV, KPFA, and WEVD represented a considerable break in the antigay pattern of media coverage, but gays and lesbians would find the media a complex terrain. Each of their breakthroughs would be more episodic than lasting. No single event would influence the media nationwide, and gays and lesbians had to face continued resistance and challenge additional barriers.

LESS TALK, MORE CONFRONTATION

The receptive tenor among broadcasters shifted somewhat in the mid-1960s when talk shows began to experiment with a format that relied on antagonism to spark conflict and confrontation. Phyllis Lyon, cofounder of the Daughters of Bilitis, discovered the shift in an appearance on a Los Angeles talk show. She spent considerable time before the program date providing the producer and the host with a basic understanding that lesbians were no different from other women, except for their affections. To her surprise, when the program went on the air, the polite host asked, "How are you different physiologically from other women?" Lyon sat in

stunned silence. "My mouth dropped to the floor," she later recalled. "I don't recall exactly what I said. But I remember thinking, I don't believe this is happening to me" (Lyon 1992, n.p.).

Some viewers might have celebrated the attack, but others saw Lyon's appearance as a link to greater understanding of themselves and the increasingly visible movement. When Lyon returned from the studio to her office, she found it flooded with telephone calls. Some wanted to know more about Daughters of Bilitis. Others were heterosexual women who called to discuss their annoyance with their husbands. A few wanted to know how they could change their lives for the better. Lyon tactfully assured them, "That's not on our agenda" (Lyon 1992, n.p.).

An even more dramatic confrontation erupted during a 1967 segment of *The Dennis Richards Show*, a call-in program on a Washington, D.C., television station, WOOK. The program featured activists Franklin Kameny and Jack Nichols, cofounders of the Washington Mattachine Society. Both men used their real names. Midway through the segment, the animated host suddenly began pounding his fist on a desk and shouting, "Get off my stage! Get out of my studio, you vicious perverts! You lecherous people! You make me want to vomit!" The outburst stunned Kameny and Nichols. Unexpectedly, callers began to turn on the host. One asked Richards if he was homosexual. "No, I'm not. They are!" he shouted into the television camera ("Washington-Baltimore" 1967, 6).

Several weeks later, the producers invited Kameny and Nichols back on the program, this time accompanied by Lilli Vincenz, one of the few women members of the organization. "The second time he was as sweet as can be," recalled Vincenz. "I don't know if I made a difference, or if he had a change of heart and realized that wasn't the way to deal with gay people." Richards never offered an apology. "The public didn't know that the stereotype wasn't true of the majority of gay people," she said. "Once we started appearing on TV and on talk radio shows, they started seeing us more real. A lot of people connected because of our visibility" (Vincenz 2001, n.p.).

Perhaps the strangest confrontation took place in a November 1961 segment of *The Ben Hunter Show* on KTTV, the same Los Angeles station that ran the White interview seven years earlier. Panelists included a psychiatrist, a municipal judge, and a Los Angeles attorney who was not gay but served as the Mattachine Society legal counsel. At one point, a heated discussion erupted after Judge Arthur S. Guerin claimed that gays became homosexuals "because they were seduced by sailors when they were twelve or thirteen years old." Attorney Herbert Selwyn challenged the characterization by saying teenagers more often preyed upon homosexuals than the reverse. In a fit of intense anger, the judge suddenly slumped in his chair, and the host went into a panic and stopped the show. An ambulance rushed Guerin to a nearby hospital where doctors determined that he had suffered a serious stroke.

He died two months later at age sixty-two (Selwyn 2001, n.p.; "Judge Guerin Collapses on TV Show," *Los Angeles Times*, 26 November 1961, A-3; "Arthur Guerin, City Judge for 25 Years, Dies," 13 January 1962, A-2).

GAY ACTIVISM INTENSIFIES

One of the most significant gains for gays in New York City came in the summer of 1962 at WBAI radio. Like KPFA in Berkeley, the station was a Pacifica Foundation property that subscribed to the same social philosophy of providing a platform for marginalized groups. The station had aired a panel of antigay psychiatrists, prompting gay activist Randy Wicker to march into the station and demand that gays be allowed to speak for themselves. "We're the real experts on ourselves," he told the startled station manager. WBAI agreed to Wicker's demands, provided he would arrange for several gay guests. But Wicker ran into strong opposition from conservative Mattachine Society members, who steadfastly refused to support the project.

Refusing to be swayed by dissension within the ranks, he established the Homosexual League, a front organization with no members. He would use this organization to conduct a campaign for visibility in the New York media. His first project was WBAI, and he set out to reach as many men as he could find who would be willing to speak openly on the radio. The program aired on July 16, 1962, featuring six gay men who discussed promiscuity, social responsibilities of gays and nongays, careers, and problems with the police.

He used a pseudonym, "Randolfe Wicker," a name he legally adopted after his father objected to his using the family name in media appearances (Wicker 2001, n.p.). The host guided the discussion with questions: "Is there harassment?" he asked. "Yes," said one of the guests. "I work in a firm that specializes in minority groups. They know what I am, and I work in spite of it. But I work for a lot less salary than I would elsewhere." Another described police harassment: "[The officer] roared up, jumped out of the car, grabbed me, and starting giving me this big thing about 'What are you doing here, you know there are a lot of queers around this neighborhood.' He said, 'You know, there's only one thing worse than a queer, and that's a nigger' " ("Live and Let Live" 1962a; "Live and Let Live" 1962b).

Much of the broadcast sank into tedious arguments over the nature of homosexuality and the competing cultural values of homosexuals and heterosexuals, but it was a breakthrough in New York City broadcasting. What made it unusual was the absence of the obligatory antigay psychiatrist or law enforcement officer, standard fare at most stations that had taken up the subject. The *New York Herald Tribune* called the program "the most extensive consideration of the subject to be heard on American radio" (Ann Warren Griffith, "Conversation at Midday,"

9 March 1958, television sec., 7). *Newsweek* praised WBAI for allowing homosexuals access to the public airwaves without "expert" testimony from mental health or law enforcement officials ("Minority Listening," 48; see also "Radio: Taboo Is Broken," *New York Times*, 16 July 1962, 48).

Soon after the broadcast, however, a group of disgruntled listeners retaliated against WBAI by filing a grievance with the FCC to block the renewal of the station's broadcast license. Ultimately, the FCC ruled in favor of WBAI and granted the license, saying that denial of broadcast licenses based on content would mean that "only the wholly inoffensive, the bland, could gain access to the radio microphone or TV camera" ("Cross-Currents" 1964, 11). In effect, the FCC lifted a barrier that blocked many broadcasters from addressing topics related to the gay community by signaling that homosexuality had become a topic that would not jeopardize station licensing. Almost immediately, homosexuality became an acceptable topic on popular urban radio talk shows in major broadcast markets, including Chicago, Boston, Los Angeles, and Baltimore. Gay activists told the Chicago television talk show, *Off the Cuff*, that homosexuality was nothing to be ashamed of. "It is not a disease, a pathology, a sickness, a malfunction, or disorder of any kind," said gay activist Franklin Kameny ("Special Report" 1964, 9). Del Shearer, president of the Chicago chapter of Daughters of Bilitis, said, "Yes, it is possible to be a happy homosexual," directly contradicting the conventional wisdom among psychiatrists that homosexuals were constitutionally incapable of happiness (10). "Much of the research on homosexuality is contradictory," said Randy Wicker. "There is too much bogus authority, too many pat cures, too many charlatans in this area" (11).

Continuing his media activism, Wicker appeared in early 1964 on the popular *Les Crane Show* and became the first openly gay guest on a New York television talk show. Unlike his predecessors, he agreed to appear without concealing his true identity or his appearance. He talked about his life as a gay man who moved from his native Texas to New York City in the 1950s, and he responded to telephone calls from viewers. "I know my uncle is gay and I'm worried about my kids being around him," said one caller. "You should let your uncle know that you know he's gay, and that you're not worried about your children being around him," Wicker responded. "I know it's unlikely, but that would minimize [the awkwardness] even more" (Wicker 2001). Jerry Hoose, a resident of Queens, remembered watching the program at home. He had been out to his family for several years. The segment on the *Les Crane Show* left him convinced it was time to join the gay movement and move to Greenwich Village (Hoose 1992).

Wicker soon learned that his achievement with the local program did not extend to a national audience. ABC Television began carrying Crane's show, and the producers scheduled another segment on homosexuality. They invited members of the Daughters of Bilitis to appear on a panel while the organization was holding its

national convention in New York City. But, shortly before the telecast, network officials abruptly canceled the show. Conservative station owners in rural areas had threatened the network, vowing to drop the program if ABC "put perverts like that on the air" (Wicker 1971).

At the same time, more breakthroughs occurred among local broadcasters. Gay guests on a Philadelphia radio show in 1963 credited the host for setting an "intelligent and sensible" tone that made their "harrowing experience" worthwhile. "Mr. Harvey caters to a middle-class, somewhat parochial, audience," said one. "His listeners are often those people we label as 'Society'—the agitators as it were, who, because of misinformation and lack of education condemn that which they do not understand. Because of his intelligent approach and honest compassion, Harvey was able to make his listeners feel that homosexuals are not ugly or sick as some people would perhaps imagine. If nothing else, Harvey's broadcast succeeded in sowing a few empathetic seeds for the homosexual" ("Comment" 1963, 2).

BREAKING THROUGH ON A NATIONAL SCALE

Gays did not gain access to a national audience until 1967, when *The David Susskind Show* broadcast a segment entitled, "Sickness or Perversion." Well-known theater and television producer David Susskind began his broadcasting career in 1958 with *Open End*, a late-night talk show that aired primarily on public television stations in major cities. In 1967, the show went into syndication as *The David Susskind Show* and aired on independent and public television stations in a host of cities, including Boston, Chicago, Denver, Detroit, Grand Rapids, Honolulu, Houston, Los Angeles, and Miami. Under the syndication arrangement, Susskind retained the power to decide what subjects to discuss and which guests to invite, without having to concern himself with network executives watching over his shoulder (*Broadcasting* 1967; Head & Sterling 1987).

Susskind had addressed homosexuality on a segment of *Open End* in the 1950s, but the lineup did not include a gay or lesbian guest. Beginning in 1965, Wicker began urging the producers to examine the subject again, only this time with a gay guest. "It's still a bit too controversial for us," one of the producers told him, "maybe next year." The producers relented in 1967 and invited New York Mattachine Society President Dick Leitsch, along with two prominent New York psychiatrists, for a show to discuss homosexuality (Wicker 1971).

Susskind began the show by expressing fascination at the apparently increased number of homosexuals in America. "Why does a person become a homosexual?" he asked, turning to Dick Leitsch. "Was it always latent?" Susskind continued. "Latent?" Leitsch responded, seeming surprised. "No, as soon as I discovered that I was

a homosexual I went out and found a way to be a homosexual," he said without apology. Lawrence Hatterer, a New York psychiatrist who subscribed to the medical model of homosexuality as a mental illness, challenged Leitsch. "Why don't we ask the question this way," Hatterer asked, "What is it that makes a person prefer his sexual satisfaction with a member of the same sex as opposed to a member of the opposite sex? Why would someone prefer a less adequate form of sexual satisfaction than the more normal and more satisfactory one? When you look at the problem this way, we find that every homosexual is an emotionally disturbed person" (*David Susskind Show* 1967, n.p.).

Seated in the audience, Wicker could barely contain himself. The producers had not included him among the guests because he was not an official representative of the Mattachine Society. He squirmed in his seat as Leitsch seemed to struggle to make a good case for homosexuals. When Susskind invited questions from the studio audience, Wicker seized the opportunity to voice a more forceful argument. "I've been homosexual I guess since I was five or six years old in an emotional and intellectual sense, having crushes on other playmates and wanting to befriend them and get to know them better," he said. "I've been actively and happily homosexual for the last fifteen years. In my view point, and the viewpoint of many happy, healthy homosexuals, who these psychiatrists would never see and never bleed for money, is that a positive thing?" Then Hatterer jumped in. "Homosexuality is not an illness but a symptom of an illness," he said. "Emotionally disturbed people have some problems with sexuality" ("Suskind's Homo Seg," 1967, 38).

Susskind jumped to Wicker's defense, although it may only have been an attempt to enliven the exchange. "That young man, is he ill?" Susskind asked Hatterer as he pointed to Wicker in the audience. "He may be here to convince us and to convince himself that he's happy," Hatterer responded before Susskind interrupted. "Is it your business to convince him he's unhappy?" Susskind asked. The studio audience burst into laughter and applause (*David Susskind Show* 1967, n.p.).

The program brought Susskind his largest audience in the four months the program had been on the air ("Susskind's Homo Seg" 1967, 38). It received a rave review in the entertainment newspaper *Variety*. "The homosexual legion have seldom had it so good in full public view," it said. "Their spokesman Mattachine Society prez Dick Leitsch made it seem mostly logical and right in the face of some fumbling and even foggy theorizing by a pair of psychiatrists on and before the 80 minutes or so closed on the topic. Even host Susskind was up to admitting some of his going-in notions had been shaken" ("David Susskind Show" 1967, 46).

The segment proved popular in New York, but it hit a snag in Pittsburgh where a school board member threatened to cut off funding for the public television station that carried the show. He dropped his objections, however, after the *Pittsburgh Post-Gazette* rallied to the station's defense. "Though Susskind's 'Open

End' is often controversial . . . this should not be taken as a pretext for someone to organize pressure groups to douse the show," the newspaper was quoted as saying ("Susskind's Homo Show" 1967, 33).

That year, CBS took the bold step of airing the first network documentary on the subject, "The Homosexuals," which included comments from several gay men (but never mentioned lesbians). Host Mike Wallace asked gay activist Jack Nichols, "What do you think caused your sexual orientation?" Nichols responded, "I have thought about it, but it really doesn't concern me much." He explained that he had no more guilt about his homosexuality than about his blond hair or light skin ("The Homosexuals" 1967, n.p.). Highly edited documentaries did not offer gays the same freedom to express themselves and to challenge stereotypes as interview programs did.

Susskind pushed the limits again in 1971 when he broadcast two gay-themed shows, one a panel of seven lesbians discussing the topic, "Women Who Love Women." In the case of gay women, Susskind felt no obligation to include a psychiatrist or other expert to argue the other side. When he asked one guest when she realized she was lesbian, author Barbara Love asked when Susskind realized he was heterosexual. Lesbian activist Barbara Gittings told Susskind, "Homosexuals today are taking it for granted that their homosexuality is not at all something dreadful—it's good, it's right, it's natural, it's moral, and this is the way they are going to be!" The studio audience burst into applause (Tobin & Wicker 1972, 220).

Throughout the 1970s, Susskind continued to invite gay guests to discuss such topics as gay couples, gay marriage, gays who came out of hiding, and gays in professional sports. "Since 1958 Susskind's shows have provided more national air time for homosexuals than has any other program," said a 1978 article in the gay newspaper, the *Advocate* (Chesley 1978, 12). Talk show host Phil Donahue also began to include gays on his Dayton, Ohio, television show in 1968. "I was so scared," he told *TV Guide*. "A woman called in and asked, 'How's Phil look to you?' My career passed before my eyes. I felt, oh my gosh, everyone is going to think I am gay. That's what you were afraid of in those days" (Simon 1978, 28).

Donahue continued to include gays when his show became nationally syndicated in the early 1970s, tackling nearly every facet of the gay experience and prompting the *Advocate* to proclaim him in 1980 "The Host Who's Done the Most" (Baker 1980, 31). But gays disagreed over whether their acceptance by talk show hosts revealed a friend or a television personality who was exploiting them for ratings. David Susskind, for example, expressed incredulity before the taping of this 1967 program that some professionals did not consider homosexuality a mental illness. When he invited lesbians on his program, he disclosed that he would be "very upset" if he learned that his children were gay, because he regarded it as "a sickness derived from some form of family disorganization," prompting the studio audience to respond with hissing sounds (LeRoy 1971, 5; Wicker 1971).

A single program would have had a negligible impact on public opinion generally, but the programs left a lasting impression among gay men and lesbians, many of whom lived in isolation. Mark Segal, who later became the publisher of *Philadelphia Gay News*, remembered watching the program as a sixteen-year-old. "I had a little 9 inch, black & white portable TV in my bedroom and I remember getting my blanket and putting it over my TV because I was ashamed that anybody might hear or see me watching the show," he said. "I realized that if that could help educate me to some extent, imagine what it could do for other people who didn't have the feeling I had or did not realize they were in the same position I was in" (1993, n.p.). A Susskind segment on homosexuality in 1964 brought an outpouring of letters and phone calls from viewers who said they had never heard a gay person on radio or television before (Chesley 1978). "I didn't care if there was this element of the freak show," recalled Lilli Vincenz who appeared on the lesbians segment. "I knew I wasn't a freak and nobody ever openly was insulting to us either" (2001, n.p.).

WELL SPOKEN, UNAFRAID, UNASHAMED

Regardless of what gay and lesbian guests said during the interviews or the reception they received from hostile hosts, their willingness to acknowledge their homosexuality publicly spoke volumes to other gays and to the public at large. Their appearances alone countered the prevailing stereotype that painted gays as too timid and ashamed to make themselves known. Gay and lesbian guests appeared well spoken, unafraid to make their sexuality known, and unashamed to talk openly about their desires for relationships with the same sex. Some made forceful arguments against discrimination and for social justice.

The appearances during the 1950s and 1960s demonstrated how broadcasters on the margins—independent, nonaffiliated, listener-supported stations—were more willing than their mainstream counterparts to allow gays and lesbians to speak for themselves. The desire to attract a larger audience surely motivated the producers of some programs, but others took the unusual step of including gays and lesbians within the realm of social responsibility of broadcasters to inform their communities. Producers found gays and lesbians increasingly willing to appear and found viewers and listeners less offended than expected. To the contrary, discussions on unusual and controversial topics, including homosexuality, attracted radio and television audiences.

One cannot overstate the significance of the broadcasts within the fledgling gay community during the 1950s and 1960s. Even those who could not see or hear the broadcasts read accounts of the appearances in the fledgling gay press—*ONE, Mattachine Review, The Ladder*, and the *Advocate*. Each appearance provided greater

incentive for more appearances and for heightened public visibility. After 1969, gay and lesbian activists used a variety of strategies to protest when mainstream outlets failed to include gays or lesbians in discussions about homosexuality. Although they may have been confronting the media transgressions of the moment, in the long run, they were continuing the process that pioneering gay and lesbian activists had begun almost two decades earlier.

REFERENCES

Alwood, Edward. 1996. *Straight News: Gays, Lesbians & the News Media*. New York: Columbia University Press.

Baker, Joe. 1980. "The Host Who's Done the Most." *Advocate*, 7 August, 31.

Bennett, Lisa. 1998. "The Perpetuation of Prejudice in Reporting on Gays and Lesbians: *Time* and *Newsweek*, the First Fifty Years." Research Paper R21, Joan Shorenstein Center, Harvard University, September. Available at http://www.ksg.harvard.edu/presspol/research_publications/papers/research_papers/R21.pdf.

Berube, Allan. 1991. *Coming Out under Fire: The History of Gay Men & Women in World War Two*. New York: Plume.

Broadcasting. 1967. 9 January, 51.

Brown, Patti. 1959. "Should Homosexuals Marry?" *The Ladder*, May, 21.

Capsuto, Steven. 2000. *Alternative Channels: The Uncensored Story of Gay & Lesbian Images on Radio and Television*. New York: Ballantine Books.

Chauncey, George. 1994. *Gay New York: Gender, Urban Culture, and the Making of the Gay Male World 1890–1940*. New York: Basic Books.

Chesley, Robert. 1978. "David Susskind or Unkind?" *Advocate*, 20 September, 12.

"Comment on a Breakthrough." 1963. *Janus Society Newsletter*, February, 2.

"Confidential File," *Daily Variety*, 4 May 1954, 9.

"Cross-Currents." 1964. *The Ladder*, April, 11.

"The David Susskind Show." 1967. *Variety*, 15 February, 46.

The David Susskind Show. Audio recording. 1967. WNEW-TV, New York City, 12 February. Gay and Lesbian Archives of Philadelphia, William Way Community Center, Philadelphia.

D'Emilio, John. 1983. *Sexual Politics, Sexual Communities: The Making of a Homosexual Minority in the United States, 1940–1970*. Chicago: University of Chicago Press.

"DOB on New York Radio in September." 1961. *The Ladder*, August, 7.

Duberman, Martin. 1981. "1948." *New York Native*, 29 June–12 July, 15.

Freeman, David L. "One Salutes Curtis White." *ONE*, May 1954, 27.

Gamson, Joshua. 1998. *Freaks Talk Back: Tabloid Talk Shows and Sexual Nonconformity*. Chicago: University of Chicago Press.

Glazer, Ruth. 1955. "From the American Scene." *Commentary*, April, 396.

Grindstaff, Laura. 1997. "Producing Trash, Class, and the Money Shot: A Behind-the-Scenes Account of Daytime TV Talk Shows." In *Media Scandals: Morality and Desire in the Popular Culture Marketplace*, 164–202. Ed. James Lull & Stephen Hinerman. New York: Columbia University Press.

Gross, Larry. 2001. *Up from Invisibility: Lesbians, Gay Men, and the Media in America*. New York: Columbia University Press.

Head, Sydney W., and Christopher H. Sterling. 1987. *Broadcasting in America*, 5th ed. Boston: Houghton Mifflin.

Hilgenstuhler, Ted. 1953. "Is Paul Coates a TV Fluke?" *TV-Radio Life*, 11 December, 40. From the collection of Roger M. Grace, *Metropolitan News-Enterprise*, Los Angeles.

"The Homosexuals." 1967. *CBS Reports*, 7 March.

Hoose, Jerry. 1992. Interview with the author, New York City, 9 November.

Kepner, Jim. 1998. *Rough News—Daring Views: 1950s Pioneer Gay Press Journalism*. New York: Haworth Press.

Kisseloff, Jeff. 1995. *The Box: An Oral History of Television, 1920–1961*. New York: Viking.

KPFA. 1959. "The Homosexual in Our Society: Transcript of a Radio Program in Two Parts." Paperback pamphlet. San Francisco: Pan-Graphic Press.

KTTV-TV. 1954. *Confidential File*. Transcript, 25 April, 28–29. Mattachine Society, ONE, Inc., Papers, Baker Memorial Library, Los Angeles.

Lasar, Matthew. 2000. *Pacifica Radio: The Rise of an Alternative Network*. Philadelphia: Temple University Press.

Legg, W. Dorr. 1993. Interview with the author, Los Angeles, 8 February.

LeRoy, John P. 1971. "The David Susskind Follies." *Gay*, 8 November, 5.

"Live and Let Live." 1962a. *The Realist*, 1 August.

———. 1962b. *The Realist*, 12 October.

Lyon, Phyllis. 1992. Interview with the author, Los Angeles, 15 September.

Martin, Del. 1959. "2-Hour Broadcast on Homophile Problem." *The Ladder*, January, 7.

"Mattachine Speaks Out on TV!" 1958. *The Ladder*, April, 3.

"Minority Listening." 1962. *Newsweek*, 30 July, 48.

Newsletter. 1954. San Francisco Mattachine Society, 25 June.

Segal, Mark. 1993. Interview with the author, Philadelphia, 24 March.

Selwyn, Herbert. 2001. Interview with the author, Los Angeles, 26 January.

Simon, Roger. 1978. "There's No Phil Donahue without the Audience." *TV Guide*, 27 May, 28.

Slater, Don. 1995. Letter to the author, 3 May.

"Some Facts about Lesbians." 1959. *The Ladder*, September, 4–26.

"Special Report: Off the Cuff." 1964. *The Ladder*, October, 9–11.

Streitmatter, Rodger. 1995. *Unspeakable: The Rise of the Gay & Lesbian Press in America*. Boston: Faber and Faber.

"Susskind's Homo Seg Whips Up a Rating." 1967. *Variety*, 22 February, 38.

"Susskind's Homo Show Puts Carrier WQED on ETV Hot Seat in Pitt." 1967. *Variety*, 22 February, 33.

Talbot, Lorrie. 1958. "*A Daughter Watches T.V.*" *The Ladder*, 19 March, 10.

Tobin, Kay, and Randy Wicker. 1972. *The Gay Crusaders*. New York: Paperback Library.

Vincenz, Lilli. 2001. Interview with the author, Washington, DC, 31 January.

"The Washington-Baltimore TV Circuit." 1967. *The Homosexual Citizen*, Newsletter of the Mattachine Society of Washington, May, 6.

Wicker, Randy. 1971. "Randy Wicker Goes behind the Screen with David Susskind." *Gay*, 26 April, 4.

———. 2001. Interview with the author, New York City, 31 January.

The Man without a Face

Homosexuality, Homophobia, and Homoerasure

BRUCE HENDERSON

The Man without a Face, *a 1973 novel, set a benchmark in representing relationships between teenage boys and older teacher-mentors. Even within a rhetoric accepting of homosexuality, it resorted to familiar tropes from the Gothic novel, in effect reinscribing the homosexual as monster in the eyes of townspeople in the novel's setting. Mel Gibson's 1994 film adaptation erases the teacher's homosexuality but reinscribes homophobia by inventing a neurotic gay student in the teacher's past, leading to a charge of pedophilia in the present time of the film. This essay explores difficult contrasts between the de-gayed film character and the novel's gay-teacher-as-predator.*

Entering adolescence in the late 1960s, I often visited the children's/young adult section of the Oak Park Public Library. I was already moving on to the adult section for most of my reading choices, but I liked to visit and talk with librarian Margaret Bush. Miss Bush (as I always called her) was a tall, dynamic woman in her mid- to late-thirties who sometimes referred to her female roommate. She introduced a generation of young persons to such books as Louise Fitzhugh's *Harriet the Spy* (1964) and E. L. Konigsburg's (1967) series of sophisticated novels for young readers. She instituted a summer book group for middle school students and treated our opinions about these books and the issues they raised with the same seriousness she gave to adults.

From time to time, Miss Bush would slip me a new book and say, "Read this, and tell me what you think." I took those assignments more seriously than the formal

schoolwork requiring a theme about *Treasure Island* or a character analysis of Bilbo Baggins. I also knew intuitively not to discuss these books with my parents. I was participating in a subcultural experience of the closet as a place of shared, privileged discourse.

In 1972, during one of my now infrequent trips to the children's/young adult section of the library, Miss Bush handed me Isabelle Holland's just published novel, *The Man without a Face:* "I was just thinking about you. Read this—tell me what you think." At this point in my life, I was just beginning to struggle consciously with my own sexual identity. I read the novel, returning it to her with the comment that it was interesting but that the narrator-hero seemed a little whiny. "What did you think of the scene where they had sex?" *WHAT?* "I don't think it really means they had sex—just that Charles was upset and McLeod comforted him." (I still don't think I was fully aware that McLeod was gay—or I had repressed this fact in my reading of the novel.) "Oh, I think it's pretty clear," she said, with a smile.

As I continued my process of coming out, haunted by *the man without a face*, the novel and the figure, I came to see that Miss Bush was right—it was clear that McLeod was gay. Then, in 1993, Mel Gibson directed and starred in a film adaptation of the novel. I could scarcely believe it: Mel Gibson, macho film star, fervent Catholic, pro-life advocate, teller of homophobic of jokes on- and off-screen, playing Justin McLeod, a homosexual teacher? When I saw the movie, however, I understood: Mel Gibson had profoundly altered what the novel had meant to me.

In this essay, I first analyze the novel's deployment of homosexuality as character trait and plot point and then consider Gibson's transformation of its homosexual elements into the more traditional teacher-student relationship in which the teacher takes on the role of substitute father. The novel and film share a realistic Gothic perspective with some of the traditional elements of the Gothic novel, such as the monster and the haunted house translated into more quotidian elements of the disfigured face and the hermit's house. Homosexuality is more visible in the novel than in the film, but the suggestion (and fear) of homosexuality is not absent from the film. Many Gothic novels and most young adult novels from that era insisted on killing the monster—even a good, friendly, repentant homosexual; the movie allows its monster to live, so long as he is absolved of any libidinal interest in the fair lad.

THE MAN WITHOUT A FACE: *THE NOVEL*

Holland's novel centers on protagonist-narrator Charles Norstadt, a fourteen-year-old boy in a summer seaside New England town. He and his family live in New York City the rest of the year. Problem women surround him: His mother, a bitter, four-time

divorcée, seems to spend most of the summer either searching for a new husband or carping on Charles's shortcomings. His older stepsister Gloria is a shrewish seventeen-year-old, and his younger stepsister Meg loves him and is constantly fighting a weight problem. Charles's father died years ago, and a major plot point is the revelation that he died an alcoholic on skid row. Charles has deliberately flunked his entrance exam to a third-rate prep school, where all his male relatives go by tradition at age fourteen. When Gloria decides to leave her own boarding school and return home, Charles urgently wants to escape this all-female domestic space and reapply to St. Mathews. His only chance is to retake the entrance exam.

Enter Justin McLeod, the titular man without a face. As critic-librarian Alan Cuseo has pointed out, McLeod is a figure out of the Gothic tradition, the mysterious hermit with a shadowy past, a past written on his face (1992, 338). He is introduced with this epithet on the first page, with the explanation that nobody knows how he got this way. Cuseo also views the novel as part of a longstanding tradition of teacher-as-homosexual tropes. In such novels, there is a spoken or unspoken fear of pederasty, pedophilia, and the sexual predator; part of such novel's rhetorical work is to resist these constructions. At Meg's suggestion, Charles approaches McLeod, who is rumored to have been a teacher, and asks him to tutor him for the reexamination. McLeod grudgingly agrees. The novel traces the growing friendship between teacher and student as Charles learns not only how to translate Latin but also how to relate to another male figure.

About two-thirds of the way through the novel, McLeod reveals to Charles that he was disfigured in a car accident while driving drunk and that a student riding with him was killed. McLeod spent two years in jail and lost his job as a teacher (too coincidentally, at St. Mathews). In what is perhaps one of the most touching turning points of novel, Charles reaches out to McLeod:

> "Look," I burst out. I was determined to have my say. "About what you told me yesterday. About the accident—" I kept my eyes on the table where I was nervously turning the cookie dish around and around. "What I want to say is—well, it was lousy thing to happen to you, and it probably wasn't your fault."
>
> "You're wrong. It most definitely was—"
>
> "All right. So it was. What I mean is—" I wanted so badly to tell him how I felt, but I couldn't find the words. Then a strange thing happened. Without my volition, my hand reached towards his arm and I grasped it.
>
> He didn't move or say anything. The good half of his face was as white as paper. Then he jerked my hand off and walked out. (93)

Charles responds defensively, seeing McLeod, who has advised him to reach out to others, as a hypocrite, and also assuming that McLeod's response comes from a subtext of homophobia: "Like, for Pete's sake, I had made a pass at him" (94).

Later, Charles and McLeod discuss the incident, still obliquely, make up, and go for a swim together. In an interesting detail, which has Oedipal and pedophiliac resonance, McLeod lends Charles a swimming suit that was his when he was younger, and, in trying to get Charles to explain why he is still upset, addresses him as son. There is something idyllic about the scene, and yet, to minds perhaps too conditioned to stories of Michael Jackson and to litanies of priestly abuses, there is something that seems to blur boundaries between teacher and student. Perhaps not by accident, McLeod spends so much time working on the classics with Charles. The novel may be trying to invoke the teacher-student relationships of ancient Greece in a way that may not be recoverable in a modern landscape. McLeod goes so far as to put his arm around Charles and hold his hand. Charles describes the coloring and bifurcated physical appearance of McLeod's close-to-naked body: "all over one side of his body and down his leg were burns, some red, some pale, the skin shiny. Like his face, the other side was good—very thin, except for the hard muscles around his shoulders and arms and thighs" (116). Again, the description could be out of Victorian erotica, the almost Jekyll-and-Hyde physicality of the Gothic invert.

The physical, although remaining innocent of actual genital contact, moves into the romantic and even spiritual, as well as the (unconsciously perhaps for Charles) erotic:

> I could imagine what all the kids I knew . . . would say about the way I felt about McLeod. But here, lying beside him on the rock, I didn't care. I didn't care about anything. Everything else, everybody else, seemed far away, unimportant.
>
> "I like you a lot," I said.
>
> There was something in his hand or mine, I couldn't tell which. I wanted to touch him. Moving the arm that had been across my eyes, I reached over and touched his side. The hot skin was tight across his ribs. I knew then that I'd never been close to anyone in my life, not like that. And I wanted to get closer. (120)

(I am now amazed that I could have missed the erotic force of such a description, even considering my age [fourteen] and state of denial.) It is interesting that Charles needs to see as much of McLeod's body to know him—and to know his own feelings. McLeod abruptly moves, and the moment is gone, although not lost: As Charles says at the end of the chapter, "I felt like I was in a sort of golden cocoon and didn't want to break out of it" (121).

The golden cocoon sustains Charles until the final climactic night, the night that provides the novel's most overt depiction of homosexuality. It begins when Gloria reveals to Charles how their father died. In his distress, Charles runs impulsively to Justin (as McLeod now prefers to be called), where his entrance into the bedroom is unexpected: "I saw Justin reach for his robe and pull it around him as he got up. . . . But it was too late for that," (147). Charles, like Noah's son Ham, has looked upon his (father's) nakedness—except that Justin is no longer a father per

se, or only a father. What follows is a passage of romantic indirection, the one that allowed me as a younger reader to misunderstand what happened:

> The gasps seemed to come from my knees, shuddering through my body. Justin reached me and put his arms around me and held me while I cried out of some ocean I didn't know was there. I couldn't stop. After a while he lifted me up and carried me to the bed and lay down beside me, holding me.
>
> I could feel his heart pounding, and then I realized it was mine. I couldn't stop shaking; in fact, I started to tremble violently. It was like everything—the water, the sun, the hours, the play, the work, the whole summer—came together. The golden cocoon had broken open and was spilling in a shower of gold.
>
> Even so, I didn't know what was happening to me until it had happened. (147)

Reading this description thirty years later, I recognize in it the novelistic conventions of early modernists like Flaubert, James, Lawrence, Joyce, and Woolf, who used metaphor and metonymy to convey sexual responses. One can see how a reader not attuned to these conventions or one with an investment in denying the erotic and sexual possibilities of the situation could come up with an equally metaphoric reading that sees the moment as Charles's finding emotional intimacy with the father he never had. This reading even appears in the text, in paternal-filial language leading up to the scene. Nevertheless, most of the favorable critics Cuseo surveys in his book view the moment as a genuine homosexual encounter, a moment of erotic content, even if Charles does not yet have the language and experience to name it as such.

The next morning, with some remorse and some awkward moments, Justin tries to discuss what happened, and Charles tries to avoid it. Charles sees the discussion as the event that means, "everything would be over" (148). He is able to acknowledge to himself that he has been the one to reach out physically to Justin, but this moment is not a coming out for him. Justin tries to explain to Charles that a single encounter does not necessarily mean he is gay (although the word is never used—here or elsewhere in the book), but Charles fires back, asking Justin what it means about Justin. Justin responds ambiguously, "I've known what I was for a long time" (149). Again, the language of self-labeling and self-objectifying feels of its time: "what I was"—a homosexual, a pederast, a monster? Or is it just awkward language —not wanting to give a specific name to identity?

The two men (Charles doesn't feel like a boy anymore) are at an impasse, but the arrival of Barry, Charles's soon-to-be-stepfather, saves them. Presented sympathetically in the novel, Barry, it turns out, has known Justin. Barry takes Charles home and, with some symbolism, addresses him as son. The novel then jumps forward. Charles has passed the entrance exam and is at school, where he is haunted by the memory of Justin: "That night I dreamed about Justin. It was like the dream I had had before. But Barry was in it this time. He was holding the little snapshot of my father and saying, 'But, Chuck, *he's* The Man without a Face. Not Justin' " (153).

Charles runs away from school, determined to see Justin, but, as in all Gothic tales, the house is a haunted one—empty of Justin. Charles takes down one of the books Justin wrote and finds a letter, where Justin reassures him about their relationship and adds, "You gave me something I hadn't ever again expected to have: companionship, friendship, love—yours and mine. I know you don't care for that word. But try to learn not to be afraid of it" (154). Barry comes to the house, reveals to Charles that Justin died a month ago in Scotland of a heart attack (a broken heart?), and has left the house and all it contains to Charles. And so, father and son go off, back to school, as the novel ends.

The representation of homosexuality in the novel feels dated in some respects—harkening back not only to the closet novels of the 1950s but also to the haunted house stories of James and other late Victorians. It also provides interesting opportunities for revision through postmodern, post-gay lenses. More recent gay and lesbian young adult novels (such as Sánchez 2001; 2003; and Hartinger 2003) tend to deal with narratives of coming out and identity in ways that name queerness as a type of final destination for their protagonists. In contrast, there are few, if any, novels of gay teen bisexuality. Perhaps this pattern accurately targets the desired demographic audience, but it may also reflect of a continuing need of these adult writers to reinscribe binary categories. Anecdotal reports suggest that the current generation of adolescents is more resistant to this kind of typology; the young adult novels they write may move along different paths.

In that sense, *The Man without a Face* does offer, in its open-ended denouement and in Justin's own discourse on sexuality, the possibility that sexual desire and love can come in different forms, with different meanings, at different times: "It could have been anyone—boy or girl," he assures Charles in their aborted attempt to discuss the sexual encounter. For some readers, the statement might rob gay identity of its authenticity, suggesting that sexual desire need not be tied to any specific sense of self. For others, it may provide the courage to follow the myriad directions that libido and heart may point, despite censorship or censure.

Which raises the question of how does the target audience of adolescent readers use the novels? In her book on adolescent literature, *Disturbing the Universe*, Roberta Seelinger Trites argues, "Adolescent literature is often an ideological tool used to curb teenagers' libido as it is some sort of depiction of what adolescent sexuality actually is" (2004, 85)—an allusion to Foucault's theories of surveillance. Novels of unwanted pregnancy, abortion, and, even more recently, AIDS, have this policing effect. But, she continues, "non-heterosexual teen romances employ a different set of ideologies that are meant to empower queer teenagers" (102). Because such romances usually adopt the point of view of a queer teenager (even when written by heterosexual authors, such as Holland), an ideology of containment is restricted to novels that prescribe safer sex as the equivalent of abstinence. Such romances are

often realistic about teenage desire and do allow for some degree of sexual perfor-mance but still tend to be modest and to advise against mixed sero-status relation-ships (in *Rainbow High*, a young man dates an HIV-positive youth and considers whether life would be simpler if he himself became infected; see Sánchez 2003).

Trites offers a Lacanian framework for viewing how adolescent readers might use such novels, an observation of particular relevance for queer readers:

> Discovering their sexuality is powerful to adolescents because it represents a new forum in which to interact with the Other. Jouissance, especially, brings with it at least the tempo-rary illusion of unifying the Self and the Other, of an Imaginary healing of the division cre-ated by the subject's entrance into the Symbolic Order. (115)

It is possible to see *The Man without a Face* as performing this kind of process, with the sexual encounter a type of imaginary healing for Charles and Justin. Charles bonds with a father he never really knew (and who died as a drunk), and Justin is able to reunite with the student who died because of his own drunkenness. Their sexual pleasure, *jouissance*, helps both men become men again or for the first time.

Such *jouissance*—and I would argue that a reading of this kind of narrative is itself a form of *jouissance* in its attempt to use metaphorical language to represent bodily pleasure—can also help readers move from unconscious sexuality to the regulated, ordered sexuality of public discourse about sexuality in general and queerness in par-ticular. In the novel, the shifting sense of desire and of objects of desire, of moments of fusing self and other, gives it a power to liberate, please, and move three decades later. Librarians and teachers continue to include it in lists of Best of the Best Young Adult Books and Best 100 List for Young Adult Readers (Carter 2001; Donelson & Nilsen 1997).

THE MAN WITHOUT A FACE: *THE FILM*

Twenty years after Holland's novel appeared, Mel Gibson released his first direc-torial effort, the film adaptation of it. Technically, Gibson is not the author of the screenplay, but interviews with him make clear that it represents his vision of Holland's novel. It seems an anomalous choice for an established action-movie star: A minor novel with homoerotic elements written for adolescent readers is far from *Lethal Weapon*. Nevertheless, the film and his subsequent films *Braveheart* and *The Passion of the Christ* display an odd continuity: All three feature men martyred by a dominant, soulless culture and a fascination with the male body in pain.

There are, of course, minor differences between the novel and the screenplay. For example, it transformed McLeod from writer to artist, presumably to take advantage of film as a visual medium and to allow the audience to see self-portraits

that underscore the cinematic motif of the split self. But there are larger changes at work in the film as well. Ironically, some of them seem to transform the tragic Gothic elements of the novel into a more family-friendly, warm-hearted view of adult-adolescent male bonding. Perhaps the most succinct way of describing the transformation from page to screen is that it erases the authentic homosexuality of its hero-martyr and reinscribes homophobia by replacing it with a false accusation against him. As noted earlier, McLeod indicates his own homosexual identity to Charles, saying, "I've known what I was for a long time" (Holland 1972, 149). As fraught with problems as the wording of that statement may be, it is, nonetheless, a declaration of the queer self as someone known and not denied.

In contrast, Gibson's film flirts throughout with the possibility of McLeod's homosexuality but (as I shall show later) ultimately and emphatically removes it. For example, Charles and McLeod are hiking in the woods when they come upon two hunters. The hunters stare at the pair, and Charles yells back, "What are you lookin' at, assholes!" Whereas Charles assumes that the men are staring at McLeod's face, the more astute adult viewer (including McLeod, perhaps) will also consider the hunters suspicious of an adult man and pubertal boy-man alone in the woods—when the man's notoriety ensures that everyone knows he is not the boy's father. In case one misses this point, the film has the local police chief police ask Charles if he has gone hiking lately. Charles lies, enhancing the suspicion that he is hiding aspects of his relationship with McLeod.

The two most significant plot changes relevant to queer discourse involve McLeod's indirect but overt declaration of sexual identity and the role played by homosexual desire in the accident that caused his disfigurement. Describing the accident to Charles, McLeod explains that a boy burned to death in the car crash. Holland's novel draws no overt connection between McLeod's drunkenness and his homosexuality—it never makes clear that the boy who died in his car was a sexual partner or lover and never makes clear whether readers should infer this conclusion. The novel bases McLeod's guilt on his drunken irresponsibility, not on his queer desire, whatever its object may have been.

In the film, after the night when Charles learns the truth about his father and runs to McLeod's house, in a new scene that takes place much later, McLeod speaks to a panel informally convened to investigate the implications of Charles's spending the night at his house. When pressed to describe his relationship with the student who died in the accident (the film gives him a name: Patrick Scott), McLeod narrates a tale of a seductive, neurotic boy. He describes Patrick as not only bright but also "very troubled, from a broken home, full of guilt, full of violent fantasies" and says, "He developed a fixation with me, which I didn't know how to deal with" (*The Man without a Face* 2004). When McLeod confronted him on the drive home from Boston, Patrick "tried to step from the vehicle into the highway," leading to the accident. Thus,

McLeod's crime was bad counseling, not driving while drunk. One might also argue that the only crime he committed was being an object of sexual desire—that, in some fairly twisted logic, Patrick's desire for McLeod caused the accident—and McLeod's willingness to talk with Patrick about his desire contributed to the ambiguous suicidal gesture. Because of the film's own homophobia, it is impossible to derive a coherent narrative of the meaning of this moment. To define Patrick's desire for his teacher as a fixation (which it certainly could be) is nonetheless to conflate the somewhat usual feelings students may develop for teachers (parallel to many a heterosexual crush) with the less usual same-sex feelings of desire. Would McLeod have viewed a female student's feelings for him as a fixation?

Thus, the film erases McLeod's homosexuality from the film, as is, by implication, Charles's potential homosexuality as well. The only homosexual left in the film, a ghostly one haunting McLeod's reputation, is Patrick Scott, the young man defined by pathology. Even here, the film implies that he may not have been homosexual but may have mistaken the need for a father figure for sexual desire: The broken home reference is a familiar trope for all social and sexual deviance. Even more disturbing in McLeod's description of Patrick is the reference to his violent fantasies; the film keeps vague whether these fantasies are suicidal ideations or sadomasochistic scenarios. Either draws a rather uneasy metonymy between queer sexuality and a death wish.

The film reinscribes a discourse of homophobia and the narrative that all male homosexuals are pedophiles-in-waiting. Even though the film makes it clear that McLeod is not, and never has been, homosexual in desire or act (and how could Mel Gibson ever be queer?), the entire town ostracizes him and engages in acts of witch-hunting reminiscent of the McCarthy era. Charles's mother interrogates her son: "Last night, did he or at any other time did he touch you?" To which, Charles, straightforward and innocent, replies, "Yeah sure." His mother probes: "How did he touch you?" Charles recognizes that touch has a darker meaning for his mother and denies that anything wrong, as he puts it, occurred between them.

In another scene from the film, McLeod shows up at Charles's house to try to explain what happened, and his hysterical mother sends him away, saying "What [have] you been doing to my son!" McLeod meekly leaves, as if he were guilty of the supposed crime. Charles is also subjected to outside interrogation. His parents bring in a psychologist to administer projective inkblot tests, apparently to ferret out whether Charles was molested or is homosexual himself. The film depicts the psychologist, who, even in 1968, might have been sympathetic and open to a teenage boy's sexual issues, as a stereotypical bureaucrat.

The film adds an additional denouement to the novel. In both, Charles returns to McLeod's house. In the novel, the house contains food, furniture, and books. In the film, the house is all but empty, and it becomes clear that McLeod has agreed

to leave the town to avoid being charged with a phantom crime of pedophilia. He has left a letter and a painting he made, showing the two of them, in a seascape from a happier day earlier in the film, and a letter. Again, the contrast between novel and film is striking, particularly given the notion of both as tales in the Gothic genre with the haunted house as a romantic symbol of the self. Holland's novel seems to intend McLeod's absence as temporary. His death by heart attack is a convenient anomaly that makes him eternally unavailable—or available only as a memory in which Charles can project his own sense of self. In the film, the empty house suggests banishment, an erasure of the ambiguous sexuality that the townspeople attributed to McLeod by the townsfolk. Charles is free of the Gothic monster, who will reappear only from afar, at his graduation from military school, once Charles has passed the rite of entry into the world of men.

In the letter he leaves for him, McLeod speaks of what Charles has given him— "a gift of your love and trust . . . touchable grace" (*The Man without a Face* 2004). It is the second time he has mentioned grace—the first being in the courtroom scene, when he explains what his relationship with Charles has meant to him, an opportunity to be forgiven and become a teacher again. This touch of Gibson's brand of Christian redemption, grafted onto an otherwise secular text, portents of things to come ten years down the road, when Gibson again shows the scourging of a misunderstood savior—a scourging that leads to grace in overtly religious terms.

The final scene of the film is Charles's dream realized: an image of him graduating from the military academy, with mother and sisters present. As the crowd clears, he looks across an empty field and sees a man walking away, proud and tall, wearing sunglasses, no longer visually defined by facial disfigurement (he is too far away for that): It is McLeod. Charles waves to him, and he waves back. End of film.

There is no off-stage heart attack for McLeod, but Charles has no direct reunion with him either; they must each remain unattainable for the other. The novel fills the death of McLeod with pathos and, in my view, feels forced and retributive (if the novel took place in the 1980s, presumably someone would die of AIDS). In the film, the relationship between McLeod and Charles, however sanitized, is nonetheless an authentic one, and the sense that both have survived provides the audience an emotional relief. Yet the open-endedness of Charles's own future in the novel is foreclosed in the film. Holland's moral order is an assured one, especially in allowing a range of possibilities for what might constitute ethical love. In contrast, Gibson's moral order can neither allow McLeod to have a queer desire for Charles nor permit Charles's life possibilities to remain so open-ended.

In a retrospective interview on the recently released DVD of the film, Gibson makes a point of saying that the two characters had "a perfectly natural relationship"

(2004). Presumably, a queer critic could respond that a loving relationship between the two, which might involve sexual intimacy, is perfectly natural for these two—it's McLeod's insistence on keeping them physically apart that feels unnatural. This reading is hardly what one infers from Gibson's response: *Natural* equals *heterosexual* in Gibson's world. He continues, making sure to use terms like *father figure* and *teacher-student* to supposedly clarify the platonic quality of the relationship, ending the segment by describing the relationship as involving "love," but "in a very healthy way." Again, the word healthy can contribute to an equally queer-positive reading: Sexual intimacy, when entered into consensually and without exploitation of either partner, is healthy. It is doubtful that Gibson could read any homosexual relationship as healthy, let alone one that flirts across intergenerational issues.

CONCLUSIONS

Much in Gibson's film is admirable. I consider it his best film, despite its complex discourses of homoerasure and homophobia. Gibson does a solid job as a director in telling his story; he works well with actors as a fellow actor and as the director. His scenes with Nick Stahl, who plays Charles, feel genuine and moving. The sense of period is real and authentic to one who was Charles's age during the time the movie is set. The major characters and many of the minor ones retain the sense of complexity, dimensionality, and integrity that made the novel so powerful. As an actor, Gibson did probably his own best work, one of the few films where he plays a real person, rather than himself or the stock type he can perform in his sleep.

The film still raises fraught issues of visibility and representation. In some ways, I am glad that Gibson de-gayed McLeod. The change allows a sensitive and compelling relationship to develop between him and Charles without raising the thorny issues of intergenerational sexual relationships. As a teacher, I am particularly glad that the film erased the gay-teacher-as-predator trope. At times, I thought that it would have been better for the novel to make McLeod's sexuality invisible as well.

In the updated version of his classic study *The Celluloid Closet* (1987), Vito Russo ends the book with a necrology, a catalogue of all the homosexual film characters who meet untimely ends, often as villains or as victims of violence or moral retribution. Gibson's film continues that necrological approach to gay male representation. Although McLeod, the heterosexual male teacher, lives on, the film kills his queer, spectral counterpart—a ghost left to haunt the viewers' imaginations along with poor Patrick Scott and, perhaps, the Charles who might have awakened to the erotic and romantic possibilities of his own queer potential. In Gibson's world, these are truly the men without faces.

REFERENCES

Carter, Betty. 2001. *Best Books for Young Adults*. Washington, DC: American Library Association.

Cuseo, Alan. 1992. *Homosexual Characters in Young Adult Novels, A Literary Analysis, 1969–1982*. Metuchen, NJ: Scarecrow Press.

Donelson, Kenneth L., and Alleen Pace Nilsen. 1997. *Literature for Today's Young Adults*, 5th ed. New York: Longman.

Fitzhugh, Louise. 1964. *Harriet the Spy*. New York: Harper & Row.

Hartinger, Brent. 2003. *Geography Club*. New York: HarperTempest.

Holland, Isabelle. 1972. *The Man without a Face*. Philadelphia: Lippincott.

Konigsburg, E. L. 1967. *From the Mixed-up Files of Mrs. Basil E. Frankweiler*. New York: Atheneum.

The Man without a Face. DVD. 2004. Dir. Mel Gibson. Perf. Mel Gibson, Nick Stahl. Burbank, CA: Warner Home Video. (Orig. released 1993.)

Russo, Vito. 1987. *The Celluloid Closet: Homosexuality and the Movies*, rev. ed. New York: Harper & Row.

Sánchez, Alex. 2001. *Rainbow Boys*. New York: Simon & Schuster.

———. 2003. *Rainbow High*. New York: Simon & Schuster.

Trites, Roberta Seelinger. 2004. *Disturbing the Universe: Power & Repression in Adolescent Literature*. Iowa City: University of Iowa Press.

And Baby Makes Three . . .

Gay Men, Straight Women, and the Parental Imperative in Film and Television

JAMES ALLAN

Relationships between gay men and straight women have long been a significant theme in popular representations of queerness, creating and reinforcing cultural myths about male homosexuality, femininity, and the supposedly natural links between them. This chapter explores one surprising element of this representational history: how pregnancy and parenting recur throughout forty years of gay-man–straight-woman stories. Highlighting tensions between heteronormativity and queer models of social interaction, these texts present a consistent set of narrative patterns over a time that saw remarkable shifts in the lived possibilities for men and women, queer and straight.

The late 1990s saw a familiar cultural figure achieve a new prominence in North American film and television. Long an occasional presence in popular representation, this image was suddenly cropping up everywhere: hit Hollywood films, television teen dramas, independent films, maternal melodramas on Lifetime, newspaper articles, a hit sitcom on NBC, and sexual self-help books. The time of the gay-man–straight-woman duo had arrived.

The film *My Best Friend's Wedding* earned more than $127 million in 1997, making it the surprise hit of the summer and placing the image of a friendship between a gay man and a straight woman firmly in public view. Julia Roberts revived her then-sagging career by playing Jules, an uptight food critic who schemes to stop her ex-boyfriend's wedding to a new woman, and Rupert Everett became a Hollywood leading man by playing George, Jules's editor and best friend who is handsome, suave,

witty, British, and, of course, gay. The film's unexpected success opened the door for a multitude of similar projects to follow, as mainstream film and television, always eager to copy a successful formula (see Gitlin 2000, 63–85, for more on television's recombinant culture), soon produced a spate of other gay-man–straight-woman texts.

Will & Grace (1998–2004) debuted on NBC: Its story lines revolve around not one but two gay-man–straight-woman duos, and it became one of the breakout new shows of the season, drawing critical praise and high ratings. Also that year, the film *The Object of My Affection* made a modest box-office success out of the story of a straight woman who decides to raise a child with her gay best friend. Gay-man–straight-woman friendships began to appear more and more frequently, cropping up in films like *The Opposite of Sex* (1998), *Bedrooms and Hallways* (1998), *Trick* (1999), *Blast from the Past* (1999), and *The Next Best Thing* (2000) and in television series like *Sex and the City* (HBO 1998–2004), *Oh, Grow Up* (ABC 1999–2000), and *Dawson's Creek* (WB 1999–2003).

This chapter is part of a larger project that investigates the historical and cultural development of the gay-man–straight-woman friendship in popular American image culture from 1959 to 2000. The investigation strives to understand the ways American popular culture imagines, represents, and reproduces discourses about gay men, straight women, and the friendships between them. More broadly, it explores how that culture imagines relationships between men and women more generally. What ideas and ideologies underlie the commonsense notion that gay men and straight women make good friends? How can we characterize the representations of such friendships, and how do those characterizations change over time? What historical situations underscore the ebb and flow of these representations, and why did they experience a surge in popularity in the 1990s?

My research starts from the premise that friendship "is not simply a personal, psychological enterprise of unlimited choices; it is a social process, embedded in a culture of meaning and delimited by a society's gender, sexual and political scripts" (Nardi 1999, 33). Mass media representations of friendships provide clues to contemporary friendship practices, as well as social scripts for audience members to draw on as they think through and live out their own relationships. Although sociological data on relationships between gay men and straight women are scarce before the late 1970s, general patterns found in friendships between (straight) men and (straight) women can provide some context. Scott Swain asserts that widespread *cross-sex friendships*, a term used in sociological studies of friendship to describe a friendship between a man and a woman (Swain 1992; Nardi 1999), are a recent phenomenon in Western culture emerging from the twentieth century shift from homosociality to heterosociality. Most friendships involve men with men or women with women (Swain 1992). Cross-sex friendship remains hazily defined and socially unexpected, often interpreted based on heterosexual coupling or sexual relationships (Swain 1992, 154).

If cross-sex friendship is still relatively new and uncommon in North America, it is striking that there exists "no more persistent stereotype about gay men's friendships than the notion that gay men and straight women make good friends" (Nardi 1999, 114). Various sociological studies (Nardi 1999; Bell & Weinberg 1978) have reported that gay men, like straight men, generally prefer to socialize with other men. Nardi reports that 79 percent of gay men cite another gay man as their best friend, compared to only 10 percent who cite a straight woman as best friend. In his study, about 60 percent of gay men had only "two or fewer close friends who were women; around 3 percent said that the majority of their friends were women" (Nardi 1999, 107–108). Despite the low incidence of these relationships, North American popular culture consistently generates stories that present, promote, and naturalize relationships between gay men and straight women. The discontinuity between lived experiences and representational culture is clear. The question, then, is why should anyone care?

Richard Dyer argues for taking representation seriously because "how social groups are treated in cultural representation is part and parcel of how they are treated in life. . . . How we are seen determines in part how we are treated; how we treat others is based on how we see them; such seeing comes from representation" (Dyer 2002, 1). Unfortunately, the gay-man–straight-woman stories that market-driven media generally produce rely on extremely limited, conventional, and regressive ideas about what being a gay man or a straight woman means. These ideas restrict the kinds of stories told and friendships depicted, belying the complexity and variety of the lived experiences of gay men and straight women. The stories operate ideologically to limit how culture imagines relationships between men and women, gay and straight. In Nardi's terms, they limit the friendship scripts available. The increasingly frequent narrative pairing of gay men with straight women—instead of with straight men, lesbians, or with other gay men—speaks to long-standing fears about gay male sexuality and queer community. Creating gay-man–straight-woman duos is one of the least threatening ways to include gay male characters in mainstream media texts, while carefully avoiding the specter of gay male sexual community and practice. The strategy, however, is more apparent in some stories than in others, and so I turn to a specific subset of texts to investigate these implications fully. An illuminating set of stories revolves around pregnancy and parenting.

WE ARE FAMILY

Andrew Sullivan, in his book, *Virtually Normal*, argues that marriage—and, by extension, the nuclear family—is one of the most important issues facing the gay community today. In claiming the value of gay marriage as a political goal, he asserts

that acts of social responsibility, like marriage or parenthood, generate social value: Simply put, our society rewards those who support its structures and rituals. Leaving aside the desirability of seeking social acceptance within the status quo, Sullivan promotes the fight for gay access to marriage rights (rather than, say, the fight to de-couple those rights from the institution of marriage) by arguing that those who choose marriage "make a deeper commitment to one another and to society; in exchange, society extends certain benefits to them" (Sullivan 1995, 182). Gay individuals, he argues, should have the same right as straight individuals to make this pro-social commitment and should become eligible for the same benefits. Although Sullivan refers to specific legal benefits, many of the benefits of marriage and other pro-social acts are social and psychological, such as the warm glow of approval that greets the news of an engagement, the public display of support at weddings, and the emotional reinforcement offered to young parents. The benefits society extends to those who make a deep commitment to society and to each other are not merely legal and do not affect only economic prospects, but also reinforce social position and psychological well-being.

Lisa Henderson, although worlds apart from Sullivan's political perspective, explores similar ideas about the production of social value, particularly in mass media texts. Her essay on the film *Go Fish* stresses the importance of genre conventions for understanding the film. It is a typical romantic comedy, she argues, except that it recasts the conventions of the genre with a new set of characters: lesbians. She writes, "*Go Fish*'s lesbian re-articulation of romantic comedy . . . invests romantic capital—long used to affirm characters as worthy—in unions that are elsewhere symbolically and socially excluded" (Henderson 1999, 47).

The idea of romantic capital and its capacity to affirm certain characters as worthy is key. Henderson uses it to highlight the importance of a long history of accumulated viewing and pleasurable experiences of, in this case, romantic comedy: A tradition of positive feelings toward characters who exist in preordained situations and relationships carries cultural weight and power. This structure of feeling, she argues, encourages viewer identification with and enthusiasm for the story of Max and Ely, the women who eventually become lovers in the film. The encouragement may be particularly important for nonlesbian audience members who need a small push to identify with the lesbian protagonists: a push that would be necessary, Henderson points out, for the film to reach " 'crossover' success in the sharply targeted distribution of independent feature films" (1999, 48).

Taken together, Sullivan's conservative promotion of social rewards for certain acts and relationships and Henderson's analysis of the power of genre conventions in romantic narrative help explain the plethora of gay-man—straight-woman stories revolving around pregnancy and child rearing. The social value attributed to procreation and child rearing as narrative devices is sufficiently powerful to valorize the

characters in the stories, to affirm them as *worthy* in Henderson's formulation. Many pregnancy texts rely on parental capital to assert value for their characters, drawing on visual and narrative devices to make them more familiar and their story lines more acceptable to audiences who might otherwise feel uncomfortable with them. The themes of pregnancy and parenting help bring gay male and straight female characters into recognizable settings and situations: doctor's visits, morning sickness, food cravings, delivery rooms, and the like.

The parental capital generated by articulating these genre conventions with the unconventional coupling of the gay man and straight woman makes the stories more understandable within a heteronormative frame and also more universal, broadening their appeal and possible crossover success. Such capital, however, may distribute unequally between the members of the couple, and it may come at too high an ideological cost.

DADDY DEAREST

One of the key figures emerging from these films and television programs is the gay man who wants to be a father. This character has a long lineage, stretching from 1961 in *A Taste of Honey* all the way to contemporary texts like the NBC sitcom *Will & Grace* and the film *The Object of My Affection*. *A Taste of Honey* tells the story of Jo, a young, working-class English girl who leaves home when her boyfriend goes off to sea. She shares a flat with a young gay man named Geoffrey, who, when Jo realizes that she is pregnant, takes her in hand. One day he is working at the flat, cutting fabric, and she is purposely bothering him: poking him, disturbing his work.

> GEOFFREY, *annoyed.* Jo! How much longer is this going on for?
>
> JO. What?
>
> GEOFFREY. Your present performance.
>
> JO, *petulant.* Well, nobody asked you to stay. You moved in on me, remember? If you don't like it, you can get out. But you wouldn't do that, would ya Geoffrey. (*Cruel.*) Got no confidence in yourself, do ya. Afraid the girls would laugh. (*Pause.*) You like babies, don't ya Geoff.
>
> GEOFFREY. They're all right.
>
> JO, *mocking.* Would you like to be the father of my baby, Geoff?
>
> GEOFFREY, *pause, and then very seriously.* Yes I would.
>
> JO, *surprised pause, then quietly.* I . . . I feel stifled in here. I'm going out. . . .

Jodie, the gay character from the television sitcom *Soap* (ABC 1977–1981), has a similar reaction, although not until later in the process. Jodie and Carole slept together once, leaving Carole pregnant. Carole, however, ran away from town before Jodie saw his daughter. When he sees the young child for the first time, he

develops an automatic and instinctive bond: Fatherhood emerges as a natural impulse.

> JODIE. She's my daughter. Can you believe it. This is my daughter. What's her name?
>
> MRS. DAVID. Her name's Wendy.
>
> JODIE. Wendy. It's very nice to meet you Wendy . . .
>
> JODIE. Oh boy, Wendy. It was so much easier when I didn't know anything about you.
> 'Cause now that I've seen you and now that I've held you, I never want to let you go . . .

George, the gay man from *The Object of My Affection* is particularly eloquent about his desire to be a father. A first-grade teacher, he finally talks to his friend Nina, who has asked him to raise her child with her:

> GEORGE. I spent all yesterday afternoon watching this little kid play catch with his father. I always thought that I could teach other people's children. But someone else, a real guy like Vince, gets to take 'em home. And then I thought, I don't always have to be the one watching them leave, I don't always have to be the one who waits for twilight to pass. And for the first time I thought I could be the guy who says "goodnight."
>
> NINA, *long pause*. What are you saying to me?
>
> GEORGE, *pause, and then trembling*. I'm saying yeah.
>
> (*They hug.*)

A desire for children has several potential interpretations. *A Taste of Honey* articulates it specifically with effeminacy: Geoffrey is a bit suspect in Jo's eyes because of his child-rearing impulses, and the film produces a number of visual jokes based on the supposed humor of a man behaving like a woman. Various sequences present him in the typical pregnancy-genre situations: sitting in a room full of women at a family planning clinic, cradling a doll tenderly, sewing curtains, and so forth. The NBC television movie *Sidney Shorr: A Girl's Best Friend* (1981) follows much the same path, although made twenty years later. Sidney appears in waiting rooms and getting the nursery ready—in one stop-motion sequence reminiscent of a slapstick Keystone Cops pantomime, he even gets morning sickness. Again, the viewer finds hilarity in male effeminacy.

In *The Object of My Affection*, the desire for children more firmly articulates with fatherhood and normative masculinity. As noted previously, George decides to say yes to Nina after watching a man teaching his young son (presumably) how to throw a baseball. This pivotal scene deserves careful attention to understand how gay-male child rearing comes to signify something different from its meaning in the earlier films. As organized, the sequence accentuates father-and-son-playing-catch as an archetype of American culture. Shot in a natural setting (a park)—and at a distance, so that the father and son remain types rather than individuals—the late afternoon

sun streams through the overhanging canopy of trees, giving the scene a glow of time-lessness. The camera shoots George from inside the chain-link fence surrounding the park, placing a visible barrier between him and the scene he longs to make his own. He walks up to the fence, opens the gate, and steps awkwardly inside, affording him a clear view of the father-and-son pair and the audience an unobstructed view of his face. By articulating George's parental desires with an archetype of American masculinity, the film denies anything particularly feminine about his desire for children and offers his longing for the identification of all male viewers, gay and straight, who have had similar feelings. The moment in the park amounts to a realization that George can be a real guy like Nina's straight boyfriend Vince.

Herein lies one of the apparent instabilities within these stories. Parenting provides socially acceptable roles for gay men, making them understandable in seemingly heteronormative situations and relationships, but it also draws upon the long cultural tradition that imagines gay men possessing a woman's spirit in a man's body. The writings of nineteenth- and early twentieth-century sexologists and gay political activists, such as Karl Heinrich Ulrichs and Edward Carpenter (Blasius & Phelan 1997), posit gay men as inherently nurturing, caring, and supportive. Their desire for children makes Geoffrey (*A Taste of Honey*) and Sidney Shorr (in *Sidney Shorr: A Girl's Best Friend*) more effeminate but also makes George (*The Object of My Affection*) more masculine. These two models of male homosexuality coexist within the figure of the gay male parent. Although somewhat subversive, the coexistence leaves both models intact and functional and leaves aside the rather prickly matter of sex.

Of course, gay men in some pregnancy texts express little interest in children on any level, despite the important part children play within the narratives. Robin from the Canadian film classic *Outrageous!* (1977), Zack from the film *Making Love* (1992), and Wai-Tung from the Ang Lee film *The Wedding Banquet* (1993) run the gamut from the drag queen to the Taiwanese businessman but share at least one characteristic, a sexual subjectivity linking them explicitly to a gay male community. These characters stand in marked contrast to the gay men who yearn for children. Sidney Shorr has no lover and no friends but simply exists by himself until Laurie enters his life. Geoffrey from *A Taste of Honey* is a loner without friends or even a place to live, until he meets Jo. Even in *The Object of My Affection*, George had a lover and lives in New York City but seems asexual for most of the film. His discomfort with Dr. Goldstein, a large, thickly muscled, hairy man who shows up for a disastrous date wearing the tight blue jeans, white t-shirt, and vest associated with gay leather culture, highlights his limited connection to any sexualized gay community. However, when George meets another man, Paul, and wants to develop a sexual relationship with him, his arrangement with the pregnant Nina begins to crumble. Certain models of gay male subjectivity, such as "gay men are just like

women" and "gay men are just like everybody else," fit well with the parental capital paradigm. An unabashedly sexual identity that includes desires, practices, and communities does not. Parental capital as a model for affirming certain kinds of characters as worthy would seem to have definite limitations.

MOMMY DEAREST

The limits of parental capital also become apparent in the women characters. Besides the gay man who desires parenthood, the other main figure is the straight woman who doesn't, or at least doesn't seek it out. Most of the women in the stories have accidental pregnancies, outside any serious emotional relationship. The collection of female characters faces the unexpected prospect of motherhood on their own.

The stories paint most of them as unfeminine and unfit for motherhood. Jo from *A Taste of Honey* is a markedly antidomestic girl, who Geoffrey must take in hand by cleaning and decorating the apartment, making dinner, washing windows, darning her socks, and drawing her bath. *The Wedding Banquet* portrays Wei-Wei in about the same way. An artist, not a homemaker, she cannot cook, cannot clean, cannot run a household. When she poses as Wai-Tung's wife during his parents' visit from Taiwan, his boyfriend Simon must perform all the wifely duties, while Wei-Wei takes the credit. The audience chuckles to watch a woman incompetent in the kitchen, who must have a man—a gay man, of course—show her how it's done.

DeeDee, the oversexed teenager from *The Opposite of Sex*, embodies a nonmaternal image in a slightly different fashion, although she is equally nondomestic. Callous, calculating, selfish, and aggressively sexual, she does not present many aspects of normative femininity. She runs away from home, seduces her gay half brother's boyfriend, and then persuades him that he fathered her baby, before stealing thousands of dollars from her half brother and running off to Los Angeles, where she has an affair with an old boyfriend. When she becomes pregnant, she ignores middle-class conventional wisdom about what is good for the baby, constantly smoking cigarettes and drinking alcohol. When Lucia, the other straight female lead in the film, criticizes DeeDee for ordering a Long Island Iced Tea while she is pregnant, DeeDee responds dryly, "This baby owes its life to Long Island Iced Teas, if you know what I mean."

In their behavior, the women contrast markedly with the gay men in the films. The men often present a normative femininity. Where the women are cold, the gay men are sensitive, and where the women are nondomestic, the gay men are perfect homemakers. Where the women are actively sexual, the gay men are not, and where the women may not want children, the gay men do. The women's behavior encourages the audience to ask whether the gay men in these films are playing father or mother.

Many texts about motherhood represent two mother figures, good and bad, angel and witch. The good mother is self-sacrificing, passive, and devoted to her children. The bad mother is self-interested, "evil, possessive, destructive, and all-devouring" (Kaplan 1992, 48). The distinction between the two illuminates some tropes in the gay-man–straight-woman narratives, specifically, the distinction between the selfless gay man who devotes himself to the child and the questionably liberated woman, who puts her own interests first.

Jo from *A Taste of Honey* violently opposes motherhood. In a gray, outdoor scene toward the end of the film, Geoffrey gives her a child care practice doll that he got for her from Health Services. She picks it up, looks at it, and then begins to scream as she bashes it against a stone.

> JO. I'll bash its head. I'll kill it! I don't want this baby Geoff. (*Crying in frustration.*) I don't want to be a mother. I don't want to be a woman.
>
> (*Geoff picks up the doll from where she threw it, holds it carefully. Jo walks off in silence.*)

Geoffrey's move to retrieve the doll signals his willingness to play mother, while Jo remains alone and distant. In the next scene, Geoffrey goes to Jo's mother for help, sealing his own fate by fetching the woman who will throw him out on the street later in the film. His is an instance of maternal sacrifice.

Soap features a similar, although less dramatic, distinction. At points in a months-long plot arc centering on their baby, Jodie gets to stake his claim to the child and to a virtuous lifestyle, in contrast to Carole's irresponsible philandering. When Carole demands custody, he refuses:

> CAROLE. I'm her mother, Jodie.
>
> JODIE. Why? Because you changed her once, and threw a little powder on her bottom? Forget about it, Carole. I raised this child. I'm the one who got her through teething and colic and crying in the night. I'm all the family she has; she stays with me.

In *The Opposite of Sex*, even DeeDee's own child rejects her callous young mother in favor of her gay half brother.

> DEEDEE, *voice-over.* Bill was cute with RJ, that's Randy Junior. Even though it spooked me at first, him changing a boy baby and getting good peaks at his little thing. But he said straight dads change girl babies all the time, and nothing comes of that. Is he naive or what? (*Pause.*) Anyways, RJ was crazy about him, and vice versa. But he never really took to me. Maybe Jason was right: I'm not the mommy type. I don't care. (*She leaves the house without telling the others.*)

All the texts imply that the gay male character would make a better mother than the mother herself. A darker side of the model plays out in the texts, which distribute

parental capital unevenly between the male and female characters but valorize gay men at the expense of straight women.

PARENTAL CAPITAL

The domesticity-pregnancy scenario generally functions to affirm gay men as worthwhile, as socially and emotionally responsible members of society, worthy of even Andrew Sullivan's approval. It also produces female characters who are selfish, self-interested, and unfit for motherhood. A few of these women do go through character transformations—Abbie does in *The Next Best Thing*, as does Wei-Wei in *The Wedding Banquet*—but it is the power of motherhood, not any particular strength of character on their own part, that transforms these women from selfish to caring.

Several reasons may explain this treatment of women. Foremost is the need for narrative conflict. The texts fall into the categories of drama, melodrama, or mock melodrama, genres that rely on conflict for narrative drive and development. This need makes it structurally economical that conflict should spring up between the gay male and straight female characters. Having introduced these characters into each other's lives, writers then add drama by pitting them against each other, reducing the need to introduce other major characters to produce the necessary conflict. Because the stories seem designed to affirm the gay male character, writing him into the position of bad guy would then be counterproductive. Instead, the selfish woman and the bad mother fill that role. The figure who puts self and career before the needs of her children became common in popular representation in the mid- to late 1970s. Drawing on that character lends familiarity to a story that might otherwise disorient viewers uncertain of how to relate to a gay male character who falls outside the sissy or sidekick stereotypes. These texts also operate in a culture that asserts the sanctity of motherhood and compels courts to award custody to mothers over fathers. Given this context, a gay man could be fit or even credible as a parent only when the mother is entirely unfit. The films go against the grain of positive but sexist images of the naturally good mother to present negative but equally sexist images of the bad mother. Thus, heteronormativity enables the production of liberal, supposedly positive images of gay men as sexless father figures.

The recurring choice to create conflict and drama from within the gay-man–straight-woman duo (rather than pitting them against some external force) has important consequences for which stories can be told and which resolutions they can reach. Although seeming to revolve around the possibility of establishing alternative family structures, in which gay men and straight women join to create new social arrangements, almost all these texts end in separation and division. *A Taste of Honey* ends when Jo's mother returns her to her life and sends Geoffrey packing.

The plot arc in *Soap* ends with Jodie getting custody of his daughter but earning the eternal hatred of his former friend Carole. *Sidney Shorr* ends with Laurie moving to the West Coast, taking her daughter with her and leaving Sidney alone again in New York. *The Opposite of Sex* ends with DeeDee sitting on a curb, having left her half brother and her son behind, and trying to decide between striking out on her own again or returning to the family fold. *The Next Best Thing*—in many ways just an updated version of *Sidney Shorr*—turns its best friends into sworn enemies, ending with a tentative but still fragile truce in the name of responsible parenthood.

The vaunted baby never makes an appearance at all in about half the stories. Pregnancy and parenting are the major narrative concerns at work, but, in six out of thirteen texts, either the woman miscarries or aborts the fetus or the story ends before the child is born. *A Taste of Honey* leaves Geoffrey out on the streets but also ends before Jo gives birth. *Outrageous!* ends with Robin bringing the unstable Liza to live with him in New York, after she miscarries and has a mental breakdown in Toronto. In *The Wedding Banquet*, Simon, Wai-Tung, and Wei-Wei decide to raise the child together, but the film ends during the pregnancy. The independent film *Relax . . . It's Just Sex* (1998) ends with Tara's miscarriage and the funeral service she and her friends hold for the unborn baby. Even *The Opposite of Sex* flirts with a theme of disaster. In a voice-over, DeeDee attempts to persuade viewers that she dies during childbirth, before admitting that the labor went smoothly.

If the baby does appear, there is a certain skewing of the gene pool. Of seven children who enter a narrative, five are girls. The two films that feature gay men helping raise young boys come from the late 1990s. The pattern circumvents the specter of the gay male pedophile, or perhaps simply preempts the possibility that a straight male child—because he could not, of course, be gay—might have a gay man as a role model (or, nearly as bad, might be raised by a single mother). *The Opposite of Sex* refers to the former possibility when DeeDee decides to leave her son with her brother Bill and talks of being spooked about a gay man changing her son's diapers. One of the two films to present a gay man as father thus raises the prospect of pedophilia. The preponderance of baby girls in the films circumvents the image of gay pedophilia but also recreates the gay-man–straight-woman duo for the next generation. One can foresee a gay uncle in the young girls' lives, the gay-man–straight-woman affinity eventually reproducing itself.

Evidently, parental capital goes only so far. It may affirm the gay male characters as worthwhile, but their worthiness depends, in most iterations, on the desexualization of the gay man and demonization of his straight counterpart. A structural opposition between gay men and straight women precludes the realization of the very idea that gave the texts their initial spark: gay-straight affinity and the formation of alternative families-of-choice.

MODELING QUEER FAMILIES

Despite important historical shifts in the makeup and structure of the American family, a remarkable consistency remains in the representations of gay men and straight women attempting to create families. Being unmarried and pregnant in the early 1960s was much different from the same condition than in the 1990s, but the women in these films seem remarkably similar. The gay characters also inhabit similar subject positions. The texts are historically grounded and emerge from particular moments. However, the narrative devices presented over the last forty years—the unfit mother who resents pregnancy, the nurturing gay man who desires fatherhood—retain cultural currency today. The specifics vary with historical circumstance. Jo's violent but ineffective railing against impending motherhood in 1961 emerges in a context different from that of Laurie, who can go to an abortion clinic in 1981, but the reactions themselves are consistent. Others simply do not change: Jo's incompetence in the household of 1961 clearly echoes for Wei-Wei in 1993 and DeeDee in 1998.

Some historical developments find expression in these characters. Although the notion of representational progress deserves skepticism, a few films and television programs from the 1990s present new opportunities for more complex narratives that include possibilities for queer families and refuse to demonize the straight woman character to valorize the gay man.

A Taste of Honey and *Outrageous!* provide glimpses of opportunities to rethink and refigure the characters in parental capital narratives, but recent examples, such as *The Object of My Affection* and *Relax . . . It's Just Sex*, give substantive and extended play to workable queer families, with and without children.

As a Hollywood film focusing on the question of queer family, *The Object of My Affection* presents an interesting case study. The film does connect George's parental desire to normative masculinity and does reject the sexual mores of gay communities, but it puts forward a gay man and straight woman who are likable, responsible, and (eventually) sexual beings and who exist in a world that includes Queer Nation activists and leftist politicos. Nina herself—played by Jennifer Aniston, whose popular every-girl persona spills over into her character—is a beautiful, intelligent woman and an avowed feminist who frequently declares the importance of women's rights to choose what happens to their bodies and their lives. When she finds out she is pregnant with her sometime-boyfriend Vince, she wants to be with George.

> (*George and Nina at an amusement park; Nina asks George to help her raise her child.*)
> GEORGE. Of course. I'll be Uncle George. You're never gonna get rid of me.
> NINA. Actually, I was thinking we should keep living together. Like a family.

GEORGE. What about Vince?

NINA. There's no question about Vince. He's the father. He'll always be in my baby's life. (*Wistful.*) But he's not home to me. You are.

GEORGE, *uncomfortable.* I can't do that to Vince.

NINA, *determined.* George. My father married somebody wrong because he thought it was good for me. I can't do that to my baby. Me and Vince and the baby is a bad equation!

GEORGE, *frustrated.* Jesus Christ Nina, Vince is the father. You should be with the father of your child.

NINA, *urgent.* Don't you see how exciting this could be? You love children, you could raise a child. I don't want to marry Vince. I don't have to marry Vince.

GEORGE. I don't want to marry you.

NINA. George, I'm not proposing marriage. We can make this up for ourselves. None of the old rules apply.

Nina's statement about new rules foregrounds the idea of the alternative family. Although the fledgling alternative eventually collapses in conflicts over emotional monogamy, a feel-good ending still manages to affirm the complicated, extended gay-straight family that welcomes Nina's daughter, Molly.

(*Scene: Molly is in grade 1 and she's singing on a school stage. Cut to audience shot of Nina and Vince being proud parents. Track to reveal Nina hugging her boyfriend Lewis. Track to Nina's sister Constance and her husband Sidney and their daughter. Then to George's boyfriend Paul, who is sitting next to his friend Rodney.*)
* * *

(*Scene: Molly, Nina, and George walking down the street together after the show.*)

MOLLY. Uncle George, I had more people come see me than anyone. I had mommy and daddy and Lewis and Uncle Roddy and Uncle Sidney

NINA. Honey, you are the luckiest little girl.
* * *

(*Nina and George decide to go out for coffee together. The two of them walk off into the distance together with Molly as the final credits roll.*)

The long pan across Nina and Vince, the proud parents; then Nina and her partner; then Nina's sister and her husband; then George's partner Paul; and then Paul's friend Rodney displays the size and complexity of Molly's extended family: Nina's statement about how Molly is the luckiest girl in the world asserts the value of such a family. George and Nina remain good friends, a marked change from *A Taste of Honey, Soap, Sidney Shorr,* and *The Next Best Thing.*

Tara and Vincey, from *Relax . . . It's Just Sex,* present another gay-man–straight-woman duo who may offer a new and less restrictive model for family relationships. Although, on one level, the film conforms to some of the restrictions of the parental capital model—Tara does lose her baby through a miscarriage—it also refuses to

restrict the sexual, romantic, or social lives of its characters to convention. Like Nina and George in *The Object of My Affection*, Tara and Vincey get equal time throughout the text. The story concerns both of them equally, starting first with Vincey as the central character and then shifting focus to Tara, who becomes one of the most interesting characters in any of the films. She is sexually assertive, politically aware, and actively seeking pregnancy. She alone in the films is trying to get pregnant and doing so with a long-term heterosexual partner, Gus.

The scene where she reveals her miscarriage makes clearly constructs Tara so that the audience can empathize with her character:

> TARA, *very quietly, and somewhat dazed.* I lost the baby. I lost the baby. That's what they told me. Like, it was an umbrella. Or a ball game. Or something. I didn't let the doctors put me under, I was going to do everything in my power to make sure this child lived. (*Sad.*) But his lungs just weren't fully developed yet. There was nothing in any of the tests that could've told us that, it's just, one of those things. (*Teary.*) The doctors all said that they were surprised the pregnancy had gone on as long as it had. They let me hold him, my little son. (*Pause.*) He was really tiny. And when I was holding him, he gasped, like a tiny whimper. I heard a nurse in the hall. She said it was nature's way of weeding out the weak, and that it was God's will. (*Determined and getting angry.*) And I wished I had one ounce of strength left in my body so I could get out of bed, slap that nurse silly and tell her that was god's will. (*She starts to laugh, and then breaks down and cries, sobbing.*)

It is rare in these films to give such a long and powerful speech to the female character. In the courtroom sequences from *Soap* and *Sidney Shorr*, the pontificating falls to the gay men, who assert their claims to social worth. Here, Tara gets a chance not only to express herself but also to invite the audience to identify with her experience.

The funeral service for Tara's son serves as a moment for Vincey to assert the power of a large, extended chosen family—the multiethnic, multiracial group of men and women, gay and straight, HIV positive and negative, who make up her social world.

> (*Scene: Funeral service on a sun-drenched beach.*)
>
> VINCEY, *voice-over.* Just thinking about that baby's life and how it never even got started, the strangest thought occurred to me. I thought about how that life began with sex. And how sex sometimes leads to life, sometimes to death, sometimes to love. And then I thought about my friends. 'Cause every day people are born and people die. And in between we find a lot of ridiculous and important things to keep us busy, like love and sex—although not necessarily in that order. And those people who can find both with the same person should count themselves among the lucky ones. As for the others, like me, hey, I've got plenty of love. I've got my friends. And you know what? That is something to cherish, in this amazingly brutal, crazy but truly wonderful world.

The film stands as an exemplary story where a gay-man–straight-woman duo transcends the parental imperative altogether. It is not necessary for them to have children, to invest in parental capital, to achieve social worth, or to appeal to audience sympathy.

CHOSEN FAMILIES

At their worst, many gay-man–straight-woman texts reinscribe extremely limited and dehumanizing representations about gay men and straight women: that gay men cannot be sexual and responsible at the same time; that career women cannot be good mothers. At their best, gay-man–straight-woman texts eschew these clichés to create characters and friendships that expand the possibilities for gender identities, sexual practices, and social roles of men and women, gay and straight. Nearing the end of his life, Michel Foucault in several interviews stressed the importance of friendship for reorganizing and reinventing culture. He said relationships specifically outside the traditional institutions of marriage and family have the transformative power of "affection, tenderness, friendship, fidelity, camaraderie, and companionship, things that our rather sanitized society can't allow a place for without fearing the formation of new alliances and the tying together of unforeseen lines of force" (1997, 137). Popular representations of friendships between gay men and straight women, like those found in *Relax . . . It's Just Sex* and *Object of My Affection*, create and circulate different models of loving relationships, alternative family structures, and relations that confound the boundaries between friend and lover, gay and straight.

The stories may also posit a model of social value worth pursuing: Those who want children can have them, but those who do not needn't get pushed into parenthood simply to gain social acceptance. Chosen families afford workable alternatives or valuable supplements to biological ones. In place of Sullivan's model of social worth that must be earned, a system of social valuation could establish that all persons are inherently worthy of care and rights. Films like *The Object of My Affection* and *Relax . . . It's Just Sex* create memorable, complex characters and relationships across sex and gender lines and spread these ideas in popular discourse. Queer relations, in turn, may help expand the variety of models for socially valued relationships available in the culture.

REFERENCES

Bedrooms and Hallways. VHS. 1998. New York: First Run Features.

Bell, Alan, and Martin S. Weinberg. 1978. *Homosexualities: A Study of Diversity Among Men and Women*. New York: Simon & Schuster.

Blasius, Mark, and Shane Phelan, eds. 1997. *We Are Everywhere: A Historical Sourcebook of Gay & Lesbian Politics*. New York: Routledge.

Blast from the Past. VHS. 1999. New Line Cinema. New York: Time Warner Inc.

Dawson's Creek, ser. 1998–2003. Burbank, CA: WB-TV Network.

Dyer, Richard. 2002. *The Matter of Images: Essays on Representation*, 2nd ed. London: Routledge.

Foucault, Michel. 1997. "Friendship as a Way of Life." In *Ethics, Subjectivity, and Truth: The Essential Works of Michel Foucault, 1954–1985*, 135–140. Vol. 1. Ed. Paul Rabinow. New York: New Press.

Gitlin, Todd. 2000. *Inside Prime Time*. Berkeley: University of California Press.

Henderson, Lisa. 1999. "Simple Pleasures: Lesbian Community and *Go Fish*." *Signs: A Journal of Women in Society and Culture* 25.1 (Autumn): 37–64.

Kaplan, E. Ann. 1992. *Motherhood and Representation: The Mother in Popular Culture and Melodrama*. New York: Routledge.

Making Love. VHS. 1992. Los Angeles: Twentieth Century Fox.

My Best Friend's Wedding. VHS. 1997. Culver City, CA: Columbia Tristar Home Entertainment.

Nardi, Peter M. 1999. *Gay Men's Friendships: Invincible Communities*. Chicago: University of Chicago Press.

The Next Best Thing. VHS. 2000. Los Angeles: Paramount Home Entertainment.

The Object of My Affection. VHS. Los Angeles: Twentieth Century Fox Home Entertainment.

Oh, Grow Up, ser. 1999–2000. New York: ABC-TV Network.

The Opposite of Sex. VHS. 1998. Culver City, CA: Columbia Tristar Home Entertainment.

Outrageous! VHS. 1977. Hen's Tooth Video. New York: Castle Hill Productions.

Relax . . . It's Just Sex. VHS. 1998. New York: A-pix Entertainment.

Sidney Shorr: A Girl's Best Friend. 1981. New York: NBC-TV Network. Television broadcast, 10 October.

Sex and the City, ser. 1998–2004. New York: HBO.

Soap, ser. 1977–1981. New York: ABC-TV Network.

Sullivan, Andrew. 1995. *Virtually Normal: An Argument about Homosexuality*. New York: Alfred A. Knopf.

Swain, Scott O. 1992. "Men's Friendships with Women: Intimacy, Sexual Boundaries, and the Informant Role." In *Men's Friendships*, 153–171. Ed. Peter M. Nardi. Newbury Park, CA: Sage Publications.

A Taste of Honey. VHS. 1961. Los Angeles: Hallmark Home Entertainment.

Trick. VHS. 1999. Fine Line Features. New York: Time Warner Inc.

The Wedding Banquet. VHS. 1993. Los Angeles: Twentieth Century Fox Home Entertainment.

Will & Grace, ser. 1998–2004. New York: NBC-TV Network.

The Brass Check
and Thomas Paine

STUDS TERKEL

I feel evangelical, I feel redeemed—and I haven't yet seen Mel Gibson's film—and I do have a sin to confess: I am a fellow alumnus of U.S. Attorney General John Ashcroft; that is, we both attended the University of Chicago at different times. I was in the class of 1934; he was in the class of 1960-something. But I'm convinced he's much older than I am. In fact, I figured out that John Ashcroft is 308 years old. I'll tell you why. He had a previous incarnation in Arthur Miller's play, *The Crucible.* You recall the play? It was about Salem, Massachusetts, in the late 1600s.

The terrorists of the time, the outsiders, were witches, the terrorism was witch-craft. The town was in fear of the outsider, the old women. And so the preacher comes in, Reverend Paris—but my friend Brother John, his previous incarnation—and he says to the hysterical young girls, Name names! If you're not with me, you're against me (a familiar phrase). If you're not with me and God (in that order of importance, no doubt) then you're consorting with the devil. So they hang a couple of old women as a result. That's when the USA Patriot Act was first drafted.

Who is the outsider? The American revolutionaries were outsiders. Most people at that time, to be truthful about it, didn't mind being under Tory leadership or King George III, as long as they could make a buck or two. But here were the agitators, here were these trouble-makers, here was Thomas Paine speaking of being free from fear—fear being the big thing. Tom Paine was the most eloquent voice of the American Revolution. And here was Sam Adams, doing something called

the Boston Tea Party, not too removed, by the way, from Stonewall and what happened at that liberating moment in 1969 New York. What the Boston Tea Party was for freedom, Stonewall was for gays and lesbians, outsiders too.

We've come a long way since then, both good and bad. I'm in Chicago now, speaking of the press, the media. At least some members of the press now were not allowed to be members of the press back then. There's been, of course, a tremendous change, and that's thanks to the 1960s. But there's still a long way to go. Are we there, as far as affirmative action is concerned? Are we there in every respect, whether it be black or Latino, or women, or gays and lesbians? No. It's a scrap all the time, and it will have to be until we do become free. That's a long way off.

But, in the meantime, the media have a hunger for sensationalism. Hanna Arendt wrote of the banality of evil, but now I speak of the evil of banality. From the media, we're getting the banal, the trivial. It's in so much of what the media are doing today, and it's accompanied by gratuitous violence that also becomes banal. What gives banality space is a lack of dignity and decency. It reminds me of *The Brass Check*, a book written by Upton Sinclair, the famous muckraking gent who wrote *The Jungle* and transformed thinking about stockyard work.

A brass check was about a different kind of work: When a trick went to a brothel, he paid the madam two dollars, let's say (this was before inflation), and he'd receive a brass check that he'd give to the girl. At the end of the day, she'd cash in the brass checks and get perhaps half a buck apiece. In a sense, Upton was saying, journalists are brass check artists, meaning for hire, as a good number of them are.

A media for hire won't tell some stories, stories of courage and love. So thinking about Chicago and being hopeful (knowing also that we have a long, long way to go), I'd like to share a few stories—five of them—that should be retold.

VALERIE TAYLOR'S PAYBACK

In Chicago back in the 1950s, I became known not to Senator McCarthy but to his colleagues, and I was knocked out of the box for a while—the word is *blacklisted*—because I have a big mouth, you see. I used to work a lot with Mahalia Jackson, the gospel singer. She said, "Studs, you have such a big mouth, you should've been a preacher." During the Red Scare in the 1950s, Chicago had something called the Red Squad. They would investigate school teachers, social workers, and all those considered left of whatever-it-was, but also homosexuals. The Red Squad made sure they got everybody they considered outsiders.

Valerie Taylor, an old, old friend of mine, was a poet. She's a lesbian grandmother who went to Tucson later on. Valerie tells a story of how the Red Squad would come into bars patronized by gays and lesbians, plant a little bit of *tea* (what

they called marijuana back then), and arrest all the patrons. The next day, Robert Rutherford McCormick, the famous publisher of the *Chicago Tribune*, who was slightly to the right of Genghis Kahn—one of his correspondents called him "the finest mind of the 12th century"—would have the names of all the patrons arrested in those raids, their addresses, and their phone numbers on the front page. And so, of course, they lost their jobs, and they were threatened in other ways. That gives you an idea of how things were. The *Chicago Tribune* has come a long way since the days of Colonel McCormick.

There was one member of the Red Squad who pretended to be gay, came into the bars, and informed on them, fingered every one of them. Valerie told me they decided they'd got to get this guy. One day when he came in, they grabbed him and they embraced him and they kissed him, saying, "You're one of us!" And he never appeared again.

PEARL HART'S TOUCH

Those were the days of a very great woman I knew in Chicago, whose name is unknown to many of you: Pearl Hart. Chicago to me has three great women: Jane Addams; Ida B. Wells, the famous African American journalist; and, I think, Pearl M. Hart.

Pearl Hart was a founder and longtime leader of the Chicago Mattachine Society, as something on the side. Pearl was manly in appearance and was a lawyer. She was a public defender, and, during the Red Scare of McCarthy, when people were terrified, there was Pearl, defending everybody.

My wife was a social worker at the time the Great American Depression was on. She was in Women's Court, and one of her clients was a young girl arrested for being a hooker. A hooker! She wanted two bucks to buy a pair of shoes, the Depression was that deep. She was arrested, and there was Pearl Hart, her public defender.

The judge was a small-time Antonin Scalia, that is, small time—Scalia's rather literate, but this was an illiterate, brutish lout of a guy who humiliated this girl, especially upon discovering that the trick with whom she was picked up was a black man.

My wife remembered one thing; this girl just shriveling and Pearl putting her hand on the girl's shoulder and the girl straightening out—she never forgot that moment. This was Pearl.

JIM OSGOOD'S INVITATION

One of the honors of my life as a heterosexual (I can't help that, but I am one) was being invited to speak at the Mattachine Society. Harry Hay was the founder of

a real, fighting answer to oppression. A *mattachine* was a medieval jester who spoke the truth no one else would tell the king. I was invited to speak about Pearl Hart and will never forget that.

My book, *Will the Circle Be Unbroken?* (2002), has someone named Jim Hapgood in it. When Jim Hapgood's friend died—he and Edward Louzao were together for forty-seven years—and Jim was alone, I called up the old guy, remembering him.

I didn't know until later that he was also known as Jim Bradford, the head of Mattachine Midwest, the one who invited me to speak about Pearl Hart. I'll never forget that moment; it was a moment of great honor for me to be invited there.

MATTA KELLEY'S THUMB

There are others I have to mention. Matta Kelley was a Finish girl, and, long after World War II, she was with an American soldier stationed in Iceland, a young Irish American kid. They fall in love. He goes back home, and she comes to see him, thinking they're going to get married. His Irish American family, very poor, doesn't know what to do about her. She doesn't speak English or anything. But they get married, and they have a couple of kids.

Then, she says, she wandered. She got in with drugs and lost custody of the kids. She has one little girl left, who takes care of her, but Matta is going down, down, and looks like she's going to die. Then the government came through, with a program called Community Outreach Prevention, right here at the University of Illinois School of Public Health. These are the programs, like Head Start, that our friend, our appointed chieftain Mr. George Bush, would like to eliminate.

The program gave her a chance to do some work. She would travel the drug infested areas of Uptown, Chicago, with a bottle of bleach in one hand and water in the other, to clean the needles for drug addicts. It takes one to recognize one—she could tell by the body movements—and she was so good at it that they made her a case manager. If you're a case manager, you're in charge of someone who's dying and, in the case of AIDS, in charge of the life of that person, who's given you power of attorney.

She had a black client, named Norma but born a he: Norman. Norman dressed as a woman—was a transvestite—and became a she. Norma was dying, dying in the hospital. Matta has all the rights, but when she asks for Norma, the hospital staff says, "You mean Norman?" And she gets so mad at the lack of respect for this woman, who wants to live as a woman and die as a woman with dignity.

One day she comes into Norma's room, and there's a strange odor in the air. She realizes it's the wig. Norma's wig is old and rotted. So what Matta does is this: She cuts

off the wig. and she gets a picture of Norma in the red dress she loved and a beautiful wig and hangs it above her bed. She tells the staff that *this* is the Norma lying in that bed.

Meantime, the nurses and doctors were debating what to do about her. They know she's going to be a vegetable. Matta has power of attorney and promised Norma that when the time came she would pull the plug, but they're still debating, Should we do it, or shouldn't we? And she's furious at them.

She knows Norma only has a short time to live, and so she goes to ask her whether the time has come. Matta doesn't know if she can hear, but says she'll put her thumb inside her hand. If the answer is yes, she says, then squeeze my thumb. So she puts her thumb in Norma's hand and asks, You want me to pull the plug? Norma squeezes, and Matta asks again, and she squeezes again.

The next day Norma died of a heart attack. And that, to me, is a story of great dignity and freedom.

RON SABLE'S SONS

There are several other stories, but one involves two women: Dr. Kathy Fagan and Linda Gagnon. Kathy came from an upper-middle-class family in Cleveland and did her residency at Cook County Hospital in Chicago. She realized that she was gay, but she had a hunger for a family; she wanted a child. She gets to know a certain doctor in town, Ron Sable. He was a gay doctor at the hospital, a tremendous guy—courageous. He ran for alderman and almost got elected and was in civil rights groups, peace movements, everything. Dr. Fagan tells Ron that she wants a baby so bad, and then asks, Could she have some of his sperm? He says, Of course! And so she has a baby boy to raise.

Now way up in Massachusetts is Linda Gagnon. Linda is more openly gay. In fact, she says, I "spent all my money on women and booze" (quoted in Terkel 2002, 402). That's the way she put it, but she said that a moment came when "I had a strong desire to have a child" (402). Through a Chicago friend, she heard about Ron Sable, and Ron agreed to meet her. He believed lesbians have a right to have children. When it was time, Linda called, and Ron came by and went to a spare room to leave his donation. She had a baby boy two months before Kathy did.

They never met, these two women and these two wonderful boys, until Ron Sable became ill. There was a tribute to him, and about two hundred Chicagoans were there—I was there, coworkers from Cook County Hospital were there, and the two women came with his two boys—all paying tribute to Ron. The mothers met there and fell in love.

Eventually, they decided to live together with the two boys, and Ron would see them once in a while. Originally, donating sperm was a political decision: They have a right! But with time, he came to love the boys as a father loves his sons.

When the boys were seventeen years old, one was thinking of going to Elmhurst College, and so they came to Chicago. That's when I got to see them, and they described the last dinner they had with Ron. It was one of love and delight.

What are family values? There's a lot of talk about family values, about saying the right word at the right time or else. What are family values about? They mean nothing unless there is one thing, as there was in that case: love. They knew Ron was dying, but he was visiting them, these two kids. That's what family values are really all about.

THE CHALLENGE

Chicago had a great cardinal named Bernadine, a marvelous man. He was pro-gay, and he also was for single-payer health insurance and believed in the First Amendment. Cardinal George is somewhat different; he's a decent guy, but he's closer to the current Pope. (It's amazing how being antigay goes along with asking priests to be celibate.)

I'm not a Catholic, I'm an agnostic. You know what an agnostic is—a cowardly atheist. I do believe in a God somewhere, but I've always asked a question of guests on my radio show: Has it ever occurred to you that Jesus might have been gay? It's a shocking sort of question, but why not? Would that difference alter the Sermon on the Mount? Would it alter all the phrases saying the "least among you . . . shall be great" (Luke 9:48) or the "last shall be first" (Matthew 19:30, 20:16)?

Or could it be possible that Jesus was a girl? Does it matter whether God is a He or a She? I'm not talking about the Catholic Church but about something more general, about how race, or gender, or sexuality are all related to basic decency. Fundamentalists say, "My God is the one, and no one else counts." Fundamentalism, whether Islamic or Christian or whatever it might be, is the opponent.

There is a battle on, and it can be challenging. The phrase *liberal media* is one challenge. Liberal media? Public television that's called liberal is stocked with William F. Buckley, Jr., *The McLaughlin Report*, and conservative commentator Robert Novak. You'd think Noam Chomsky were on every night. It's a joke, liberal media. Fewer and fewer multinationals control more and more means of communication, and so we have a battle. All of us are engaged. It's a battle against an assault that occurred in 2001, on a horrendous day, but also against another assault, one upon our native intelligence and upon our sense of decency.

What is new or different about the war on terrorism? September 11 was the first time the continental United States has ever been physically attacked from outside. My friend Gene La Rocque, a retired admiral and war hero, says that the United States has engaged in more military adventures elsewhere than any empire in history. Start naming the places: Granada. Ever hear of Granada before the media reported that enemies there were going to invade here? Nicaragua. Ronnie Reagan was president when the Sandinistas were supposedly going to go through Mexico to invade here—and nobody laughed.

I wrote a book called *The Good War* (1986), but *good* had quotation marks around it. My wife suggested that. No war is good. War makes savages, on all sides, of sweet kids who would otherwise be decent. The fundamentalists who attacked the United States of course were loonies, barbarians who should be tracked down. But the attack was also a wake-up call saying the United States is part of the world. Not once did our appointed chieftain speak of the United Nations. We are part of the world, all of us, no matter who we are or where we are.

Ordinary decency takes courage. In law school, I was a lousy student who didn't want to study. In fact, I wanted to get away after I finished. I got a civil service job in Washington, D.C., and shared an apartment in Georgetown with a friend of mine—fifty bucks a month in Georgetown. My friend was gay, my apartment mate. I was worried about him because he liked rough trade, but he was a wonderful guy. It took courage back then to be gay, and he was terrific.

Courage comes in all sizes, all dimensions, all sexes, all everything. We all have that something in us. Why does a bully behave a certain way when you challenge him? Is he scared of something inside himself?

James Baldwin asked what his people came here for—not came, they were kidnapped. If they saw the Statue of Liberty, they didn't see freedom, because they were in chains. Did they arrive to live and fight and work for freedom and liberation, only to get—I remember the phrase he used—"a lousy Cadillac"? Baldwin had just come from self-imposed exile in Switzerland. He left to write the book, *Nobody Knows My Name.* That's a great title, meaning, of course, that whites don't know the black person's name, because the servant who was there just served. But the servant knew more about the master than the master knew about the servant. Nobody knows my name, but I know yours.

Decent people know that race and sex and everything else are all related. I'm a hotel keeper's kid, I was raised in a hotel, and a hotel has everybody in it. When I walk down the street, just as a matter of course, I greet everybody. As I walk down the street, there's a woman, a black woman, carrying two heavy bags, and she's tired. So I say, "How's it going?"—just as a matter of course. She says, "Fine, and you?" Invariably, how are you? And you? She is suddenly recognized, and here are three

black kids going by, teenagers. But here's this old gaffer—me—walking by, asking how it's going. And you? That's the most natural thing in the world.

Jimmy Baldwin represented all that, basic human decency, human courage, and overcoming all these burdens—not self-imposed but the ones that society imposed. Everything is related: race, origins, gender, sexuality. Everyone is connected: black or white, immigrant or native born, male or female, gay or straight, and in between. We are all part of the world. Only courage and decency can win the battle and make us free. So we have to tell our stories, whatever they are. And what are we talking about? We're talking about freedom. Freedom.

REFERENCES

Terkel, Studs. 1986. *The Good War: An Oral History of World War II*. New York: Random House.

———. 2002. *Will the Circle Be Unbroken?: Reflections on Death, Rebirth, and Hunger for a Faith*. New York: Ballantine Books.

Part II
Flaming and Fashioning

Queer Markets

DEIRDRE McCLOSKEY

The essays here illustrate what I regard as an exciting possibility for a new turn in queer studies. But it's one that will not please everyone. Most queer academics think of themselves as progressives or socialists. Anything but advocates of free markets. Having been there myself—a long time ago, and in another gender, I was a Joan Baez, folk-singing version of a Trotskyist—I can understand the progressive point of view. I can remember its attractions. As one peruses the pages of the *Nation* or Noam Chomsky's latest, it *feels* like one is doing good. Imagine that: You can do good just by reading and nodding your head.

And I know the charm of political opinions, left or right, as an identity. We acquire our political identities at the romantic age of young adulthood. Like gender, settled in one's personal theories at age two or so, most people don't trouble to rethink later their political opinions acquired at age twenty or so. Saul Bellow said of his early Trotskyism, "like everyone else who invests in doctrines at a young age, I couldn't give them up" (Bellow 1994, 308). People come as young persons to *hate* the bourgeoisie or to *love* capitalism or to *detest* free markets or to *believe passionately* in the welfare and regulatory state. It becomes part of a cherished identity, a faith. I appeal to you to rethink your faith.

Fair warning, then: I want to make the libertarian case in queer media studies. Consider the evidence here assembled. In all three essays, I claim, Sender, Doyle, and Kama show—often reluctantly—the power of the market for good. That is, they

show the power of the market for advancing the project of human freedom and, in particular, queer freedom.

The focus is on the media, and it should be noted right away that the media examined do not depend on government handouts or even a sweet socialist co-op of journalists. They are *commercial* outlets, as is especially clear in the essays by Sender and Doyle. And they are mass media, with a sovereign listener supplied with a television clicker or, at worst, an on-off switch. From a perch in Israel, Kama observes that a mediated discourse coming over the airwaves allows in practice more dignity and more genuine human contact than does person-to-person communication. Status, gender identity, and an undeconstructed hierarchy of difference squat like a toad on a person-to-person conversation. Imagine you are dropped into a conversation about the so-called gay lifestyle between Bill O'Reilly and George W. Bush. Set it in the Oval Office. Add a few television cameras. As much as you can, in private, diss their opinions with eloquence, in a public one-on-one or, in this case, two-on-two, you will be rendered speechless. The ethos of the president, the ignorant assurance, the skill at partisan shouting, and all the other inequalities of the tête-à-tête, mano-a-mano, win.

Academics often think of personal conversation between two honestly engaged individuals as the ideal: uncoerced, uncommercialized human communication. I love it, too, this ideal speech situation, and have practiced it clumsily over my life with a few people I love. Lloyd, Derek, Joanne, Arjo, Steve, John, Ralph, step forward. But, without love, notice, a so-called personal conversation never sheds the burden of ethos, the who-you-are that oppresses every chat you have with your boss or every competitive sports talk session you have with your straight male buddies. More room exists for queer talk and queer behavior and queer theorizing in a rich, *commercial* society than in a conversation between two individuals.

Some worry that the commerce of media empires will stifle free speech. But as long as we are allowed to make up new media, like new printing presses or new mail services—witness the internet, the explosion of blogs and arm's length conversations on e-mail with strangers—I doubt it. There's nothing bad, now that we're on the subject, by the way, about paying someone else to make your arguments, Colonel McCormick running the Chicago *Tribune* as a mouthpiece for reaction. That he didn't let New Dealers write in his newspaper was not *censorship*, as is sometimes loosely claimed. Arguing is not against the Constitution, nor is paying for the argument, as long as you don't rely on the state—that is, as long as you don't call in the cops. What the First Amendment says is that the *government* shall make no law abridging freedom of speech. It's not about being unable to get an audience of half a million readers for your side of the argument because you don't own a newspaper. You can say to yourself or your hubby, "Oh, that's a lot of nonsense. The *Tribune is* wrong, and if it goes on saying that I'm not going to buy the bloody newspaper."

That's argument in a free market society, as the blessed Adam Smith once remarked (and is in fact pretty much what happened to the Chicago *Tribune*, which nowadays is a left-Republican paper).

Having a media problem is not the same thing as being disenfranchised or censored, not unless the state is involved. There's no ideal speech community of easy access to serve as the utopia relative to the actual, messy market for Google or newspapers or whatever. The transgender community, for example, faces a media problem in our battle against Michael Bailey, who stepped down as chair of psychology at Northwestern University after publishing *The Man Who Would Be Queen* (2003). "Most gay men are feminine," Bailey writes, "or at least they are feminine in certain ways" (xi). The professor's gaydar can spot those "certain ways" from across the street—on the basis, for example, of the pronunciation a man gives the sound of the letter *s*. And from a long city block away Bailey can spot a *real* gender crosser—those are the pretty ones, the ones whom the professor feels are sexually *attractive*. According to his primitive theory, they're just an extreme form of gay men. He can distinguish them from former men who are *not* attractive to him, the type that, contrary to what they will say (they are all liars), experience "sexual arousal at the idea of themselves as women" (xi).

It's really quite simple, Bailey says. Weird born men (he doesn't talk about born women in the book) are driven by sex. It's either sex with other men or sex with themselves. Sex, sex, sex. *Identity* has nothing to do with it. You can think of Bailey as an identity politician's worst nightmare.

Bailey is attacking the by-now accepted scientific view that whom you love and who you identify yourself to be are not the same issue. Au contraire, says the professor. It's not that formerly male gender crossers have an identity of womanhood, felt or desired, the way you feel or desire that you want to be a lawyer, say, or a resident of Florida. Nor do the more feminine-looking (because earlier changed), pretty ones have such an identity. No *identity* about it. Both are driven by sex, because that's what *men* are interested in. Bailey calls gender crossers *men* throughout his book. Born a man. Too bad. Like certain second-wave feminists, such as Mary Daly or Germaine Greer, Bailey is an essentialist. As the guys down at the Veterans of Foreign Wars post have always known, men are men, and women are women. Period.

No one should be surprised that Bailey's ideas have been seized on by the religious Right. John Derbyshire, a homophobe who contributes frequently to *National Review* in print and on line, wrote a nice piece about the book, drawing the moral, "Male homosexuality, in particular, seems to possess some quality of being intrinsically subversive when let loose in long-established institutions, especially male dominated ones" (2003, 51; see also McCloskey 2003). (Where is Roy Cohn when we need him?) For God's sake, let's not let the queers *loose*.

Believe me, this is a gay issue too. The gay press, again, hasn't quite caught on. My pastor, who is gay, allowed himself to be interviewed by Bailey because the gay press has *not* exposed the professor's nonsense. Kama's structural analysis of the careerism of the gay presses is relevant to this particular controversy. Members of the gay press think, "Oh well, it's about those trannies, who are anyway embarrassing in the Gay Pride parade. Let's not make too much of *them*."

But I have no deep complaints about the capitalist media here. *Reason* magazine, a capitalist institution, let me rant against Bailey for seven pages. The internet campaign against him, run by Lynn Conway, an emerita professor of electrical engineering at the University of Michigan and a member of the National Academy of Engineering (she was fired by IBM for transitioning from male to female in 1967 and then went on to invent crucial pieces of modern computation), has been effective. My only complaint—and it should be yours—is that Bailey has been supported by the *other* National Academy of Science, by its Joseph Henry Press, which has been turned, in recent years, to the uses of homophobes in the Bush administration. *That's* a sort of censorship with a minus sign, the encouragement of hate speech by state-financed entities.

What I'm saying is that the market is not the enemy of queers. The restaurants and bars from which the drag queens exploded in political action in the 1960s in San Francisco and then in New York were after all profit-making entities. The enemies were the gender cops, not the owners of coffee shops. States use conservative institutions, anti-queer institutions, anti-free institutions, institutions that keep citizens sitting where they can be taxed and won't cause trouble.

There's a lot of talk on the left about coercion in the marketplace. But all three of these essays show market institutions working for queer rights. Imagine if the government ran all the newspapers and all the television stations and all of the internet and all the public forums. It's not too hard to imagine: China or Iran or Putin's Russia. It's been tried, you know; it doesn't work for queers. I have a sophisticated Polish friend who is straight but, in other respects, is among the most cool and clued-in persons I know. She has worked since before Communism fell in Sweden as a distinguished professor of management. The issue of homosexuality in Poland came up. She said, "Oh, I don't think we have homosexuals in Poland." "Dearest," I said, "what are you talking about? Poland like everywhere else has 5 or 10 percent of the population gay." She was stunned by this news. She had grown up in a non-market environment, where all the news, all the publications, everything came straight from the Polish Communist party. That and the Polish Catholic Church.

I want to shake your age-twenty-one political convictions a little. I want you, as Oliver Cromwell expressed it in vexation at the quarrelsome Presbyterians, to, in the bowels of Christ, think it possible that you may be mistaken (Cromwell 1650, 18). A startling expression: In the seventeenth century, *bowels* meant merely "your emotions,

your heart." If you think that being progressive about matters of gender identity and of sexual preference fits just perfectly with being against the market, consider in your heart, I beg you, that you may be mistaken. The Polish Communist Party, the Catholic Church, the House of Representatives, or whatever nonmarket institutions with a state backing it are not good places for queers. The way forward is not more government. It is free societies.

REFERENCES

Bailey, J. Michael. 2003. *The Man Who Would Be Queen: The Science of Gender Bending and Transsexualism.* Washington, DC: Joseph Henry Press.

Bellow, Saul. 1994. *It All Adds up: From the Dim Past to an Uncertain Future.* New York: Penguin.

Cromwell, Oliver. 1650. Letter CXXXVI to the General Assembly of the Kirk of of Scotland, 3 August. In *Oliver Cromwell's Letters and Speeches: With Elucidations.* Vol. 3, Part 6, pp. 16–21. Ed. Thomas Carlyle. New York: Scribner, Welford & Co., 1871.

Derbyshire, John. 2003. "Lost in the Male." Review of *The Man Who Would Be Queen: The Science of Gender Bending and Transsexualism*, by J. Michael Bailey. *National Review*, 30 June, 51–52.

McCloskey, Deirdre. 2003. "Queer Science: A Data-bending Psychologist Confirms What He Already Knew about Gays and Transsexuals." Review of *The Man Who Would Be Queen*, by J. Michael Bailey. *Reason 35*.6 (November): 46–52.

Professional Homosexuals

The Politics of Sexual Identification in Gay and Lesbian Media and Marketing

KATHERINE SENDER

Many workers in gay and lesbian media and marketing are professional homosexuals: openly gay, lesbian, bisexual, and transgender employees and consultants whose sexuality contributes to their professional expertise. They must negotiate between their professional and sexual identifications, that is, between, on the one hand, an identity once seen as an obstacle to professionalism and, on the other, an identity that provides subcultural capital necessary to their work. The strategies they employ to balance their occupational and sexual identities shape not only their professional culture but also the cultural products they produce, including advertising, magazines, and internet sites.

Since the early 1990s, the United States has seen a rapid increase in the visibility of a new consumer niche: the gay market. More national corporations, including Subaru cars, Tanqueray gin, Abercrombie & Fitch men's wear, and American Express Financial Advisers, have courted readers of the gay press, and Bravo, a cable channel owned by NBC, launched the hit makeover show *Queer Eye for the Straight Guy* in 2003. Together, the initiatives signal a mature phase of the gay market and an increasing acceptability of (some) gay images in mainstream media. Marketers tend to talk about the development of the gay market as an evolution (Farber 2002) or as though a preexisting gay market simply came to life (Landry 1999) in the 1990s. Their perspectives disavow the efforts of lesbian, gay, bisexual, and transgender (LGBT) marketers and media professionals since the late 1960s to organize gay male and, with some ambivalence, lesbian consumers, although almost never anyone

bisexual or transgender, as the gay market. If LGBT critics of gay marketing consider its creators at all, they envision cynical exploitation: heterosexual employees of multinational corporations producing gay marketing texts to impose false representations upon an unwitting gay population just to increase profits. Within this model, LGBT-identified professionals are either invisible or entirely co-opted in the service of goals that work against the interests of LGBT communities. Yet the exploit–co-opt model is insufficient to address the competing demands on the professionals involved in gay marketing, most of whom are LGBT identified. First, despite many corporate spokespersons' claims that gay marketing is a matter of business not politics, LGBT marketers must be responsive to the business practices and the political stakes of their work. Second, as professional homosexuals, LGBT marketers must navigate between the sometimes contradictory demands posed by their professional and their sexual identifications. For, on one hand, the display of personal identity—especially when sexually and politically marked—tends to appear unprofessional, a barrier to career advancement. On the other, LGBT-identified marketers and other professional homosexuals get hired precisely for the experience afforded by their sexual identification. Consequently, LGBT marketers' professional credibility rests upon and risks being undermined by their sexual identity. Third, sexism and racism exacerbate the effects of homophobia in professional contexts, meaning that LGBT women and people of color tend to be more reticent about their sexual identity than are white men. As a result, white gay men are more likely to advocate for gay marketing and to produce images that look like them. In this way, the gay market, as imagined and appealed to, is a direct consequence of these strategies marketers employ to balance the demands of their occupational, sexual, and other identities. The strategies shape their professional cultures and the cultural products they create: advertising and ad-supported LGBT media.

Since January 1998, I have interviewed 45 professionals who work in gay marketing and media, including magazine publishers, ad directors, journalists, sales representatives, advertising agency creatives and account executives, corporate marketers, market researchers, and public relations consultants. Of the interviewees, 26 were men, 18 were women, and 1 was transgender; 34 self-identified as gay, lesbian, or bisexual, and 4 self-identified as heterosexual, but 7 did not disclose their sexual identity. I acknowledge the complications of interviewees identifying themselves as lesbian, gay, bisexual, or heterosexual—the terms can suggest a reductive, essential, or stable sexual identity. For my purposes, however, the identifications proved valuable in making claims about the investments of marketers in their gay-specific work. Most of the interviewees considered themselves upper-middle class, professional, or bourgeois, although not all of them had come from affluent backgrounds. Only one interviewee identified himself as a person of color.

Besides conducting the interviews, I attended nine presentations on different aspects of the gay market, such as how gay and lesbian magazines court national advertisers and how marketers advertise to gay and lesbian consumers on the internet. I examined ads and consumer content from gay, lesbian, bisexual, HIV-positive, pornographic, and other magazines since 1967, as well as from local gay papers. I counted ad pages and ad content in three issues each of the *Advocate*, *Curve*, *Girlfriends*, and *Out* magazines from the fall and winter of 2002 to 2003. I reviewed ads and content on three internet sites with lesbian, gay, and bisexual content, and collected more than two hundred newspaper and trade press articles on gay marketing that have appeared since 1972.

PROFESSIONAL HOMOSEXUALS

Economist M. V. Lee Badgett argues that no one foisted gay consumer culture upon unwitting people with a LGBT identity, nor did mainstream advertisers simply co-opt a gay sensibility, but "this latest stage of commercialization is the result of a complex interaction between market forces, corporate marketing practices, gay collective action, less homophobic public policies, and the rise of the 'professional homosexual' " (2001, 103). The term *professional homosexuals* describes open queers who work in professional-managerial status occupations and whose sexuality constitutes part of their professional expertise. Like other professional homosexuals—openly gay lawyers, health workers, academics, and fundraisers, for example—gay marketers must sell their subcultural capital while minimizing the risks their sexual identifications pose to their career advancement and professionalism. According to a report from the National Gay and Lesbian Task Force (NGLTF), in 2001, only ten states protected openly gay and lesbian employees from employment discrimination, and two more, plus Washington, D. C., also protected transgender employees (NGLTF 2003, 18). The majority of LGBT workers in the United States face being fired, demoted, and harassed because of their sexual identification. Despite the risks, business scholars Annette Friskopp and Sharon Silverstein (1995) found that increasing numbers of gay and lesbian Harvard Business School graduates chose to be open about their sexuality with at least some of their colleagues, some of the time.

Friskopp and Silverstein also discovered that lesbians and people of color across a range of professions were less likely to be open about their sexual identification than were white, gay men, largely because they already suffered workplace sexism and/or racism, and believed that to also be known as gay would result in a double dose of discrimination. Although it is impossible to measure reliably the number of open lesbian marketing and advertising professionals, my research suggests that

the group is fairly small. Jack Schlegal, board member of the New York Advertising and Communications Network (NYACN), said that women made up about 15 percent of their members. Journalists Ivy Kazenoff and Anthony Vagnoni (1997) estimate that, although 39 percent of advertising students are women, the percentage drops rapidly at each level of seniority in agencies. From interviews with current and former agency creatives, the authors report that some women found off-putting agency life perceived to be " 'a boy's club where women have to adapt,' and 'a big boy gang-bang' " (19). Advertising agencies perceived to be inhospitable places for women, especially in creative departments, present additional challenges for lesbian agency workers. Feminist-identified lesbians may struggle with ideological questions about being in the lion's den of patriarchal capitalism: "While lesbian cultural norms are changing, the expectation that lesbians should be politically correct—that is, anti-capitalist, downwardly mobile do-gooders—remains an obstacle for those who wish to pursue careers in business" (Friskopp & Silverstein 1995, 362). The tensions for lesbians working in advertising, epitomized within some feminist critiques as exploitative, manipulative, and oppressive of women in particular, may further mitigate against their pursuing careers there. Openly lesbian professionals are more present in other sites of gay marketing, particularly in public relations and in marketing departments of corporations, than they are in advertising agencies; although 40 percent of my interviews were with women, none of the lesbian interviewees worked at ad agencies.

Friskopp and Silverstein found that, like women, LGBT people of color were less likely to be open at work than were white male professionals. Howard Buford, president and CEO of Prime Access advertising agency that specializes in marketing to Black, Latino, and gay consumers, was the only participant who identified as a person of color among forty-five interviewees. *Advertising Age* journalist J. W. Ellis, IV (1998), found that the numbers of people of color in ad agency management positions declined during the 1980s and 1990s. He argues that white-owned agencies tend to assume that there are few qualified minority candidates to hire, do not have diversity and mentorship programs to support minority employees, and are perceived by those employees to be hostile to complaints about racial discrimination in the workplace. If agencies do little to support their racial minority employees, the added effects of sexual marginalization are likely to further mitigate against the employment and retention of LGBT people of color. In an interview, Buford (2001) discussed with me the low numbers of women, queers, and people of color in advertising agencies. He commented that agencies have "no investment in hiring these people. They may by accident get someone good for a year or two, but they don't go anywhere inside that agency; so we have a wonderful talent pool looking for a place to go—really good people unable to be who they are and to really express themselves" in mainstream agencies. Niche agencies, such as Prime Access, take

advantage of their predicament, gaining access to talented staff with gay subcultural expertise by offering a congenial work environment, if not large salaries.

LGBT-identified marketers' sexuality is a central factor in their professional identity, but not the only identity of significance. Women and people of color face additional challenges in negotiating the complex set of demands posed to all LGBT employees by occupational professionalism, a nondominant sexual identification in somewhat gay-friendly work environments, and LGBT cultural politics. Communication scholar James Woods (1993) identifies a variety of identity management strategies that gay male professionals use to handle their sexuality in their professional lives. Because he focused on gay men, most of them white, it is hard to extrapolate his findings to LGBT women and people of color. Nevertheless, he argues that "there are at least as many ways of shaping a gay identity as there are of trying to evade one, and while the man who reveals his homosexuality no longer finds it necessary to hide, his change in strategy brings with it a new set of obligations: . . . he now faces decisions about where, when, and how often his sexuality is to be displayed" (172). Some of Woods's sample remained closeted by counterfeiting a heterosexual identity (by fabricating opposite-sex dates, for example) or by avoiding conversations about their private life. Others, however, deployed a range of strategies to integrate their sexual and professional identities. Integrative strategies included minimizing the importance of their sexual identity by allowing a tacit understanding of being gay and normalizing what others perceived as an abnormal sexual identity by, for instance, calling their partner a spouse. Sometimes, gay professionals would dignify their sexuality: "Rather than emphasize how normal homosexuality is, assimilating it to the mainstream," dignifying "tactics *preserve* its marginality. Differences are transformed into assets" (188). Woods calls more confrontational strategies politicizing marginality: If making it seem normal or an advantage could not absorb being gay, then gay professionals would pursue more active political means, such as forming professional groups within companies to push for greater acceptance and equal benefits. Queer professionals did not always deploy one strategy over others, but moved between them as situations demanded.

Many of Woods's gay-identified subjects did not work in gay-friendly environments, making them more likely to employ counterfeiting, avoidance, and minimizing strategies to lessen the possible impact of their sexuality on their professional lives. By contrast, the majority of my interviewees (34 of 45) identified themselves to me as gay, lesbian, or bisexual and based their professional expertise in part on that very identification. This is not to say that their gayness was not a problem and needed no managing: After all, many of the LGBT marketers worked in mostly heterosexual agencies or corporations and regularly interacted with heterosexual colleagues and clients. The interviewees dignified and politicized their roles by positioning themselves as experts, as members of a professional community, and as political progressives.

They did not situate themselves *either* as professionals *or* as political activists, but as both: Their activism enhanced their professional expertise, and their work advanced the politicized project of LGBT visibility.

EXPERTS

Almost all the LGBT-identified marketers I spoke to assumed that LGBT professionals are more effective than heterosexuals in marketing to LGBT consumers, because she or he possesses knowledge and tastes particular to a subculture not easily accessible to nonmembers. French sociologist Pierre Bourdieu imagines cultural capital in class terms; the value of what you know increases as you climb the socioeconomic ladder. Cultural capital is not only class based, but is also organized around other forms of identification, including sexuality. Cultural studies scholar Sarah Thornton develops Bourdieu's notion of cultural capital, arguing that *subcultural capital* may function in a semiautonomous relation to more established hierarchies of cultural capital: "Subcultural capital confers status on its owner in the eyes of the relevant beholder" (Thornton 1996, 11). For gay marketers, the subcultural capital afforded by their sexual identification and participation in urban LGBT enclaves equips them with an expertise that becomes marketable.

In the early to mid-1990s, large corporations began to seek out gay-owned agencies and LGBT freelancers for the gay subcultural capital they could offer. In an interview, Dan Baker (1998), the former editor of the gay marketing newsletter *Quotient*, told me that many companies "didn't know—and their advertising agencies didn't know—anything about the gay market, and . . . they wanted to deal with people they felt could tell them something that they didn't know." Recently, some general-market agencies have used the skills and subcultural knowledge of their openly gay employees on ads with gay themes. In 1998, former *Advertising Age* columnist Michael Wilke (1998) told me, "As more gay-specific ads come along, the mainstream agencies are going to try and suit those needs. They may do a medium job on that unless they start becoming more specialized and up-front about appealing to the market and bringing on people who will do a good job in that area and will specialize in it within the mainstream agencies."

In a phone interview, marketing and public relations consultant Bob Witeck (1998) talked about a client's agency that had put young, heterosexual creatives on a gay-themed campaign, and the problems that a lack of gay-specific expertise and research produced. His marketing and PR agency—

> took on a mission of meeting with [the client's] advertising agency, and their straight staff who were doing it . . . well, we imputed that they were straight, we don't know one way or the other. . . . We brainstormed with them on some ideas that they were eager to talk about,

and the thing we were puzzled by [was that] they didn't know about basic things about imagery in the gay community—what was appropriate, what was inappropriate imagery, or what are appropriate messages and what's inappropriate. There are certain things you can say that talk about being special or unique that can connote being ghettoized, and some that can talk about it in a way that is refreshing and appropriate. And they would come up with some that were not quite right at all, and some that could have been downright offensive.

The quotation indicates how fine the distinctions are between supposedly unique and appropriate or offensive ways of talking about gays. Although Witeck naturalized the distinctions, he was not clear about how to adjudicate between them: An indefinable, but necessarily gay, judgment set the boundaries. Insider knowledge, positioned as key to navigating the murky waters between appropriateness and inappropriateness, legitimates marketers' gay expertise in the production of successful advertising to gay consumers.

Although helpful, gay subcultural capital may not be sufficient to create a successful campaign. Howard Buford (1998) argued that simply identifying as gay did not offer specific enough expertise but that some campaigns required a gender-specific sensibility. He told me about a commission to develop a campaign for a lesbian dating service:

They asked us to design the logo and treatment and that kind of thing for it. And at the time they asked, in house we didn't have a lesbian designer, so I contracted outside to make sure that it was really right, because I wasn't confident, you know—a gay man can't design something specifically for lesbians, . . . unless they're really, really, incredibly sensitive, you know what I mean? Yes, white people can do some of the stuff for African Americans and sometimes it can be incredibly authentic looking, but usually that's not the case.

According to Buford, appeals based on identifications—gay, straight, lesbian, African American—require the particular knowledge of that identification to be successful.

The question of gay subcultural capital was a particular problem for those marketers who identified themselves as heterosexual (4 of 45 interviewees). LGBT- and heterosexual-identified interviewees alike stressed that, if marketers were not themselves gay, they needed to acquire knowledge about gay culture and concerns to make successful appeals to the gay market. In our interview, Patrick Sullivan (1999), account supervisor for a large brewing company, recalled the process of learning how to appeal to gay consumers: "I am not gay, so I have had to put aside my own stereotypical perceptions and really go out to a lot of gay bars and try to learn about this marketplace, and there's no way a straight person can market to gays and lesbians without getting out there—you know, you can't do it from a desk." Sullivan's comments suggest that straight-identified marketers cannot fully share gay subcultural knowledge but can understand only vicariously by looking in on a gay world.

In some cases, prospective customers' discomfort in dealing with openly gay sales representatives overshadows the advantage that LGBT-identified marketers' subcultural expertise offers. In an interview, *Out* sales representative Caitlin Hume (1999) said that, as a heterosexual woman, she was much more successful selling ad space for *Out* to some alcohol beverage companies than were her gay male colleagues, because she could respond less defensively to corporate executives' homophobia: "I don't walk around thinking, 'Oh, I'm straight,'" she said, but "I am very conscious of it when I am championing the magazine with conservative advertisers." Wild Turkey marketers had ignored all efforts by *Out* sales representatives to lure the brand into the magazine. Hume did not usually sell ad space to alcohol companies, but when she called, Wild Turkey said, "'Sure, come on in.' They didn't know what my story was. Maybe it was just the fact that I was a woman. . . . If there's a conservative good ol' boy, he'll say, 'Cate, get down there,' and I'll say, 'Okay.'" As a heterosexual woman, Hume gained access to a company that did not want to deal with gay-identified magazine sales reps but was happy to make profits from sales to gay consumers.

Considerations of who does the best gay marketing therefore raise interesting and sometimes contradictory perceptions of subcultural knowledge and expertise. Most of the time, gay marketers' deployment of expertise in their professional lives demonstrates Woods's dignifying difference strategy by turning their marginal status into an asset. Dignifying strategies mark a bold move by openly gay professionals to neither hide nor minimize their sexual identifications. On the contrary, the strategies help gay marketing professionals distinguish their skills and expertise, offering advertising agencies and corporations access to gay media, communities, and consumers not available to heterosexual marketers. Gay-specific agencies and openly LGBT personnel have a vested interest in protecting the boundaries of expertise, especially as more general-marketing agencies formulate appeals to gay consumers, and heterosexual marketing professionals feel equipped to carry out such appeals. Dignifying strategies therefore reaffirm the specific expertise of gay marketing professionals in part to ensure ongoing employment.

EMPLOYEES

Even as more gay employees in companies and marketing agencies protect their jobs by offering their gay subcultural expertise, the employees are usually in the minority in corporations and agencies. Their status offers them leverage, assuming their expertise is in demand, but also makes them vulnerable to antigay hostility and marginalization. LGBT marketers have straddled the often uncomfortable position by making the most of their gay subcultural capital while gaining social and professional support from other LGBT employees within and beyond their place of employment.

They have formed LGBT employee groups within companies, such as the Lesbian, Bisexual, Gay, and Transgender United Employees at AT&T (called League), and have organized gay professional associations, such as Out Professionals.

The function of employee groups is not only to provide support for gay and lesbian (and sometimes bisexual and transgender) employees. Some interviewees referred to the role of employee groups in encouraging corporations to initiate and sustain marketing to gay consumers. When I talked to Ginny Schofield (not her real name) (1999), engineer and cochair of a gay and lesbian employee group in a high-tech company, she related that the company had banned such groups for years out of fear they would function as trade unions. In the mid-1990s, her employer began forming a gay and lesbian employee group and then charged it with suggesting measures to improve the recruitment, training, retention, and productivity of gay and lesbian employees. As a result, the company adopted a nondiscrimination policy based on sexual orientation and domestic partnership benefits. In addition, the company chairman asked the group to provide specialist expertise on marketing to gay consumers: "How can we reach your target constituency and sell more products to them?" Schofield said that cochairing the employee group, including having input into gay-specific ad campaigns, was "one of the more fun things that I have done, because I don't normally touch advertising—it was fun to actually give opinions on things." Gay subcultural expertise supersedes profession-specific expertise, as an engineer becomes an (unpaid) advertising consultant, at least temporarily.

Although some client companies encourage the organization of gay groups, most advertising agencies do not offer similar open environments. Despite claims by Frank, Woods, and Friskopp and Silverstein that advertising is one of several supposedly gay-friendly industries, the overwhelming view the trade press and my interviews offered was that advertising agencies are not sympathetic to, or supportive of, their openly gay employees. *Adweek* journalist Betsy Sharkey argued that, although more advertising professionals were open than in previous decades, gay and lesbian ad executives had plentiful stories about ongoing homophobia, closetedness, and stalled careers:

> Agencies like to consider themselves as progressive and forward-thinking places, always ready to anticipate or respond to social trends. The gay market has become increasingly desirable for certain clients, with ads directed at or depicting gays now appearing in mainstream publications. And yet for years, many gay men and lesbians have chosen complete silence—either avoiding the issue entirely or trying to pass for straight, sometimes creating elaborate fictions of wives, husbands, children, dates, sometimes actually marrying and leading a double life. (Sharkey 1993, 24)

Sharkey acknowledges that there were some differences related to age among her one hundred interviewees, where younger agency personnel "have, for the most part, made their sexual orientation clear from the moment they started their job" (29).

Furthermore, given the rapid expansion of the gay market through the 1990s and consequent demand on general market agencies to profit from the gay subcultural expertise of their employees, homophobia and closetedness in ad agencies may have diminished. Yet Michael Wilke (1998) told me that even in the late 1990s he did not believe that gay agency personnel "have been encouraged to be out, because at this point the advertising business among agencies is still fairly closeted, to many people's surprise." In an interview, marketing consultant Stephanie Blackwood (1998) said that, although agency life was "as closeted as the individual decides to make it, surprisingly there are very few—*very* few—agencies that offer non-discrimination policies [or] domestic partner benefits." Only seven of the top fifty ad agencies responded to an *Advertising Age* survey on their nondiscrimination and domestic partnership policies for gay and lesbian employees, a fact, Wilke (1997) suggests shows a lack of commitment to the issue. Those agencies that did respond reported some pro-gay policies (three offered same-sex health insurance benefits; five had gay-inclusive nondiscrimination clauses), but the low response rate reveals agencies unmotivated or unwilling to disclose their policies (or lack thereof) toward gay employees. My interviewees saw some general-market agencies as more gay friendly than others. They often mentioned Deutsch, for example, as one of the best agencies for openly gay employees and, not unrelated, as the producer of gay-themed television commercials for Ikea furniture and Mistic beverages.

Although gay agency workers might have limited opportunities to organize within their companies, the growth of gay professional associations offers interorganizational networking opportunities. Journalist Thomas Stewart (1991) recalls that gay professional groups "mushroomed" in New York alone in the late 1980s and early 1990s, when the Bankers' Group, the Publishing Triangle, and the Wall Street Lunch Club joined the New York Advertising and Communications Network (NYACN). The groups often functioned as social meeting places as well as professional networking contexts, and Stewart's description of them offers insight into their class specificity. He explains that, together, the New York gay professional associations "are simply called the Network" and make their annual dinner such an event that "you'd have thought you were at a corporate dinner for US Steel" (46). One agency employee told him, "I've brought in business through this network. And I've grown. I've been exposed to normal people—people with ambition, not people in bars" (46). Stewart's article describes the conservative tenor of gay professional groups, at least in the early 1990s, and hints that members have in mind distinguishing and maintaining not only their sexual identity, but also their professional class position through membership.

NYACN was the primary professional organization for advertising, public relations, and communications personnel in New York, the city that produces more gay marketing than any other. Formed in 1983 with 10 lesbian and gay members,

the group grew rapidly to 200 members by 1985, to more than 950 in the late 1990s, and reached 1,200 members after it changed its name to Out Professionals in 2000. The increase of membership during these years reflects larger numbers of gay professionals becoming open at work, a parallel increase in gay marketing in the same period, and the growing reputation of such organizations, if not their clout. Yet, despite its growing size, the gender distribution of NYACN members remained unequal: Women made up only 15 percent of members, and lesbians' attendance at NYACN events tended to be even lower. NYACN board member Jack Schlegal (1999) declined to estimate the numbers of people of color in the organization, and my sense from attending meetings was that they were few indeed. The low membership and attendance rates of women and people of color in NYACN reflect, in part, how few women and people of color work in gay marketing and may also reflect differentials in the value of what Pierre Bourdieu (1991) calls social capital. Besides how much one owns (economic capital) and what one knows (cultural capital), *whom* one knows (social capital) contributes to one's position on social hierarchies. Professional organizations institutionalize the cultivation of social capital, offering members opportunities to elevate their status by shrewd networking. The benefits for lesbians and bisexual women and for men of color may be minimal. These groups tend to have fewer resources to tap into than do white men: fewer other women and people of color with whom to network and fewer material benefits—jobs, contracts, leads—to offer. In an employment culture often negotiated through networking, LGBT women and people of color are at a significant disadvantage, with less to gain from professional organizations where something else has replaced the old boys' club: the white, gay boys' club.

Some marketers I spoke to questioned the benefits of membership in gay-specific professional associations, even for white, gay men. In a phone conversation, advertising executive David Mulryan (1999) said,

> NYACN just doesn't make any sense to me. . . . [T]here's no good work that comes out of there. It's sort of like a little social club. . . . It's kind of interesting because there's all these associations—gay doctors, gay lawyers, gay bank tellers, and all this—and yet the mission and the charter of them all is sort of fuzzy, you know? What is it [they] do exactly? I don't belong to any of those, I belong to all of the regular advertising things.

Neither all of my interviewees, nor all of the men, were members of gay professional organizations.

LGBT associations, within companies and in professional groups, nevertheless offer solidarity and social opportunities to many personnel who might otherwise feel in the minority and stigmatized. They give employees leverage with corporations to treat LGBT staff equitably and, in turn, provide employers access to gay expertise that professional associations beyond the company may hone. It was striking to me

that corporate employee groups tended to adopt a more overt political agenda than did NYACN and Out Professionals. The professional groups' literature made no mention of the possibility that the groups might organize on behalf of members at a particularly nonegalitarian agency, for example, or campaign for more, or more representative, images of gays in advertising. Members may have seen the latter function as the domain of the Gay and Lesbian Alliance Against Defamation (Glaad), the LGBT media watchdog group, and some interviewees talked about being members of Glaad and Out Professionals. Nevertheless, Out Professionals' more personal approach to LGBT professionalism and subcultural capital contrasts with the political agenda of groups, such as Glaad. In the tension between business and politics that structures the gay market, marketers' associations stress professional development and elide the political potential of their organizations.

ACTIVISTS

Even though NYACN and Out Professionals did not take an activist role toward the production or circulation of gay marketing images, the interviewees I spoke to often commented on what they saw as the progressive aspects of their work. Some marketers, like Walter Schubert (2001), president and CEO of a gay financial web site (http://www. gfn.com), argued that activism was a state of being. In a phone interview in 2001, he told me that "when you are openly gay you are considered an activist and you are automatically making a political statement." Others considered their activism outside their professional roles. When I asked Howard Buford (1998) whether he saw himself as an activist, he at first listed all the LGBT organizations he worked with, such as Glaad and the HRC, and only later talked about some of the more active elements of his involvement. The discussions revealed a tension between the activist possibilities of their roles and the damage that being seen as an activist might do to their professional reputations. When marketers did talk about the political value of their work, they tended to stress a polite politics rather than a confrontational one. Promoting gay and lesbian visibility and educating homophobic corporate employees, advertising executives, and the heterosexual majority about the merits of appealing to gay consumers together manifest polite politics.

In a phone conversation, Matt Farber (2002) described his activism as arising from his work on developing a gay cable channel for Viacom:

> I'm not historically at all an activist So it's kind of strange for me to be in the spotlight around the [gay channel] My partner and I live in the suburbs . . . and it's not like we're living in West Hollywood or the Village or Chelsea. . . . So I guess part of what I think about is that [in] the very entertainment people see, they'll see all shapes and sizes [of queers] and we're just the same, and I think that's entertaining and empowering.

Farber describes here what I call an accidental activism, a role not unusual among my interviewees. Because they can promote gay visibility, many marketers see themselves as activists. Part of their status as professional homosexuals may rely upon an activist identification, but the common sense of marketing that separates business from politics requires that marketers distance their professional activities from their activist ones. With few exceptions, my interviewees framed their activism as respectable, with emphasis on the progressive and pedagogical, not the radical and confrontational, aspects of their work.

Marketers expressed a progressive perspective on gay marketing that associated visibility with validation: They took advertiser recognition of gay consumers as evidence of increasing political or social recognition of gay people, even if such visibility also raised the profile of antigay responses. When I talked to Patrick O'Neil (1998), a former Deutsch creative who developed a gay-themed Ikea commercial in 1994, he commented that he watched gay appeals with interest. He enjoyed anticipating "the influence, and what's going to happen with it, and how's it going to change people's opinions: the more you see, the better off we are, the more visibility." *New York Times* advertising columnist Stuart Elliott (1998) told me that "people perceive it as, quote-unquote, *progress* when Ford or Chrysler runs an ad for a car in a gay magazine, or runs an ad in a mainstream magazine showing two women in flannels and Birkenstocks driving away in a car." Showing queers in ads—especially those that appear in general-market media—appears progressive, on par with earlier commercials showing underrepresented populations. As Deutsch agency executive Andrew Beaver (1998) commented to me, "the working woman in advertising was a new idea once too, . . . or women who smoked, or . . . Black couples, whatever. All those things had their taboos and to greater or lesser degrees they were overcome in advertising." Marketers positioned themselves as central in proliferating gay and lesbian visibility through advertising and other media and sponsorship efforts.

Part of achieving greater gay and lesbian visibility required teaching mainstream companies that gay consumers were a desirable and acceptable market. Catherine Draper (1999) and Kurt DeMars (1999), magazine ad directors, acknowledged in our conversations that getting some corporations to advertise was still what they called an uphill battle, because of homophobia, the risk of antigay boycotts, and anxieties about conservative investor protests. Magazine sales staff saw advertising agencies as the route to persuading large companies about the value of the gay market. Agencies often have a lot to learn before they can advocate for gay marketing. In an interview, Caitlin Hume (1999) lamented ad agencies'—

> lack of understanding about what a powerful market [gays represent], then you get them over that bump and you suddenly realize that it pays to advertise to gays, and then they're scared to go and talk to their clients about it. Quite often because they don't know how to. We've

> got to educate them on that until they get there, and then you've got to say "Go and tell the client" and then the client may respond—and we're talking about a worst-case scenario now—so [our role is] hand holding all the way.

Marketers educate prospective advertisers and their agencies about the market in three main ways: its size, its spending power, and its tastes. *Out* sales and editorial executives, such as DeMars, distributed not only data about its circulation figures but also its readers' higher-than-average household incomes, positioning the "premium, upscale, bold, and beautiful" publication as an ideal vehicle to reach affluent gay consumers. Howard Buford (1998) heads an agency with a specialty in marketing to Black, Latino, and gay consumers. He saw his role not only as educating prospective advertisers about the demographics of the groups but also as presenting a sophisticated, respectful, and nuanced view of those communities to prospective advertisers. His view did not surface readily from other agencies.

Marketers saw themselves as progressives, rather than as radicals, in an industry perceived as conservative. The conservatism placed limits on how far the marketing industries could further gay visibility and civil rights. Beaver (1998) observed, "advertising is just a very knee-jerk reaction to what the culture is, . . . a very superficial interpretation of the culture." As long as the broader culture retains narrow-minded views of sexuality, advertising can do little to change it. Interviewees tended to blame institutions other than their own for maintaining the conservatism of advertising: Publishers blamed advertising agencies, advertising agents blamed corporations, and corporations blamed public opinion. Interviewees were anxious to play down the potential of advertising for social *change*, in favor of the more moderate idea of social *responsibility*. As Buford (1998) stated,

> Advertising is not about social change, it's about marketing. And we don't lose sight of that. But we also can't lose sight of the fact that right now we're at a stage when people are forming their opinions and impressions and defining things they had no definition for before, and we do have a role in that, we do have a responsibility in that.

Deutsch creative Liz Gumbiner (1998) also acknowledged in conversation that hoping for social change through advertising naively disregarded the industry's conservative climate. It was possible to aim for some social good, she said, citing the lesbian-themed Mistic commercial as having an affirmative and educational function. Although some marketers worked within narrow constraints placed upon them from the outside (by clients, media, and audiences), they could still aim for a progressive outcome from individual campaigns.

Not all marketers were so cautious. Sean Strub, direct marketer and publisher of *Poz* magazine for people with HIV and AIDS, straddled the line between activism and entrepreneurship in complex ways, including some that troubled his relations with potential advertisers. In an e-mail message, Strub (2002) told me, "three or four months prior to the publication of the first issue of *Poz*, a friend at Ogilvy, Adams, and Rinehart, (the PR agency . . .) leaked me an internal memo from them to their client, Burroughs Wellcome, analyzing the BW relationship with Sean Strub and his companies and what the new AIDS magazine would mean for them." As a vocal member of New York Act Up, Strub went head to head with pharmaceutical companies by advocating in *Poz* that HIV-positive people delay taking medication unless or until they became sick. In an interview, he said, "We've been critical of ads, highly critical, in fact sometimes when we've run the issue [with the ad in]. . . . Almost every company at one time or another has been furious with us" (Strub 1998). Strub's criticism of pharmaceutical companies has alienated many advertisers *Poz* depends on for revenue, and his ongoing activism means that some drug companies continue to boycott the magazine.

Strub acknowledged that his status as a publisher and entrepreneur afforded him more flexibility in straddling activism and professionalism than other jobs permit. Openly LGBT employees in mainstream companies have much stricter limits placed on their political initiative. Yet, the limits of the roles, he suggested, might suit those employees well. In the same conversation, Strub (1998) said,

> More often than not, people who are hired as a gay liaison or to deal with the community are hired because the company has confidence that they won't make waves. I know some of these people and like them, and even respect them, so I hesitate to call them Uncle Toms, but it's that kind of thing—they are being used to co-opt the community. A lot of the PR firms that have dealt with the difficult issues, or companies that have awful policies or that have an incident of some kind, that's what they are being hired to do. Now in some cases that does result in some change at the company, in the culture or the policies of the company; even caring about what the gay community thinks about them is better than not caring at all, even if it's in a callous or bottom-line kind of way.

Strub acknowledged that, even in those limited environments, LGBT employees could have some beneficial impact. In a professional culture that deflects the tensions between business and politics by framing marketing efforts within a pedagogical context, Strub was in a minority, working to make those tensions as productive as possible. For the most part, marketers were content to claim that their work had modest social value—at the very least, increasing gay visibility and educating mainstream America—despite the constraints of corporate conservatism.

CONTAINED VISIBILITY

Advertising executives, journalists, public relations consultants, and publishers who appeal to the gay market and are themselves LGBT identified are among a small group of professionals whose nonnormative sexuality is less a liability than an asset, even an attribute necessary for the work they do. Yet they must also navigate the standards of their profession, their gender and race identities, and the demands placed upon them by the still contested status of homosexuality in the United States. The strategies the marketers employed to ease the strain between professional and identity demands have broader implications for the visibility that gay marketing affords LGBT people: how LGBT marketers have shaped the very idea of the gay market and how they have represented LGBT people in marketing and media. When I asked David Mulryan (1999) how he imagined his intended audience when he was creating an ad, he said, "They are like me [pauses]. Gay, white, whatever, you know? That they have the same things that I want [pauses]. That they've had a tough time and they've recreated themselves and they live in New York." The relationship between professionalism and identity plays out in marketing, then, in a couple of ways. First, the low numbers of women and people of color involved in gay marketing mean that there are few professionals invested in advocating for race- and gender-diverse images of the gay market. As a result, most marketers remain interested only in courting affluent white gay men. More advertising revenues go to white-and-male- or male-dominated media, and the ads appearing there tend to show white men more than any other group. The pattern gives the impression that the gay market is a white, male market and, by extension, that the LGBT community is a white, male community.

Second, the marketers I interviewed were aware that gay marketing is always political, although often in contradictory and implicit ways, and believed that the presence of LGBT images in a mainstream culture of inequity and homophobia had a significant impact on the welfare of queers. In contrast to the claim that marketing to gays was a matter of business, not politics, all of my interviewees couched at least some of their approaches to gay marketing in political terms. In many cases, their involvement in progressive causes contributed to their subcultural capital and their professional credibility. I found the prevalence of political perspectives reassuring, as it suggests that gay marketers invested themselves in influencing perceptions of LGBT people among their heterosexual colleagues, clients, and audiences. Many interviewees somewhat complacently equated consumer visibility with political progress. This assumption is a problem for two reasons: It claims that their work alone constitutes a sufficient level of activism to effect social change, and it positions the free market economy and its popular manifestations—advertising, advertiser-supported publishing, and public relations—as the rightful place of social

struggle. With few exceptions, by identifying themselves as politely political, most marketers distanced themselves from a more confrontational image of the LGBT community. They were "normal . . . people with ambition," not "people in bars" (Stewart 1991), "silly queens" (Baltera 1972), or "dykes on bikes showing their breasts" (Mulryan 1999). The contrast between normality and stigma distinguishes two worlds: one of adult, decorous responsibility and another of sexual and playful excess, making unimaginable the prospect that gay marketers—or gay consumers—could be dykes on bikes with professional ambitions.

REFERENCES

Badgett, M. V. Lee. 2001. *Money, Myths, and Change: The Economic Lives of Lesbians and Gay Men.* Chicago: University of Chicago Press.

Baker, Dan. 1998. Gay male. Former publisher and editor in chief of *Quotient* newsletter, New York. Interview with the author, 17 September.

Baltera, Lorraine. 1972. "No Gay Market Yet, Admen, Gays Agree." *Advertising Age*, 28 August, 3.

Beaver, Andrew. 1998. Gay male. Executive vice president, Deutsch advertising agency, New York. Interview with the author, 23 February.

Blackwood, Stephanie. 1998. Lesbian. Partner, Spare Parts and, subsequently, Double Platinum public relations and marketing agencies, New York. Interview with the author, 19 January.

Bourdieu, Pierre. 1991. *Language and Symbolic Power.* Cambridge: Polity.

Buford, Howard. 1998. Gay male. President, Prime Access. Inc., advertising agency, New York. Interview with the author, 13 February.

DeMars, Kurt. 1999. Gay male. Advertising director, *Out* magazine, New York. Interview with the author, 1 April.

Draper, Catherine. 1999. Lesbian. Advertising director, *Girlfriends* and *On Our Backs* magazines, San Francisco. Interview with the author, 21 January.

Elliott, Stuart. 1998. Gay male. Advertising columnist, *New York Times*, New York. Interview with the author, 18 November.

Ellis, John W., IV. 1998. "It's Not Enough to Throw Open the Shop's Doors." *Advertising Age*, 16 February, S-10.

Farber, Matt. 2002. Gay male. Consultant, MTV Networks, New York. Telephone interview with the author, 27 September.

Friskopp, Annette, and Sharon Silverstein. 1995. *Straight Jobs, Gay Lives: Gay and Lesbian Professionals, the Harvard Business School, and the American Workplace.* New York: Scribner.

Gumbiner, Liz. 1998. Heterosexual female. Creative director, Deutsch advertising agency, New York. Interview with the author, 7 September.

Hume, Caitlin. 1999. Heterosexual female. Sales and marketing representative, *Out* magazine, New York. Interview with the author, 2 February.

Kazenoff, Ivy, and Anthony Vagnoni. 1997. "Babes in Boyland." *Creativity*, October, 18–20.

Landry, Joe. 1999. Advocate publisher, remarks at the Boston Ad Club, Boston, 20 January.

Mulryan, David. 1999. Gay male. Partner, Mulryan/Nash advertising agency, New York. Telephone interview with author, 24 January.

NGLTF. 2003. "2001 Capital Gains and Losses." Report of the National Gay and Lesbian Task Force. Available at http://www.ngltf.org/downloads/cgal2001.pdf. 14 September.

O'Neil, Patrick. 1998 Gay male. Art director, Deutsch advertising agency, New York. Interview with the author, 18 November.

Schlegal, Jack. 1999. Gay male. Board member, New York Advertising and Communications Network, editor of NYACN's *Newsbreaks* newsletter, New York. Telephone interview with the author, 11 January.

Schofield, Ginny (pseudonym). 1999. Lesbian. Co-chair of high-tech company Gay and Lesbian Task Force, an east coast city. Telephone interview with the author, 22 February.

Schubert, Walter. 2001. Gay male. President and CEO, gfn.com, New York. Telephone interview with the author, 24 August.

Sharkey, Betsy. 1993. "The Way Out." *Adweek*, 19 July, 2–31.

Stewart, Thomas A. 1991. "Gay in Corporate America." *Fortune*, 12 December, 42–56.

Strub, Sean. 2002. Bisexual male. Publisher, *Poz* magazine; President, Strubco, New York. Email correspondence, 12 November.

———. 1998. Interview with the author, 28 October.

Sullivan, Patrick. 1999. Heterosexual male. Account supervisor, Integer Group advertising agency, Denver. Telephone interview with the author, 17 February.

Thornton, Sarah. 1996. *Club Cultures: Music, Media and Subcultural Capital.* Hanover, NH: Wesleyan University Press.

Wilke, Michael. 1997. "Seven Top Shops Disclose Policies on Gays." *Advertising Age*, 27 October, 22.

———. 1998. Gay male. Journalist, *Advertising Age*, New York. Interview with the author, 19 January.

Witeck, Bob. 1998. Gay male. Partner, Witeck Combs public relations company, Washington, D.C. Telephone interview with the author, 22 November.

Woods, James D. 1993. *The Corporate Closet: The Professional Lives of Gay Men in America.* New York: Free Press.

Insiders–Outsiders

Dr. Laura and the Contest for Cultural Authority in LGBT Media Activism

VINCENT DOYLE

From 1997 to 2001, a campaign emerged to oppose the homophobic rhetoric of radio and television host Laura Schlessinger. This ethnographic and archival study contrasts the work of two groups. An insider organization connected to the media, the Gay and Lesbian Alliance Against Defamation (Glaad), engaged in access-based tactics. An outsider group, StopDrLaura.com (SDL), employed internet-coordinated street activism. The campaign succeeded, but not because outsiders emerged victorious over insider politics. A better way to understand the campaign is as a whole field of relations where professionalized media activists competed for the cultural authority to influence LGBT representations.

In April 1999, Paramount Domestic Television, a subsidiary of Viacom, signed the popular radio talk show host Laura Schlessinger, also known as Dr. Laura, to develop a new television talk show. The deal, reportedly worth $3 million to Schlessinger personally, represented a $76 million investment for Paramount, making it the most expensive new show in the studio's history. With 20 million weekly listeners and 3 million books in print, Schlessinger, known for haranguing her callers with moralistic invective, was riding a big wave of popularity. This made her extremely attractive to Paramount executives who hoped she would deliver a built-in audience for her show in the crowded afternoon television market. Within a few months of the announcement, without so much as a pilot or preview tape, Paramount had sold the new program to CBS and UPN local affiliates covering 90 percent of the U.S. television market.

The Gay and Lesbian Alliance Against Defamation (Glaad), meanwhile, had been monitoring Schlessinger's radio program since 1997 as the result of complaints about her use of antigay rhetoric. Glaad has a mandate to "promote and ensure fair, accurate and inclusive representation of individuals and events in all media as a means of eliminating homophobia and discrimination based on gender identity and sexual orientation" (Glaad 2004). With an annual budget of about $6 million and a staff of about forty, Glaad is one of the principal gay and lesbian movement organizations in the United States.

Historian John D'Emilio has written that the movement is undergoing a period of slow, uneven change. Its "core outlook" he sums up with the phrase "we want in," referring to the current emphasis on inclusion within the dominant institutions of "family, school, and work" (D'Emilio 2000, 42–49). According to the authors of *Out for Good*, a voluminous post-Stonewall history of the movement, the emphasis on mainstream integration took root in the years after the collapse of its first organization, the radical and multi-issue Gay Liberation Front. As the 1970s progressed, the movement increasingly fell into the hands of "pragmatic and moderate mainstream homosexuals" who steered it toward a much narrower strategy of gaining minority status for homosexuals (Clendinen & Nagourney 1999, 75).

The strategy has led movement organizations to form relatively permanent, formal, and routinized relationships with powerful social actors. The movement became part of the established institutions it sought to reform and, as its influence grew, took on specific roles and functions within them. To further its positions and garner influence, it asserted expertise in particular areas and sought to "constitute *and control* a market" for that expertise, a process known as professionalization (Larson 1977, xvi).

This essay begins from the claim by gay journalist and activist Michelangelo Signorile that the tactics Glaad employed in its *Dr. Laura* campaign are evidence that the organization has overinvested in professionalization. Glaad, he charged, has gone too far in the direction of Hollywood insider, lost touch with its gay and lesbian constituency, and compromised its ability to "apply pressure from the outside when needed" (Signorile 2000, 31). In contrast to his criticism of Glaad, Signorile has championed an ad hoc group of gay and lesbian activists called StopDrLaura.com (SDL), which he called "one of the most impressive weapons in the American lesbian and gay activism arsenal" (29). More confrontational in its tactics, SDL made creative use of the internet to recruit and mobilize its constituency, to coordinate street protests and other forms of direct action, and to apply pressure on Schlessinger's corporate backers.

Based on ethnographic and archival fieldwork conducted in the New York and Los Angeles offices of Glaad between January 2000 and June 2001, my account of the Schlessinger campaign supports many aspects of Signorile's critique of Glaad but

takes a wider view. The evidence argues against framing the success of the campaign too simply (and romantically) as the triumph of outsiders and their confrontational tactics over insiders and their polite politics. Glaad and SDL are constituent parts of a common field of relations, and my aim is to describe the anti-Schlessinger campaign by incorporating some of the subtlety missing from Signorile's highly partisan reporting and from the gay and lesbian press more generally. Glaad leaders had complex motivations and faced difficult dilemmas in the struggle to reconcile their personal, professional, and institutional investments with their obligation to represent an LGBT constituency. This chapter asks what viewing the Schlessinger campaign as a competition for cultural authority among professionalized activists can reveal about the possibilities and limits of gay and lesbian media activism in the current cultural climate.

INSIDERS

From its grassroots beginnings in the mid-1980s, Glaad has become a national organization controlled by a board of directors and staffed, in many cases, by skilled professionals who hail from corporate media and public relations. Before taking the top Glaad job, Joan Garry was an executive at Showtime Networks, which is, like Paramount, part of the Viacom media empire. Before that, she was among the executives who launched MTV, also a Viacom subsidiary. Scott Seomin, the Glaad director of entertainment media, had been a producer at *Entertainment Tonight*, a property of Paramount Domestic Television. Steve Spurgeon, the Glaad director of communications at the time of the Schlessinger campaign, had been a vice president at one of the top public relations firms in the United States. Keven Bellows, Laura Schlessinger's head of public relations, had once been his boss.

In October 1999, Garry gave a speech to the gay and lesbian employee group at Bell Atlantic in which she described herself as someone from a corporate background who, until she came to Glaad, "did not consider myself political at all" (1999, n.p.). She said, "My activism was all about my family." As a partnered lesbian with kids living in the New Jersey suburbs, she told her audience, she brought a unique ability to put herself "in the other guys' shoes." She went on to describe her sense of how Glaad evolved:

> Things have changed in fifteen years. We've made solid progress culturally And as a result of that progress, Glaad's strategies have changed. Today I see our work is largely . . . about building relationships and much about education.

In a key section of the speech, Garry invited her audience of corporate managers and executives to "revisit the images we conjure up when we consider the word

'activist' " (1999, n.p.). Activism, she said, is no longer just the "direct action methods" that "helped create a picture for America of a gay rights activist." Referring to the early years at Glaad, she said, "Back then, no one was paying any attention, and the only strategy that made any sense was of the 'in your face' variety," a mode of activism she compared to banging on the door. "Their job," she said, "was simply to be heard and to do what they could . . . to get that door open." The new professional activism, by contrast, is about building relationships and about education, Garry said. Her comments imply a shift in the ground of advocacy, away from the unruliness of the street and toward the businesslike efficiency of the boardroom.

One can forgive Garry for suggesting that the doors of corporate America had swung wide open. In 1999, Ellen had already been out for two years, *Will & Grace* was already a big success on NBC, and corporations seemed to be tripping over themselves to land a piece of the burgeoning gay and lesbian consumer market. The speech also bespoke a lack of knowledge of movement history and a narrow conception of direct action as little more than a prelude to the more serious business of walking through the corporate door, briefcase in hand, to hold polite discussions. The role of direct action in community building and identity formation had completely disappeared, as had the circumstances and motivations that first gave rise to Glaad.

At one point in the speech, Garry went so far as to say that the "folks who founded Glaad back in 1985 probably did not consider themselves activists either but rather just a group of writers fed up with how the *New York Post* was covering the AIDS epidemic" (1999, n.p.). This would no doubt come as news to Glaad founders Marty Robinson, Jim Owles, Vito Russo, and Arnie Kantrowitz, all of whom cut their teeth in the militant Gay Activists Alliance in the early 1970s. In an interview, Kantrowitz told me that, when he introduced myself to Joan Garry at a Glaad function, she responded with a "uh-huh" that betrayed a complete lack of recognition. Said Kantrowitz, chuckling under his breath, "I felt very nice about that." Then, in a high, campy voice, he said, "But Joan! You're my daughter!" (2000, n.p.).

Although the new professional breed at Glaad sometimes acknowledged their lack of prior involvement in the movement as a limitation, they pointed to their professional skills and connections as compensation. Steve Spurgeon, for example, told me in an interview that the movement now requires persons who have what he called a "sophisticated understanding of how the world works," a product of extensive corporate experience like his own. When he interviewed for the post of Glaad director of communications, he said, someone with a long history of movement activism told him that they could not picture him "chained to the fence in front of the *New York Times*." He replied, "Why would I chain myself when I can just call them up for a meeting?" (2000, n.p.)

So it was that, when Schlessinger began spouting antigay rhetoric in 1997, referring to homosexuality in a syndicated column as a "biological faux pas" and to gay

and lesbian parenting as a lesser form of child rearing ("Heterosexual Families Are Best for Kids," *Montreal Gazette*, 25 May 1997, D-6), Joan Garry called her up for a meeting. Schlessinger agreed, and discussions ensued. Afterward, Glaad staff kept up their monitoring of the program. In August 1998, Schlessinger announced on air that she was officially changing her position on homosexuality, but not in the direction Glaad leaders were hoping for: "I've always told people who opposed homosexuality that they were homophobic, bad, bigoted, and idiotic," she said. "I was wrong. It *is* destructive" (Premiere Radio Networks, n.p.).

In response, Garry asked for a second meeting, noting in a letter to Schlessinger that "your words about our community reaching 20 million people have become stronger and infinitely more damaging" (Garry 1998, n.p.). On March 10, 1999, Schlessinger and Garry met for a second time. Afterward, in a newsletter distributed to her fans, Schlessinger went out of her way to characterize the encounter as a "reasonable dialogue" between individuals who "respect each other personally" (1999, 2). Garry, she wrote,

> is a thoughtful, intelligent woman with a good sense of humor (I love those!), and she is the first gay activist I've ever come across who actually takes the time to try and understand my positions. . . . As you might expect, we have a lot of differences. As you might not expect, we were also delighted to find some common ground. (2)

For Schlessinger, framing the dialogue in this way made it seem as though her perspectives on homosexuality are matters about which reasonable persons living in a pluralist society might expect to disagree. And, surprisingly, for the leader of a national gay and lesbian rights organization, Garry appeared eager to go along with this genteel framing of the encounter. According to a jointly produced transcript of the discussion, Garry told Schlessinger:

> I think that we do need to engage people more in a conversation. . . . I think . . . that we are beyond the place in society where I stand on one side of the line and I shout and I scream and I wave my finger. I think I have to go across the line to the people who disagree and understand them. (Glaad/Premiere Radio Networks 1999, n.p.)

Garry clearly hoped that this act of conciliation might lead Schlessinger to understand *her* and to realize that gays and lesbians are not so different or deviant after all. With tears welling up, she said, "I'm not here as an activist. I mean, I'm an activist because of my kids" (Glaad/Premiere Radio Networks 1999, n.p.). Here, Schlessinger erupted, scoffing at the notion that the executive director of a national gay and lesbian organization was meeting her simply on behalf of her kids:

> Okay, if you're not here today as an activist, then let's go shopping and be friends. Because I don't need this crap. You're here as an activist and we're discussing my position. If you are here as my friend, let's go eat. I don't want to do this. I don't want to be sitting and having you cry.

Throughout the meeting, Garry tried to personalize the issues, downplay her role as an activist, and assert a common humanity with Schlessinger based on a shared sense of the importance of family. But the problem was neither Schlessinger's lack of personal acquaintance with gays and lesbians—she said during the encounter that she counts gay men among her colleagues and family—nor a disbelief that Garry could be a good parent to her children. The problem was the public position Schlessinger had taken on homosexuality. The position derived from a toxic and ideologically powerful mix of biological determinism (homosexuality as biologically disordered, a biological error or faux pas) and religious absolutism (acting on one's disordered impulses as immoral because the Bible says so). To hold a polite meeting with a person holding such a position, let alone *two* meetings, lent Schlessinger legitimacy and may have contributed to her sense that she could not only get away with it but also likely profit from it.

Instead of toning down her rhetoric, Schlessinger followed the meeting with another public escalation. Emboldened by her deal with Paramount, signed in April, Schlessinger treated her listeners to this monologue on June 9, 1999:

> Rights. Rights! Rights? For sexual deviant . . . sexual behavior there are now rights. That's what I'm worried about with the pedophilia and the bestiality and the sadomasochism and the cross-dressing. Is this all going to be rights too, to deviant sexual behavior? It's deviant sexual behavior. (Premiere Radio Networks 1999a, n.p.)

Then, on June 22, 1999, Schlessinger said,

> if you folks don't start standing up for heterosexual marriage and heterosexuality pretty soon, that which you know as this country and family is going to be gone. . . . That men have to have sex with men is not something to celebrate. It's a sadness. It is a sadness, and there are therapies which have been successful in helping a reasonable number of people become heterosexual. (Premiere Radio Networks 1999b, n.p.)

The boldness of that rhetoric, combined with the prospect of having it reach a wider television audience, set off alarm bells. In the estimation of the Glaad leaders, Schlessinger had become the most dangerous homophobe in the nation, and it was now time to mount a campaign to oppose her.

Introduced as the new Glaad director of communications at a board meeting in September 1999, Steve Spurgeon presented a Schlessinger campaign plan defining its primary goal as to "stem the escalating influence of Dr. Laura Schlessinger's homophobic advocacy" (1999, n.p.). What he proposed was a public relations effort to counter Schlessinger's messages in the media. The ability of Glaad to become visible with its opposing messages, he hoped, would persuade Paramount to regulate Schlessinger. The more high-profile media exposure Glaad could get, the more influence it could hope to have with Paramount in private meetings. The only role

imagined for the Glaad membership was to monitor the local coverage of the campaign and respond with letters to the editor.

Shortly after Paramount announced its deal with Schlessinger, Glaad staff requested to meet with top Paramount executives. They agreed to the meeting in principle but did not schedule it right away. In preparation for that eventual meeting, Steve Spurgeon and Scott Seomin of Glaad held an informal lunch in August 1999 with two Paramount media relations executives, one of them an openly gay man by the name of John Wentworth. In an interview I conducted with the entire Glaad communications team, Seomin said the objective of the meeting was to get the message across to Paramount that they had bought themselves trouble by signing Schlessinger. The Paramount executives, however, did not react as Seomin and Spurgeon had hoped. As Seomin explained, "I believe he just felt that he did his job so he could say, 'Well, I had lunch with the guys at Glaad so I could hear them out'" (2000, n.p.).

Meanwhile, the Glaad request to meet with top executives at Paramount was beginning to stagnate. It was time to crank up the pressure. By this time, Spurgeon had hoped to generate coverage of the Schlessinger campaign in the gay press. He recalled in the interview I conducted with the communication team that Glaad did not succeed in piquing the interest of LGBT media outlets, something that became a bit of a sore point:

> We had tried like hell to get a couple major [gay] publications to work this story and to get some interest and momentum going on it. [They] couldn't have been more bored, couldn't have given us a bigger yawn. It was sort of like, yeah, yeah, call us when it's something a lot bigger. So, where we would have broken the story in the gay press, we couldn't get any interest. (2000, n.p.)

The lack of interest is perhaps not surprising given that "the lesbian and gay press is torn between acknowledging its historic role as a committed advocate for the interests of a marginalized community and a desire to be seen as fulfilling the professional role of objective journalism" (Gross 2001, 247). Seomin turned to the *Los Angeles Times*, which, Spurgeon told me during the interview with the communication team, "snapped like that with it" (snapping his fingers). "As it turned out," he said, "that was exactly the lever to push" (2000, n.p.).

Seomin approached Brian Lowry, the *L.A. Times* television columnist, who published an article on January 11, 2000, describing Glaad concerns about Schlessinger and the reactions of some gay employees at Paramount. Lowry quotes openly gay *Frasier* writer and Paramount employee Joe Keenan:

> What gay person working for Paramount could be happy about this? . . . We feel the way the Von Trapp children would feel if Dad decided to divorce Maria and marry Joan Crawford. She's not a happy addition to the family. ("Dr. Laura: All Is Fair in Syndication," F-1)

Interest in the campaign among the media exploded. Glaad communications staffer Sean Lund told me that he sent out about 150 press kits in the two months following the publication of Lowry's article. And, ironically, many of the reporters requesting information were the same ones from the LGBT media who had little interest in the story when the Glaad communications staff had approached them a few months earlier.

All the media attention had another desired effect: Paramount finally scheduled its top-level meeting with Glaad. The discussions, lasting three hours, took place on February 14, 2000, and involved senior Paramount executives and the executive producers of Schlessinger's radio and television shows, as well as Garry and Spurgeon. The Glaad objectives for this meeting, consistent with the campaign strategy Spurgeon had outlined, were to demonstrate to Paramount how extreme Schlessinger's rhetoric had become and to persuade the studio to institute a zero-tolerance policy on defamatory speech (including words like *deviant* and phrases like *biological error*).

The meeting, however, produced only *private* assurances from Paramount that Schlessinger's views on homosexuality would not go unopposed and that discussions of homosexuality would cite credible research. A joint public statement issued after the meeting characterized it as "a positive exchange of differing perspectives." Although it said that "the dialogue with Paramount executives is expected to continue," the statement gave no indication of when further discussions might take place. Schlessinger's program, it said in the vaguest of terms, would "vary from Dr. Laura's successful radio show" and offer "many points of view, derived from a variety of sources, guests, and a studio audience" (quoted in Joyce Howard Price, "Dr. Laura to Offer 'Many Points of View' on Homosexuals," *Washington Times*, 17 February 2000, A-9). Beyond this statement, the parties agreed not to discuss the specifics of the meeting in the media.

The statement, lukewarm as it was, created a stir in conservative circles. Responding to concerns that Schlessinger and Paramount might have caved in to pressure from Glaad, a spokeswoman for Schlessinger told the conservative *Washington Times*, "It's not true that Dr. Laura capitulated to anyone or anything . . . that's totally wrong" (Joyce Howard Price, "Dr. Laura to Offer 'Many Points of View' on Homosexuals," 17 February 2000, A-9). The article also quoted an unidentified spokesperson for Schlessinger, breaking the agreement not to discuss the meeting with the media, saying that she had retained total control over content. The statements by Schlessinger's public relations team left the Glaad leadership in an embarrassing position, appearing as though its insider efforts were not bearing fruit. Its strategy compromised, the organization soon found itself under attack from within the gay and lesbian community.

OUTSIDERS

A few days after the meeting with Paramount executives, gay journalist and activist Michelangelo Signorile interviewed Joan Garry on an internet radio show. Conceding the point that meeting with Schlessinger directly had not produced the desired toning down of rhetoric, Garry spent much of the interview defending the Glaad strategy, which was still "to work with Paramount to make sure that they create a balanced show" (Garry 2000a, n.p.). Signorile, in his characteristically aggressive style, criticized this strategy as corporate because it consisted of meeting behind closed doors and asking only for balance instead of calling for Paramount to cancel the show as a matter of principle. He questioned the motives behind the unwillingness at Glaad to call on the community to put direct pressure on Paramount, implying that the strategy appeared designed to keep Glaad in the good graces of Paramount. By repeatedly invoking the importance of holding on to what she called Glaad's place at the table, Garry did little to dispel this impression. The organization had never before enjoyed such a level of access, Garry argued, and Glaad still had an opportunity to use that access to persuade Paramount to control Schlessinger's speech.

A few days after the confrontational interview, an e-mail message from an unidentified source began circulating on the internet. It opened with three simple words and as many exclamation points: STOP DR. LAURA!!! It expressed its straightforward call to action in all capital letters, the internet equivalent of shouting: E-MAIL PARAMOUNT NOW AND DEMAND DR. LAURA BE DROPPED. Designed to get gays and lesbians everywhere riled up, the message spread like wildfire.

On February 28, 2000, Glaad leaders responded with "A Letter from Glaad Executive Director Joan M. Garry." It began by acknowledging criticism within the community of how Glaad had handled the campaign: "During the last two weeks, some of you have expressed concern about Glaad's recent work concerning Dr. Laura Schlessinger and her move to television. Although some of this criticism has been hard to hear, we know how important it is to listen. And we've been listening" (Garry 2000b, n.p.).

At the end of the letter, Garry informed her readers that Glaad had sent a letter to Paramount requesting a second meeting within seven days and a written assurance "that Paramount has a zero tolerance for defamation directed at the gay and lesbian community" (Garry 2000b, n.p.). Failing that, Garry wrote, Glaad would "call on Paramount to pull the plug on Dr. Laura." And, for the first time since the campaign began, Garry called on the Glaad membership to "put pressure on Paramount" by writing letters to its chairman.

The next day, Glaad published full-page ads in two entertainment industry trade publications, *The Hollywood Reporter* (29 February 2000, 20) and *Daily Variety*

29 February 2000, 89). The top of the ad read, "Dr. Laura says: 'I have never made an anti-gay commentary,' " followed by the words, "Oh, really?" and four verbatim excerpts from Schlessinger's radio program. Meant for media professionals, the ad aimed to create pressure from the inside—from within Paramount and elsewhere in the media industry—and to embarrass Paramount executives.

For the ad hoc coalition of activists who had disseminated the Stop Dr. Laura e-mail message, the response from Glaad leaders came as too little, too late. On March 1, 2000, they launched StopDrLaura.com, a web site that also gave the coalition its name. The SDL founders took the stand that calling for anything less than the cancellation of the program amounted to a capitulation to an unacceptable double standard. No television studio would give a platform to an avowedly racist or anti-Semitic host. So why give an unrepentant homophobe a national talk show? The response to this way of framing the issue was immediate and overwhelming: Within three days of going on line, with the help of high-profile media coverage, the site logged more than a million hits.

The SDL home page, under the heading, "StopDrLaura: A Coalition Against Hate," featured a close-up photograph of Schlessinger doctored to appear as if lit from a low angle, making her look like the caricature of an evil harridan. To the right of her face, the site designers added a scrolling list of some of her most infamous quotes about homosexuality. Designed as the hub of a grassroots mobilization effort, the SDL web site invited visitors to organize and attend demonstrations, as well as to flood Paramount and Viacom executives with telephone calls, faxes, and e-mail messages. Adopting aggressive tactics from the beginning, SDL listed the direct numbers and electronic addresses of key executives, with the goal of overwhelming their communication systems. Within a day of this information being posted on the web site, SDL reported, a senior Paramount executive had changed his number, and the studio had temporarily shut off all but the internal portion of its e-mail system.

With SDL pulling the grassroots from under her feet, Garry called an all-staff teleconference on March 3, 2000. I recorded in my field notes that she declared: "One of the things I've come to grips with in the last two weeks is that we have to be mindful of our goals with Paramount, but also mindful of our obligations to the community. Within the following two weeks, she predicted, Glaad would either claim victory based on a statement by Paramount or add what she called the "significant influence" of Glaad to the voices calling for the cancellation of the program. The Paramount response came in the form of two statements issued on March 10, 2000. The first, by Schlessinger, said, "I never intend to hurt anyone or contribute in any way to an atmosphere of hate or intolerance. Regrettably, some of the words I've used have hurt some people, and I am sorry for that" (Schlessinger 2000, n.p.). The second statement, by Paramount, affirmed "a commitment to present society's issues without creating or contributing to an environment of hurt, hate, or intolerance"

(Paramount Television Group 2000, n.p.). Was this akin to the statement of zero tolerance for which Glaad had asked?

SDL leaders dismissed the statements as halfhearted and announced a major protest in front of the Paramount gates on March 21, 2000. The Glaad leadership, by contrast, reacted with carefully worded optimism:

> Glaad welcomes Schlessinger's new public commitment to conduct her self-proclaimed moral and ethical advocacy in an environment free from hate and intolerance. We will be listening to and watching her current and upcoming radio and television broadcasts to be sure she is true to her word. (Glaad 2000a, n.p.)

It did not take long, however, for Schlessinger's apology, such as it was, to fall apart completely. On March 15, 2000, a column by conservative columnist Don Feder in the *Boston Herald* quoted her saying that her statement was a clarification and not an apology. Feder wrote, "She will continue to recommend reparative therapy (for homosexuals who want to change), to oppose same-sex marriage and adoption, and [to] champion Judeo-Christian sexual ethics" ("Sham from Glaad Won't Fly on Main St.," 33).

Sixteen days had passed since Glaad had issued a seven-day ultimatum—and without a second meeting with Paramount executives. What was worse, the statements by Schlessinger and Paramount seemed little more than evasive rhetorical maneuvers now that Schlessinger had recanted her apology. Without much hope left for a continuing dialogue with Paramount, the Glaad leadership issued this statement:

> Glaad now has no assurance that Schlessinger will not publicly defame lesbians and gay men in her radio or upcoming television broadcasts. . . . Glaad now calls upon Paramount to . . . [abandon] its plans to produce and distribute any program featuring Laura Schlessinger. (Glaad 2000b, n.p.)

With the announcement that Glaad would join SDL in front of the Paramount gates, the Schlessinger campaign entered a new stage that had Glaad engaging in public protest for the first time since 1995. The campaign would continue, but its tactics would shift to a wider set of targets: television critics, local UPN and CBS affiliates, and the advertisers planning to buy air time on the program.

The Glaad decision to protest against Paramount had wide-ranging ramifications. The gala fund-raiser Glaad Media Awards were coming up and Paramount was among the media companies that had made a donation to take part, as were many other companies in the Viacom empire. Should Glaad return the donation from Paramount? What about money from other Viacom subsidiaries?

Glaad senior staff met to discuss the issue. Confident that corporate money never influences their decision making, they reached a consensus to keep the money. When they presented their recommendation to the executive committee, however,

two board members raised serious objections. One of them, Howard Buford, who heads an advertising firm specializing in ethnic, racial, and sexual minorities, wrote an e-mail message arguing that the "only value of this gesture [returning the money] is as a piece of communication" and that "we have to be seen as doing the right thing." He wrote, "To remain focused, we must focus on the Paramount brand name. And our actions must be informed by this focus. Anything else is confusing to the outside world and, ultimately, untenable" (2000, n.p.). After further discussions, during which Garry consulted with Glaad board member Joe Lupariello, a Paramount executive and opponent of returning the money, Buford's argument prevailed, and Glaad returned the Paramount donation.

Buford worried that Glaad had been slow to take strong action in the Schlessinger campaign and that SDL was scoring victories on ground that Glaad should have been occupying. In an interview with me, he said,

> we had become a corporate, comfortable board that didn't even want to act on "Dr. Laura." . . . They were like, "well she has a right to say what she wants to say." And I said . . . you know what these letters [G-L-A-A-D] stand for? If we don't do it, who's gonna do it? That's our job! (2001, n.p.)

In executive committee discussions, he told me, Buford warned his colleagues:

> Has anyone been to the internet and seen what's being said about Glaad out there? . . . You don't think that's upsetting that they're saying that we're not doing anything, that we're all basically looking for jobs in media and so we're not going to ruffle feathers. You don't think that that's going to have repercussions? And that kind of got people thinking about it. . . . (2001, n.p.)

To drive the point home, he argued in his e-mail message to the Glaad executive committee that the Schlessinger campaign was a "defining moment for Glaad," and an issue that is "ours and ours alone" whose "savvy handling . . . can make Glaad the premier gay and lesbian community advocate" (2000, n.p.).

In the months that followed, SDL efforts, combined with those of a more assertive Glaad, spelled disaster for Schlessinger's television debut. The turning point came with the early defection of household goods giant Procter & Gamble, which came under intense pressure from Glaad and SDL the moment it announced its intention to sponsor the *Dr. Laura* program. The web sites of both organizations were quick to list contact information for the companies that remained, many of which dropped their advertising within a matter of days, after e-mail messages and phone calls overwhelmed them. Through its web site, SDL also coordinated protests of local CBS or UPN affiliates in thirty-four cities in the United States and Canada, while Glaad helped local organizations obtain meetings with station managers and, through its web site, provided resources to local activists for monitoring and responding to local coverage of the controversy.

On the heels of the Procter & Gamble decision not to advertise on *Dr. Laura*, Glaad launched an aggressive and high-profile advertising campaign. At a cost of $200,000, it bought full-page ads in the *New York Times* (24 May 2000, C-5) and the *Los Angeles Times* (24 May 2000, C-7) to appear on the Wednesday before Memorial Day weekend. Under the title, "Ad Time with *Dr. Laura* Is for Sale. Here's What You're Buying," the ad argued that—

> Laura Schlessinger has angry and hurtful things to say about all kinds of Americans. Many advertisers don't realize how alienating her program has become. Consumers judge brands by the company they keep. Aren't there better ways to reach women 18–49, or anyone else?

The last sentence, in bold, read, "*Dr. Laura*. We don't buy it." Targeted at media buyers (individuals who make decisions about where to place advertising), the ad ran a second time the following week in major trade publications (*Advertising Age*, 29 May 2000, 91; *Adweek*, 29 May 2000, 83; and *Broadcasting and Cable*, 29 May 2000, 25; *Daily Variety*, 30 May 2000, 31), so that it would confront decision makers again upon their return from the long weekend.

The visibility of this ad campaign also helped the Glaad communications team generate high-profile mainstream media exposure in the months that followed. The esteemed PBS *News Hour* featured a fifteen-minute debate (15 June 2000). Spurgeon and Garry secured a full-page opinion piece in *Time* magazine as a rebuttal to an interview they considered overly deferential toward Schlessinger (17 July 2000, 14). Spurgeon also worked with the producers of the NBC *Today* show on what became a seven-minute segment devoting exceptionally long coverage to the Schlessinger controversy (8 September 2000). All the media attention to the controversy, from the Glaad perspective, amplified the message in the ad, that buying *Dr. Laura* was a bad business decision.

Glaad and SDL documented that more than 170 companies pulled out of advertising on the *Dr. Laura* television show over the course of the campaign, not to mention the unknown number of companies that decided not to advertise in the first place. Thirty more companies reportedly dropped their ads from Schlessinger's radio program, resulting in a revenue loss of some $30 million for Premiere Radio Networks, even though activists had not specifically targeted the radio show.

It did not hurt the activists' cause that Schlessinger's program premiered to weak ratings and universally terrible reviews, almost all of which made some reference to the controversy over her views on homosexuality. Seomin at Glaad helped plant the seeds for this critical drubbing when he attended the Television Critics Association conference the previous July and distributed the Glaad *Dr. Laura* media kit to more than fifty critics. In a widely syndicated September 15, 2000, review for the *Washington Post*, Tom Shales described the situation as "A Case of the Creeps: *Dr. Laura* on UPN

Looks Better on Radio," (2000, C-1). The review made clear that Schlessinger's public image had taken a dramatic turn for the worse.

After just two weeks on the air, amid declining ratings and an unmistakable advertiser exodus, Paramount announced that it was stopping production of the show for retooling. Then, on October 4, 2000, four Canadian television stations announced that they were dropping the show. In an attempt to stave off the hemorrhaging, Schlessinger published a full-page ad a week later on the back cover of a special issue of *Variety* devoted to the topic of gays and lesbians in Hollywood (11 October 2000, 56). Entitled "A Heartfelt Message from Dr. Laura Schlessinger," the ad again fell short of an explicit apology but made a few overtures in that direction. Through insider contacts, Glaad representatives obtained a faxed copy of the ad a day before its publication and had plenty of time to formulate a response, call up reporters, and help shape the coverage. By the official Glaad account, the tactic produced high-profile, national media coverage that incorporated the Glaad perspective and succeeded in casting suspicion on Schlessinger's motives. In its coverage, *PR Week* noted approvingly that Glaad had been "typically speedy" in "issuing a same-day press release rejecting Schlessinger's apology and refuting her arguments" (Grove 2000, 2). It later gave Glaad an award as "non-profit PR team of the year" (Glaad 2001, 10).

The death knell of the *Dr. Laura* program began resounding loudly during the November sweeps period, when affiliates in many large cities began shifting the program to time slots in the wee hours of the morning. Other affiliates soon followed suit, prompting Spurgeon to joke around the office that Schlessinger had expanded her audience to "breast-feeding mothers and insomniacs." Lowry reported in the *Los Angeles Times* on December 6, 2000, that, since her move to late night in that market, Schlessinger had averaged a 0.6 share or a mere 30,000 viewers ("It Must Be the Neighbors Who Watch These Shows," F-1). By then, the only advertising left on the program was an odd assortment of supposedly exclusive television offers (for such gadgets as talking beer openers), Anne Murray CDs (which is ironic, given her lesbian following), psychic hot lines, and other so-called remainder ads that run only when no other advertisers will buy time at regular rates.

Reporter Melissa Grego wrote in a December issue of *Variety* that the *Dr. Laura* television show was a case study in "how to fail in syndicated television." She attributed the show's dismal showing to a "toxic mix of protesters' rancor, advertisers' anxiety, and Paramount's misguided spending." The most expensive new show in Paramount history had become its most disastrous failure, incurring "a loss said to be in the seven-figure range" (Grego 2000, 1). Finally, on March 29, 2001, Schlessinger taped the last episode of her first television season. The next day, having fulfilled its contractual obligation to produce one full season of *Dr. Laura*, Paramount quietly announced it was canceling the program.

ANY NUMBER CAN PLAY . . .

Although the program had been on the air only a few weeks, it was already clear by the September 2000 Glaad board meeting that *Dr. Laura* would not last beyond a first season. "When do we claim victory?" Spurgeon asked the board. "I would hate," he said, "for this whole thing to be summarized by . . . StopDrLaura.com." By the end of October 2000, John Aravosis of SDL would claim in the *New Republic* that no "matter when Schlessinger's TV show is finally canceled . . . StopDrLaura.com has already won" (2000, n.p.). Then, on January 17, 2001, he posted an article entitled, "We Stopped Dr. Laura," to a widely read internet newsgroup, announcing that the SDL site had shut down even though, he said, "Dr. Laura's television show is still on the air in many U.S. markets, and Paramount has yet to announce that the show won't be coming back next fall" (Aravosis 2001, n.p.).

The group that had called itself Stop Dr. Laura and set itself up in opposition to the perceived willingness of Glaad, in the words of SDL, to allow a known bigot to host a television show, was now claiming victory in terms reminiscent of the initial Glaad campaign objective. SDL has already won, Aravosis wrote, because "we've gotten Schlessinger to tone down her anti-gay rhetoric" (2000, n.p.). The claim left Glaad leaders with little choice but to occupy the space left by the abrupt departure of SDL and to wait for the actual cancellation of Schlessinger's television program before it could declare *Dr. Laura* truly stopped. By then, exhausted Glaad staffers had been feeling for months that, as Spurgeon told the Glaad board of directors, StopDrLaura.com was actually StopGlaad.com. As I recorded in my field notes, Garry expressed a similar sentiment when she told board members, "Here we all are fighting for a place at the table and our own table isn't a very welcoming place." Glaad employees told me they often discussed how they had not expected the backlash. As communications staffer Sean Lund said during an interview, "some people in this thought that there was a finite amount of power, visibility and promotion available through this, and that's how they played the game" (2001, n.p.). In contrast to what they saw as the competitive SDL framing of the campaign, Glaad leaders sought to affirm an "any number can play" view of movement politics (the phrase is Spurgeon's). In response to an internet newsgroup posting by Aravosis, for example, Garry wrote, "For our movement to have different dimensions, I don't believe we all should see and do things the same way. Working to combat Schlessinger has taught me that there is room here and a need for a variety of tactics and objectives" (2000c, n.p.).

Her statement of tactical pluralism might appear benign, but it betrays a limited picture of media activism as a level playing field and of SDL as solely responsible for making the campaign competitive. Just as simplistic, or perhaps disingenuous, is the tendency in gay and lesbian press accounts to cast SDL as the outsiders who

won the campaign on behalf of a grassroots constituency. Signorile suggested as much when he wrote on Gay.com that "the majority of thanks and congratulations needs to go to the activists in StopDrLaura.com who weren't paid for their efforts, and who showed us all just how powerful we could be" (2001, n.p.). SDL efforts undeniably provided valuable opportunities for unaffiliated individuals to participate in the campaign, but the fact that SDL leaders did not get paid for their efforts does not, by itself, make them outsiders.

Whether directly or not, the leaders stood to benefit professionally from the Schlessinger campaign. SDL cofounder William Waybourn is a former Glaad executive director who now owns Window Media, the largest group of gay and lesbian newspapers in the United States. (The LGBT press benefited from an ongoing story and rousing victory.) Another SDL founder, Alan Klein, is a public relations executive and a former Glaad director of communications. (The success of the campaign added to his resume.) Aravosis, the SDL web guru, is president of an internet consulting group that develops web-based strategies for nonprofit organizations. (SDL gave him national prominence.) The other SDL founders were a television producer and public relations consultant, respectively. (SDL expanded their claim to professional expertise.)

Although SDL emphasized that most of its funding came from t-shirt sales, more than 25 percent of its $18,000 operating budget came from a grant by the Human Rights Campaign, the largest gay and lesbian rights organization in the United States and arguably the most oriented to insiders. In sum, the outsiders in the Schlessinger campaign were not really outsiders at all but professionals cut from the same cloth who, using the internet in novel ways, stitched themselves into a competing banner (Henderson 2003).

Understanding the campaign as a contest for cultural authority among professionalized activists better recognizes the possibilities, limits, and power relations of gay and lesbian media activism as it exists today. Despite an indisputable room "for a variety of tactics and objectives" (2000c, n.p.) in media activism, as Garry pointed out in her response to Aravosis, the extent of network power to "disarm, contain, and control" advocacy groups constrains this tactical range (Montgomery 1989, 54), because the system is not of the activists' own making. It is the historical product of network strategies designed to channel grievances into manageable forms. In this system, as Thomas Streeter has argued, "not everyone is heard from, not all arguments are heard, and, even among those who do get a hearing, the power to influence the process is not evenly distributed" (2000, 80). Getting heard at all requires the skills and connections that Glaad and SDL possessed and ways of framing arguments that do not question the structural inequality at the heart of media activism—that large corporations can decide what to broadcast on the public airwaves, usually in the interest of profit. The system has, since the mid-1970s, offered limited opportunities for

democratic participation, ranging from the cooperative to the moderately confrontational. It falls to those who possess the professional skills and connections necessary for functioning effectively within the system to select tactics from the available range and to compete for the cultural authority to wield limited kinds of power and influence.

Confronted with the potential threat of being supplanted, Glaad leaders took steps to secure their position. Glaad became more like SDL in the process, even as SDL became more like Glaad in declaring victory based on toning down Schlessinger's rhetoric. The two organizations appeared so similar in the end, because they were not so different to begin with, in large part because they held similar strategic objectives and possibilities for action. As significant as their victory was in defeating a homophobic media personality, it should not be mistaken for long-term structural change in the war to defeat media homophobia.

REFERENCES

Aravosis, John. 2000. "StopDrLaura.Com." *New Republic*, 23 October. Available at http://www.wiredstrategies.com/tnr_sdl.htm. Accessed 29 February 2004.

———. 2001. "We Stopped Dr. Laura." Soc.motss newsgroup, 17 January. Available at news:soc.motss. Accessed 17 January 2001.

Buford, Howard. 2000. E-mail message to Glaad executive committee, n.d.

———. 2001. Interview with the author, New York, 19 April.

Clendinen, Dudley, and Adam Nagourney. 1999. *Out for Good: The Struggle to Build a Gay Rights Movement in America*. New York: Simon & Schuster.

D'Emilio, John. 2000. "Cycles of Change, Questions of Strategy: The Gay and Lesbian Movement after Fifty Years." In *The Politics of Gay Rights*, 31–53. Ed. Craig A. Rimmerman, Kenneth D. Wald & Clyde Wilcox. Chicago: University of Chicago Press.

Garry, Joan. 1998. Letter to Laura Schlessinger, 14 August.

———. 1999. Speech to Gay and Lesbian Bell Atlantic Employees (Globe), 15 October.

———. 2000a. Interview by Michelangelo Signorile. *The Signorile Show*, GAYBC Radio Network, 19 February.

———. 2000b. "A Letter From Glaad Executive Director Joan M. Garry on Glaad and Dr. Laura." E-mail posted on the Glaad listserv, 28 February. Accessed 28 February 2000.

———. 2000c. "Activism and Criticism." Posted on the soc.motss newsgroup, 13 September. Available at news:soc.motss. Accessed 13 September 2000.

Glaad. 2000a. "Statement by the Gay & Lesbian Alliance Against Defamation (Glaad) Regarding Laura Schlessinger." Glaad.org, 10 March. Available at http://www.glaad.org/publications/resource_doc_detail.php?id=2830&. Accessed 25 February 2004.

———. 2000b. "Glaad Calls on Paramount to Terminate Relationship with Laura Schlessinger; Move Comes after Schlessinger Recants Apology." Glaad.org, 15 March. Available at http://www.glaad.org/publications/resource_doc_detail.php?id=2830&. Accessed 25 February 2004.

———. 2001. Glaad Annual Report. Ed. Bob Findle.

————. 2004. "About Glaad." Glaad.org. Available at http://www.glaad.org/about/index.php. Accessed 25 February 2004.

Glaad Communication Team. 2000. Interview with the author, Los Angeles, 6 November.

Glaad/Premiere Radio Networks. 1999. Transcript of meeting between Joan Garry and Laura Schlessinger, 10 March.

Grego, Melissa. 2000. "*TV's Gay Pride Parade.*" *Variety*, 11–17 December, 1.

Gross, Larry. 2001. *Up from Invisibility: Lesbians, Gay Men, and the Media in America.* New York: Columbia University Press.

Grove, Aimee. 2000. "Dr. Laura Issues Apology, Glaad Fires Back Missive." *PR Week*, 16 October, 2.

Henderson, Lisa. 2003. Personal correspondence with the author, 30 June.

Kantrowitz, Arnie. 2000. Interview with the author, City University of New York, Staten Island, 18 July.

Larson, Magali Sarfatti. 1977. *The Rise of Professionalism: A Sociological Analysis.* Berkeley: University of California Press.

Lund, Sean. 2001. Interview with the author, Los Angeles, 13 February.

Montgomery, Kathryn C. 1989. *Target, Prime Time: Advocacy Groups and the Struggle over Entertainment Television.* New York: Oxford University Press.

Paramount Television Group. 2000. "Following Is a Statement Released Today by the Paramount Television Group Regarding Dr. Laura Schlessinger." Glaad.org, 10 March. Available at http://www.glaad.org/publications/resource_doc_detail.php?id=2830&. Accessed 25 February 2004.

Premiere Radio Networks. 1998. *Dr. Laura.* Transcript, 13 August. Available at http://www.glaad.org/publications/resource_doc_detail.php?id=2856&. Accessed 23 February 2004.

————. 1999a. *Dr. Laura.* Transcript, 9 June. Available at http://www.glaad.org/publications/resource_doc_detail.php?id=2850&. Accessed 23 February 2004.

————. 1999b. *Dr. Laura.* Transcript, 22 June. Available at http://www.glaad.org/publications/resource_doc_detail.php?id=2847&. Accessed 23 February 2004.

Schlessinger, Laura. 1999. "I'm Accused of Being Too Hostile and Too Soft!" *Dr. Laura Perspective*, August, 2.

————. 2000. "Statement by Dr. Laura Schlessinger." Glaad.org, 10 March. Available at http://www.glaad.org/publications/resource_doc_detail.php?id=2830&. Accessed 25 February 2004.

Signorile, Michelangelo. 2000. "Takin' It to the Streets." *Advocate*, 9 May, 29–31.

————. 2001. "The Fall of *Dr. Laura* and the Rise of Internet Activism." Gay.com, 4 April. Available at www.gay.com Accessed 5 April 2001.

Spurgeon, Steve. 2000. Interview with the author, Los Angeles, 6 November.

————. 1999. Glaad board of directors meeting minutes, 25–26 September.

Streeter, Thomas. 2000. "What Is an Advocacy Group, Anyway?" In *Advocacy Groups and the Entertainment Industry*, 77–84. Ed. Michael Suman, Gabriel Rossman & UCLA Center for Communication Policy. Westport, CT: Praeger.

Israeli Gay Men's Consumption of Lesbigay Media

"I'm Not Alone . . . in This Business"

AMIT KAMA

Media produced for, by, and about gay men construct a sphericule that reflects sociohistorical transformations in Israeli life. Forty-five gay men discuss their uses and perceptions of lesbigay media. Printed media and the internet supply tools to overcome feelings of isolation and exclusion that are still prevalent in spite of recent developments. The interviewees need gay media partly because they offer ways to combat dislocation and mostly because they gratify pragmatic objectives, such as meeting partners and providing information. These media constitute a beacon of hope and provide a source of validation of self. Other patterns encountered include intentional consumption and disengagement.

The majority of mass mediated images reflect the interests and experiences of the dominant majority of a given culture. The smallest amount of media content is of, by, and for minority groups (Gross 1998). In recent years, national public spheres have been giving way to discussions of relatively homogenous groups that converse within their own rather autonomous sphericules (Gitlin 1998). Sphericule discourses form as a primary countermeasure to the hegemonic forces that allow national media to annihilate symbolically and render some groups voiceless. Like the media the American civil rights and feminist movements produced in the 1960s, the lesbigay channels of communication offer information the mainstream media rarely disseminate (Fejes & Petrich 1993) and are aimed to present role models for emulation as well as to promote political struggles and ideological causes (Streitmatter 1993). The functions of the lesbigay media divide into two main categories: political objectives and psychosocial objectives.

Political objectives include the following: (1) To form a shared consciousness. These media provide a forum for free discussion of the lesbigay community's concerns. Here, political agendas and questions of a shared future ferment and consolidate. (2) To identify and mobilize political leaders. These media serve as recruitment agents to enlist new activists. (3) To provide reservoirs of collective memory. Because the annals of official transcripts exclude their existence, lesbigays have never had their histories documented. Their media record and preserve shared experiences and become the basis for building a collective memory (Jackson 1999). (4) To foster empowerment and communal consolidation. As a result of the former practices, the sphericule media constitute a nucleation center where a cohesive and interconnected community can grow, offering its members an emergent sense of belonging.

Psychosocial objectives include the following: (1) To act as socialization agents. Unlike other minorities whose members are born into their group of reference, lesbigays are born into heterosexual families. They hence experience hardships involved in acknowledging their homosexual identity in an environment devoid of others like themselves (Cass 1979). The lesbigay media fill the void by mapping and affirming an array of beliefs, norms, and values, as well as furnishing practical information. (2) To remedy alienation. Lesbigays grow up feeling lonesome, with no one to ease the sense of alienation and the hostility that peers and family members express (Morris 1997). The lesbigay media can offer a remedy because they constitute a symbolic space where neophyte individuals (Troiden 1993) may feel a sense of belonging, free from severe judgments against anyone atypical. (3) To validate the self. Unlike the official transcripts that deliver negation, the small media validate the self and acknowledge the right to be different.

ISRAELI LESBIGAY SPHERICULE

The Israeli lesbigay sphericule underwent a vital and profound change during the past decades (see Gross 2001; Kama 2000a; and Kama 2000b for fuller details). In 1975, the Society for the Protection of Personal Rights (SPPR) was founded. This had enormous repercussions, not only in forming a communal identity, but also in triggering a public discourse that called for a platform for expression. In 1982, the SPPR began publishing a journal, *Nativ Nossaf* (Another Path), published irregularly and circulated free of charge until 1994. The abolishing of the sodomy law in 1988 and the increasing tolerance in Israeli political, judicial, and cultural establishments prompted developments within the lesbigay sphericule. Since the late 1980s, several men (except for two women who briefly published *Ga'ava* [Pride]) have published commercial monthly magazines: *Maga'im* (Contacts) from 1988 to 1994; *Duet* (1995); *Hakehset* (Rainbow), also known as *TOP* and appearing erratically during

the 1990s; and *Zman Varod* (Pink Times), founded in 1996 and the only surviving magazine. Women discontent with the male-dominated media founded KLAF (Lesbian Feminist Community) in 1987 and published *Klaf Hazak* (Strong Card)—later renamed *Pandora*—in varying formats and frequencies until 2005.

During the period when a print lesbigay sphericule flourished in Israel, *Zman Varod* came to occupy its center. Its format remained fairly stable from the time of its inception. Printed in color, it usually comprised sixty-odd pages and contained the following: news from Israel and the world, articles about actual events, in-depth interviews, letters to the editor, personal columns, fashion photographs, cartoons, photographs taken at parties, personal ads, and listings of events and organizations. The magazine circulated free of charge and relied on income from ads.

Electronic media have proved to be quite ephemeral. The SPPR produced *Ge'im Lehatzig* (Proud to Present), a television program aired on cable, for a couple of months in early 1996. There have been several short-lived radio programs and one pirate radio station (Limor 1998). Today, a local Tel Aviv radio station broadcasts a weekly two-hour radio program, *Ge'im Ba'avir* (Proud on the Air).

Gross and Woods (1999a) delineate historical developments of the American lesbigay press that apply, to a large extent, to the Israeli scene. Yet, the latter lagged some twenty years behind its transatlantic role model. Five features are parallel: (1) Symbolic annihilation by national media triggered the establishment of the lesbigay press. (2) The media evolved side by side with the establishment of political, social, and commercial institutions serving the lesbigay community. (3) Most contributors are voluntary and not professional journalists. (4) Unstable and unreliable financial basis was a result of limited commercial interest. The publications are short-lived because they fail to solicit ads from commercial firms that refuse to advertise in media that they perceive to be harmful to their reputations. Although the American lesbigay press has been successful in garnering growing numbers of advertisers in recent years (Sender 2001), the Israeli situation is far from financially stable. (Israeli firms are apprehensive lest their Orthodox Jewish consumers boycott their products if they seem to be friendly to the practitioners of the biblical abomination.) (5) Lesbians and their concerns remain a minority, with almost no voice even within the so-called lesbigay sphericule.

Two attributes that Gross and Woods discuss do not apply to the Israeli situation. First, the rather swift inclusive practices by the Israeli public sphere toward lesbigays took place concurrently with processes within the lesbigay sphericule. As a result, no clear-cut division of labor exists between what the small and the national media present and cover. Second, North American authorities have taken detrimental actions (Jackson 1999), but the Israeli establishment never infringed on any lesbigay publication. There has never been any attempt to censor a publication or interfere in any way with this sphericule. On the contrary, the Tel Aviv municipality, for

instance, subsidizes some of *Zman Varod* issues. *Ha'aretz*, the most prestigious daily, disseminates the paper to celebrate Gay Pride every June.

INTERNET

The relatively new medium of the internet occupies the junction between interpersonal and mass communications. Chat rooms, forums, and, certainly, e-mail are obvious interpersonal communications for which the net serves as a channel. Sites that disseminate information adhere to the institutional definition of mass media, produced by central organizations for the consumption of unspecified audiences. Cyberspace creates a postmodern agora, presenting a plethora of information and stimuli for effortless use and a market of opinions liberated from conventional tethers. For lesbigays around the globe, the internet is a transnational meeting place whose greatest advantage lies in the fact that it eliminates the problems of entering a public venue. Because users do not have to reveal their real identities, coming out plays no role in participation. Here, they can perform vital activities, from masturbation to finding a partner, from having cybersex to acquiring political savvy (Silberman 1999; Tsang 1999). Lastly, the internet can provide a lifeline for gay neophytes and others trapped in enemy territory (Gross & Woods 1999b).

The question that prompted the present study was, How and for what aims do gay men use and make sense of gay media? What are their patterns of interpretation and consumption? This chapter will thus attempt to describe the cultural arena from the consumers' point of view.

SPONTANEOUS AUTOBIOGRAPHIES

Forty-five Jewish-Israeli gay men volunteered to unfold their life stories. Participants were recruited through newspaper ads, the internet, gay venues and public events, and personal referrals (snowballing). The group ranged from activists in gay organizations to men who shun the gay world and refrain from coming out (Harry 1993). The distribution of age, education, and occupation was relatively wide and heterogeneous (see Harry 1986): The youngest interviewee was sixteen years old, the oldest seventy-two years old. About 40 percent lived in the Tel Aviv metropolitan area, and the rest lived elsewhere, mainly in towns. About half of the interviewees attended university, a third attended secondary schools, and the rest had lower levels of schooling. The majority were secular, and four were semireligious. No Arabs

took part because they do not share cultural arenas with Hebrew-speaking Jews. No obvious differences emerged among the interviewees along sociodemographic lines. That is, the commonalities among the interviewees (particularly in their views on media) transcended sociodemographic disparities.

The interviews took place between September 1997 and September 1999. All commenced with a standard request: "Tell me your life story." I intended to elicit spontaneous autobiographies (Bruner 1990) and so conducted unstructured interviews. Narrators related the perceived, subjective importance of their own communication patterns as they were woven within their biographies. After transcribing the recorded interviews, the main themes were distilled according to the grounded theory guidelines (Strauss & Corbin 1994). Ingredients of the narratives relevant to the study were looked for without judging in advance what would prove important or what the possible themes might be (Kearney, Murphy & Rosenbaum 1994). To corroborate and illustrate the conclusions, the next sections include citations from the life stories. Translations adhere to the colloquial Hebrew. A caveat: Although the following sections focus on gay men, it does not mean that conclusions are invalid for lesbians.

CONTENT

The gay press supplies important information that is an essential resource for the gay individual, particularly the neophyte or one who lives outside the urban hub of Tel Aviv. The need is even more acute when the national media do not report the comings and goings of the gay community. Despite great changes in the Israeli public sphere recently, exclusionary processes have not ceased. Raphael (an alias, as with all names here), a forty-four-year-old foreman living in a small, remote town in northern Israel, described his basic needs that the gay media can, at best, gratify virtually:

> My needs: Where to have fun, for example. . . . A man wants to go to a disco. This is his needs, the things he consumes, he wants, like his food.

The sphericule press can satisfy needs, because its producers, by being gay themselves, are well attuned to and aware of them. The first-hand experience of those involved in the gay press enables them to create texts that emanate from and reflect the prevalent issues common to gay men. Tal, a thirty-year-old journalist, elaborated on subjects not addressed in the mainstream media:

> I think that *Zman Varod* is doing its job. As the paper of the gay community it first of all brings things that interest us, that are unique to us, that we cannot read in other papers. . . . Information

for people from around the country, and for people in Tel Aviv who don't know what's going on. . . . Things that are close to us, that characterize us as a community.

Ya'akov, an eighteen-year-old high school student, maintained that the gay press constituted the only public forum where same-sex couples receive serious discussion. The gay press devotes columns and even entire issues to the topic, not only validating them but also furnishing readers with role models.

I think that *Zman Varod* serves the community well. . . . For example, the items about couples. It deals with the questions of relations between guys on the personal level, on the sexual level. . . . It is a good service to the community from the aspect of information and community unity.

Dudy, another eighteen-year-old who is about to enter the army (a three-year service mandatory for all Israelis at the age of eighteen), said that *Zman Varod* assisted him in forming ideological attitudes and consequently played a socialization role for him:

There was an article about a TV program with drag queens. To accept them or not. And then I found out that I was a hypocrite. And it like affected me. . . . So, through the paper I got the perspective that like: "OK, I am like this, there are [people] like that, and others like that."

A majority of the interviewees accentuated the central role personal ads play in the gay media. The ads draw even those not interested in reading the papers. Andrey, a twenty-five-year-old new immigrant from Russia, could barely read Hebrew, yet looked for "post boxes," as he put it.

Finally, interviewees perceived the texts to be representative of the entire gay world. Zohar, a twenty-year-old soldier, believed that the gay media are a showcase where gay men reveal themselves to the outer world. He argued for the gay representation constructed to present a proper or correct image of all gay men. Texts in mainstream media cling to the ridiculous and loathsome image, and the gay media bear the moral responsibility to present a different one, one that is not stereotypical. Zohar wanted the gay media to be vigilant because nongay persons may also consume them. The gay media must not become a two-edged sword by providing homophobic persons with negative gay images. Zohar's view was prevalent among all interviewees, who believed the gay social group to be monolithic and homogenous. They expected one image to represent the entire group and considered any one image to reflect on all gay men.

There was one issue where they published some poem on its cover. . . . Even I was embarrassed . . . and I thought of the guy who looks at the kiosk and sees this gay magazine and reads the . . . I felt really bad. . . . A gay newspaper should not deal all the time with. . . . Not that we have to be ashamed of anything, . . . but, generally, not only gays take this paper, also their parents can accidentally see it. . . . A bit of modesty, some good taste. . . .

CONSUMPTION

Two complementary trends stand out in the context of consumption (similar patterns were found for mainstream media consumption; see Kama 2003): intentional consumption versus disengagement. Consider the first: Li'or, an unemployed twenty-three-year-old whose family is Orthodox Jewish, reported that, as a teenager, he felt lonely, as if he were the only gay man in the world. Reading *Maga'im* was a source of consolation and relief and bolstered his self-confidence.

> First of all, it [reading the magazine] gave me a sense that I'm not alone. Although I now know no one like this, but there is an organization and there are pubs, and there are beaches where gays exist. It gave me a sense that I'm not alone. Not alone in this business.

Amnon, a twenty-five-year-old undergraduate student, asserted that consumption of gay media enhanced his gay identity. The medium as such seemed more important than the message. The very existence of a newspaper and a television show, beyond their content, proved critical for Amnon, who gained psychological benefits from just knowing that they were out there. The act of consumption was less significant, and Amnon was happy with the information itself. The gay media proved that there is a world out there waiting for him whenever he was ready.

> Even though I nearly never watched the show, even the knowledge that *Ge'im Lehatzig* is there. Really, I watched it once or twice, but I remember that I used to open the TV guide in order to see that it is still broadcast. I wouldn't even watch. But, like "OK, it's on," now I can continue. . . . I think that it was like a substitute. It is difficult to be gay. . . . I used to live next to a bookstore, and they had a stand, and every month they put out [a magazine]. It was more significant to take it than to sit at home and read it.

For the gay man who lives in Tel Aviv, participation in the gay world is easier because of geographical proximity than for one who lives in the periphery, has fewer options for involvement, and faces stricter social control (Weston 1995). Gay media can serve as a vicarious substitute. Barak, a thirty-year-old graduate student who lives in a northern city, explained,

> I really love *Zman Varod* . . . it is what connects me to the community. And in Haifa I can't quite connect. . . . As far as I'm concerned, it makes me feel like a part of it.

The gay media are a metaphorical umbilical cord that not only supply information, but also a sense of belonging to a social group of peers. The gay individual alienated and exiled from other symbolic and social structures can remove the masks he needs to wear in his daily transactions. Such media provide a forum that contributes to social cohesion and assists the individual to validate his self and identity. First, the gay media override the processes of negation that typify the national public sphere.

The end result of these dialectics is a symbolic locale where the gay individual can feel at home. Here he fits in and can draw mental vigor. Shlomi, a thirty-seven-year-old accountant living in Jerusalem, put it this way:

> The program on cable . . . there was somehow something that gave me, how shall I put it, that I feel I'm part of this group. That is, it gives some empowerment. It strengthens the sense of identification and consolidation of the community.

Yuval, a thirty-five-year-old computer programmer who preserves an entrenched silence about his homosexuality, discussed a gay radio program. In spite of his enthusiasm, like others who distinguished between the medium and the message, he was not too happy about the latter.

> I used to listen to this program, although it was on a terribly low level. Really. But, I enjoyed the thing that even though it did not fit me as a human being, it nevertheless belonged to a very important side of my life. . . . It was very refreshing. When you live a life that you are actually gay and everything around is just straight. Straight. Straight. So, after all, you can hear something, even if it isn't exactly to your taste.

In contrast to the previous respondents, several others articulated a pattern of disengaging themselves from the gay media as a result of ontological anxieties. Some men expressed antagonism toward the very notion of formation of individual and/or communal gay identities. Gay media and their consumption are among the obvious components of these unwelcome identities. The common denominator among the interviewees who detached themselves from the gay media was their reluctance or inability to construct an identity that revolved around or emanated from their sexual orientation.

Yosi, a thirty-eight-year-old computer programmer who married a woman, raised two children, and now shares his life with a man, had no interest in gay affairs because of anxiety about reducing his identity to sexuality. Equating the human totality to sexuality is among the cultural practices most threatening to the gay individual. Disengagement does not depend on the contents of the media but reflects another notion: "If I don't read a gay paper, my identity is not solely demarcated by my sexuality." Consumption may reinforce one's labeling as gay and diminish anything else. Danny, a thirty-eight-year-old nurse, maintained that identity affected media consumption. Sexual orientation fell low in the hierarchy of what constituted Danny's identity. He did not consider it vital to his self.

> My partner reads *Zman Varod.* I occasionally leaf through it. I do not read it. NO. I think that I have a different idea than other gays. . . . I don't take homosexuality and make it a leading thing. . . . My homosexuality is manifested in whatever is related to the home and close friends and whatever happens between me and my boyfriend at home.

Another explanation for the disengagement pattern stems from an aversion some men felt toward the gay community, as if it were a monolithic entity in which they could not find a place. The respondents positioned themselves outside a social body perceived to embody all that heteronormative culture detests. They internalized heterosexism and expressed homophobia by limiting how much they generalized from their own homosexuality. Doron, a twenty-year-old soldier, articulated an aversion to all that is not concomitant with heteronormativity, including *Zman Varod*, which is the communication channel of a group with whom he shared sexual orientation but nothing else. Others reiterated Doron's claims, that the magazine echoed gay men's obsessive hunt for sex:

> I know the paper. I read it. Too provocative for my taste. . . . Everything is too extroverted. They use words that I really don't like to use. Such cheap language! The paper is half trash. . . . I mean it is vulgar and cheap

FEAR OF OUTING

Notwithstanding dramatic changes in Israeli society, their impact has not yet penetrated all private realms. Practices of coming out do not necessarily echo the current era of relative tolerance and acceptance. The closet is a palpable feature in many gay men's lives. Disclosure of one's homosexuality is still a perceived threat to one's welfare. In the present context, the question of whether to come out interweaves with the consumption of gay media. The likelihood of hindering attempts to protect a heterosexual front affects consumption, which may produce an inadvertent and even harmful outing (that is, unwilling exposure). Various writers have already documented furtive consumption of gay texts, printed materials in particular (Gross 1998; Thistlewaite 1990). The interviewees claimed that only lesbigays consume lesbigay media, and consumption denotes an identity. Being caught off guard reading a gay magazine spoils, to borrow Goffman's (1963) term, one's identity. No'am, a twenty-seven-year-old graduate student, said,

> I was 18, just before my military service . . . I started buying *Maga'im*. I learned that, I don't know how, there is such a newspaper for homosexuals. And I was willing to take a risk. My shame at buying such a paper was a little less strong. I remember that I didn't dare to ask for it. I took it, paid, and immediately split.

Sa'ar, a twenty-year-old soldier, explained why he could not read Zman Varod:

> I sometimes leaf through it. When I find it in [gay venues] by chance. I don't really read it. I never take it home. . . . I don't feel comfortable bringing it home.

Adam, a twenty-three-year-old member of a communal agricultural settlement, reflected on the problem of buying a gay paper. The very act of buying it constitutes

a defiant act of coming out to strangers. To safeguard his identity, Adam took double safety measures:

> I went and looked for it [a gay magazine]. It's a very embarrassing story. I went and looked for it in a big bookstore. . . . I asked the saleswoman. Of course I said that it was not for me. . . . She didn't know about it. So, I tried a few more times until I finally found it on a news stand in the central bus station. . . . I put on sunglasses and a hat. And first of all, I said that it wasn't for me, and asked for it. . . . The stand also has pornographic magazines, and although I didn't like the association, it did make sense to me. The lady was very nice, and she gave me the paper, and she wrapped it in an opaque bag. And she said, "If you want, it comes every month. You can get it every time." Of course I said to her, "No, no, it's not for me."

Dudy's tale, although exceptional, illuminates the pattern of fear about outing. Dudy used the magazine to come out without a verbal statement. Dudy was well aware that he was being defiant and provocative, considering the small, rural town he lived in. Unlike other respondents, he read the paper in a public space as part of his campaign to raise awareness among his neighbors. Reading in public is subversive because our culture does not tolerate overt expressions of homosexuality. Any such manifestation is readily labeled as flaunting behavior supposedly performed, at best, within a domestic, enclosed territory.

> I used to always have a paper in my bag when I was on the train. And on the train I would force myself to read. . . . So I mainly tried to read *Zman Varod* on the train. It was real fun. Like, "Ah-Hah! A gay paper on the train!"

THE VIRTUAL PARK

Participants in computer-mediated communication (CMC) construct virtual communities whose members share a sense of togetherness even though most of them remain anonymous (Rheingold 1993). Furthermore, CMC encourage manipulation of presentation of self either by adopting a playful false identity or by pretending to be someone else. Chatting programs (such as internet relay chat [IRC] and its Israeli versions) enable users to communicate with each other, whether one-to-one or publicly, in real time. Accordingly, in these arenas, one can fulfill fantasies, challenge societal norms, or perform in modes not permitted or accepted in routine life circumstances. Chat rooms constitute a liminal space outside conventional social interaction and afford anonymity along with another crucial characteristic relevant to lesbigays and to neophytes in particular: namely, secrecy. Gay men covet the unique characteristics combined in virtual chatting. They can gratify their need to meet each other without the burden of entering a gay material space that could expose their identity. The need is additionally urgent in a small country like Israel, where one can never be unknown (Nir 1998).

The prevalent—and, in some cases, the only—use of the internet which the interviewees in the present study mentioned was meeting sex partners. They enjoy the advantages of anonymity and secrecy, avoiding the problems of visiting traditional cruising places, particularly public parks. Unlike other Western countries where public parks are unsafe and stigmatized, in all large Israeli towns, the public parks, many called Independence Park, provide grounds for cruising and sex. For years, the parks constituted the only viable spaces for communication among gay men, who could enter without being labeled, even if a relative or an acquaintance spotted them. Another explanation for their popularity was the absence of venues (such as clubs, bars, and community centers) catering to gay men (Hirsch 1999; Sumakai-Fink & Press 1999). Although visiting Independence Parks has been quite a common pastime, the introduction of the internet decreased their functionality. Bo'az, a thirty-four-year-old executive advisor, explained,

> Last night I dropped in somewhere not far from here. We spoke over the internet at 3 in the morning. He said to me, "Come over." I got into my car and went. It was nice. A substitute for the park. A virtual park.

In contrast to cruising in the park, the chat rooms neither require any resources nor entail any threats like police harassment or being spotted by relatives. Above all, virtual cruising is available to anyone who wishes to remain closeted. The use of nicknames instead of given names also provides a turf for playing with one's identity and for encapsulating demands, whims, and personas. Because everyone uses a nickname, and anonymity is normative, individuals who wish to remain closeted are not subject to prevailing pressures to come out.

Hagai, a forty-eight-year-old executive who had been married to a woman, has avoided the gay world until recently. For the past two years, he has been sharing his life with a man. The internet furnished a useful channel of communication when Hagai began his journey and gratified his growing needs to meet men. Unlike other respondents who felt that the internet relieved them of the burden of walking in the parks, Hagai and others enjoyed the chat forums for their discretion.

> I've been cruising the IRC for many years. . . . If it wasn't there, I wouldn't have met him [his partner]. . . . And we started talking, and I was looking for sex. Yes, the internet is like the park, going to the park. But instead of going to the park, you do it at home. You find someone you like and you meet him.

Gil, a twenty-seven-year-old computer analyst, led a discrete lifestyle. He never participated in the actual gay world and instead established intimate relationships with men solely through the net.

> I feel more comfortable in the IRC. . . . You can talk for a long time without even knowing each other. The only thing that connects you, that makes you recognize him is his nick. . . . If

> I don't want to be recognized, I log on and it [the nickname] is totally different from the last time. There is no reason to think that it is me. I had this option to decide that I wanted to be anonymous. . . . This is like getting into the first gear when you are afraid. . . . I met people only through the IRC.

The celebrated anonymity and discretion in the context of CMC can be a two-edged sword. The internet encourages interaction patterns that are pervasive between gay men and nongay others. False presentation of self and fabricated identities have roots in the crucial need to remain undisclosed but then tend to permeate gay men's habitual relationships. The normative use of nicknames sometimes becomes a taken-for-granted pretext for evading authentic, sincere, and honest dialogues. The benefits of the internet may, under some circumstances, reinforce negative phenomena that nearly all interviewees reported.

Tal's story exemplifies the model of interpersonal interactions based on bogus identities, insincerity, and even purposeful deceit. He made two contradictory claims. On the one hand, like all other informants, he demanded interpersonal dialogues to be based on honesty; on the other, he practiced what he himself considered wrong. To be clear, the use of nicknames usually ends after the initial conversation, when the interlocutors assume their virtual relationship is heading toward a real one. Tal demanded that his partners be honest but did not apply the directive to himself. Finally, not only closeted gay men enjoy the internet, but also public figures like Tal, a well-known activist.

> TAL. Usually people address me because they like my nickname, and three seconds later, "How long is your dick? R U passive or active? My place or yours?" They are not really looking for love. It immediately turns into sex. . . . Chats of another kind can be very amusing, very funny and witty. And after three minutes I find out that I know the person.
>
> AMIT. You don't identify yourselves during the chat?
>
> TAL. No, no, no. Why on earth? I call myself Teddy or Tommy. Why? If it eventually doesn't lead to anything, why should they know that the gay Tal is like this and that? The internet is a virtual space. Sometimes I send photos not of myself. They ask me how I look, and I send someone else's photo. It's virtual.

Assaf, an eighteen-year-old high school graduate, lamented the virtual community of gay chatters for their lack of authenticity and candor. He was unhappy with the prevalent objectification that makes gay men into mere sexual objects and constructs other men only as a means of sexual satisfaction. This ontological reduction is all too common in the chat forum.

> If I log on, everything revolves around sex. There are very few people who address me or I address them and we chat for fun. Because it's fun to talk to them, because they are interesting, because they are nice, because they are funny. It is very hard to find these people. And when you find them, you say, "Ah, here is a person like this." And they also have the same

feeling—that there aren't enough people to just communicate with because they are nice. It is especially obvious on the net, because I don't live the life of the clubs. My encounter with the community is especially through the net.

THE INTERNET AS A RESOCIALIZATION AGENT

Because society acclimates all its members into heterosexuality, gay men must be resocialized into new models of behavior, that is, to be equipped with the necessary behavioral tools, norms, and values that are appropriate for their new social roles. Gay neophytes know that their heteronormative socialization may not fit their new role, and they need to search for relevant information (Kielwasser & Wolf 1992). The internet is a great mechanism for resocialization and for making contacts with appropriate socialization agents. In other words, the internet encompasses a capacity to function as a metaphorical doorway, as Dudy called it, into the gay world.

Interestingly, none of the forty-five interviewees made any reference to using the infinite and variegated information resources of the internet. It seems as if the informative contents of the medium that can be important for an individual tackling gay identity formation processes are negligible in comparison to its incredible potential for facilitating interpersonal communication with other individuals situated in the same position or in later stages, who can serve as mentors (see also Koch & Schokman 1998, for similar findings). Raz, a sixteen-year-old high school student, specified, "Most of my internet hours are on the e-mail and most in the chats with people."

The gate metaphor is accurate, for the internet enables penetration into a virtual space where myriad individuals situated in different positions communicate with each other. It is a marketplace in the sense that its vendors are busy with commerce of personal goods, be them corporal or mental. Gay men find valuable educational lessons derived from personal experiences related among members of virtual communities. Dudy did not log on to seek formal information that is abundant in the net but as an option for interpersonal communication unfeasible in his small, rural hometown.

> It's like a doorway to a way of life. . . . I logged on *gay.il*, and there I spoke with a lot of people. . . . So, from there I met several people. . . . And from there I got like to the doorway to the gay community in Israel.

Doron also accentuated the importance of the internet for social purposes in the geographical periphery:

> Somewhere in the middle of adolescence, I was upset. Such a small place. It was a very closed environment. I was not exposed to other things enough. And then I started to look

for interesting things outside. . . . The truth is that at this stage I started with computers. And through the computer and later through the internet I managed to meet a lot of people from other parts of the country. And so I had places to go, things to do, where to be. . . . About a year after I started with the computer thing, I also started to accept the idea that I am gay, and to understand what I was looking for, and that surely in my neighborhood I will not find, and through the computer it was much easier.

PORNOGRAPHY AND CYBERSEX

The internet is an endless reservoir of homoerotic images consumed for aesthetic as well as bodily pleasures. Bo'az enjoyed this supply:

> I download pictures of fucks and naked men. . . . I found out that nearly every gay man I know who has a computer has a reservoir. And if he doesn't have it now, he had it. And if not, he's preparing one. Everyone has a pool of pictures of fucks. . . . My collection is like a stamp collection with names. I nurture it.

Unlike other media (pornographic videos and magazines), the internet is advantageous because one can enjoy oneself without the burden or risk of getting caught. Nir, a twenty-year-old soldier who still lived with his parents, said,

> I prefer the computerized pornography. I mean, I'm not in the thing of sex talks with someone, but the pictures to view. . . . My drawers can be searched. But can anyone search my computer? "You [his parents] will never find your hands and feet there!"

A few interviewees reported having cybersex. Computer-mediated simultaneous masturbation can take place through verbal correspondence or by using an online camera. This is effective when circumstances preclude meeting other men, for example, among young adults and boys who cannot leave home and enter a gay meeting location. Doron recalled,

> I used to do it [cybersex] in the past. When I was 14 or 15. . . . When I was 17 I stopped. I had enough friends, I didn't need this nonsense.

For a long time, Gil's fear of being exposed as gay had kept him from meeting men or entering the gay world. For sexual gratification, he participated in cybersex that would not jeopardize his secrecy. But, even here, he was too anxious and so had cybersex only with foreign men.

> There was the initial enthusiasm of doing something and not alone. At the age of 25 I did it for the first time. Having sex. I never touched anyone before, so I really got excited by the idea. . . . It was on an American channel. It was before I even dared enter the Israeli channel. God forbid I meet here someone who

THE QUEST FOR HUMAN CONTACT

The recent transformations in gay men's life in Israel—communal consolidation, legal changes, diminishing societal sanctions, and the like—are manifest in constructing a sphericule, with its media produced by, for, and about gay men. These media supply crucial tools to overcome feelings of isolation, exclusion, and negation that are still prevalent in spite of the sociohistorical developments. Several intriguing patterns of use were found in the present study.

The cultural processes that positioned the homosexual as a pariah are nowadays diminishing, yet their impact on the individual is still palpable. Many gay men feel exiled from social and symbolic realities and view themselves and their world from the standpoint of Others. The forty-five gay men who unfolded their spontaneous autobiographies expressed their feelings of being situated in a borderland between the culturally constructed normal and abnormal territories. Their positioning constitutes a source of discontent and affects their dialogues with their environments. As seen here, the sphericule media play a crucial role in their lives because of these intricate existential issues. They need the gay media partly because they offer ways to combat cultural, social, or psychological dislocation.

One of the principal phenomena characterizing gay men's lives is a lack of information about themselves. They tackle a vast array of questions—from the existential "Why am I different?" to the pragmatic "How do I contact other gay men?"—with neither a ready nor accessible pool of answers. The neophyte gay man, in particular, cannot rely on his loved ones (particularly, his parents) nor on mainstream media for reliable, trustworthy, and unbiased information. He must unravel the heteronormative, as well as homophobic, narratives to pave his own way in life. The gay sphericule is a beacon of hope within the scheme of negation. Above all, it provides a source of validation of self.

Another common denominator among gay media consumers is their focused use for pragmatic objectives; chief among them is meeting lovers and sexual partners. It seems that the media function as a supply of information is important but may be secondary to their function as convenient watering holes. Personal ads in magazines and chat rooms are priceless assets that effortlessly gratify needs to make contacts for pleasure and sociability. They alleviate the numerous obstacles involved in visiting gay meeting places, whether public parks or commercial venues. Some forty years ago, Hooker (1965) maintained that the important social institution of the American homosexual subculture was the bar, which served as a center for resocialization and integration and as a market for exchanging sexual goods. What has changed since the introduction of the newer forms of communication is perhaps a spatial relocation, from semipublic spaces to the domestic sphere. Today, one need not leave home to achieve the same goals as in yesteryear.

Despite the vital roles the gay media play in the lives of many interviewees, others shun gay media because of ontological anxiety, fearing its consumption may reduce their self to a caricature or because they are anxious to keep their gay identity closeted. Outing is unique to social identities that are not readily noticeable and whose stigma is not overt. Men who, for whatever reason, do not wish to announce being gay perceive the consumption of gay materials as threatening. Indeed, some gay men feel that they need to monitor their media consumption habits closely. Reading a gay paper cannot be an off-hand activity but requires a cautious and careful planning.

Another ontological anxiety further complicates consumption of gay media: namely, reductio ad absurdum. Several respondents reported reluctance to have mere sexual orientation or sexual practices categorize and label them. They dislike the idea of conceiving their identity by what they consider external or bodily behavior that has nothing to do with their innermost selves. These men feel threatened by a tendency to reduce their entire being into a mere Homosexual. Consequently, they shun the gay sphericule and look down on its media.

Finally, the gay sphericule plays a central role in the lived experiences of gay men. It affords crucial conduits for interpersonal contacts. The human dimension proves to be stronger and more alluring than the technological medium and its content itself. Reading magazines, listening to radio programs, watching television shows, and surfing the internet are perceived as primarily means to meet other human beings. Other men have significance far beyond the mediated content as mentors, resocialization agents, or friends. This conclusion has an optimistic implication. Notwithstanding the apocalyptic gloom voiced by many thinkers and scholars about the decline in human contact as a result of the supremacy of the mass media (such as Postman 1986), there is at least one group for whom interpersonal communication is of immense value on the collective and individual levels. Together, producers and consumers of gay media have found an arena based on solidarity and a shared sense of togetherness. Mediated discourse is crystallizing a community and validating all involved actors, in the face of negating social and symbolic realities.

REFERENCES

Bruner, Jerome. 1990. *Acts of Meaning*. Cambridge: Harvard University Press.

Cass, Vivienne C. 1979. "Homosexual Identity Formation: A Theoretical Model." *Journal of Homosexuality 4*.3 (Spring): 219–235.

Fejes, Fred, and Kevin Petrich. 1993. "Invisibility, Homophobia, and Heterosexism: Lesbians, Gays and the Media." *Critical Studies in Mass Communication 10*.4 (December): 396–422.

Gitlin, Todd. 1998. "Public Sphere or Public Sphericules?" In *Media, Ritual and Identity*, 168–74. Ed. Tamar Liebes & James Curran. London: Routledge.

Goffman, Ervin. 1963. *Stigma: Notes on the Management of Spoiled Identity.* Englewood Cliffs, NJ: Prentice Hall.

Gross, Aeyal M. 2001. "Challenges to Compulsory Heterosexuality: Recognition and Non-Recognition of Same-Sex Couples in Israeli Law." In *Legal Recognition of Same-Sex Partnerships: A Study of National, European and International Law*, 391–414. Ed. Robert Wintemute & Mads Andenaes. Oxford: Hart.

Gross, Larry. 1998. "Minorities, Majorities and the Media." In *Media, Ritual and Identity*, 87–102. Ed. Tamar Liebes & James Curran. London: Routledge.

Gross, Larry, and James D. Woods. 1999a. "In Our Own Voices: The Lesbian and Gay Press." In *The Columbia Reader on Lesbians & Gay Men in Media, Society & Politics*, 437–441. Ed. Larry Gross & James D. Woods. New York: Columbia University Press.

———. 1999b. "Queers in Cyberspace." In *The Columbia Reader on Lesbians and Gay Men in Media, Society, and Politics*, 527–530. Ed. Larry Gross & James D. Woods. New York: Columbia University Press.

Harry, Joseph. 1986. "Sampling Gay Men." *Journal of Sex Research 22*.1 (Winter): 21–34.

———. 1993. "Being Out: A General Model." *Journal of Homosexuality 26*.1 (Winter): 25–39.

Hirsch, Dafna. 1999. "Independence Park: Homosexual Territory within the Public Open Space." [in Hebrew]. *Israeli Architecture 36*: 60–65.

Hooker, Evelyn. 1965. "Male Homosexuals and their 'Worlds.'" In *Sexual Inversion: The Multiple Roots of Homosexuality*, 83–107. Ed. J. Marmor. New York: Basic Books.

Jackson, Ed. 1999. "Flaunting It! A Decade of Gay Journalism from *The Body Politic*." In *The Columbia Reader on Lesbians and Gay Men in Media, Society, and Politics*, 461–466. Ed. Larry Gross & James D. Woods. New York: Columbia University Press.

Kama, Amit. 2000a. "From *Terra Incognita* to *Terra Firma*: The Logbook of the Voyage of Gay Men's Community into the Israeli Public Sphere." *Journal of Homosexuality 38*.4 (Autumn): 133–162.

———. 2000b. "Towards Inclusion: Patterns and Trends of Israeli Gay Men's Participation in the Public Sphere." Paper presented to the International Society for Justice Research, Rishon Letzion, Israel, September.

———. 2003. "Negation and Validation of Self via the Media: Israeli Gay Men's (Dis)Engagement Patterns with Their Representations." *Communication Review 6*.1 (Autumn): 71–94.

Kearney, Margaret H., Sheigla Murphy, and Marsha Rosenbaum. 1994. "Mothering on Crack Cocaine: A Grounded Theory Analysis." *Social Science and Medicine 38*.2 (January): 351–361.

Kielwasser, Alfred P., and Michelle A. Wolf. 1992. "Mainstream Television, Adolescent Homosexuality, and Significant Silence." *Critical Studies in Mass Communication 9*.4 (December): 350–373.

Koch, Nadine S., and H. Eric Schokman. 1998. "Democratizing Internet Access in the Lesbian, Gay, and Bisexual Communities." In *Cyberghetto or Cybertopia? Race, Class, and Gender on the Internet*, 171–184. Ed. Bosah Ebo. Westport, CT: Praeger.

Limor, Yehiel. 1998. *The Pirate Radio in Israel: 1998 Report* [in Hebrew]. Jerusalem: The Hebrew University Press.

Morris, Jessica F. 1997. "Lesbian Coming Out as a Multidimensional Process." *Journal of Homosexuality 33*.2 (Spring): 1–22.

Nir, Lilach. 1998. "A Site of Their Own: Gay Teenagers' Involvement Patterns in IRC and Newsgroups." Paper presented at the International Communication Conference, Jerusalem, 22 July.

Postman, Neil. 1986. *Amusing Ourselves to Death: Public Discourse in the Age of Show Business.* New York: Penguin Books.

Rheingold, Howard. 1993. *The Virtual Community: Homesteading on the Electronic Frontier.* Reading, MA: Addison-Wesley.

Sender, Katherine. 2001. "Gay Readers, Consumers, and a Dominant Gay Habitus: 25 Years of the *Advocate* Magazine." *Journal of Communication 51*.1 (March): 73–99.

Silberman, Steve. 1999. "We're Teen, We're Queer, and We've Got E-Mail." In *The Columbia Reader on Lesbians and Gay Men in Media, Society, and Politics*, 537–539. Ed. Larry Gross & James D. Woods. New York: Columbia University Press.

Strauss, Anselm, and Juliet Corbin. 1994. "Grounded Theory Methodology: An Overview." In *Handbook of Qualitative Research*, 273–285. Ed. Norman K. Denzin & Yvonne S. Lincoln. Thousand Oaks, CA: Sage.

Streitmatter, Rodger. 1993. "The *Advocate*: Setting the Standard for the Gay Liberation Press." *Journalism History 19*.3 (Fall): 93–102.

Sumakai-Fink, Amir, and Jacob Press. 1999. *Independence Park: The Lives of Gay Men in Israel*. Stanford: Stanford University Press.

Thistlewaite, Polly. 1990. "Representation, Liberation, and the Queer Press." In *Democracy: Discussion in Contemporary Culture*, 209–212. Ed. Brian Wallis. Seattle: Bay Press.

Troiden, Richard R. 1993. "The Formation of Homosexual Identities." In *Psychological Perspectives on Lesbian and Gay Male Experiences*, 191–217. Ed. Linda D. Garnets & Douglas C. Kimmel. New York: Columbia University Press.

Tsang, Daniel C. 1999. "Notes on Queer N Asian Virtual Sex." In *The Columbia Reader on Lesbians and Gay Men in Media, Society, and Politics*, 531–536. Ed. Larry Gross & James D. Woods. New York: Columbia University Press.

Weston, Kath. 1995. "Get Thee to a Big City: Sexual Imaginary and the Great Gay Migration." *GLQ: A Journal of Lesbian and Gay Studies 2*.3 (Summer): 253–277.

Commentaries and Reactions

TRACY BAIM, JASON DeROSE, DEBORAH KADIN,
ELLEN MEYERS, AND LAURA KIPNIS

TRACY BAIM

In 1984, when I graduated from Drake University, I was fortunate to have two paths in front of me. My mother worked at the *Chicago Defender* and my father worked at the *Chicago Tribune*. I saw which was the right path: the independent press. I started at *GayLife* in 1984, thanks to my mother, who heard about the job. I cofounded *Windy City Times* in 1985 with three other individuals and left there after one of them died from AIDS, because one of the others really had a different vision for the paper. Thirteen years later, I bought *Windy City Times* back.

I had a choice in journalism school of whether to be a journalist or not. I was told I could not be a journalist and a feminist and an activist—could not believe in all the things I was going to work for. I almost didn't finish school, because I never thought there was such a thing as objectivity. I always sat on the far side of the class-room, after the journalism teacher had us line up along a spectrum of how often we thought journalists could be objective. I was on the side that said never, but the others did not enter or stay in journalism.

There is no such thing as objectivity, but journalists have to strive to be as fair as possible. My position is different from that of a reporter at the *Chicago Tribune*, who has to quote each side of an issue. A gay media person has to quote not only certain leaders, but also many different views in the community. Windy City Media

is developing voices of columnists and writers and sources and editors who have many perspectives, not that we have any right-wingers—I draw the line there.

Journalists have a way to get to more truth, more truths different from our own, because there really is no single truth. I can try to quote as many sources as possible on a story on marriage, for example, and I can take the picture of Fred Phelps protesting, but I am not interviewing sources every week who say my audience is going to hell. I interview them once in a while, to keep some perspective and to record for history what they said, but, otherwise, I do not feel the same obligation that a *Tribune* reporter feels. That is why I chose this path, instead of going into the mainstream.

There is no need to denigrate the gay press by calling it laughable. I've dealt with disrespect for a long time, but I am a lesbian with a sense of humor. I think the gay press does not always take its job seriously either: We cover fluff; we cover the news. We follow mainstream news to avoid doing the same thing, now that the mainstream press is covering marriage and other queer issues. The gay press at least has to find a different take. Windy City Media is fortunate to have stringers in Washington, D.C., and California who give us first-hand reports and more feature coverage. Some issues of the *Windy City Times* have a lot more news space than others—although some weeks we have a small issue, sometimes we publish fifty pages.

Our most common interaction occurs when mainstream reporters call to ask, Can you find us a source? It has been the oddest thing for the last two decades. I am on their list to call, to see if I can find them, say, a married couple in DeKalb. I am happy to do it, because, if they cannot find those sources, then they will not do the story right. Fortunately, I can now refer them to more paid community spokespersons. Lambda Legal Defense and Education Fund has half a dozen working in their Chicago office, and so I can refer reporters to sources available during daytime hours for an interview. When the marriage story broke here, a Chicago couple, one of whom works at the *Windy City Times*, got married in San Francisco. One Chicago television station sent cameras to our office to interview them, and then, ten minutes later, reporters from another station came by. It was fun to watch it happen in a row, one after another.

I find it surprising to act as a conduit to the community, because one would think mainstream reporters would have developed their own list of contacts after all these years. Do they call the *Chicago Defender* when they need an African American source? I know turnover happens in the mainstream press, especially when low-level reporters move in and out of the *Tribune* within a year. But some newspaper reporters, and certainly the producers of television and radio news, have been covering the LGBT communities for a long time. They should have much more comprehensive rolodexes. Are they afraid to have a gay person in their rolodex because they fear other journalists might consider them gay? Somehow, they have only two or three names to call, and I try not to be the one they quote. I think others should be the ones quoted in the

145

media. Only rarely will I let reporters off easy, with one stop to talk to me. I try to filter their requests, because it is too easy for reporters to talk to the same two or three sources.

Another issue with the mainstream is whether to use a wire service. While I am alive and publishing a gay paper, I will never use a mainstream wire service. That option has been a downfall of regional gay papers around the country. What's the point? Readers can get that news anywhere. I have little news space and am always seeking more, to publish the original content our writers produce. Maybe eighteen years ago, when publishers could not get access to information through other means, the mainstream wire services were a low-cost solution. Today, there are many other options. Rex Wockner, who runs his own service, started working as a full-time reporter for me in 1986. We met at an activist event downstate, and I am proud that he is surviving full time as a freelance gay reporter, now working out of California. I agree with that kind of news service, rather than relying on the Associated Press, which often has homophobic writers on its staff.

The gay press does cover breaking news. The Windy City Media web site gets fifty thousand unique visitors every week—more visitors than the print publication—because we put 99 percent of our content on line. We also have a radio show that streams content, and we do put breaking news on the air. When there was an outbreak of meningitis on a weekend, we made sure a warning did not wait for the next print edition. When there was a marriage protest downtown, we beat the television stations to the punch by getting the pictures on our web site before they had their five o'clock newscast. We also send out breaking news to e-mail subscribers, who don't pay to join the list. The future of the gay press will be through the internet, which has become the best way to reach the largest audience. As an environmentalist, I would rather have it that way, but we do need other means to reach the community. So we will have print, we will have radio, and, most importantly, we will have the internet. That is a lot for a small regional gay paper.

To say that the Windy City Media Group is a conglomerate would make it out to be a lot larger than it really is. We do have several publications, mainly because I come from an activist, as well as an editorial, background. For years, the racism within the gay and lesbian community frustrated me, not being able, in the media, to make change concrete and be part of change. About twelve years ago, I held six months of forums with the African American gay community in Chicago. We found a need to create a stand-alone publication, but decided that Windy City Media would not do it if one came out from the community—in that case, we would help. Everyone said it was okay for us to start one with the community, and so we did. Six months later, the same thing happened with the Latino community. For nine years, we published *Black Lines* and *En La Vida*, and, three months ago, we merged them into something called *Identity* (which is on line only).

They have never made money. They have been labors of love. To keep them alive, I recently had to make a decision. I struggled over that decision with the more than twenty-five donors who gave money to start those papers and to keep them going. I realized that, as separate publications, they had served their purpose. The community is in a different place nine years later. The distinct needs have now merged and overlap with transgender issues, other gender identity issues, and race. I decided to make them one, so that, maybe, they can get to the next level. The new publication has now expanded.

We at Windy City Media also realize that sex is a big part of the community, and, almost seventeen years ago, we separated out the sexual content, because a lot of our audience did not want a newspaper, they wanted a bar rag. We called it *Nightlines*, and it was black and white on newsprint for years. A few months ago, we decided to make the leap to glossy color (at a price competitive with newsprint). Now renamed *Nightspots*, it does serve a niche. It has sex advertising; it has sexual images. We have a difficult time balancing males to females in it. At least one out of four issues has a woman on the cover, but the nightlife community in Chicago (and everywhere) is male dominated. Male business owners in Chicago have called me, as a woman publisher, every name in the book. I faced a lot of sexism, but now I have the reverse. The women in the community are saying, "Tracy, where are our lewd images." The gender balancing act, across the country, has been difficult for the gay press.

Almost every gay and lesbian paper in the country is run by a man. There are women's papers run by women: *Southern Voice* was a great example. Two women started it a year after I started *Outlines*, and, for a long time, we passed advice back and forth. When they were bought out, I thought, "You can't move out! You're the only women publishers I know from gay and lesbian media who try to be balanced." The reason we bought the *Windy City Times* name, even though I felt we would be fine without it, was to get membership in the National Gay Newspaper Guild, an elite group of twelve gay newspapers, all run by men. After we bought the membership, more than three years passed before they met. Meeting in Philadelphia for the first time promised fascinating dynamics, in a room with eleven white gay men, one other white woman, and myself, trying to figure out where the organization is going. Can it change to benefit the other papers out there? (By 2006, besides the two woman-run newspapers, co-gender teams ran two others among the thirteen.)

May 2004 marked my twentieth anniversary of doing weekly gay newspapers in Chicago. A small press publisher passes every day in survival mode. Not a week has gone by without a fight and a compromise and a debate. We have lost advertising over editorial decisions, and it happens constantly. Dealing with the sexism has cost us advertising because of stereotypes in the gay community. When we started *Black Lines* and then *En La Vida*, holy hell, most of the white gay businesses did not understand it at all. They thought we were going to become something that would

not serve them. Chicago is a racist town to begin with, and so starting these publications was something we had to do. We did it without support in any form, and they never had enough advertising to sustain them.

The reality is that gay and lesbian newspapers need to take advertising from major companies, but we also need to cover those same companies in a way that gives the community a broad understanding. If a pharmaceutical company facing a boycott ran ads, we would run stories on the front page about their price increases. Fortunately, we have not been put on the spot. We do not generally take advertising from companies under boycott. The official campaign against Coors, for example, continues in some areas of the country, although, technically, it ended in others. We are in a position to educate readers about it, and we tell them why we either would not take ads or would donate the money to a nonprofit organization. There have been few hard choices like that. We are in a different position, because corporations in Chicago support nonprofits and alternative newspapers.

Corporate fundraising, in the United States anyway, can be activism to get money back to the community. The committee I have co-vice chaired to bring Gay Games VII to Chicago went after corporate money and tried to hold corporate donors accountable to the community that spends money on their products. Sydney or Amsterdam, when they hosted the Gay Games, had government support. They were going to get money in a different way. The agencies in Chicago need corporate money because government support is not available without a lot of strings attached.

Windy City Media evolves all the time to make sure we stay relevant for the persons we want to reach in Chicago. Our radio show is fun to have out there, and, when we were on FM radio, we had a lot of straight listeners. In 2006, we switched to Windy City Queercast, a podcast, and we still have many nongay listeners. We know we reach a wide range of community members through many different media. *Nightspots*, geared to the bar community, is advertiser driven. But we put a gay wedding—the one I mentioned earlier, between Robert and John—on the cover. We sometimes put politics in *Nightspots*, because we know it is certainly one way to get the news to the community. Even if they never pick up the *Windy City Times*, they will find news through other channels, and so I put my activist background to work.

We balance all these things: mainstream and alternative, male and female, minority and majority, entertainment versus news, corporate versus community, print and other media. It is fascinating to think about, in an academic setting, but most of us in media businesses never get the luxury to step back, ask questions, and ponder the bigger picture. We always face the next decision to take, a payroll to make, or other pressures. I work in the media every day, but thinking about it is almost more exhausting than doing the work. Over the last twenty years, immersed in it, I am sure that our own paper, regardless of a merger, has changed. Because of the internet, we now send our e-mail newsletter to twelve thousand readers, most of whom go without the

print edition. Because the *New York Times* now covers the gay community, we have to cover it differently. The movement itself has changed, and so have we.

JASON DeROSE

I am never quite sure about the divide between mainstream and gay media, because one-third of some newsrooms are gay, and the percentage is probably higher in some places but lower in others. Most gay journalists look through the gay papers, and then try to do something different. Sometimes I check out the *Windy City Times* and the *Chicago Free Press* just to see what the issues are, because otherwise I do not feel connected to the gay and lesbian community. At WBEZ Chicago Public Radio, we differ because reporters do not often spend time covering daily news. We put most of our effort into think-pieces on ideas. We have that real luxury, but the problem is that sometimes we can spin into unreality.

I do not cover many gay and lesbian issues, but I often have the opportunity to be somewhat transgressive when I cover religion. Because my academic background as an undergraduate and in graduate school was in church history and theology, I can take pleasure in being transgressive, in winking at my listeners, when reporting on religious issues. But what I find is that I often seem a bit too focused on insiders. Then the only listeners who get my little winks and nods are those who already understand what the story is really about.

For example, I did a piece (DeRose 2004) about a book called *Killing the Buddha: A Heretics Bible* (Sharlet & Manseau 2004). It is an anthology of poetry, short stories, prose narrative, and some reporting. I had a running Buddhist joke through the piece, and Buddhists sent in hate mail saying I was making fun of them. The story also has a scene from a strip club near Geneva, Illinois, where part of the book is set. The chapter on revelation takes place in a strip club, and that illustrates how the authors put the book together. I have reported on real controversies and did not expect this little book to generate so much hate mail. In the story, I say, "They danced with pagans in Kansas, and the word became flesh at a strip club in Illinois." A right-wing Christian group got hold of the piece from the web and circulated it; they were almost as upset as listeners were about Bob Edwards leaving *Morning Edition*. I can stand behind my statement because it is a joke, I can explain why it works as a joke, and I can wink as I say the line. I can be transgressive in the area I know best, religion, but am not as comfortable doing that in and around gay and lesbian issues, probably because I cannot cover them with the same finesse as I do with religion.

I especially dislike covering media stories because they tend to be an insider conversation, but the discussion about marriage is different. I have been doing a lot of reporting on marriage, and what I find fascinating is that, no matter whether they

complain about the way marriage is reported, listeners complain about one way of understanding marriage, which is as a sentimental act. One either has good or bad feelings toward that act. In the novel, *The Solace of Leaving Early*, Haven Kimmel (2003) says that sentiment is the big problem with talking about marriage. Marriage has nothing to do with sentiment, and anyone who enters it thinking that way will end up getting divorced. The only way to understand marriage is as an existential act. When I report on same-sex marriage issues, I try to understand marriage that way. When I bring up marriage as an interviewer, everyone thinks I'm going to follow them around their sun-dappled living rooms. Sun-dappled doesn't make sense in radio, nor in print. When I ask, "What does marriage mean to you?" I get the sentimental response: "Everything is good." In my interviewing, I try to talk about what is wrong with marriage and why marriages tend to fail. Interviewees don't like those questions, and, when I pull out the word *existential*, they get upset because they don't know what it means, although I try to explain. These thoughts apply to the ways research discusses marriage as well.

Another issue for researchers is the myth of sound bites. When I start working on a news story, I sit the person down, tell them how far away to sit from the microphone, and say, "We will talk for about an hour or two." I can take two hours because I work in public radio, already a rarified world as it is, and I work a boutique beat within that rarified world. (Covering religion in public radio means that maybe twelve listeners have an interest in my stories.) I try to explain to those I interview that everything they tell me will go into the decisions I make when putting the story together. If we talk for an hour, and they hear themselves for eight seconds in the piece, it's not that I thought only eight seconds of what they told me was important. Instead, it's that in the course of reporting a five- to eight-minute piece—most of mine fall into that range—I'm trying to squeeze in twelve or fifteen sources, trying to make complex arguments, and, mostly, trying to tell narratives.

When I speak to academics, I often get this complaint by e-mail or by voicemail the next day: "We spoke for an hour, and you gave me eight seconds on the air." I never reply, "This is more about your narcissism than about the piece itself." Instead I explain—and I think this is true—that academics want to hear themselves on the radio. We talk for an hour, and I think, "What am I going to do with this?" I have to make their ideas make sense in a few minutes. Because of the medium where I work, I have the luxury of time to try to do that. But here is my comment on the myth of sound bites: Remember that the story is not about you. Normally, academics are there in the stories I do, but the report is mostly someone else's narrative. Narrative journalism is the best thing one can do in radio, because radio is a warm medium. It's an intimate medium, and so, instead of hitting listeners with a bunch of facts, reporters try to tell a story.

The difference between facts and stories leads to another point: representation versus presentation. I don't claim that my stories are great truths for all time, and the

way I discern my stories is less magical than one might think. When trying to put together a story, especially for radio, I find many decisions depend on who can get the story told. In radio, it has to be somebody who can speak English with relative fluency—I'm not talking about accent, but fluency in English. It's difficult to listen for eight minutes, and, if the syntax is scattered and broken, the story will not get told on the radio. It may make a great story in print, but it won't get told in radio.

In the same way, for stories that involve complex ideas or numbers, the rule of thumb is that, if there are more than three numbers, none of them can end up in the story. Otherwise, it will just not be understandable because of the way listeners use radio. For television, viewers may sit and stare blankly at the screen without paying attention, but they're pretending to watch. In radio, listeners are waking up, showing, driving, or getting the kids dressed. Reporters cannot present certain kinds of information. For example, charts are wonderful, but they have the sort of information that radio cannot present clearly. Some creative individuals in the world of radio have done wonderful things. An economics reporter once tried to explain interest rates for NPR by staging an opera on *All Things Considered*. Robert Krulwich now works for ABC News, where he tried to explain chaos theory on *Nightline* by using the scene of robotically controlled penguins in the movie *Batman Returns* (1992). He is one of the most creative journalists in America. If a story requires a quick turnaround to get it on that afternoon for *All Things Considered*, certain types of stories cannot get told or can so be told only vaguely.

I appreciate Todd Mundt's point that public broadcasting is one of the last places to hear certain types of stories told. Ira Glass, the host of *This American Life*, says that the best thing radio can do is build empathy with others. His program tries to empathize with each character. Listeners may not like the person, but at least they are empathizing by the end of the show or the interview. When I'm not hosting *All Things Considered* and trying just to report what sentence stumbled out of Mayor Daley's mouth that day, I can try to tell a story that will make listeners empathize with others. I don't cover many stories about gay and lesbian issues, but, in religion, media, or even disability stories, the best thing I can do in my medium is not try to import facts. Radio is terrible for that. What I can do is help a listener understand something about another person, empathize with that person, and understand that person as less unlike and more like oneself than one had thought. At the end of the day, the final goal of public radio has never been to make it all make sense and has only partly been to try to inform. The original mission statement aimed for something else: to enlighten and to inspire the public.

DEBORAH KADIN

A challenge for me has been covering LGBT issues in Republican-land. As the only person in the newsroom who was out, especially during the six or seven months after

I started at the *Daily Herald*, I found it a challenge to cover anything at all related to what gays experience. There are a number of reasons for the difficulty, but one is visibility. In the suburbs, unlike the city of Chicago, invisibility is the real issue. Invisibility makes it a problem, for instance, to find couples who are either talking about marriage or dealing with discrimination in the schools. The gay and lesbian couples I have interviewed for stories are reluctant to have their names in print. They want their names changed, want to use only first names, or want to avoid any kind of identification at all beyond, say, just their initials. Part of the problem is the fear of backlash, a point I will return to later.

Most Americans have heard of conservative Orange County, California. I'm from Orange County, and so I can say something about it. At least when I knew the place, it was Republican and extremely conservative, with a strong, fundamentalist Christian bent that was local in origin and focus. I imagine fewer Americans know anything about politics in DuPage County, Illinois, but it is also relatively conservative. It reminds me of Orange County, primarily in communities like Wheaton. The town is home to Wheaton College, which recently made news when it voted to allow dancing at school socials. Imagine having to cover a community where many ultraconservative, fundamentalist Christians live.

One of the campaigns I had to cover when working for the *Herald* was the 2000 reelection bid of Republican Representative Henry Hyde, who served the Illinois Sixth District for more than thirty years and became notorious for having an affair revealed while he chaired the committee that voted to impeach President Bill Clinton. As a reporter, I may not want to ask some questions, but I have to ask them. The Hyde campaign was tough to cover, primarily because I am pro-choice, and everyone knows where Henry Hyde stood on the issue. The campaign also followed Bill Clinton's impeachment, which was another an issue I had to cover. Writing about it made me uncomfortable, because, even though for many reasons I think that Clinton did a good job as president, I wish he had kept his fly zipped up. Covering the Hyde campaign challenged my commitment as a journalist to be unbiased. Coverage without fear or favor is the basis for the credibility of journalists. The more impartial we become, the more credible we are going to be. Even when I do stories I want to do, readers should be able to see my byline (I do believe they look at bylines) and say, "She really can cover the story."

Reporting on ultraconservative Republicans and working in a suburban area like DuPage County was a real eye opener. Imagine covering, for example, the National Day of Silence in some of the high schools in the county or reporting on stories such as bullying in the schools. Persuading sources to come forward to talk about their experiences is tough. The process is more complex in the suburbs, and my beat went beyond schools and municipal governments to include everything from park districts and libraries to features on religion. Walking the line between being an advocate and being

objective is especially hard when writing about issues one cares about, not just LGBT topics, but everything from deer culling to breast cancer. I had editors who were good about taking a step back, reading my stories and saying, "You're advocating here."

Readers will know how a reporter feels about issue based on the choice of stories and the depth of the writing. I wrote a story a few years ago on welcoming and affirming churches in DuPage County. It ran the day of the pride parade, and a number phone calls came in asking why I decided to write the story then: "Why is it coming out now?" I said that pride week was an important time for readers to understand the complexities for gays and lesbians who live a religious life in DuPage County. Some callers understood, but others said, "There really is no issue to cover," and I replied, "Well, there really is." Without arguing on the phone, I was able to turn them over to supportive editors, who knew how to handle any problems. I cannot begin to describe how tricky it is, and that was one reason I decided to leave mainstream journalism. There is a fine line between being a reporter and being an advocate, and political involvement, such as working on a campaign, crosses that line.

I want to leave you with one story about a person I know best: myself. I wrote my story about coming out, and it was, for a lot of readers, an eye-opening experience when it ran in the newspaper. I approached the feature staff with the idea, because I was fifty years old when I came out, and it was a tough decision for me. I imagine anybody, anybody at all, has a hard time making a decision like that, and I wanted to write a piece to educate readers, so that they would realize that members of the LGBT community are just like everyone else. Telling the truth and standing up for oneself, no matter who that may be, makes a difference. Writing the story changed my life, and I think it changed the lives of others as well. What I found enlightening was receiving e-mail messages from attorneys I had worked with or had known while covering news events. One said, "I read your story, and I actually cried." This came from a man in his mid-forties, a conservative Republican. The message could not have been more genuine if it had arrived with tear stains on the e-mail window. I want to emphasize that this new understanding grew from the text of a suburban newspaper. I also learned that, like many sources I interviewed, I was afraid of backlash. I was relieved to learn that readers were not going to threaten me.

I read both of the gay Chicago newspapers almost every week and use them as a source of information. When generating story ideas for a mainstream newspaper, I turned to publications like the *New York Times* and the *Chicago Tribune* or listened to NPR to see what they were writing about, particularly on issues involving the LGBT community, such as the elevation of Gene Robinson of New Hampshire, who become the first gay head of an Episcopal diocese. After getting a sense of how they handled a topic, I would then try to come up with a different angle. If something came up in a national report in the morning, I could look for a local angle. As a reporter, I would try to make sense of a particular issue or story

for readers in the local area. The idea was not to reinvent the wheel. Newspapers do a reasonably good job of covering LGBT news, considering how far the community has come.

The National Lesbian and Gay Journalists Association (NLGJA), an organization I was proud serve as chapter president, has worked hard behind the scenes to change journalists' attitudes about LGBT issues and lives. One key is fair and accurate reporting, making sure that language is precise and evenhanded. For example, using the term *gay marriage* is vague and unbalanced compared to the phrase *marriage of gays and lesbians*. Why single out *gay marriage?* No one says *straight* marriage. The term would suggest something strange or different from just plain *marriage*. The right thing to do is to call the event what it is: marriage of gays or marriage of lesbians. Another key is openness. Journalists need to talk about things like hate crimes, rather than hide or ignore attacks against gays. The NLGJA encourages reporters to talk about these issues out in the open. Our chapter put a toolbox on its web site that gives reporters and editors a picture of how to cover LGBT issues well.

The group has also worked to diminish workplace discrimination. About six months after I started at the *Daily Herald*, I proposed that the company provide domestic partner benefits. I never thought I would see the day when one of the most conservative newspapers in Illinois, if not in the Midwest, decided to offer benefits. I nearly fell on the floor when they not only did that, but also established a nondiscrimination hiring policy, as well as said that workplace harassment of gays and lesbians would not be tolerated. The *Herald* is not the only media organization that has fought workplace discrimination. Besides, of course, the *San Francisco Chronicle*, the *Chicago Tribune*, the *New York Times*, CNN, the Associated Press, and the *Los Angeles Times* are just a few in the industry that offer some form of domestic partner benefits and discrimination protections.

Those of us in the media have worked hard to build credibility and to move from invisibility. One thing that I am proud of is having urged my straight colleagues to become a little more sensitive about LGBT life and issues. Eventually, I began to get either e-mail messages or telephone calls from colleagues saying, "Tell me a little bit about this," "Tell me about what's going on," or "Tell me how I can cover this topic a little bit differently." Sometimes, they would send copies of their stories for me to read, just to be sure they got it right. I was not the only one doing this sort of work; dozens of colleagues in the mainstream press do the same. We have made strides in helping straight reporters and straight editors understand what the LGBT community is about and what the issues are. There is also recruiting going on for LGBT journalists. I have seen dozens of places look for resumes and read clips from LGBT reporters. They want lesbian and gay reporters on the staff so that they can cover these issues better. There is much to do, but we have already come a long way in the coverage of the LGBT community. Once my straight colleagues understand the value

of having LGBT reporters on staff, the result will be not just more visibility but also more accurate and fair news and more public understanding.

ELLEN MEYERS

Coming out is a political act, and the power of being out is just one part of gay identity. Coming out is also a lifetime experience, an ongoing process that never finishes. When I had my first job as liaison for lesbian and gay issues at the Office of the Cook County State's Attorney, I was an out lesbian in law enforcement. I was working in government and working for a Republican, and that just blew my parents' minds. One day, as I came to sign in at work—every day we would sign in—the office manager, a grandmother several times over, said to me, "Ellen, what did you do this weekend?" I said, "Annette, I lived the lesbian lifestyle." Everybody in the office had to check in and had moved forward to do that, and so their ears were ready to hear all about living the lesbian lifestyle. I proceeded to say things like, "Well, I did my laundry, and, after the laundry got done, well, then the cat was sick, and so I had to take her to the vet," and so on. After this mundane recital, she said to me, "Ellen, you're just like I am," and I said, "Absolutely right." That was a coming out moment.

My philosophy has always been co-opt to convert. *To co-opt* means to take things for one's own use or win others over by joining them. As my example shows, I worked to co-opt an everyday process—signing in—to make it belong to my community. That's my way of doing things. In the arena of the workplace, I have worked within the system. By co-opting, I can then move forward to change things.

Sometimes you have to know what you're getting into before you begin. I work in government, but I always feel a moral obligation to assist members of the LGBT community. I never turn my back on my community and never compromise myself or my job, and so there is always that tension for me in the workplace. Fortunately, I work with someone who has been an advocate of lesbian and gay civil rights since 1974. I'm not compromising myself by working for a cretin, because I work with someone who is progressive, and that's helpful to me. But, in the workplace, one must also be seen not only as a lesbian, gay, bisexual, or transgender person. That identity is one part of us. We also must be seen as being effective, able to do a job.

LGBT employee groups have historically worked to set nondiscrimination policies within their places of work. With those established, most groups have moved on to domestic partner policies, before expanding to larger issues. In Illinois, we worked to encourage corporations to come forward in support of either local initiatives in the municipality of their headquarters or civil rights issues that affect everyone in the state. We have used academic studies, such as a poll conducted at the University of Illinois at Springfield. The researchers took a sample across the

state and broke down the results by regions, to examine attitudes toward LGBT civil rights. Their findings helped tremendously, especially with legislators who would say, "Nobody cares about that issue in my district," "Nobody is interested in this issue in my district," or "Everybody in my district wants me to vote no on this issue." Showing them academic statistics pushed them into a corner. We couldn't change everyone's vote, because another excuse always exists for bigotry and homophobia, but we did change some minds.

The image of the LGBT community is evolving. I remember sitting in a theater at Water Tower Place in the 1980s, cringing as I watched the film, Personal Best, because I was so desperate to see a lesbian image. There was Mariel Hemingway, running, and I thought it was just great! Of course, she does go back to a man, and so that particular film was an easy sell to the mainstream. Since then, LGBT images in the media have changed. What transformed things? I would suggest that efforts on workplace and equal rights issues have pushed the transformation. Now more than ever, LGBT communities have integrated into mainstream life. Co-opting the mainstream, instead of capitulating (as that film did), changes things. Domestic partnership laws and corporate programs have an effect, because a discrimination-free workplace is a productive workplace. Coming out moves an individual beyond stereotypes, so that we can define ourselves. No community is monolithic or static. We are moving.

LAURA KIPNIS

The question of media access can't really be disentangled from questions of form and style. This probably sounds obvious, but I've found it to be a complicated issue in practice, and one that occupies my attention a fair amount these days, because when you attempt to write for larger audiences than an academic one alone—the choice I've increasingly made—you quickly realize (or you'll quickly be informed) that you have to leave certain academic stylistic tendencies behind: the in-group jargon, the reassuring presumption that your audience will pick up your subtle references to Foucault and Butler and grasp the minute yet cataclysmic distinctions between your position and theirs, or will even recognize what you think of as utterly commonplace terms like *queer theory*. Of course, form and style can't be disentangled from the political either: For instance, in choosing to write for a larger audience, to what extent are you compelled to soft-peddle any non-mainstream political positions you may hold, and is it worth it? Are you fatally politically compromised from the outset: Is it simply the case that the larger the audience you're granted access to, the more political limitations on what you're allowed to say? In other words, can you only say hard-hitting, politically left, or queer and contestatory things to the numerically limited audience of those who already agree with you?

In my own experience, nothing is so clear-cut or determined in advance about any of this: Each piece of writing is its own battlefield. Every writer has to figure out how to negotiate the process and what kinds of compromises she can tolerate. What I think of as being canny you may think of as being a media whore. On which charge, okay, I admit to an unseemly degree of flattery when earlier this year the *New York Times* invited me to do an op-ed piece on the Bush administration's plan to spend $1.5 billion on an initiative to peddle "healthy" marriage to low-income groups. In case you've forgotten or blocked it from memory, this was a harebrained scheme cooked up by conservative groups in conjunction with administration officials, none of whom could figure out why—since heterosexual marriage is "one of the most fundamental, enduring institutions of our civilization," as they like to put it—so many of the heterosexuals who are supposedly its beneficiaries seem to be fleeing it in droves. Conservatives are getting a little *panicked* that this "enduring institution" may prove not to be as enduring as they'd assumed.

Since I'd written about the politics of marriage in a fairly contrarian fashion in my last book, *Against Love*, dropping names like Marx and describing modern marriage as a factory for social compliance, presumably, the op-ed page editors knew what they were getting into. But the reality of the situation is that even if you're solicited to write one of these things, you're doing it on spec; if you want it to run, they're calling the shots. There are certain rules you have to play by, both overt ones (the space you're allowed, not making unsubstantiated assertions or ad hominems), as well as numerous unstated ones (how sarcastic you're allowed to be, how politically left wing). The unstated constraints you find out after you've drafted the piece and enter into negotiations with the editor you've been assigned, negotiations which can include protracted discussions about the implications of a single word and a fair amount of horse-trading (I'll lose this if I can keep that). If you want this prime real estate, and access to those readers, you become involved in a collaboration.

What's complicated in this, I began to realize, is the task of factually justifying your deeply held political assumptions, exactly the ones that everyone at every academic conference I've ever been to would nod knowingly about—you know: the essential evil of the current administration, the smugness of the religious right, and so on. Everything *we* all know to be true about the world somehow isn't quite as taken for granted by the editors at the *Times*, or, according to them, by their readership either. But still, it's not exactly that you have to cater to their political views. What you have to be able to do is make a good enough argument to pass their credibility test and be able to do it efficiently and elegantly. You don't get all the words in the world, another way this differs from academic prose. Which brings us back to form and style.

In this case, I found out I could be relatively hard hitting about class issues, as long as I could back up assertions with documented facts (of the sort that would

withstand maniacally anal fact checking). But I ended up having to cut an argument I'd made about the backdoor racism of the marriage initiative; the reasons were both irritating and interesting. First, the question of form came into play. As I learned, the rule of op-ed form is that an opinion piece focuses on one main idea, and race was considered to be one idea too many. I, of course, argued that race and class are inseparable in contemporary American and even presented statistics about the racial breakdown of unwed mothers, who were targeted by this initiative. I think I could have won this argument on political grounds but ended up losing on the style-form side (well, ostensibly): The editor argued that the race argument watered down the piece and detracted from my main point about class. Of course, this was itself a crypto-political argument, an instance in which form and politics are wedded, so to speak.

Essentially, this is the political premise that underwrites all mainstream American journalism—well, it underwrites liberalism generally. It's a political understanding of the world that's fundamentally opposed to the premise of a social totality that I was implicitly arguing, in which (to put it inelegantly) state power is deployed by the class in power to reproduce existing social relations. This last thing is precisely the kind of point you'd have little success getting into the *Times:* How would you get it past the fact checkers? How could you back up this argument in twelve hundred words: Marx took three volumes. So in my case, I settled for a few sarcastic remarks (Where were the initiatives devoted to rehabilitating all the millionaires in failing marriages or fleeing commitment?) and gave in on a few others ("You'll lose the readers," I was told—this probably wasn't wrong). I was also informed at the eleventh hour that the word *irony* isn't in the *Times* style manual and thus can't be used in its pages unless you're referring to classical Greek theater or Aristotle. Are you aware that there aren't any adequate synonyms for irony? I lost a good point for lack of a synonym.

I could have pulled the piece rather than compromise, of course; I could have stomped off and resubmitted it to a more like-minded publication like *The Nation*, where it would be read by an audience who'd probably concur with every word and who fully understand that race and class aren't separate issues, where you don't fact-check the existence of structural racism, and where the use of the word *irony* is permissible. Instead, I let it run, in as strongly worded and argued a version as I could get past the editors. (I also managed to elicit a promise that nothing would be changed without my approval before it went to press, which wasn't the case in my last experience with the *Times*—that was at the magazine.)

Here's an admission. At some point in the editorial process, I realized that it was probably advantageous to try to be reasonable: to pick my battles, not to be too rigid or too precious about the prose, because I wanted the piece to run. And also I figured that if I had something to say on a national issue in the future, if I didn't

piss off the editors too much, I'd have a better chance of having my phone calls returned. On their side, they ran it on a Sunday, let it run at a decent length, commissioned a cute drawing for it, and let the mocking tone stand. I got some laudatory emails from those who already agreed with the argument, some negative mail from those who didn't, and a few hate letters. At least I'd managed to ruffle some feathers. So there you have it: a combination of pragmatism, self-censorship, writerly narcissism, and, last but not least, getting to vent about the political affronts of the Bush administration in a national venue.

Obviously, not everyone would be willing to make the same compromises I did. I'm not trying to justify them. It's just that for me, at a certain point, it started to seem too comfortable and too comforting—too *easy*—to keep on writing only for academics on the cultural left, that is, for an audience of people essentially like me, who would nod their heads knowingly at phrases like *social totality*. Still, moving between these worlds isn't an entirely graceful activity, at least I haven't figured out how to do it gracefully yet. Though maybe when you manage it too easily, it's time to worry.

REFERENCES

DeRose, Jason. 2004. "*Killing the Buddha.*" *Eight Forty-Eight*, 91.5 WBEZ Chicago, February 6. Available at http://www.wbez.org/audio_library/ram_2004/848/848_040206b.ram. Rebroadcast as "Killing the Buddha: Promoting Religious Inquiry." *Morning Edition*, NPR, 23 March 2004. Available at http://www.npr.org/templates/story/story.php?storyId=1785326.

Kimmel, Haven. 2003. *The Solace of Leaving Early*. New York: Anchor.

Sharlet, Jeff, and Peter Manseau. 2004. *Killing the Buddha: A Heretics Bible*. New York: Free Press.

Part III
Radical Decoder Rings

Queer Change Agents

JAIME HOVEY

Every Sunday night in January and February for the past three years, lesbians have been coming to my house to watch television. What once was a mere one or two friends coming over to see the HBO production of *Angels in America* or the last season of *Sex in the City* has escalated into a weekly party in my living room. Somewhere between eight and nine o'clock on a school night, friends I've known for years, new acquaintances, casual contacts from my girlfriend's work, and others we know from our local queer gym show up at my door, some of them bringing new friends I'm meeting for the first time. I would like to believe that my sudden abundance of community—and it is community—has to do with my warm personality finally connecting with other kindred spirits after six lonely years in Chicago, but I know the real reason has more to do with my thirty-six-inch flat-screen television, my subscription to digital cable premium channels, my preference for real popcorn made with plenty of real butter, and the development by Showtime of a series about lesbian life and love in Los Angeles called *The L Word*. Every week, we watch the show at a fevered pitch of excitement. We shout advice to the characters, we hoot at the sex scenes, we pan the cheesy dialogue, we cheer and boo infidelity, we feel awe when lovers make up and make out, we analyze relationships, and we predict future relationship developments. Because of this lesbian soap opera, I have a wide circle of lesbian friends and acquaintances that continues to grow. I hear about more lesbian events than I did before I knew these visitors, and I recognize more and more faces when I go to the events.

My example illustrates how queer representation helps construct visibility and intelligibility within queer communities, as well as outside of them, and suggests that queer representation continues to resonate as something exciting and important to queers. Long after the 1980s and 1990s conversations that framed media representation of lesbians and gay men (and almost never transgender individuals) as either positive or negative stereotyping, on the one hand, or as out-loud-and-proud visibility, on the other, queer shows and networks continue to tell us how we are seen, which of us are not seen or not considered to be worthy of representation, how we see ourselves, and how marginal we still are—or aren't—to mainstream culture. *The L Word* has caused excitement not only in my life, but in the lives of lesbians across the United States. Dyke bars screen the show and end up jam-packed with women. In these bars, the enthusiasm of the crowd is so loud that closed captioning is the only way viewers can follow the plot.

This enthusiasm continues although most of us have gotten used to a certain level of queer representation on television and in the movies. Most of us have forgotten a time when Ellen wasn't out. We have grown weary of the once cutting-edge *Will & Grace* in its tired hetero pairings of gay men with straight women. The explicit man-on-man action of *Queer as Folk* now seems quaint in its deliberate outrageousness. And even straight viewers know on some level that the Queer Eye that poses as new as it dresses and designs for Straight Guys has been looking awry for decades, if not centuries. Yet, somehow, dykes still go gaga about a premium cable drama set in Hollywood, a weekly series filled with impossibly thin, plastic-surgery gorgeous, unbelievably well-off, mostly white, lipstick lesbians. I can't remember such excitement among so many women, a feeling so big and so palpable that it feels, oddly enough, political.

How could it feel so important? Why does this importance seem political? To open this section, I want to ask a question that any one of the chapters addresses in different ways, namely, Why does mainstream media representation mean so much to queers? The excitement may mean something about politics, community, and representation, or perhaps we are merely responding to the happy opportunity to consume a palatable version of ourselves as thinner, prettier, whiter, younger, richer, more pleasure-seeking, and less apathetic than we really are.

To make connections, I want to review how each of the chapters makes its argument. Gavin Jack argues that the invisibility of male sex workers reflects whorephobia and that this invisibility needs to be remedied so that life will improve for them. His chapter, "A Case of Whorephobia?," argues, via Foucault, that more talk does not necessarily mean more truth, but that more talk nevertheless needs to happen, in the interest of visibility, even if such representations reflect and proliferate negative stereotypes.

Marguerite Moritz argues that the framing of news stories reflects and follows changes in mainstream cultural acceptance of gays and lesbians but also produces

and accelerates those changes at the same time. Her chapter, "Say I Do: Gay Weddings in Mainstream Media," complicates the argument that the media reflect how individuals lead their lives by emphasizing the influence of framing. Media frames contextualize information, play on audience prejudices, and tell readers what to think. The essay suggests that Foucault's notion of sexuality is something produced at the very moment of its management and regulation but goes beyond Foucault's binary of speaking silence to emphasize that the way something is said is as crucial, or more crucial, than the thing itself.

Finally, Lisa Henderson, in her chapter, "Queer Visibility and Social Class," argues that, although commercial popular culture compresses and homogenizes the class spectrum, erasing the poor as well as the rich and powerful as it spins its fantasies of middle-class opulence, these fantasies remain popular because they speak to values of social belonging, normativity, and virtue common to queer and straight audiences alike. Although comportment, family, and modes of acquisition come to signify queer worth in the popular media, other class meanings and values also become visible in the process, helping to *queer* class itself, as well as to represent queers by means of class markers.

Aside from Foucault, all three chapters share a belief that queer representation—whether in a marriage announcement, a narrative of male prostitution, or the articulation of queer identity as class aspiration—is a powerful agent of change. The chapters in this section also agree, for the most part, that visibility can have positive as well as negative effects. Queers know what visibility is when we see it and know that the more we are visible, the more society is changing and will change, although not all queers agree that these changes are necessarily good, or even political. "A Case of Whorephobia?" suggests a model of visibility where discursive representation might lead to political representation. "Say I Do: Gay Weddings in Mainstream Media" suggests that politics follows visibility, that visibility produces politics as a reflection of the ways individuals lead their lives. "Queer Visibility and Social Class" argues that queer representation actually changes the terms for circulating and understanding class, although it mostly pulls queer life toward middle-class, normative aspirations.

To some degree, the authors suggest that something from real queer culture gives the representation of queers an essential quality, even if that quality is a reflection of the culture, is made by the culture, and is given back to the culture as a truth about its real self, although queers may not recognize it at the time. Eventually, these arguments suggest in different ways that queer culture will recognize its real self, and then change will happen. Do these arguments mean that lesbians are keen on *The L Word* because it represents what has lacked adequate representation before? Do we believe, now that we have represented lesbian lives, even narrowly, that the lives of real lesbians will get better? What about our misrecognition of our real selves?

Are we happy, as Henderson suggests we might be, to be called out as consumers of idealized images of ourselves, and do such images insert us into mainstream culture, if only in fantasy, in a way we long to see?

If all representations are, to some extent, narrative fictions, what political value might visibility actually have? What can it bring into being? What about the negative aspects of visibility? How do you understand the ways visibility produces the right impression? The wrong impression? How do we determine which phenomenon needs representing in the first place? How do we account for what audiences do with text, other than identification? Clearly, these texts become things that allow community to constitute itself around them. Although such communities seem to take primary interest in directly consuming and responding to these texts, the public act of consumption, in large groups rather than alone in the house, seems to be about something else as well. Henderson suggests that this something else might be the class project of queer visibility, where, as in the instance of wedding announcements in the *New York Times*, "good citizenship and happiness by national standards," must balance against "the compression of possibility and the misrecognition of other cultural equations and the persons who live them" (see Chapter 10, pp. 197–216). Jack and Moritz suggest more transformative possibilities, where new identities and communities come into being in the moment of representation. All three chapters agree that no matter what you decide about *The L Word* and other queer representations circulating in the popular media, they continue to serve as a social and political mirror whose recognized and misrecognized images are important to mainstream and queer cultures alike.

A Case
of Whorephobia?

GAVIN JACK

The media have neglected a queer issue: male sex work. Deploying a framework from Foucault, this chapter draws upon a range of media reports and interviews to describe conditions of male sex work and to explain the implications of its invisibility. What causes the fucking invisibility of male sex workers? Addressing the question exposes complex gendered and sexual relationships among patriarchy, heterosexism, and homophobia, all of which the media regulate through talk and through silence. The chapter explores the potential consequences for the political and media agendas of sex work groups.

As often noted, recent times have seen marked progress in the visibility of gays and lesbians in the media and in public life. The typical evidence refers with approval to gay visibility in an increasing number of popular cultural forms, notably film (Seidman 2002) and television. Many commentators read visibility as proof that "the war for acceptance is practically won" (Jesse Green, quoted in Seidman 2002, 2) and that different sexualities have achieved a certain equality. Such claims assume that greater talk about queer lives in the media necessarily amounts to progress in the political struggle for sexual recognition. The point of departure for this chapter is to question claims that visibility achieves practical equality and that a more talkative media is necessarily more progressive. Such claims seem optimistic and may too easily ignore the kinds of invisibility that are a necessary counter product of carefully manufactured visibility. Male sex workers and male sex work occupy one area of queer life that a shiny, happy media-scape has made invisible. If the neglect of

male sex work in contemporary media coverage of sex, sexuality, and prostitution is willful, what might lie behind such a strategy?

Perhaps media neglect presents yet another case of whorephobia, as part of the duplicitous relationship that many Western cultures have with the cultural figure of the whore. Does the neglect result from a fear and profound misunderstanding of all sex workers, male and female, as a social and occupational group? Or does a group view cover a set of important gender-based differences in the meanings and experiences of sex work? And what about the role of homophobia? Is this not a simpler problem, a fear of the potential for pleasurable same-sex intimacy? The answers to these questions and their interrelationships have implications for the sex work community as a whole. What's the problem? That ostensibly simple question generates some complex and contradictory answers at the interstices of gendered and sexualized social, economic, and cultural forms.

THEORY

This chapter follows a constructionist framework. The media actively constitute their subjects of investigation and, in the process, produce and regulate particular understandings of social issues and associated identity politics. They legitimate *certain* versions of social groups and their problems and subordinate and render invisible others. Yves Patte (2003) investigated the role of the media in producing and regulating social issues, as much as reflecting them, in his analysis of the recent media debates that took place in Belgium over proposed changes to the prostitution laws. He describes *mediatized space* as a key site for ideological struggle between the different groups that had a stake in the representation of (mainly female) prostitutes. Between advocates for prostitutes and journalists, he describes how a particular kind of struggle unfolded, with,

> on the one hand, social actors looking to the media for a certain recognition, a visibility, a legitimation, and on the other, journalists looking to deliver consumable media products for a predetermined audience. (Patte 2003, 125, translated from the French by the author)

Patte says that these competing agendas became most apparent around the issue of how the media portray prostitutes. Belgian journalists, for the most part, chose the predictable, narrow route of presenting prostitutes either as victims or as fallen women, options that caused much frustration and anger, as well as a sense of deception, among prostitutes and their organizations. Patte argues that the choice of a one-dimensional view of prostitutes in the Belgian media results from a working assumption journalists employ. Their perception of what is "legitimate to think in

a given society" (Patte 2003, 126) determines what counts as a consumable media product. The predetermined notion of the audience, of an exterior other and its legitimate knowledges, according to Patte, is a cultural structure. The imaginary audience and its imagined sensibilities play a key role in filtering the representation of social problems. This structure is the central issue that prostitute organizations must address to pursue a political agenda that would legitimate their work and their identities.

I would like to develop Patte's critical, cultural view of the media and society by drawing upon the work of Michel Foucault from his introductory volume to *The History of Sexuality* (1978). Contemporary concerns with media representations of male sex work have cultural and institutional precursors that require an understanding that springs from a wider history of sexuality. Foucault's main object of criticism in his first volume is the *repressive hypothesis* about the history of sexuality. The hypothesis asserts that the moderns, and Victorians in particular, viewed sex as a taboo subject that one must hide and subject to silence. The Victorians repressed sex, making it part of private, and not public, life. They practiced but did not talk about sex, because talk would have offended the social conventions and petty prejudices of bourgeois morality.

Foucault argues that the repressive hypothesis presents a misleading picture of sex and sexuality in the period. For him, Victorian times did not witness decreasing talk about sex but a proliferation of discourses about the subject. Increasing talk brought into existence a number of different sexualities. He argues that the discursive explosion formed part of an emergent Western *scientia sexualis* that provided a grammar for speaking about, defining, and regulating the legitimate boundaries of sex and sexuality. Allan Sheridan defines the discourse of *scientia sexualis* as a set of "procedures for telling the truth about sex that are based on a form of power-knowledge" (1980, 176), an explanation that points to the close connections between talk, truth, sex, and power.

Foucault's critique teaches some important lessons. As for truth telling, first, talk deserves mistrust, and the intensified talk that he identifies in Victorian society should come under some suspicion. The discursive incitement to sex represents a will to knowledge among social actors, a desire that, despite claiming to have found and made visible the truth of sex, also marginalizes a range of sexualities (such as homosexuality). The problem with all this sex talk, then, is that it often serves to render invisible the thing it claims to bring to light: sex itself. *Scientia sexualis* never fully tells the truth but banishes it to the shadow lands.

In the context of the talkative media, Foucault's historical analysis has implications for truth telling about sex and sexuality: One cannot trust it. More talk does not mean more truth. The power of media discourse to enable and constrain particular social experiences (sexuality, in this case) signals the irony at play in power relations. Besides viewing talk as suspicious and as a product of the knowledge-power nexus, this essay follows Foucault to understand the power effects of the media.

To study the subject of the media and male sex work, I first collected media texts (newspaper and magazine articles, for example, and television programs) that talked about and represented male sex work. My interest was to gain an understanding of how the media in the United Kingdom talk about male (and female) sex work and to identify any contentious issues. Next, I gathered accounts of the first-hand experiences of individuals with government agencies and other organizations that represent the interests of sex workers (male and female) in dealing with the media. My aim was to gain a sense of how the politics of representation took form in social interactions between the media and the mediated. By broadening the scope of analysis beyond textual analysis and toward experiential accounts, I gained access to three aspects of the discourse: talk in the media (the presentations of media texts), talk about the media (general perceptions about the representation of sex work issues), and talk with the media (sex worker advocates on their contact with the media).

JUST WHAT IS THE PROBLEM?

To discover whether to attribute the invisibility of male sex work to a wider problem of whorephobia in the media and society, the remainder of this chapter presents different versions of the problem that, together, paint a complex picture in response to this simple question. There is no single or correct answer to explain the neglect of male sex work in the media. The problem has many interconnecting layers that cut across the identity politics associated with male sex work, as well as the working practices and assumptions of the media and of sex work groups. Any simple explanation of the problem throws up many more questions than answers.

THE PROBLEM IS . . . THE INVISIBILITY
OF ALL FORMS OF SEX WORK

To begin, one might consider the neglect of male sex work part of the invisibility that all forms of prostitution—male, female, or transgender—suffer in the media. A number of respondents expressed this view, including Joanna Brewis, an academic researcher from the United Kingdom, who told me that "the problem is the visibility of all prostitution, full stop" (2004). As our discussion went on to reveal, settling for this explanation not only decides too much in advance, but also presents prostitution as monolithic. Such a view is a problem because prostitutes are a heterogeneous group (Browne & Minichiello 1995; Cameron, Collins & Thew 1999; Hickson et al. 1994; West & de Villiers 1993), whose relations toward themselves, each other, and their clients are complex and cut across gender, sexuality, ethnicity,

and socioeconomic position, among other divisions. Despite the attempts of sex worker organizations to raise media awareness of the complex lives and problems of prostitutes, the media in the United Kingdom (and elsewhere) continue to perpetuate negative, one-dimensional, and uncomplicated views of prostitutes. As Hilary Kinnell of the U.K. Network of Sex Work Projects (U.K. NSWP) says, "The media don't do subtle" (2004).

Even so, scratching away at the surface of the facile media treatment of prostitution does hint at some other explanations for why the media neglect male sex work. The first of these explanations relates to the myth that only women do sex work and presents a distinctly gendered version of the problem.

THE PROBLEM IS . . . THE MYTH
THAT ONLY WOMEN ARE SEX WORKERS

Media coverage is not alone in peddling the myth that only women fill the ranks of sex workers. The assumption guides much (naïve) academic research as well, as one contestable definition of prostitution demonstrates: "low-skill, labor intensive, female, and well paid" (Edlund & Korn 2002, 181). An attempt to understand why female rather than male sex work has received most of the limited media interest leads into a number of important debates about how the media regulate the intertwined structures of patriarchy, heterosexism, and homophobia. One can begin with the argument that Julie Cwikel, an academic researcher from Israel, made in an e-mail exchange with me: "Due to the fact that most commercial sex workers are women, women tend to get more media coverage" (2004).

Given the attitudes toward the activity, an accurate number of sex workers (whether male or female) who ply their trade at any time is difficult to obtain (Cameron, Collins & Thew 1999). Hilary Kinnell estimated that sex work by gender breaks down roughly to 85 percent female, 10 percent male, and 5 percent transsexual. In my interview with her, she did emphasize that these approximate figures indicate the greater percentage of women compared to men in the sex labor market (although perhaps the percentage for transgender prostitution is a little high, she surmised) (2004).

Although such arithmetic does offer an important explanation for the lack of media coverage of male sex work, there are broader cultural and historical issues to consider. A fruitful view sees the greater visibility of female to male sex work as a cultural and institutional outcome in the history of sexuality (in a Foucauldian sense). Through that history, the discursive structures of patriarchy and the heterosexual matrix have regulated the female body. Here, one can read the differential treatment of male and female sex workers as a reflection of the differential treatment

of men and women by the emergent institutional and cultural structures of Western society (part of the *scientia sexualis*).

Representations of female prostitution in U.K. media coverage provide an access point for understanding these structural issues. Recent representations of female prostitution have taken place in three key contexts. The first is the issue of tolerance zones where street workers can ply their trade in a safer, more monitored way. Second is the perennial discussion about decriminalizing activities associated with prostitution and recognizing sex work as a legitimate, legal occupation. Third is the discourse about illegal trafficking of women and children brought into the United Kingdom for purposes of sexual servitude. All three discursive contexts have ruled out male sex workers.

The reasons for the exclusion of male sex workers from these recent debates, I would suggest, result from differences in the practice of male and female sex work. Only a small and ever decreasing percentage of men compared to women do street work (Gaffney & Beverley 2001), and, when they do, they occupy spaces (the usual cruising spots, public parks, and so forth) different from those that women frequent. As Hilary Kinnell informed me, they will rarely "share the same patch" (2004). Because of this difference, tolerance zones are less important for the male sex work community, and the media cover male prostitutes less in accounts of the subject. The story is similar for trafficking. Traffickers mainly bring women, boys, and girls into the United Kingdom for prostitution. There is not the same demand for trafficking men, again leaving them out of the media picture.

There is a wider point to make about the differential institutional arrangements for male and female sex workers. In the three discursive contexts mentioned earlier, a complex interplay takes place among different institutions, including the British government, the media, social services, the National Health Service, female sex work organizations and support groups, trade unions, the United Nations, and academics, among others. The debates on female sex work are taking place within a complex but well-developed institutional framework. Such a framework does not exist in the same way for male sex workers. The relative lack of support services for male sex workers compared to female sex workers has made this fact obvious. The Irish group of the European Network Male Prostitution (ENMP) also makes the point clear:

> Experience shows that specific service provision for male sex workers is the exception rather than the rule. Many services have contact with male sex workers, but many do not recognize their specific needs or even acknowledge their identity as sex workers. The perceived small number of boys and young men, selling sex to men, and the taboos on male sex work, combined with the difficulties to receive funding, discourage agencies from developing specific services in this field. Therefore, agencies need to be informed in order to become more aware of the needs of male sex workers, who might use their services as well. (Irish Network Male Prostitution 2001, 4)

The greater media coverage of female sex work reflects a more developed institutional structure that emerged over time for the surveillance and regulation of the female (prostitute's) body. The theme of the intense regulation of the female body plays a key part in Foucault's history of sexuality. The regulation and surveillance of the female body have consequences for sex workers. On one hand, greater visibility for female sex workers yields a greater awareness of their needs, a fact that translates into better institutional support (from cooperatives, self-help groups, medical services, drop-in centers, legal advice, to trade unions and the like). On the other hand, visibility raises questions about how much control women enjoy over their own bodies and their own sexualities. Feminist scholars Justin Gaffney and Kate Beverley sum up this contradiction and its implications for male sex workers:

> paradoxically and contextually, malestream legal regulation in itself creates a certain sense of "visibility" for women prostitutes. This is not shared by male sex industry workers, who remain largely invisible within U.K. malestream heterosexist society. (2001, 134)

At the institutional level, female and male sex workers enjoy a different visibility that reflects their fate in the historical writing of sexuality. The irony is that patriarchy may have contributed visibility to female sex work. Beneath the regulatory apparatus, however, female and male sex workers share important commonalities in their *experiences*. Gaffney and Beverley did focus group-based research with male sex workers in central London, finding parallels between the "traditionally subordinate position of women" and the "contextual experiences of the 'hidden' population of male sex industry workers" (2001, 133). The similarities in experience lie in the subordinate position both groups occupy, thanks to the "hegemonic and heterosexist constructs" of patriarchal relations (133). From discussions with male sex workers about selling sex, the study found that the workers become subject to their male clients through four processes: techniques for control (psychological and behavioral), objectification (of their bodies), economic dependence, and self-regulation (of their appearance). Through these processes, male sex workers, like their female counterparts, also became sexual objects—the victims of violence, psychological game playing, financial dependency, and poor self-esteem—under the damaging structures of the male gaze. Although the public zone, then, treats female and male sex workers differently, the private zone of subjective experience reveals many similarities in their relations to male clients.

THE PROBLEM IS . . . HETEROSEXISM AND PATRIARCHY

The discussion of how patriarchal institutions make male sex work marginal can extend into the realm of heterosexism and provide a heterosexist version of the

problem. Sex work only gets mainstream media coverage when the media have something sensational to report, when it makes for good copy, and when it is news-worthy. Recent research from criminology and media studies (especially Lowman 2000) suggests that a key criterion for deciding the newsworthiness of sex work is violence, preferably something extreme like murder, linked to a sex work con-text. The connection between sex work and violence presents sex workers as victims, a predictable portrayal of women that many sex worker groups (such as the English Collective of Prostitutes) and academics (e.g., Brewis & Linstead 2000), have been trying to battle in the representational wars with the media. It is part of the jour-nalist maxim, "If it bleeds, it leads" (Carll 2003, 1591), identified in Elizabeth Carll's study of how the news portrays violence against women and violent women.

John Lowman's (2000) study of the interconnected roles of the media, the legal system, and political hypocrisy in the increasing rates of violence and, in particu-lar, the increasing murder rates of female street workers in British Columbia, Canada, between 1982 and 1994 demonstrates how the newsworthiness of sex work connects to violence. His argument, in part, is that the media (in this case, news-papers) helped create the conditions that permitted violence against sex workers to increase. As evidence, he identifies and traces changes in a *discourse of disposal* that labels female street workers as nuisances, scumbags, and sleazebags. Lowman finds that the discourse created

> a social milieu in which violence against prostitutes could flourish. The same exclusionary discourse continues to be broadcast today, amidst stories of the disappearing women. The association of this discourse of disposal to violence against prostitutes is clear enough. After 1985, the year in which the communicating law was enacted, there was a large increase in British Columbia of murders of women known to be prostitutes. (2000, 1003)

The law in British Columbia classifies street workers as outlaws and distances them from police protection and social services. Lowman shows that the media and the legal system played a mutually reinforcing role, making the women vul-nerable to the violence of men. For Lowman, patriarchy provides an explanation: The discourse of disposal forms an important part of the "ideological context in which male violence against women is played out" (2000, 1004).

The point missing in Lowman, and in many other texts on prostitution (e.g., Edlund & Korn 2002), is that, in the process of focusing on female sex work, the media (and many academics too, for that matter) are promulgating a heterosexist view of sex work. In other words, the media are leaving out of sight not just that not all sex workers are female, but also that not all sex work is heterosexual, or at least based on the straight-man-client–straight-woman-sex-worker dyad. Such heterosexism is another cultural structure, related to patriarchy, which acts to keep male sex work

out of the media. One might say, then, that prostitution is a social arena that legitimates heterosexism.

THE PROBLEM IS . . . HETEROSEXISM AND HOMOPHOBIA

Of course, heterosexism also raises questions about how much of the neglect of male sex work springs from homophobia.

One difficulty with the homophobia explanation is that covering the neglect of male sex work with the conceptual blanket of homophobia ignores the complex sexualities that exist within the male sex work community. Although studies of male prostitution have found that most sex workers are gay (typically 80 percent), that leaves a large minority who are not. Some are bisexual. Some younger men (and especially underage workers) self-identify as heterosexual. The need for financial and other forms of security to combat homelessness, or to feed a drug habit, lead some men into providing sexual services for other men. An important distinction divides the sexual acts that workers perform from their sociosexual identities. Having sex with another man for money does not automatically make the worker gay.

A further difficulty is the sexual identity of the client. Previous research (e.g., Gaffney & Beverley 2001) demonstrates that the clients of many sex workers, although married, self-identify either as bisexual or even as heterosexual, despite buying sexual services from other men. Here, the reverse case holds. Instead of the young worker performing sexual favors for money for reasons not situated within his homosexuality, the male client receives sexual favors in exchange for money, also not situated in his homosexuality. One must set aside whether such clients are deluding themselves about their sexuality, leaving the question for others to judge. The point is that assigning sexual identity in the context of a market for particular sexual behaviors is not at all straightforward.

On the surface, the neglect of male sex work in the media might reveal homophobia—a fear of same-sex intimacy—but the complex relationship between the sexual behaviors and the sexual identities of workers and clients makes this explanation unsatisfying. I am not proposing to ignore homophobia as an explanation, because I think it is a major factor. But one must be smarter about assigning sexual identity. In their book on the connections between sex and work, Joanna Brewis and Stephen Linstead (2000) cite the work of Jessica Benjamin (1995) to argue that gender dimorphism, a dualism such as male-female or masculinity-femininity used to frame the understanding of sex work and sexualities, introduces error and rigidity. They point out that masculinity and femininity are not poles, but shifting and intersecting forms of identification. Perhaps understandings of prostitution marginalize the gray areas, the polymorphic structures of gendered and sexualized identities.

A final difficulty is that male sex work also involves heterosexual men, usually as male escorts, whose clients are women. How they represent themselves and how the media represent them are integral to hegemonic masculinity. A 2002 edition of the *Trisha* show (a morning magazine program in the United Kingdom, like *Ricki Lake*) featured male escorts who represented themselves in physical terms, saying they "really liked sex" and thought they "might as well get paid for it." They focused on their physical appearance and their sexual prowess, and they saw nothing wrong with being paid for sexual services. The escorts also made it clear that their services do not have to be sexual: They also offer companionship. Apart from a certain portrayal of hegemonic masculinity, an interesting aspect of the program was the audience questions and comments about "the kind of women that would have to pay for sex." Such comments came from male and female audience members, and I do wonder whether they would have asked the question if the guests had been women offering sexual services to men.

THE PROBLEM IS . . . STEREOTYPING

Representations of male sex work most often involve perpetuating narrow stereotypes. Here is another similarity with female sex work. Male sex work differs, however, in the discursive frames the media mobilize. In the United Kingdom, recent media coverage, especially in newspapers, has focused on two particular frames. The first is *male-sex-work-as-scandal*. One recent scandal involved politicians seeing rent boys, such as the Labor politician Clive Betts, who later arranged a job for his "rent boy lover" as a researcher in Parliament (Sanderson 2003, 37). The press viewed this as a security risk to the country, because the sex worker in question, Jose, was from Brazil.

The second frame is *male-sex-work-as-pedophilia*. In 2001, the national children's charity Barnardo's published a report, *No Son of Mine*, that explored how boys and young men got into prostitution and the resulting effects on their welfare (Palmer, 2001). National broadsheet newspapers, such as the *Guardian* and the *Observer*, and public television (BBC News) gave the report extensive coverage, focusing on the worst abuses, such as boys as young as ten years old, "drawn into prostitution because they are escaping from an unhappy situation at home or in care" (BBC News, n.p.). It also focused on the parts of the report that demonstrated the so-called grooming strategies (including the offer of drink, food, or drugs) that pedophiles used to gain the trust of young boys and then for subsequent abuse. I would not want to undermine the significance of this report for documenting and raising awareness about the worst cases of pedophiles abusing young and vulnerable boys, but what messages did the coverage send out?

One was the clear portrayal of young sex workers as victims. The ENMP noted the consequences of media stereotyping in on-line comments about the Barnardo's report and the surrounding publicity:

> This has been positive in drawing public attention to the issues of sex work, and politicians have been quick to respond with funding targeted towards services working with young people involved in prostitution. However, this is often at the expense of adult services or services working with older sex workers, which in reality, represent the majority of commercial sex workers within the U.K. (European Network Male Prostitution 2004)

Here, again, some insight emerges into the workings of media discourse: It makes clear the abuses associated with underage sex work, but it also constrains understanding. Underage workers are only one small part of male sex work, and many sex workers do not consider themselves victims at all.

Such media discourse perpetuates a view of gay men as pedophiles. The press in Australia suffers from a similar focus on episodic news when covering the traffic in women and children. Cwikel (2004), the researcher from Israel, describes the episodic problem with media coverage of the issue of trafficking and child abuse:

> What the media neglects to do is to ask the tough questions: what happens to these girls (boys) after they are returned to their parents—are they simply shipped back to work (maybe in the same place, maybe in a different one)—how do their parents react to their return? What happens six months down the road?

Media coverage follows a pattern, beginning with a frenzy about trafficking and underage sex work and followed with complete silence on the aftereffects on the children and families. In news practice, journalists are under time pressure to complete their pieces, perhaps connected with the sound-bite culture of the media. The condition emerged in several of my interviews. Marieke van Doorninck (2004), a researcher at the de Graaf Foundation in Amsterdam, describes the results of news practice from her perspective as a media contact person for one of the largest prostitution research organizations in Europe. Journalists often call her up for information and opinions, and "sometimes the media wants me to hand them some sex workers they can interview. I don't do that (as I don't run an escort agency). This often leads to irritated journalists."

Hilary Kinnell (2004) of the U.K. NSWP also describes how journalists approach her. Their request goes something along these lines: Produce for me a sex worker, who is HIV positive and can speak English, in the next twenty-four hours. Like van Doorninck, Kinnell too takes umbrage at this quick-and-dirty approach. It appears that journalists have little interest in learning about male or female sex work in any depth. They already know what they want to say, and they need a quick sound bite from a supposed expert and a few lines from a so-called sex work victim

to finish their story. Their demands, of course, say more about conditions of news production than about any individual journalist.

THE PROBLEM IS . . . LACK OF MEDIA INTEREST
IN THE PUBLICITY EFFORTS OF SEX WORK GROUPS

This section turns to the experiences and stories that sex worker advocates tell about their attempts to get particular aspects of their sex work agenda onto newspaper pages and television screens. Van Doorninck and Kinnell describe the great difficulties and resistance they have experienced in their active attempts to gain attention for issues important to their organizations or to find publicity for events they are running. Van Doorninck (2004), returning to the earlier theme of sensationalism, stated,

> For the majority of journalists, it is hard to get them interested if not is not about something spectacular. For example, last autumn we organized a conference on the future of street prostitution in the Netherlands, but because we could not guarantee that we would come to very strong conclusions, only the journalists with whom I regularly work turned up for the press conference.

The key phrase here is about guaranteeing "very strong conclusions." Instead of offering the Dutch media quick and easy sound bites to use in their coverage, the event asked journalists to take part in the tensions and complexities of debate around the subject of street prostitution. According to van Doorninck, the lack of interest among the media when she is contacting them is universal.

Kinnell had two stories of interest. The first was her unsuccessful attempt a few years ago to get a press release published on violence against sex workers. The press release attempted to provide a more complex and less stereotypical view of the subject. Later, she describes how she telephoned the offices of the *Guardian*, a major, left-of-center broadsheet in London, to complain about how one of their journalists had written about female prostitution. The article said that anyone who professes tolerance on the issue of prostitution is "colluding with exploitation," to quote Kinnell (2004), who called the piece an "irresponsible and inaccurate rant." Hearing that the same journalist received an assignment to do another piece on sex work provoked Kinnell to call the paper about the questionable way the reporter had previously covered the topic. The call was to no avail.

Perhaps the most distressing story of low media interest in alternative experiences of sex work comes from Mistress L, whose personal account of how journalists from a women's magazine treated her appeared in a special issue of *Feminist Review* in 2001. A female journalist from a young women's magazine approached

Mistress L at an opening for an art exhibition aimed to promote open attitudes about sex. Mistress L works in London at a domination house, which specializes in the offer of sadomasochistic and related sexual services. Because of the kind of sex work she did, Mistress L faced personal risks, including potential loss of anonymity and privacy. After taking time to consider the journalist's request, she decided to say yes to the interview, hoping the risk would help explode myths about female sex workers.

The journalist spent two days with her, talking to her partner, her clients, and her co-workers in the domination house. Mistress L read the published article with considerable shock and distress. Instead of writing about the choice she had made to be a sex worker and the independence she felt it gave her, the reporter wrote about "the filthy job" that "made her rich" and the "dirty money" she earned through sex work. The article ignored the different world of female sex work, instead peddling a predictable and reductive narrative that patronized Mistress L and her community. Mistress L concludes her personal account by saying,

> The article could have exposed some of the real facts about one person's real experience of working within the sex industry and dispelled some of the myths. They were privileged to be invited into our work place. They had amazing material in front of them yet they chose to write an ill-informed piece of moral vigilantism. A crass sensational interview not based in truth but on their stereotypical views. I am left with a feeling of impotency, that I have no power to make a real difference, a mistrust of the media in general and a desire to sneak back under the umbrella of anonymity. (2001, 150)

THE PROBLEM IS . . . THAT MALE SEX WORK REPRESENTATIVES SHY AWAY FROM MEDIA ATTENTION

A key assumption that initially guided my research was that groups and organizations representing the interests and welfare of male sex workers would want active contact with the media to correct factual inaccuracies, respond to narrow or negative representations, or to raise awareness of male sex work issues. Working with the media would be in the interests of male sex workers, but the assumption proved not to hold for all male sex work organizations. When talking to Justin Gaffney from the ENMP based in London, I found out that the organization (one of the most prominent in the United Kingdom and in Europe) shies away from interaction with the media. Based in a large London hospital, the ENMP leaves any media inquiries to the main press office in the hospital and will respond only to inaccurate or biased reporting. The ENMP works with a few trusted journalists, one working for a professional nursing magazine and one for national broadsheet newspaper, who have taken an interest in explaining the Working Men Project to their audiences.

When asked why ENMP sought to maintain a distance from the media, Justin Gaffney (2004) informed me that—

> Media interest is not a prime directive for us, and in many ways, unless handled sensibly, can have negative effects for our project. The project is primarily a clinical service, which provides HIV prevention and sexual health promotion to sex-selling men. Many of these men find it difficult either to access mainstream clinical services or to be honest about their paid sexual activity. Much of this stigma is driven by what they read in print media and see on the small and big screen about the way that Western society treats such minority groups.

Gaffney says what matters is "that the project is seen as a safe place. Attracting a large and mainstream media attention would undermine that sense of trust." He describes the interactions of ENMP with the media as "very distant (talk on neutral ground, not in the clinic) and with a high degree of editorial control," and with only the print media. Encouraging dialogue with the media might drive away sex workers, who fear being found out and pilloried.

Although ENMP policy dictates minimum media contact, it does encourage interested sex workers to talk to the media and actively supports them. ENMP provides written guidelines for sex workers speaking with the media. A further project, called SW5, trains sex workers so that they can use the media to tell their own stories (to use the project's phrase) and to give more detailed and realistic accounts of sex work than those typically found in the mainstream press. The generalization does not always hold that minority groups always perceive benefits in forging greater connections with the media.

CONCLUSION

Within the context of a purportedly talkative media environment on issues connected to sex and sexuality in the United Kingdom and elsewhere, the silence on male sex work is deafening. In my view, a fear of the whore is of crucial importance in explaining the lack of visibility obscuring all forms of sex work. However, to stop there, ignoring the manner in which whorephobia articulates with patriarchy, heterosexism, and homophobia, is to elide and, in turn, to misunderstand the subtle similarities and differences in the experiences of sex workers. These divergences bring to the surface the complex gendered and sexual relationships and tensions between patriarchy, heterosexism, and homophobia, which the media regulate. To collapse these differences into a single explanation—whorephobia—is a potential problem, which a more layered account of particular kinds of sex work can unpack. Accounts of the neglect of male sex work must consider its production at the intersections of a patriarchal whorephobia, a constraining heterosexism, an unspoken homophobia, and a general ignorance about the polymorphism of human sexual identities.

A layered account of identity issues must also connect with the wider institutional issues that separate male and female sex work. Female sex work, for reasons connected to the cultural and institutional history of sexuality, is subject to a greater number of structures for the surveillance and regulation of the female body. The evidence shows that women have more support services and that female sex work receives more media coverage. The same institutional framework simply does not exist to regulate male sex workers and their bodies. The neglect of male sex work in the media is part of a wider institutional neglect of the male body revealed in the history of sexuality. In short, although the media are complicit in issues of visibility and invisibility, they comprise only one social actor responsible for the systematic and institutional neglect of male sex work.

As long as the media continue to portray sex work as female work, and to portray sex workers as victims, institutional responses will remain limited to *criminal justice intervention* aimed at further regulating the *female body*. Because of these tightly knit patriarchal structures, institutional and, by extension, wider public understandings of male sex work will remain subject to patriarchal restrictions based on a heterosexist gender-sex-sexuality matrix. This wider institutional neglect is the greater barrier to improvements in the welfare, well-being, and social position of male sex workers. In short, media neglect is part of a *general* whorephobia, instantiated in the oppressive *local* structures of patriarchal and heterosexist institutional regulation, and its identity politics.

REFERENCES

BBC News. 2001. "Charity Plea over Rent Boys." *BBC News*, 4 July. Available at http://news.bbc.co.uk/1/hi/scotland/1420835.stm. Accessed 22 February 2002.

Benjamin, Jessica. 1995. "Sameness and Difference: Toward an 'Over-inclusive' Theory of Gender Development." In *Psychoanalysis in Context: Paths between Theory and Modern Culture*, 106–122. Ed. A. Elliott & S. Frosch. London: Routledge.

Brewis, Joanna. 2004. Telephone communication with the author, 16 February.

Brewis, Joanna, and Stephen Linstead. 2000. *Sex, Work and Sex Work*. London: Routledge.

Browne, Jan, and Victor Minichiello. 1995. "The Social Meanings behind Male Sex Work: Implications for Sexual Interactions." *British Journal of Sociology 46*.4 (December): 598–622.

Cameron, Samuel, Alan Collins, and Neil Thew. 1999. "Prostitution Services: An Exploratory Empirical Analysis." *Applied Economics 31*.12 (December): 1523–1529.

Carll, Elizabeth K. 2003. "Introduction: Psychology, News Media, and Public Policy: Promoting Social Change." *American Behavioral Scientist 46*.12 (August): 1591–1593.

Cwikel, Julie. 2004. E-mail communication with the author, 24 February.

Edlund, Lena, and Evelyn Korn. 2002. "A Theory of Prostitution." *Journal of Political Economy 110*.1 (February): 181–214.

European Network Male Prostitution (ENMP). 2004. "Services." European Network Male Prostitution. Available at http://www.enmp.org. Accessed 15 March 2004.

Foucault, Michel. 1978. *The History of Sexuality: Volume 1: An Introduction*. Trans. R. Hurley. New York: Pantheon.

Gaffney, Justin. 2004. Interview with the author, 28 March.

Gaffney, Justin, and Kate Beverley. 2001. "Contextualizing the Construction and Social Organization of the Commercial Male Sex Industry in London at the Beginning of the Twenty-first Century." *Feminist Review 67*.1 (Spring): 133–141.

Hickson, Ford, Peter Weatherburn, Julie Hows, and Peter Davies. 1994. "Selling Safer Sex: Male Masseurs and Escorts in the U.K." In *AIDS: Foundations for the Future*, 197–209. Ed. Peter Aggleton, Peter Davies & Graham Hart. London: Routledge.

Irish Network Male Prostitution (INMP). 2001. "Such a Taboo." Report of Irish Network Male Prostitution, May. European Network Male Prostitution. Available at http://www.enmp.org. Accessed 21 February 2004.

Johnston, Brad. 2003. E-mail communication with the author, 1 October.

Kinnell, Hilary. 2004. Interview with the author, 1 March.

Lowman, John. 2000. "Violence and the Outlaw Status of (Street) Prostitution in Canada." *Violence Against Women 6*.9 (September): 987–1011.

Mistress L. 2001. "A Faustian Bargain: Speaking Out against the Media: A London Mistress Gives the Real 'Exposé' on How She Was Unwittingly Turned into a 'Sensational Shock Story.'" Ed. Wendy Rickard & Merl Storr. *Feminist Review 67*.1 (Spring): 145–150.

Palmer, Tink. 2001. *No Son of Mine! Children Abused through Prostitution*. Report, Dr. Barnardo's Charity, Ilford, Essex, UK. Available at http://www.barnardos.org.uk/noson.pdf. Accessed 15 March 2004.

Patte, Yves. 2003. "Débat public et logiques de médiatisation: Le cas du débat sur la prostitution en Belgique francophone." *Recherches Sociologiques 23*.1 (April): 119–134.

Sanderson, Terry. 2003. "Where the Sun Don't Shine." *Gay Times*, April, 36–38.

Seidman, Stephen. 2002. *Beyond the Closet: The Transformation of Gay & Lesbian Life*. New York: Routledge.

Sheridan, Allan. 1980. *Michel Foucault: The Will to Truth*. London: Tavistock.

Trisha. 2002. Anglia Television Production, 1 March.

Van Doorninck, Marieke. 2004. E-mail communication with the author, 25 February.

West, Donald J., and Buz de Villiers. 1993. *Male Prostitution*. New York: Harrington Park Press.

Say I Do

Gay Weddings
in Mainstream Media

MARGUERITE MORITZ

Of the contested issues involving gay rights, none is more explosive than marriage. In the fall of 2002, with little fanfare and even less public reaction, the New York Times *began publishing notices of same-sex unions on the renamed Weddings/Celebrations page. National queer organizations hailed the small step as a watershed. The moment was decades in the making. The* New York Times *and other prominent cases reveal constructions of gay marriage in mainstream media over three decades, based on interviews with reporters, editors, and producers who explain changes in their professional codes and practices.*

To the Virginia judge who ruled that Mildred Jeter, a black woman, and Richard Loving, a white man, could not marry, the reason was self-evident. "Almighty God created the races white, black, yellow, malay and red, and he placed them on separate continents," he wrote. "And but for the interference with his arrangement there would be no cause for such marriages." Calling marriage one of the "basic civil rights of man," the Supreme Court ruled in 1967 that Virginia had to let interracial couples marry. Thirty-seven years from now, the reasons for opposing gay marriage will no doubt feel just as archaic, and the right to enter into it will be just as widely accepted.

—Editorial, "The Road to Gay Marriage," *New York Times*, 7 March 2004

There was a time, back in the Dark Ages of the pre-digital era, when the most influential U.S. newspaper prohibited the use of the word gay. A mere eighteen months

before editorially saying, in effect, Wake up America, the time for same sex marriage is here, the *New York Times* still was deciding whether it could reverse a long-standing policy against printing gay wedding announcements in the Lifestyle section of the Sunday paper. The decision finally came in August 2002, hailed as the watershed moment it was. Developments in the unfolding movement for gay marriage have moved so quickly—a "cultural tsunami" in the words of *Times* columnist Frank Rich—the other high water marks now make the brief moment seem almost quaint.

The last forty years have witnessed an array of gay media content that would have seemed unbelievable in the 1960s and 1970s. If one could build a montage of the headlines and the images from the archives of American news media organizations, what would it show? If one could replay the millions of words and thousands of images, what would distill from them? The composite picture would show Pride parades and paraders, the ones who cheered them and the ones who inveighed against them from pulpits and political platforms across the country. One would see bars, bath houses, persons with AIDS, and the quilt, probably in that order. Act Up and Dykes on Bikes would be there, as would brides and grooms in gowns and tuxedoes marching in the nation's capital where lectern-pounding Senators have stood in so-called defense of marriage. There would be clips from talk shows and an array of celebrities—from Rock to Rosie.

One of the earliest objectives of gay rights groups was to have media representation not dominated by negative stereotypes. In four decades of depictions, texts and images have moved from deviant loners and losers to normal couples and their kids. The gays on the wedding pages of today's *New York Times* are remarkable for their elite status, not for their sexuality. In the large scope of media content, gays have entered the mainstream, and family orientation has replaced sexual orientation along the way.

Yes, gay marriage has taken the country by storm, "driven by an array of social forces and institutions," according to the *Times* editorial ("The Road to Gay Marriage," *New York Times*, 7 March 2004). The seemingly sudden arrival of a transformative moment actually has a long and deep history where media representations have played a crucial role. With the focus now on legislative and judicial bodies across the United States, the publication of items as simple as gay wedding announcements has already taken its place in media history, a small corner in what is turning into a large landscape. That newspapers agonized for more than a decade over whether to print them seems amusing as the standards of the late twentieth century rapidly melt into what will become a bygone era. Nonetheless, how the evolving media treatment has brought gays and marriage together illustrates a great deal about how journalists, their subjects, and their audiences function, interact, and ultimately play their part in changing culture.

GAY MARRIAGE MAKES THE NEWS

In describing the debate over same sex marriage in the state of New York, gay Assemblywoman Deborah Glick told the *New York Times* that the political terrain is changing rapidly. "It's a totally grass-roots, energized movement that to me is something I haven't seen since the late 60s and early 70s. . . . Legislative bodies tend to be reactive, and advances in law come as a reflection of how people live their lives, not the reverse" (Michael Slackman, "Same-Sex Marriage Blurs Lines on Both Sides of the Political Aisle," *New York Times*, 7 March 2004, 27, sec. 1, col. 2). One might say the same of the news media. It reacts to the ways individuals live their lives, and, in exactly that context, gay couples seeking the right to marry emerged in the 1970s. One common assumption about gay activism is that it emanates from urban centers, but the earliest efforts took place in small communities, often in politically conservative states. Starting in the 1970s, same-sex couples sought marriage licenses in Minnesota, Kentucky, and Washington, where state courts ruled against the unions, but that question was the only terrain tested.

In 1975, a gay couple in Boulder, Colorado, made another attempt to secure a state-sanctioned wedding license. The story drew national media attention at a time when gays were still largely invisible in news or entertainment contexts. Clela Rorex, now long retired from local politics, set things in motion when she granted their request. In 1974, at age twenty-eight, she was in the thick of feminist activism (her license plate was "Ms One") when her consciousness-raising group persuaded her to run for county clerk in Boulder, so that at least one woman would appear on the ticket. She won the election, and, three months after taking office, she issued a marriage license to two men. "Two guys showed up from Colorado Springs," she recalls. "They had been turned down there, but the clerk said, 'Why don't you go to Boulder. They do that kind of thing there' " (2002, n.p.).

When first approached to issue the license, Rorex went through appropriate channels, checking with local legal authorities who reviewed the state marriage code. Their opinion: Even though the intent of the law seemed clearly aimed at men and women, the wording didn't explicitly say that. "They said there was nothing in the law against it, so I did it" (2002, n.p.). The basic challenge was the same one made in Hawaii twenty years later.

The Denver and local Boulder newspapers reported the story. Other same-sex couples got the news and started heading for Boulder. Local officials tried to get a recall effort underway as state legislators frantically scrambled to rewrite the Colorado law to specify that marriage was to be between a man and a woman. Her colleagues in the Colorado County Clerks Association castigated Rorex for attempting to implement her own (lesbian-feminist) political perspective on her constituents.

In his 1996 book, *Media Matters*, John Fiske argues that, because homosexuality and homophobia create "immense anxiety" in American culture, "overt references to either are typically repressed from public or popular discourse, except, of course, when they are the subject of a news report" (56). In the decades when gays were either invisible or marginal in the media, those depictions that did exist were typically negative in the extreme, "framed alternatively as a sickness, perversion or crime" (Fejes & Petrich 1993, 402). From the vantage point of today, they are blatantly unfair, inaccurate, and prejudiced. At the time, they were not particularly remarkable and conformed quite well with widely held beliefs that thrived in an era of ignorance. The most typical framing or discursive devices were deviance and abnormality, concepts an uneducated American public held without much questioning.

> Research suggests that media framing affects the mental constructs each of us carries around about the world. Media frames are particularly powerful when they relate to people, places, or issues about which we have no direct information. Media frames tend to be most influential when they provide a means for us to interpret and understand the unknown. The frames we encounter in media provide a template for our vision of the foreign, the marginal, the other. And these images are durable, though not permanent. Education and direct personal experience can enlarge or reshape our mental windows, or redirect our gaze. (Dente Ross 2003, 32–33)

In the late 1960s, "gay and lesbian demands for equal protection began to be viewed as legitimate news, although the legitimacy of their demands still was viewed as questionable" (Fejes & Petrich 1993, 402). In the Boulder case, local reporting emphasized factual developments in headlines such as these from the 1975 *Daily Camera*: "County Clerk Issues Gay Marriage License" (Thursday, 27 March, 1), "Second Same-Sex Couple Given Marriage License" (Tuesday, 8 April, 1), and "Legislation May Prohibit Marriages by Same Sex" (Friday, 16 April, 6). The *New York Times* reported the story nationally using the headline, "Homosexual Weddings Stir Controversy in Colorado" (27 April 1975, 1). The story texts invoked the frame of deviance, quoting opponents who, for example, said, "This is an abomination of the Supreme Ruler," "God condemns homosexuality," and "Homosexuality is prohibited by the Bible" (1). On a national level, conservative commentator Paul Harvey denounced the whole affair on his syndicated radio program (according to Rorex 2002).

Many assumed that Rorex herself was a lesbian. She recalls that "quite a few lesbian women wanted to date me. I'd have to say, 'Thank you, but I don't think I'm lesbian.'" Looking back on it, Rorex recalls being portrayed as a lawbreaker and outlaw. "There were letters to the editor in all the papers and people were comparing me to Patty Hearst and the Symbionese Liberation Army. One city councilwoman said I was turning Boulder into 'Lesbo-Homoville.'"

Local residents, however, used constrained language compared to statements issued from the federal government. One of the men who had gotten a license in Boulder was an Australian who sought U.S. citizenship following his marriage. The Immigration and Naturalization Service (INS) sent him a letter stating that the agency would not recognize his same-sex marriage for purposes of gaining resident alien status in the United States. According to press reports, the letter said, in part, "You have failed to establish a bona fide marital relationship can exist between two faggots" (letter to Richard Adams, 24 November 1975, quoted in Legomsky 1997, 139). The author of the letter, a deputy district director in the INS Los Angeles office, justified his use of the term *faggots* by saying it was in the dictionary. At the same time, he also agreed to reissue the letter deleting the term.

As the license stories circulated more widely, they also portrayed same-sex marriage as ludicrous, as a complete reversal of the term *marriage* and the institution it represented. Rorex also received a flood of calls and letters, along with invitations to appear on television programs. Johnny Carson made it the subject of opening monologues on the hugely popular *Tonight Show*. Humor, of course, often springs from such reversals, as do many news stories in the man-bites-dog category. Communication scholars see the journalistic process of framing as critical to public discourse and visibility.

> Through the selection, emphasis, and omission, journalists direct the attention of their audience toward the aspects of daily life that consistently warrant—or do not warrant—consideration. The selective emphasis is not random or transient. Rather, the frames employed by journalists are durable reflections of internalized professional values and social norms. . . . By framing some ideas as credible and others as laughable, media simplify the task of harried citizens with little time to devote to complicated issues. By disseminating government depictions and analyses of issues and events, media oversee government and inform the public. By omitting the assertions of the small, powerless, or unpopular groups, media endorse social values, dissociate themselves from radicals, and reflect the role of power in society. (Dente Ross 2003, 32)

In 1975, a serious, analytical national debate on gay marriage—emanating from the County Clerk's office in Boulder, Colorado—was impossible because the idea of gay marriage so contradicted social and media norms. It was easier to treat the topic as one hilarious joke, and this particular chapter concluded with a staged media event that conclusively made the point.

Shortly before the state forced an end to the issuance of same-sex marriages licenses, an old-time Colorado media gadfly rode up to Boulder City Hall on horseback and dressed in full cowboy regalia. Local television cameras were in place when he went to the office of Rorex (2002) to demand a license to marry his horse. With

the cameras rolling, he requested a license to marry his horse: "If a man can marry a man and a woman can marry a woman, why can't an old cowboy like me marry my best friend, Dolly?" Rorex recalls that she went along with the stunt, started filling out the paperwork, and asked for name of the groom, name of the bride, the age of the groom, and the age of the bride. "He said the horse was eight and I said, 'Well, I'm sorry, but Dolly isn't old enough to marry without parental permission.' "

It became a water cooler story that could make anyone chuckle and the perfect anecdote for talk show hosts around the country. It also provided "some levity which was almost healthy. It helped people see the absurdity of being so uptight over two people wanting to be together," Rorex concludes.

GAY WEDDINGS AS COMMUNITY NEWS

Legal challenges to gay marriage got little support from courts or legislatures until the Hawaii Supreme Court ruled in 1993 that the denial of marriage licenses to same-sex couples was discriminatory. Throughout the 1970s and 1980s, queers continued to form unions and celebrate them with secular and religious services. In 1984, the Unitarian Universalist Association voted to affirm what it saw as "the growing practice" of these ceremonies in their churches ("Holy Matrimony" 1996, 100). On the media front, gays remained marginal until the AIDS crisis became a major mainstream story in the mid-1980s. Reporting on AIDS further stigmatized gay men in particular, but it also raised visibility and helped expose media bias and ignorance:

> reporters and their readers were exposed to a view of gay and lesbian life very different from the 1970s hedonistic stereotypes of gay life. . . . Particularly in large urban communities with gay and lesbian communities that were mobilized against AIDS, editors and other media professionals began to learn more about the gay and lesbian community and thereby became sensitized to the homophobic slant of much of their previous accounts. Professional news journals such as *ASNE Bulletin, Presstime*, and the *Columbia Journalism Review* began to carry articles commenting on some of the more obvious examples of homophobic news coverage of AIDS. (Fejes & Petrich 1993, 404)

By the beginning of the 1990s, family values had emerged as the Republican code for anti-abortion and antigay positions. In his presidential bid, Bill Clinton actively courted the gay vote with pledges to end the ban on gays in the military, something he attempted but failed to achieve his first year in office. It was against this backdrop that a newspaper in Salina, Kansas, in 1993 published the story of a gay wedding that two residents of the town celebrated. It set off a community-wide controversy that ultimately opened at least some aspects of the topic to national discussion and debate.

In 1993, the *Salina Journal* had a circulation of thirty-three thousand and was part of a family-owned chain based in Hutchinson, Kansas. Founded in 1871, the *Journal* had a long and proud history of covering local news in the north central and northwest parts of the state, areas primarily rural and predominantly Republican. "The Democrats are the minority party and the liberal view is the minority position," according to Executive Editor Scott Seirer (2002, n.p.). The editor in charge at the time, George Pyle (2002), says there are nuances to Kansas that outsiders don't quite understand:

> People have an image of Kansas as an extremely conservative buckle of the Bible belt kind of place and there is some of that, but it is really diverse intellectually. There is a strong progressive tinge that runs back to the old progressive movement, the Grange. It's helpful if you understand Kansas as basically being governed by the Rotary Club. It's pretty business like, efficient. We want to do business, we want to see if we can make a deal. There's not too much interest really in other people's personal lives as long as the trash gets picked up, the streets get fixed and the schools seem to work okay.

The offices of the *Journal* are small and unimposing. Access to reporters and editors is simple and straightforward. When Skip Durant and Steve Bishop, a gay couple who lived in Salina at the time, came into the newspaper with an announcement of their engagement and upcoming wedding, they went directly to Pyle, perhaps because they had met him at a recent AIDS vigil in the local park.

As in many cases, newspapers consider engagement and wedding announcements news and run them as news stories. Written policies and procedures on how to handle the announcements did not exist. Pyle (2002) says any written editorial policies of any kind were rare: Editorial employees, through observation, training, and experience, would be aware of "things we do and things we don't do." Wedding announcements were community news and they went into the paper:

> It's not an advertisement, it's a news story. We have a style that we adhere to so that everybody is treated the same. They are not allowed to go on with too much flowery language just for space purposes, but otherwise we don't ask a lot of questions and we take just about all "comers" just as long as there is a local connection. If they live here or their parents live here and they went to school here, we would be happy to publish it. (Pyle, 2002, n.p.)

Pyle recalls that his immediate reaction to the request was simply to approve it. "I did not have a moment's hesitation, and then I realized I don't own this newspaper and that I probably should ask the people who do." After a discussion with the publisher, Pyle was ready to proceed. He recalls that "the only real quandary—it wasn't even a controversy, it was a quandary—was should we simply publish the announcement like any other announcement and say nothing else, or should we say more than that. Should there be an editorial, a column, an article?" Pyle argued for

running just the announcement, because making it more prominent would not be equal treatment.

"HEY, YOU'RE NOT GOING TO BELIEVE THIS . . ."

At the time, Becky Fitzgerald (2002) was the twenty-eight-year-old assistant editor for the Lifestyle section where the announcements ran. She had been at the paper since graduating from the journalism school at Kansas State University. She recalls hearing the news from her boss, the Lifestyle editor, who told her, "Hey, you are not going to believe this but two guys came in when I wasn't here and they went to George and said they want to put their engagement announcement in the paper." When Fitzgerald talked to Pyle about the announcement, "He said he didn't have a problem with it and just run it. He was our boss." Fitzgerald said she knew immediately the community reaction would be negative. "I was sort of freaked out," she recalls:

> I don't know what my feelings were about homosexuals or if they entered into it, I just knew that George, our editor, had a history of making decisions that went against the grain of our conservative community that we lived in. And this decision was going to affect me and my supervisor and how we did our jobs. I said, "Hey let's talk about this, let's talk about the ramifications." And George did not care about any possible ramifications, I mean he just did not care. We talked about possibly we would lose subscribers, we talked about possibly we would lose advertising. He felt this was an important enough issue, that none of that mattered to him and he was willing to take the fall for whatever fallout there was.

Fitzgerald (2002) argued that, if the announcement was going to run in the paper, there needed to be some kind of explanation that went with it. Pyle, she said, "wanted to just pretend like this was normal, which certainly in 1993, this wasn't an everyday thing." Fitzgerald was aware of some gay support groups in Salina because the paper published notices of their meetings. She had wondered how many gays lived in Salina and what they talked about in these groups.

> I told George that I didn't think it was fair to just run an announcement and treat it just like everyone else because I said, "You know we are not really doing a service for our readers." I said, "I think our readers would be curious: Is this legal? Are they really married? You know, as spouses, do they have the same rights and privileges as heterosexual spouses?" All these questions were in my mind, and if they were in my mind I can't imagine they would not be in our readers' minds, too.

Ultimately, Fitzgerald suggested three stories that would take up the entire front page of the Lifestyle section. One story would cover Steve and Skip's wedding day and details of their romance and relationship as well as their work lives. A second

story would provide general context and would answer questions about the legality of gay marriage in Kansas. The third story would focus on the Rev. Bob Lay, the minister who would perform the wedding ceremony in a local church. A Read More section would give Biblical references as well as contemporary titles on gay life and issues. The actual wedding announcement would run routinely on the inside wedding page with the other announcements.

Pyle (2002), quickly convinced that the added coverage was important, realized that the newspaper's role was to ask why the men were calling attention to themselves and why "they felt the need to participate in a ceremony that traditionally was not thought of for this sort of relationship." The wedding announcement itself posed little problem:

> This was long enough ago that people were not saying things like civil commitment or life partner. They called it an engagement and a wedding, and, as a newspaper editor, I think in pigeonholes. Is this an obituary? Is this a birth announcement? Is this a wedding announcement? It was a wedding announcement that is what they called it and I said, "Yeah, I have a space for that." If all those years ago they had come in and said, "We would like to put our civil commitment in the newspaper," I might have said, "Well, I don't think we have a standing headline that says Civil Commitments; so I don't know if we have a place for this." But, since they used the traditional terms, I felt like I had just the right slot for it.

Pyle had already made some of his pro-gay opinions known in the editorial pages of the paper, prompting the virulent antigay Fred Phelps, who is from Kansas, to picket, carrying a sign that read, "The Fag Rag." (A reporter acquired the sign from Phelps, who signed it, "To George Pyle, a great defender of the First Amendment." It still sits in the offices of the *Salina Journal*.) Pyle had written in favor of lifting the ban on gays in the military and that stand played a prominent role in his thinking about the weddings page. "It would have been hypocritical," he said, to editorialize in favor of gay rights and then discriminate against gays on the weddings page (Pyle 2002, n.p.). The wedding announcement ran on the inside page, and the cover page featured what Pyle describes as "a kind of traditional wedding picture with them looking longingly into each other's eyes. And that caught a lot of people's attention. John P. Harris who founded the group many years ago said that a newspaper should have something everyday that is the topic of conversation in the community. And this certainly was that."

COMMUNITY REACTION

In all, 117 readers canceled their subscriptions. Letters to the editor, most negative, appeared for weeks. Advertisers threatened to take their business elsewhere but did not follow through. Radio talk shows followed the story for days, and, among

other things, callers insisted Fitzgerald was a lesbian because only a gay person could have known how to write those stories. On that point, Fitzgerald (2002) says, she felt flattered to realize that anyone "thought I was so in touch with the issues that I had to be a lesbian. I thought that really showed I was doing my job and that I had put any sort of personal biases or feelings aside." At the same time, the newspaper sold out—

> literally sold out. There was not a copy to be had, you know, people on one hand, were saying how horrible this was, but yet they were reading every word and they were coming in and coming up to the front desk and whispering almost as if they were embarrassed: "Do you have that copy of the paper, you know the one with the gay guys?"

Some in Salina boycotted the restaurant where Steve was a waiter. Members of his church heavily criticized the Reverend Lay, and he eventually left his position. In May, when things began returning to normal at the paper, producers from the *Maury Povich Show* featured Skip and Steve along with the straight couples whose wedding announcements ran on the same day. Fitzgerald went to represent the newspaper. "People wanted to know why we were promoting homosexuality. That was the debate all through this. Was the newspaper promoting homosexuality? Was it condoning homosexuality through this?" (2002, n.p.).

In August 1993, the *New York Times* asked Pyle to write an op-ed piece explaining how "a little newspaper in Kansas did what so few other newspapers do." He argued that newspapers have no reason to reject gay wedding announcements. "We can't claim it's not news, and we can't hide behind the excuse that it is not legally recognized. Since when did newspapers let the government decide what they should print?" (Pyle 2002, n.p.). The *New York Times* found the piece interesting enough to publish but apparently not persuasive enough to change its own policy.

STRAIGHT, BUT NOT NARROW

Despite the cancellations, The *Salina Journal* did not suffer long-term negative consequences from its readership. (One gay couple sent the news paper a $25 check to help make up for subscribers who dropped the paper.) Canceling, according to Pyle (2002), is one of the few ways readers can communicate with the paper, and, when they feel strongly about an issue, they make their voices heard in that way:

> The newspaper, more so than any other kind of communication, is very one way. I mean you put all this stuff in a newspaper and you throw it on people's porches and they have a lot of identification with it, but they don't have much control over it. All they can do is receive it or refuse to receive it. I mean some people write a letter to the editor, but that is kind of swimming upstream. So about the only thing they can do is cancel their subscription. After

a while, they realize they miss the crossword or the sports, or the comics or the obituaries and they come back.

For years after the *Salina Journal* printed the wedding announcement, no other gay couples requested to have their unions publicized in the paper. Even today, it is rare to print an announcement. Pyle (2002) attributes this hesitancy to the negative reaction from a vocal minority when the first announcement ran. "Rumors were spread around town about Skip-and-Steve-this and Skip-and-Steve-that and horrible things that happened to them, none of which were true, so I would imagine that some people heard that and said to themselves, 'Forget it, it is just not worth it.' "

The gay community ostracized Skip and Steve. Fitzgerald (2002) says they were seen as "really being out there with their sexuality, really in your face, really almost militant, and some of their friends just didn't want to be associated with that and were fearful that they would be outed."

Fitzgerald (2002), raised to believe that homosexuality is a sin, says the story not only "gave me the proverbial fifteen minutes of fame," but also led to frank discussions with family and friends "who just really didn't understand." She became friends with Skip and Steve, "the first openly gay homosexuals I had met and they were great people." Kansas State invited her back to address the journalism students and featured her in the *Alumni Magazine*. Her own colleagues, who often regarded the Lifestyle section as fluff, saw that she "had the guts" to ask the hard questions and tackle the story:

> I didn't get a big raise or anything but it was fun to be noticed for your work, and with the negative, I don't care if people think it's positive or negative, I just want people to read it. And, even the woman who told me to wallpaper my bathroom with the article, well she read every word of it, I know she did, before she sent it to me and maybe I didn't reach her that day but maybe down the road something that I would write would have made an impact. . . . I don't know if I have still resolved everything about my feelings about whether it's a sin or not, . . . but I feel like they should be afforded the same rights and privileges we all have. I don't feel they should be discriminated against in jobs or anything else. (Fitzgerald 2002, n.p.)

The *New York Times* editors invited Pyle to write additional op-ed pieces on a variety of topics. In 2003, he joined the *Salt Lake Tribune* as an editorial writer. The Reverend Lay died of a heart attack. His picture still hangs in the Sunrise Presbyterian Church where he married Skip and Steve. Pyle (2002) says he lost a great friend and colleague when Lay died:

> He was the guy who officiated at Skip and Steve's ceremony and I was the guy who published the gay wedding announcement. We talked about how we ought to finally make Salina, Kansas, the gay wedding capital of the country, figure out a way if not to legalize it, at least to have a piece of paper and get bus tours and it will be great. He just thought it was all a lot of fun and you could tell he never had any doubts or regrets about taking part and he felt

that was his calling as a minister to take part in that. He is the one who gave me the button that says, "Straight, but not narrow." And, I'll always have that.

A DECADE OF CHANGE

Throughout the 1990s—often called the gay 90s—gay issues and events were a prominent part of news and public discourse. The debate on gays in the military was explosive, and the number of phone calls to congressional offices broke all records. Despite Bill Clinton's inability to change military policy, gays and lesbians felt "they had a friend in the White House," and the first official meeting between a president and a group of homosexuals took place in the Clinton White House (Fiske 1996, 57).

News coverage of the April 1993 Gay March on Washington, one of the largest protests ever seen in the capital, illustrated how the framing of gay subjects in the news was changing. Unlike earlier images of gay pride parades in San Francisco and New York, which emphasized the sexual, the stories and images emphasized the normality of their subjects. Antigay activists—who had always opposed sexualized images of gays in news accounts—now insisted that the liberal media was sanitizing its coverage, arguing that "front page images prominently featured khaki pants and polo shirts but excluded almost entirely the far more prevalent bizarre images at the event" (Moritz 1992, 401).

Soon afterward, Hawaii put gay marriage back in the news, and network coverage was largely sympathetic. In 1994, for example, ABC ran an hour-long special with anchor Forrest Sawyer referring to a national debate, most intense in Hawaii, "where gay marriage could actually become legal." Note the use of the word *actually*. It is not needed to convey the facts of the sentence. Remove the word, and the sentence stands, completely coherent and even more in line with the news values of neutrality and objectivity. The *actually* here is a judgment, a way of pointing out that something seemingly impossible might now happen.

The report itself was a sympathetic account of the gay couples who went to court in Hawaii to challenge officials' refusal to grant them marriage licenses. At one point, reporter John Hockenberry is interviewing a man on a beach:

MAN. Screw those queers. That's what's wrong with this world is these faggots.

HOCKENBERRY. Why do you think so?

MAN. Why do I think so? It's wrong. It says right there in the Bible about queers, and that's the problem with this country is we have people like this [gay couple] that's ruining it.

HOCKENBERRY. . . . how are they threatening you?

MAN. How are they threatening us? Oh, what's next? Are they going to start molesting little boys and saying it's okay?

HOCKENBERRY, *to the gay couple*, So that's what you have to deal with. (ABC News 1994, n.p.)

As with so much reporting, homophobia runs rampant in the scene: negative associations with the biblical invocation, the use of the term *faggot*, overt hostility and aggressive language, and the link to pedophilia. The man is so ignorant and offensive that his inclusion in the report creates sympathy for the gay couple. One might argue that most audience members would identify with the gay couple more readily than they would with the man on the beach.

Two years later, in another example, the prime-time news program, *Turning Point*, also on ABC, featured Diane Sawyer reporting on accomplished, attractive, upstanding queers in ceremonies that celebrate their same-sex unions. She begins by saying that weddings are a time-honored tradition. As the passage makes clear, this is a presentation aimed at a straight audience and designed to generate debate over their acceptance of gay marriage:

> SAWYER. But how would you feel at this wedding? Men marrying men, women marrying women.
> LESBIAN BRIDE TO BE. We were thinking, well, let's wear white wedding dresses. I mean, let's just be fabulous.
> SAWYER. Fabulous maybe, but what if it were your mother? (ABC News 1996, n.p.)

Throughout the 1990s, texts and images increasingly emphasized stories based on supposedly normal gay family relationships, which appeared on television, in newspapers, and on the covers of major magazines. The National Lesbian and Gay Journalists Association became a significant force for change in newsrooms around the country as did Glaad, the Gay and Lesbian Alliance Against Defamation. Both organizations pushed for the greater inclusion of gays in everyday coverage. The study, "Lesbian and Gays in the Newsroom: Ten Years Later," conducted in 2000, has tracked the concept of mainstreaming. Defined as representing gays "regularly in subjects not confined to gay or lesbian issues," mainstreaming "is getting more common," the study concludes (Aarons & Murphy 2000, 21). Of the journalists who responded to the national survey, 59 percent said that their news organizations mainstreamed stories at least sometimes (31 percent), often (12 percent), or routinely (16 percent). Another 41 percent said it happens rarely or never. "There was a time when gay people jumped for joy at any mention at all," the study quotes one respondent as saying. "Now I think people . . . want our lives integrated into mainstream coverage" (29).

BEEN THERE, DONE THAT

In August 2002, when announcing the decision to change its Weddings pages to Weddings/Celebrations and include gay couples, the *New York Times* made an

important statement. Gay unions were clearly no longer likely to shock many *Times* readers. Scores of papers around the country had already adopted the practice, and many others no longer carried wedding announcements. For papers that exclude gays, their justification would be harder to rationalize. Perhaps most significantly, the *Times* decision illustrated the increasing inclusion of gays in the discourse of relationships and families. Fiske notes that "discourse not only puts events into words and images, it also links or articulates them with other events." (1996, 6). Gay ceremonies, gay weddings, wedding photos—all of these link gays to a range of family issues that are touchstones for most Americans. Not all queers want or seek this kind of identity, to be sure, but, for those who do, it is a clear sign that something has shifted in the culture. Here it becomes increasingly difficult for the right to argue that gays want to destroy the family. Quite to the contrary, "far from wanting to weaken the family, gays and lesbians want to become families" (Fiske 1996, 57).

Stories emphasizing gays as mainstream members of society who have jobs, go to work, and contribute to their communities are increasingly the norm. Stories about the gay next door neatly fit the standard news frame of typical family life. News media tend to "create, perpetuate, and reinforce images that resonate with deeply held cultural biases and myths. It may be said that news is really a continuation of the old. Stories and images of the weak, poor, and radical in society appear when they conform to familiar narratives. The realities of personal challenges are rendered as fables of redemption and self-realization. The details included, or omitted, from such stories conform to simplistic tales of good and evil, self-sufficiency, and the value of hard work that permeate our society" (Dente Ross 2003, 33).

Community papers are not going to stop publishing wedding announcements. They are one of the few positive ways the local media portray residents. Not all community members are going to accept the publication of gay wedding announcements, as a recent example published in the *Monadnock Ledger* in New Hampshire makes clear. The paper published a photo and notice, under the heading Civil Union, of two gay men in July 2003 ("Milestones: Civil Union," 10 July, 5). Letters to the editor swiftly followed, some supporting the paper and the couple, others condemning what they called a foolish attempt to legitimize sodomy. Some persons may have even canceled their subscriptions, but gay wedding announcements will not derail community newspapers, assuming readers even know what the policies are. The executive editor at the *Salina Journal* offers a recent case in point: "After the *New York Times* made their announcement, I received a letter from a reader who noted their decision and said that if the *Journal* even considers a similar policy to the *New York Times*, she would drop her subscription. She apparently didn't realize that we had a policy in place for a decade already" (Seirer 2002, n.p.).

REFERENCES

Aarons, Leroy, and Sheila Murphy. 2000. "Lesbian and Gays in the Newsroom: Ten Years Later." Report from the Annenberg School for Communication, University of Southern California, and the National Lesbian and Gay Journalists Association. Available at http://www.usc.edu/schools/Annenberg/asc/projects/soin/pdf/completeSurvey.pdf.

ABC News. 1994. "Dearly Beloved" [segment on gay marriage in Hawaii]. *Day One*, Transcript 167–3, 13 June, n.p.

———. 1996. "For Better or Worse: Same Sex Marriage" [segment]. *Turning Point*, Transcript 164–1, 7 November, n.p.

Dente Ross, Susan. 2003. "Unconscious, Ubiquitous Frames." In *Images That Injure: Pictorial Stereotypes in the Media*, 29–34. 2nd ed. Ed. John Paul Martin & Susan Dente Ross, Westport, CT: Praeger.

Fejes, Fred, and Kevin Petrich. 1993. "Invisibility, Homophobia and Heterosexism: Lesbians, Gays, and the Media." *Critical Studies in Mass Communication 10*.4 (December): 396–420.

Fiske, John. 1996. *Media Matters: Race and Gender in U.S. Politics*. Rev. ed. Minneapolis: University of Minnesota Press.

Fitzgerald, Becky. 2002. Interview with the author, University of Colorado, 5 October.

"Holy Matrimony." 1996. *Out*, June 1996, 100–102.

Legomsky, Stephen H. 1997. *Immigration and Refugee Law and Policy*, 2nd ed. Eagan, MN: West Publishing.

Moritz, Marguerite J. 1992. "How U.S. News Media Represent Sexual Minorities." In *Journalism and Popular Culture*, 154–170. Ed. Peter Dahlgren & Colin Sparks. London: Sage.

Pyle, George. 2002. Interview with the author, Salina, Kansas, 11 October.

Rorex, Clela. 2002. Interview with the author, Boulder, Colorado, 19 September.

Seirer, Scott. 2002. Interview with the author, Salina, Kansas, 11 October.

Queer Visibility and Social Class

LISA HENDERSON

How does the high profile of queerness encounter the low profile of class difference in the popular media? With key examples from commercial television and independent cinema, this essay tracks the reciprocal mediation of queerness and class to reveal a symbolic economy of body, family, and acquisition as class measures of queer worth.

In his essay "Intellectual Desire," Allan Berube (1997) disentangles a lifetime of border living and territorial and symbolic migration. Growing up poor and of French Canadian descent in the United States, and surviving the shame and hostility rained down on his speech community, his multigenerational history of Franco-American Catholic religiosity, and the position and culture of his working-class family, Berube came out as homosexual and intellectual in conditions that predicted neither but courted both. A consciously bookish kid, he read and envisioned "a different world, full of poetry, literature, great music, philosophy, and art" through the Encyclopedia Britannica volumes purchased from the door-to-door salesman in his family's trailer park and the classical records his parents played on a hi-fi his father had constructed from a do-it-yourself kit (52).

Amid his father's job relocations, brief periods of middle-class surroundings, returns to the family farm, and permanent economic struggle following the unsuccessful strike of his father's labor union, Berube's family endured the profound and historic uncertainties of striving, achievement, and loss—liminal states that mark so many personal and community narratives (even happy ones) of class and other

forms of mobility in the United States. Lovingly, and nostalgically, Berube maps the reciprocal constitutions of class, sexuality, language, ethnicity, and region, writing, first, to an audience of queer conference-goers in Montreal, a city he had never before visited in a province from which his family had hailed. I attended that 1992 conference, *La ville en rose: Lesbiennes et gais a Montréal: Histoires, cultures, sociétés*, and, like so many others in the audience, was riveted in place by Berube's calm invitation to imagine queerness through the sociocultural kaleidoscope of class migration. In his talk, there was no appeal to a uniform definition of social class or even a stable, if multiform, one but instead a writerly model of narration and identification that exposed class experience as the historical conjuncture of many things: money, labor, desire, opportunity, alliance, displacement, education, and the stabilities and instabilities of privilege.

Neither Berube's story nor his title are likely candidates for production at NBC or even Showtime—contexts that typically require more glamor and less anxiety, more triumph and less uncertainty, and more humor and less loss to cultivate a favorable narrative environment for the sale of cars and cruises and to sustain the right audience of predominantly middle-class gay and straight consumers and subscribers. His story is also openly attentive to questions of class desire and instability, a discourse that many critics claim to be absent from U.S. popular culture and especially from the commercial media, bound as those media are by the transparency of such middle-class norms as American dreaming and upward mobility.

Why, then, lead with Berube in an essay on the class markers of queer worth in the popular media? Because his essay reminds us that the forms of distinction, pleasure, and injury that make up the culture of class run, in uneven ways, through a range of social locations and symbolic contexts, among them everyday interaction, memoir, testimony, and popular narrative. In each context, the terms are recast by particular technical, aesthetic, and economic requirements, but resonance across forms endures. We can look, for example, from Berube's "Intellectual Desire" to *Will & Grace*, asking whether there is any common ground in their discourses of class difference despite dramatic contrasts in form and genre. Discovering there are reminds us that neither example invented class and its entanglement with what it means to be queer, or gay, or lesbian, although both ground that relationship in distinctive ways. In literary memoir ("Intellectual Desire") and the camp sarcasm of commercial situation comedy (*Will & Grace*), class aspiration and arrival structure gay meaning, and sexual identification as gay underwrites stigma and the promise of cultural taste and refinement. "Intellectual Desire" and *Will & Grace* are hardly the same texts, but, as queer class stories, they draw from the same deep well of class discourse and value.

We can take this further, looking for resonance between these textual examples and social exchange in everyday life. When we find them, we recognize that the stories, fantasies, and desires organized by class and sexual difference are part of our

public condition and that those media forms that critics tend to refer to as existing unto themselves—with their tightly sealed boundaries and their external influence (think of the phrase "the effect of media on society")—are in fact more continuous with other parts of social life than critics suggest: with households, scenes, love affairs, political campaigns, and public policies. We are mistaken to ignore the organizational routines and practices of cultural production in understanding why media texts appear as they do. But we are equally mistaken to forget that popular narratives become popular in part because the fantasies they distill and promote already have some purchase among their audiences and constituencies.

In this essay, I consider popular fantasies of social class and the forms of value they grant and withhold from queer characters and queer life. My examples come from broadcast and subscription cable television, from popular cinema, and from the wedding announcements of the *New York Times*, making the case that these fantasies and the structures of feeling that underwrite them are not so genre bound as to block translation across genres and symbolic contexts but enough so that their genre features invite attention and critique.

QUEER CLASS PROJECTS

This analytic gesture—of queering class and interrogating the class character of queerness across genres—is a critical form of what Sherry Ortner (2003) calls *the class project*, a phrase that challenges the static quality of class categories (such as working class, middle class, and bourgeois, among others). *Class project* invokes the practice of social class, the things persons in various configurations—as workers, cultural producers, citizens, dreamers, policy makers, elected officials, business leaders, and critics—*do* in the ongoing formation of class difference, rather than simply who we are or what we have, in liberal, Marxist, or popular terms. Such an understanding of class returns us to Berube's recognition of class identification as historical, within and outside an individual life, and to cultural representation (including Berube's) as itself a class practice. It also demands that we consider the indissolubly material and symbolic dimensions of class, as (1) a relative and potentially unstable economic position in a social system committed to economic hierarchy and exclusion; (2) a form of social power over others and vulnerability to discrimination, prejudice, stigmatization, and pain; and (3) recognizable in the cultural practices of everyday life that are closely calibrated to and by those forms of economic and institutional hierarchy—speech, taste, and the ways in which we can and do attend to our bodies. In this essay, I address the second and third of these three categories, images of social power and cultural practice, mindful of the forms of labor and labor value to which power and practice are linked.

In commercial cultural forms, class is queered by the slow drip of queer characters into an otherwise unchanged stream of class difference. But we can also imagine *class project* as queer in the metaphoric sense, where transparent categories of class difference are destabilized and reimagined—queered—enough to challenge the familiar assertion of class absence in popular discourse. As Cora Caplan has observed of a new cultural studies of class,

> We tend now to think of class consciousness past and present more polymorphously and perversely: its desires, its object choices, and its antagonisms are neither so straightforward nor so singular as they once seemed. Class has been queered. (2000, 13)

Queering class, in this second sense, may be what makes it visible. It is no secret that, in commercial popular culture, the class spectrum is compressed, the ruling class and routine (not criminal) poverty are strikingly absent, and wealth is way out of proportion to the world as we know it. The underrepresentation of lower-middle-class citizens and communities, for example, is paired with an overabundance of super-rich celebrities and corporate up-and-comers, and even modest family life is more luxurious and better-heeled on television than in the strapped neighborhoods of working parents and their children. That doesn't mean, however, that, amid this compression, the cultural engines of class distinction are quiet. They aren't, but we do need a more deconstructive analysis—a series of hypotheses and critical moves—than the familiar language of class types offers.

To capture queer-class distinction in the comparisons to follow, I argue that the interaction of queer characters and a queered form of class recognition in commercial popular culture are visible through four gestures across a range of narrative forms and genres: (1) good queers (protagonists, familiars) are moved from the class margins to the class middle, where practices of bodily control are maximized; (2) bad queerness and powerlessness are represented as class marginality and are signified by performative excess and failures of physical control; (3) wealth becomes the expression of fabulousness, in the limited version of the good life *legitimately achieved*; and (4) class is displaced onto family and familialism as the locus of normalcy and civic viability. In the class project of queer media visibility, in other words, comportment, family, and modes of acquisition become class markers of queer worth, pulling characters and scenarios toward a normative middle but not without exploiting an array of other class meanings and values.

This queer-class interaction has an economic logic: embedding enough fragmented class recognition to appeal to a range of consumers and still flatter those at the crest of advertising trade value and sweetening content with a measure of queer edge to draw newer, hipper, and younger audiences in the hyperdiversified landscape of popular forms. Within this economic logic, queerness delivers cultural expansion, a new commercial horizon broadened beyond old typifications of queer marginality but

well shy of heterosexual disarmament. In the case of television, it is a horizon fitted to the "post-network" era (Lotz 2004), a competitive context in which smaller, more-defined niche audiences acquire industrial value, cable outlets compete as targeted brands with each other and with more traditional broadcast networks, and distinction relies on a combination of old formats (for example, situation comedy, night-time soap opera, and family melodrama) and new themes and characters, queers among them. In this new environment, an audience of "socially liberal, urban-minded professionals" (Becker, quoted in Lotz 2004, 38) has a particularly high price tag for advertisers and thus a particular desirability for networks and production companies. Many producers and executives, gay and straight, are themselves a part of that audience, brokering class fantasies, queer trade value, and industrial ratings as they shuttle back and forth between the specialized domain of cultural production and more diffuse forms of meaning making in everyday life. It is through their creative, technical, and managerial labor that the class project of queer visibility takes shape.

HISTORICAL DISCOURSES

Queer media visibility also reenacts historical discourses of class and sexual hierarchy rooted in bourgeois projections of proletarian excess and failures of bodily control (compare with Stallybrass & White 1986; Kipnis 1999; Gamson 1998). Working-class persons, who are the majority core of the U.S. population and the demeaned periphery of its symbolic universe, are imagined as physically just *too* much: too messy, too ill, too angry, too needy, too out of control, too unrestrained, and, critically, too sexual. Consider, for example, the hostile discourse of "welfare dependency," dragged out and puffed up by conservative politicians and social critics whenever "fiscal restraint" and "family values" are the political capital of the moment. "Welfare dependents" expect too much and contribute too little. Their illnesses are imagined to be born of indulgent living, not overwork and deprivation; they are the parents— usually mothers—of "too many" children (born of accident, not choice); and they are too sexual, born of surrender to temptation, not human need or desire. No matter that the same practices are more generously or less shamefully received in affluent contexts than in strapped or poor ones.

And queer bodies? We are, in history and principle, a mess of inversion, temptation, abomination before God and government, anal fascination, unproductive desire, infantile drama, illness out of bounds, and consumptive decadence. Even our stereotypical strengths mark us as excessive: too stylish, too expressive, too aggressive, politically uncivil, too shameless or shamed, too vulnerable to mental anguish born of bodily condemnation, too needful of recognition, too funny, and, often, just too damn angry. It's a lot of excess to manage on one's way back into the fold.

But that is what the promise of mobility exacts. In class and sexual forms, travel from the outer limits to even the hypocritical edges of the charmed circle (Rubin 1993) demands management and bodily self-regulation. In lived circumstances, we can witness, for example, the personal desexualization volunteered by the aspiring gay professional and his lover described by James Woods in *The Corporate Closet* (1993). In a professional universe that has historically asserted a heterosexist double standard for the acknowledgement of one's sexual orientation, the obligatory dinner invitation to the boss has been accompanied by the banishment of the gay lover (who has spent the day cooking, cleaning, and readying the home to make the right impression) to the garage for the evening. Professional life and sexuality don't belong together, explain the gay professional and his lover (both self-laceratingly compliant, if not unrealistic), notwithstanding the boss's wife joining the invisibly catered festivities.

Although such an impulse appears to surface from the primordial queer past, it lives on in the recent endorsements of *Lawrence v. Texas*, the Massachusetts marriage decision, the good-faith testimony of Bette Midler, or the biting satire of Bill Mahar (both of whom weighed in, in 2004, against a Constitutional amendment banning gay marriage). All seek a same-sex extension of the sanctity of privacy or marriage as the proper platform for relations between two individuals and, in turn, between them and the state. Similar investments in marriage as social policy and management solution are extended to poor persons needing assistance (the "welfare dependents" alluded to earlier), whose numbers are disproportionately black, Latino, Asian, and Native, although whose greatest proportions—by far—are white. In a persistent recoding of class as race, poor and working-class persons of color bear a redoubled burden of the presumption of bodily excess (too strong, too weak, too fat, too sexual, too ill, and so on), and poor and working-class white persons are racialized and then sequestered as "trash," in contrast to racially unmarked white persons in the middle and upper classes (compare with McElya 2001). In popular culture, as in social policy, race is the key arbiter of class and sexual difference.

Like so many cultural impositions, such management means less the elimination of offending possibilities than their careful distribution. This is especially true in commercial entertainment forms, where success depends on an unstable chemistry of familiarity and risk, and where propriety *hopes* to meet sexual and other bodily fascinations, but in only the right places. Consider the case of gay sex. In such nonsubscription forms as broadcast television, even in the postnetwork era, gay is good and so is sex, but queer sex remains the object of labored consideration, caution, and aversion among program directors. Poor, sexless Will, had to make do through most of *Will & Grace* with the erotic charge of sitcom camp and the occasional, misbegotten roll in the hay with Grace. And even subscription forms like

cable television (with the important Showtime exceptions of *Queer as Folk* and *The L Word*), famed for their latitude and edge, claim the frisson of gay sex while also guarding the presumed modesties of their straight audiences. Miranda on *Sex and the City* may discover herself to be attractive to her law firm's senior partner and his wife *because* they mistakenly assume that she and her new softball friend are a professional lesbian couple, who might expand the boss's social circle in fashionable ways. But at her boss's home for the first and only time, Miranda-as-lesbian is cinched to the neck in desexualized attire, in contrast to her looser professionalism as her straight self.

On the same series, Samantha's lesbian sexual experiments are unrepentant and drenched in female ejaculate, but they are just that, experiments, and the series' one expressively gay character, Sanford, almost never has sex. Samantha's exploits are also reconciled by the general sexual character of the program, by her established pansexual appetites, and by gloss: Sex works best (if only on subscriber television) among stylish, attractive, well-dressed players.

I love Samantha. She is sexy, briefly queer, and exposes conventional pieties with witty intolerance. Her character straddles the class project of queer visibility, conforming to its demands for bodily control and consumer extravagance while resisting family attachment, save among her family of friends and her rare capitulation to babysitting. Recognizing her coy—and conspicuously white—position on the borders of class propriety, and recognizing as well the continuity of fantasy on television and off, my affection and others' should come as no surprise. We love Samantha because she is at once inside and outside the hierarchies we live by as natives or aspirants to the good life. It is also no surprise, however, that she was not the narrative or ideological anchor of *Sex and the City*, a position that went instead to the resolutely straight Carrie Bradshaw and the more bashful Sarah Jessica Parker.

The strategic comparisons to follow explore body, family, and modes of acquisition as key practices and markers in the class project of queer visibility. Ranging through sitcoms, wedding announcements, cable drama, and crime adventure, they also ask how race and gender specify the queer-class relationship, then return to the place of class fantasy in everyday life.

FAMILY TIES

To begin, consider the anti-canonic examples of contemporary televisual representation: not *Queer as Folk*, not *Ellen*, *Will & Grace*, or *The L Word*, but that other staple of the new visibility, the one-off secondary character in shows otherwise unmarked by sexual difference. In 2003, an episode of *My Wife and Kids*, a family situation comedy on ABC featuring a predominantly African American cast, had

the wife chasing her husband out of the house in a fit of domestic exasperation. The series is a vehicle for its male star, Damon Wayans, fondly known for his early sketch comedy on *In Living Color*, whose most outrageous bit was *Men on Art*, a community-access television spot in which two flaming queens opined about recent film releases with the sing-songy and now iconic slogan, "Hated it!" There was affection and nervousness for the audiences of that sketch, including black, gay audiences who loved the nuances but feared the reproduction of stereotype among nongay viewers (Hemphill 1995). But the character stuck, and Wayans resurrects it with every intertextual opportunity.

In this episode of *My Wife and Kids*, turfed from his own home, Wayans's character Michael Kyle goes to meet a male friend at a local bar and finds his friend running a line with a woman on her own. To mess with his friend's smooth operation, Wayans kicks into his *Men on Art* character, chastising his friend for running out on him and trying to hook up with the woman in the bar. So much falsetto, scene making, finger pointing, hip canting, lip protruding, hoochie posturing, and just plain bitching about cheating and broken promises mark the joke, whose female character retreats in horror, although whether she is disgusted by gayness, effeminacy, or duplicity we can't quite tell.

When the woman is gone, the men resume their deep voices and comradely back slapping, the first acknowledging that Michael had indeed scored in this bit of masculine grift, whose real losers are women and male effeminacy. It is an old joke, set in place long before *My Wife and Kids* (and practiced by such Wayans mentors as Eddie Murphy in the first installment of *Beverly Hills Cop*). Here, though, it is recycled and updated to meet current standards of queer media visibility: run the joke about a bad queer but disavow the hostility it expresses, preserve the normal family at the series' center by situating the joke outside the household, and make the gay type an out-of-control gold digger (who, in exaggerated homegirl speech style, protests the loss of future vacations in Negila), someone who acts out, who fails to know when not to make a scene, who is unproductively dependent on another's discreet desire and economic largesse. Performative excess marks the character's transgression of racial, sexual, gender, and class propriety amid the urbane elegances, hushed tones, and solo piano music of the bar and the subdued ruthlessness of the scene's sexual-moral economy.

An inversion of the joke in fonder form comes from a 2003 episode of *George Lopez*, like *My Wife and Kids* and many other family sitcoms (for example, *Roseanne, Home Improvement, The Bernie Mac Show*, and *The Hughleys*), a series based loosely on the real-life biography of its stand-up comedian star. In this episode, Lopez and his costars are joined by Cheech Marin as a former employee in the factory where Lopez's mother Benny (Belita Moreno) still works and Lopez himself has become a manager. A running theme in the series is Lopez not knowing for sure who his

father is, because Benny (in a friendly Chicana rewrite of the sexually active character Blanche and the irascible Ma from *The Golden Girls*) was quite the girl about town in her youth, and she makes no apologies in retrospect. A misunderstanding arises that moves George and his sidekick to visit the home of Marin's character, Lalo Montenegro, George believing that, in Lalo, he may finally have found his dad. George's mother knows it isn't the case: However inebriated she might have been one night forty years ago with her male co-worker, they didn't have sex. Lalo knows it, too, but longs for the possibility of finding a family late in life and, at least briefly, latches onto an identity as George's father. George, longing for paternal connection, latches back.

The twist, of course, is that when George and his buddy arrive at Lalo's home, they discover that Lalo is openly gay and lives with his boyfriend of many years. Here, the class formula for queer visibility begins to add up: Lalo is mild mannered, friendly, earnest in his desire for family to the point of an entirely forgivable projection of a nonevent some forty years earlier. His boyfriend, played by John Michael Higgins, is more broadly mannered in his characterization of gayness (not unlike his earlier performance as the owner of a winning Shih Tzu in Christopher Guest's *Best in Show*), but he too is hospitable and understanding, offering his guests bruschetta and, in his devotion to Lalo and his own interest in family bonding, willing to consider unofficially adopting a forty-year-old son. Together, the two men live in an attractive, well-kept home, considerably more stylish than George's and his family's, marking gayness (and an interracial relationship between a Chicano and a white man) as the route to mobility, and further marking class mobility and taste as the measure of gay legitimacy.

Overall, the episode is irresistible in its kindness (and its characters' resolve to relate "like family" even after the hope of blood kinship is dashed), partaking of the series' ethnically marked generosity toward modest departures from conventional propriety—like Benny's sexual troublemaking—in the name of humor. But its queer class logic is not so unlike that of the more hostile scene from *My Wife and Kids*. Good queers are modest, kind, hardworking—qualities that underwrite their ascendance from lower-middle-class respectability (Felski 2000). They also long for family even where they can't have it and are thus readily integrated into existing family formations rather than estranged. They are, finally, upwardly mobile and thus enjoy the stylish pleasures of mid-life legitimately achieved. Indeed, ethnic mobility and class arrival mark both narrative contexts. Wayan's gold digger (the bad queer) is sequestered from and thus identified in contrast to the deluxe image of suburban affluence of the featured household, whereas Marin's father figure (the good queer) is integrated into a more forgiving, less affluent, but still upwardly mobile extended family. Marin's character has controlled his desire, worked hard, established a life partnership, and maintained his family yearning. Consistent with the genre

conventions of situation comedy, love and recognition are his rewards. This outcome stands in contrast, say, to the loss and uncertainty in Berube's memoir, marked though it also is by some of the same feelings of queer class longing expressed in *George Lopez*.

The comparison of *My Wife and Kids* and *George Lopez* reveals a queer-class economy whose gifts and deprivations are echoed elsewhere. Civil union and other homosexual commitment announcements appearing in the Sunday edition of the *New York Times*, for example, also reproduce an equation in which a putative meritocracy meets quasi-marital attachment. Time was, wedding announcements were the society page, whose brides, grooms, and families illustrated an aristocratic stratum and whose denizens already knew each other, although mere subscribers and other readers were welcome to look on. But times have changed (Brooks 1997). In the new nuptial pool, a couple's family pedigree is less conspicuous (or necessary) than the partners' education and professional occupation, which may either match or exceed their parents', and this is true for queer and straight announcements alike. I'm always charmed when the union occurs between partners from economically modest backgrounds (one partner's father retired from retail sales, say, their mother from service as a pubic librarian, and they are themselves theatre scenics trained at Cooper Union and now working on Broadway). These, too, are white collar scenarios, but somehow their inclusion among all the unions fit to print feels like more of an accomplishment than those partners who've traveled the compressed distance from suburban Connecticut to Wellesley to Harvard to law firm partnership by the age of thirty-two and whose fathers were law faculty at Yale.

Both scenarios, however—the less and the more elite—speak to and through the discourse of measured accomplishment, however foreordained the latter. There are no featured partners, for example, whose fathers disappeared when they were toddlers and who are now marrying up after a lifetime of social assistance, high school withdrawal, and odd jobs (although it does happen). Instead, projections of careful upbringing and education combine with steady employment and interesting love stories about wacky first dates and the transformation of early rejection into settled attachments.

The straight version of this has existed for some time, but the recent, if contested, editorial welcoming of same-sex versions into the fold in 2002 widens the stage for queer legitimacy through a class ascendance marked by bodily control (love, not sex; marriage, not dating) and legitimate achievement (precocious lawyers and Broadway scenics). The punch line is good citizenship and happiness by national standards, in contrast to narratives of war and economic decline elsewhere in the paper. The unacknowledged cost is the compression of possibility and the misrecognition of other cultural equations and the persons who live them, probably including the very persons featured in the announcements.

There are no limits to what weddings reveal about American class life (compare with Freeman 2002; Ingraham 1999). Executives at Bravo knew this when they staged their *Gay Weddings* series, crosscutting among different same-sex case studies of the soon-to-be-betrothed. Some revealed a loathsome bossiness between class-stratified partners (the high-end taste top routinely snubbing his blue-collar boyfriend's picks in the choice-riddled universe of wedding planning), others a claustrophobic match between sex, class, taste, and aspiration unmediated—to my eye— by personal effervescence or insight. Still another witnessed a kindness between two partners who felt they'd finally found a soft landing together after years of awkward and unsuccessful gestures in separate attempts to meet heterosexual partners and standards. I watched them, Sonja and Lupe, and I liked them. They were good to each other—forgiving, tenderhearted, and a little shy. Sonja's teenage son by an earlier marriage liked Lupe and, as often happens, recognized his mother's sexual relationship with her before Sonja was prepared to talk to him about it herself. Their upcoming white wedding (both partners in gowns whose silken, swishy wedding aura there could be no mistaking) would be a ritual attesting to the "truth of the self," in their own terms. They had discovered their lesbianism together, and the deepest and most public recognition of that discovery would come at their wedding.

What's not to love in such a portrait? For me, this is truthfully a difficult question to answer. I wish Sonja and Lupe well (which is more than I can say for the other couples on the same episode), but, of course, I'll never know how they fare; the wedding, not the marriage, is the show's premise. But even this loveliest example, as full as it is of apparent good faith, is equally swollen with inexorability, with the language of marriage as destiny and maturity. In all senses of the term, especially the class one, marriage *consolidates*.

We see this echoed elsewhere in the program, as another couple acknowledges their intentions to a waitress serving them in a sidewalk café. "I didn't know men could marry in California," says the waitress. Technically, they can't, the couple explains, but they go on to describe the social, if not legally sanctioned, form of the commitment they intend to make. "Cool," the waitress responds, as she leaves the men to chat with gay friends about those straight persons for whom the prospect of same-sex marriage is unrecognizable. As in the *New York Times* announcements, there are three kinds of persons in the world: straights who support gay marriage, straights who don't, and queers who want to marry but can't and so do the next best thing. (For the moment, they can do the thing itself in my home state of Massachusetts.) The wedding-driven class form of the romantic couple (serious, sexually monogamous, mature, and consumer based for all the right, life-building reasons) is the saleable basis for a subscription television reality show about relationships, more so, say, than a program about all the creative, incomplete, contingent, and sometimes painful ways that individuals—queer and not—hook up. Add to this the innovation appeal of sexual sameness, and we have

Bravo's *Gay Weddings*, not Bravo Presents Relationship Experiments We've All Tried against the Grain of Confusion, Self-Doubt, and Social Demand.

It is no surprise, however, that entertainment genres do not interrupt the very fantasies they are designed to reproduce. Rather than imagining sitcoms and wedding announcements as failures of empirical realism, we can receive them more critically as expressing in queer class terms the limits of the fantasies now wrought. And each form brings a slightly different resource to the representation. Situation comedies offer a dense reduction of social desire in twenty-two minutes of typecasting and driven dialogue. *New York Times* wedding announcements and Bravo's *Gay Weddings* offer the heightened pleasure of a quasi-documentary form. Both are products of intense social, economic, and editorial management, but, in featuring nonactors, they invite us to deepen our attachments to the romantic possibilities represented. As members of the audience, we know that even nonactors' stories are carefully selected and crafted, but their claim to originate outside the technical regimes of media work (in the so-called real world) adds a blast of expectation for fans and skeptics: Cheech Marin, we know, stopped being Lalo Montenegro once the *George Lopez* episode was in the can, but the same-sex couple in the Sunday *New York Times*, enjoying the wisdom of mid-life romance and the pleasures of a tastefully appointed commitment ceremony, could one day be us or someone we know. Some may reject that prospect or find themselves ambivalent for personal and political reasons, but such reactions don't disqualify true story images of marriage as staples in the class project of queer visibility.

QUEER THERAPEUTICS

January, 2004 saw the debut of the long-awaited and much-promoted Showtime series, *The L Word*. "Same sex, different city" was the network's clever billboard caption, designed to draw audiences who would soon lose HBO's *Sex and the City* as it entered its final season. It was a brilliant bit of network scheduling: follow *Sex* and *Curb Your Enthusiasm* in HBO's Sunday night lineup with *The L Word* on Showtime, and see what materializes. Produced by long-standing queer independent Ilene Chaiken and directed by such young lesbian auteurs as Rose Troche (whose 1994 release, *Go Fish*, I consider a watershed moment in lesbian cinema [Henderson 1999]), *The L Word* promised what other queer portrayals lacked: lesbians, and lots of them; community; and explicit lesbian sex. On those promises, it has delivered, although some critics and viewers have complained about the purely nominal character of the lesbians thus depicted and the limits of a community rooted in latte. In fairness, no television first can be all things to all people, least of all while adhering to popular standards of glamour and melodrama. But stylization and formula on *The*

L Word's first season complicated a fair response, as characters moved through a universe largely devoid of personal history or political horizon but brimming with well-dressed, soft-core lesbian and heterosexual sex—the calling cards of a risky venture that would need viewers of many sexual dispositions to survive into a second season. Characters' sexual styles, moreover, were troubling. Leads had four fairly reductive choices: They could be consciously nonmonogamous and cold, maritally committed and destined for parenthood, confused and thus romantically unsuccessful, or closeted. Better, perhaps, to have four than one.

Consider *The L Word* version of that new emblem of televised, middle-class queer visibility. Not shopping—although the series is steeped in high-end good living—but couples therapy. The therapy scenes embody a certain expository efficiency: relationship dynamics are laid out and explained, and, in principle, the dialogue offers up potential character vulnerability. But they also accomplish the class project of queer visibility. In the debut episode, the lead couple, Bette and Tina, are deciding whether to pursue parenthood through donor insemination, and, together, they see a psychotherapist to consider their future as parents. Bette, a high-powered arts administrator, arrives late to the therapy session, crossing the office threshold while speaking into her ear-mic cellular telephone. Immediately, we question the symmetry of their commitment, because Tina arrived early and has already given up her corporate career in anticipation of starting a family. The therapist, a white man, notes that the two have been together for seven years and wonders whether the impulse toward childbearing might have something to do with a loss of sexual attraction—call it compensatory intimacy. Bette and Tina resist this interpretation, reframe their desire as "readiness," and, a little later in the episode, dismiss the therapist's cautionary questions with liberated indifference: "What does he know? We don't need his permission." Thus the characters bust out of one form of well-managed, middle-class maturity—therapy—and into another—pregnancy and family planning. From the therapist's office to the fertility specialist, body management and fee-for-service expertise converge and shift, from talk about commitment and intimacy to ovular record keeping and biotechnology.

Late in the first season, however, the series introduced a couple of dramatic wrinkles into Bette and Tina's story. Tina, who is white, had acknowledged her ambivalence about the possibility of an African American sperm donor, and Bette, who is biracial, was hurt and disappointed, although the program manages not to complicate Tina's response or render it in political terms. It remained a lifestyle choice, however misguided or insulting. In the end, when their intended (white) donor's sperm turns out to be inactive, they recruit an African American artist to serve as donor, a friendly, strapping guy who connotes nothing if not stereotypical black virility and who—we are frequently reassured, with the tenor of pedigree—is an *artist* whom Bette knows through her work, not just some black Average Joe or, worse, some young hood.

A couple of episodes later, when the fertility procedure works and Bette and Tina announce Tina's pregnancy to Bette's African American father (played by Ossie Davis), Bette responds to his hostility at the prospect of a grandchild who bears no blood relation with the reassertion of the artist status of the African American donor. Her father is unassuaged; indeed, he is incensed by the idea that, by virtue of skin color, he has anything in common with this man. He reminds Bette that she is Ivy League–educated and that her lesbianism confounds what she should be doing instead: extending her father's wisdom and mode of living.

The only regular black character on the program, Bette's half sister Kit, played by Pam Grier, is a cabaret singer and recovering alcoholic, whose depth of understanding comes at the expense of a difficult and mismanaged life. Grier is terrific, delivering the show's most reliably sentient performance. I can't help but wonder, however, if the predictable racial coding of her character doesn't frustrate her as an actor. The white characters are no less predictably coded, but their numbers mask the reduction, in contrast to Kit's racial singling out among leads.

Later still, Tina miscarries toward the end of her first trimester, and religious Right foes of Bette's art organization exploit news of the miscarriage as evidence of God's will against homosexuality. Finally, a moment of political drama. Amid the series' hyperprofessionalism, hypercommercialism, hyperconsumerism, familialism, and fashion-model standards of gloss, we do learn that queer family making is neither so easy nor so welcome, certainly no guarantee of broad social legitimacy. Bette's opponent from the religious Right has her own parental hypocrisy to conceal (her teenage daughter ran away from home and became a porn actress), but Bette's humiliation rests on the presumptions that what is private and painful oughtn't be involuntarily exposed and that enough members of the public who witness this disclosure during a fictional television program will secretly agree with the right-wing activist about queer procreation, even as they distance themselves from fundamentalist histrionics and mean-spiritedness. This episode of *The L Word* confirmed the political vulnerability of even the most socially conforming if aesthetically liberal lesbian who, moreover, cannot count on protection or support from her countertypically elite, African American father. It was a moment in the series' first season where queerness was scripted to complicate the routine forms of class entitlement signaled, among other places, in the therapy scene.

In its gothic version of a shaky, entrepreneurial, middle-class family, season three of *Six Feet Under* also used the dramatic device of gay couples therapy, rendering the scene visually as a triangle among three gay men: the white therapist; Keith, the African American partner in the troubled duo who, late in season two, lost his job as a cop for outbursts of anger on the job; and David, the oldest son in a white family of funeral directors whose founding patriarch died in the series debut. David's family bears all the marks of the barely domesticated haunted house from which they hail and in

which is located the funeral parlor, chapel, and exhumation lab. They are arty, quirky, suffering, economically unstable, volatile, and alternately kind and hostile toward one another. In most respects, save for his gayness, David is the most conventional of the group—not quite venturesome, the least openly self-destructive, the most rational, and accountable in matters of family business.

The dramatic characterization of Keith's family, by contrast, enjoys some of the anxiety but, as a secondary character unit, little of the fleshing out of David's family. They are a tense, ex-military clan with an oppressive and angry father and screwed-up sister whose child is dependent on family guardians, alternately Keith or his parents. Keith thus comes by his anger honestly, as the only son of a harsh and authoritarian father, but also stereotypically, as the only regular black character in the series. Although both partners—David and Keith—end up in therapy together, Keith is more conspicuously out of control at that point, a dramatization that combines at least two things: the pressures that attach to being African American and male in the United States and Hollywood's opportunistic brand of anti-positive-image courage, which figures that, since we've had the Huxtables, we can go back to loading black characters with rage and incompetence with only the minor risk of being accused of stereotyping. David, by contrast, is fearful of Keith's anger—he tells the therapist that he feels like he's living in a minefield, that he can do nothing right, that he is routinely subject to criticism. This Keith dismisses as a whole lot of whining, at which point the therapist (in what is, overall, an arch scene) reminds him that now is the time to listen, that his turn will come.

Thus, basic, if still difficult, rules of reciprocity and recognition in domestic relationships are laid out in the scene, which also articulates the conflict between David and Keith in classed and racial terms. Keith is a hothead from a military background—historically, a key context for African American upward mobility—who needs to learn anger management, that new form of self-governance whose pedagogy is routinely worked into court procedures and settlements in cases exacerbated by male aggression. David, on the other hand, is a civil but repressed and conflict-averse white guy from a middle-class family whose fortunes have been on edge since early in the series, as competing firms seek to buy out or disable family-operated funeral services in and around Los Angeles. Keith's professional specialty is sanctioned strong-arming, a position he loses, late in season two, through his own failures of control, landing him in the humiliating and downwardly mobile occupation of underpaid guard for a security firm that serves overendowed households. David, again in contrast, is a particular—if morbid—kind of body scientist, a funeral technician whose skill, exactitude, and social calm in the face of others' grief befit his race and class identification on the series. The difference is crystallized in the private (not court-ordered or agency-based) therapy scene, enough so that it is hard to remember that the class and racial types could be inverted, Keith becoming the

second-generation funeral director and David the hothead ex-cop. But that is not the narrative or representational tradition on which the scene trades.

On *Six Feet Under*, then, the visibility of Keith and David's queer relationship intensifies in the promising project of therapy—maybe that's where they can get the control and mutual recognition that will sustain a viable, quasi-nuclear, domestic scene rather than life in the clubs, on the street, or even in a more collective household. Later in the episode, for example, we do see them practicing lessons learned in therapy about recognition and tempered anger—tentatively, self-consciously, but in good faith—as they cook together at home. But that visibility also depends, I have argued, on a familiar race-class reduction that might have been otherwise structured or recombined, perhaps featuring a volatile middle-class type and a reticent upwardly mobile one. (David becomes volatile in the traumatic wake of an assault in the final season, in terms that trouble his class demeanor in the moment, if not in the overall race-class mediations of the series.)

Unlike its counterpart scene in *The L Word*, however, psychotherapy on *Six Feet Under* does preserve the sexual privilege of gay men in contrast to lesbians. "How's your sex life?" the therapist asks both David and Keith. "Great," says Keith, with an off-handed ease that registers in contrast to an otherwise tense scene. "Oh, yeah," says David, overlapping Keith's line, "that works." The trouble they're having is not expressed as sexual conflict; indeed, attraction and sexual involvement may be what save them. At the end of *The L Word*'s debut season, in contrast, the therapist's early inquiry about sexual malaise and troubled intimacy has resurfaced. We know Bette and Tina's life together is on the rocks because their sexual relationship has cooled and Bette—under the strain of political opposition and personal attack from the religious Right—begins an affair with an installation carpenter at the gallery where the controversial exhibit is being mounted. This is quite a different symbolic economy for representing the relationship between class and queer sex, and gender defines the contrast. In Keith and David's case, at least for the time being, sex is unburdened as the measure of maturity, stability, or class arrival; the relationship can be sour but the sex stay good, and sex with others outside the relationship does not constitute a betrayal. In Bette and Tina's case, however, sex is love, and sexual monogamy, like marriage on Bravo's *Gay Weddings*, consolidates their resources as a couple. An affair is not simply a matter of desire or the release of social and professional pressure; it is a more comprehensive crisis through which the world-as-their-oyster character of Bette and Tina's relationship begins to crumble. It is also a conventional cliff-hanger to resurface in the following season.

SEXUAL HEALING?

If middle-class propriety is a condition of good queerness, how does the representational field of popular culture make room for worthy, sexual queers from nonprofessional or

working-class circumstances? The answer is "infrequently." Still, bodily control and legitimate modes of acquiring things figure in working-class queer portrayals, and the comparison I make here—between *If These Walls Could Talk II* (2000) and the commercial independent feature *Set It Off* (1996)—returns to the interaction of race and class in marking queer worth.

If These Walls Could Talk II was the second of two HBO films to follow the life of a particular house over multiple decades and multiple dwellers. In the first film, the narrative theme was abortion; in the second, lesbianism. And in the middle vignette in part two, directed by Martha Coolidge, Chloe Sevigny as Amy and Michelle Williams as Linda persuasively pair up in the early 1970s as a working-class, motorcycle butch and a college lesbian feminist. Surrendering to the attraction her roommates deride as patriarchal, Linda arrives at Amy's home one evening to return a shirt borrowed earlier during the college group's slumming in a local butch/fem bar. In this modest, clean, and well-organized apartment, Amy seduces Linda with a degree of butch top expertise, stealth, and tenderness rarely performed in commercial or even independent portrayals.

Despite her nervousness about the sexual form she is about to undertake, Linda has no regrets, and, thus, the scene becomes a familiar but still heartening rendition of butch/fem seduction across class lines, where blue-collar butch sexuality is expert, not merely aggressive, and commanding, not cowed by middle-class entitlement or derision, even as Amy is shy and otherwise self-conscious. Her sexiness makes Linda, and the audience, happy for the liberatory discovery, not shamed by a supposedly antifeminist reproduction of gender difference. They have talented butch/fem sex, and, within the context of the scene (which includes their ballsy delight in response to a shocked neighbor who witnesses their goodbye kiss on the porch), there is mercifully no irresolution, no regret, no apprehension, no price to pay. But in its stealth and stylization, its shy seduction, and its economy of sexual gesture (Sevigny wastes no moves), there returns the image of physical management, even in the service of desire. It's *controlled* sex, whose control is at once sexy and proper against the grain of gender variance between the two women.

Such a scene stands in marked contrast to another butch/fem love scene released a little earlier in *Set It Off* (1996), an independent bank heist feature directed by F. Gary Gray. The film is vaguely reminiscent of Kathryn Bigelow's *Point Break* but stars a band of four young, African American women (instead of five young, white, male surfers) frustrated by underemployment, systemic dismissal, police brutality, and living in the sweltering projects of South Central Los Angeles. One of the four, Cleo (played with love and candor by Queen Latifah), is a butch lesbian who customizes her car with the latest chrome and hydraulics. She lives in her garage where we find her mid-plot, seducing her voluptuous, short-haired, peroxide-blond girlfriend, for whom she has bought some sexy, luxurious, black underthings with

part of her take from the recent heist. It's a nice scene (notwithstanding the fem's curious lack of lines or vocalization), until the other three partners in crime (played by Vivica A. Fox, Kimberly Elise, and Jada Pinkett, the brains behind the operation) arrive at the garage and respond with contempt to Cleo and her girlfriend.

It isn't clear, however, that it's the sex that's upsetting them, so much as Cleo's profligacy—she has spent a lot of money on her girlfriend and the car—and her lack of foresight. They need more money and they need to plan, not hang out having sex on the bed in the middle of the garage, where any attentive police officer might notice the influx of cash. Stony (Pinkett) chastises Cleo, who responds with violent defensiveness and, briefly, despite their having been friends for life, with a gun to Stony's head. With steely determination at the end of a gun barrel, Stony tells Cleo that she is "real high, and acting real stupid, and better get that thing the fuck out of my face." Agitated, Cleo complies.

Toward the end of the film, Cleo is among the first to die in a grossly overpopulated confrontation with police; she sacrifices herself in the hopes of sparing the others (although only Stony survives) by driving her car pell-mell into a police blockade. It's a heroic sacrifice but, like Cleo's actions in the garage, it is also impulsive. In contrast to Amy's butch sexual prowess in *If These Walls Could Talk*, Cleo's sexuality is part of a pattern of self-destruction: sexy, yes, but out of control, the only lesbian character among the four friends and the one who doesn't plan, spends too much, and gives in to temptation. In her character, the excesses of black poverty and lesbianism converge, in contrast to Amy's white modesty and self-taught skill as mechanic or to Stony's intelligence, femininity, smooth light skin, and good looks, all of which qualify her for an upwardly mobile love affair with an African American banker (played by Blair Underwood) and ultimately for a lonely survival in Mexico endowed with stolen cash. Amy's legitimacy is rooted in settled living and sexual control, whereas suicidal loyalty is Cleo's redemption, a high price to pay as the class formula for queer visibility reasserts itself against the black butch. As is often the case through illness and violence, Cleo becomes a good queer when she dies.

THE CLASS PROJECT OF QUEER VISIBILITY

The terms of my criticism are designed less to dismiss innovations in queer programming as simple reproductions of class or race dominance than to explore with greater attention the ways in which class appears, structuring queer difference and in turn responding to the specificity of queer representation. This is not a survey of queer class types but a mode of analysis that interrogates patterns of comportment, familialism, and the legitimate acquisition of the good life in the commercial ratification of queerness. My examples are wrought largely from the media mainstream and other

sectors make visible other patterns. Berube, for example, names and explores what *The L Word* only deploys. What is conspicuous, however, is the availability of class difference for producing queerness (a different conclusion than "all media queers are rich and white"; they aren't) and the dense and constrained conditions of class representation in queer visibility. In a series of discursive turns at once ironic, powerful, and incomplete, class variance is exposed but appears in the service of pulling queerness toward a normative middle. Queerness, in contrast, does not yet—or any longer—exert enough countervailing force to pull class difference back from the river of bourgeois dominance to the radical field of class critique.

These conditions speak to a particular historical moment, dating from the early 1990s but with a postwar lineage (Gross 2001), as social possibilities and industrial arrangements are reshaped. The evolution of cable television and of niche audience formation in such other media as theatrical film have met changing sociopolitical conditions in the lives of some—but not all—gay and lesbian persons. On the one hand, this makes for nongay interest in gay characters, like Michael on *My Wife and Kids* and Lalo on *George Lopez*, and, on the other hand, for queer-identified audiences willing to pay for programs of their own, like *The L Word*. Producers and marketers have created this niche, not discovered it, but have done so as commercial interests long have: by catering to or exploiting historical deprivations of images and recognition, at a moment when the industrial risk is worth it. Showtime, home to *The L Word* and *Queer as Folk*, has branded itself as the cable outlet for courageous because sexually explicit queer programming, a brand promoted precisely in contradistinction to conventional network anxiety about so much as a gay kiss.

In one-off characters like Lalo Montenegro we have, arguably, an image of assimilation, the presence of gay characters on straight terms, and, in a series like *The L Word*, the contrasting presence of lesbians on lesbian terms, an image less of assimilation than cultural difference and community integrity. But, although I think that the distinctions and accomplishments of *The L Word* ought not be overlooked and that we should not dismiss the kick of recognition that makes even the most skeptical lesbian viewers subscribe, I have suggested that class markers of queer worth in both contexts are deployed to bring stories and characters into line with dominant discourses for dominant and nondominant audiences alike.

Those markers, finally, organize not only the concentrated narratives of popular culture, but also the diffuse and contradictory partial narratives of everyday living. The most visible fantasies commercial culture offers are not a world apart, but a part of our world, elements of a continuous cultural stream in which ideologies of class and queer worth rooted in managed bodies, family attachments, and legitimately acquired things are as likely to surface off television as on. The politics of my critique, then, do not claim that adequate representation in commercial culture will promote adequate political representation in social life or that, as critics, we

ought to expect that popular media will ever deconstruct popular fantasy. Instead, I suggest the continuity of affective investments inside the media and out, in a universe where people *really do* enjoy, endure, and equally suffer the terms of existing class projects, including the class project of queer visibility.

REFERENCES

Berube, Allan. 1997. "Intellectual Desire." In *Queerly Classed: Gay Men & Lesbians Write about Class*, 43–66. Ed. Susan Raffo. Boston: South End.

Brooks, David. 1997. "New-Class Nuptials. " *Urbanities 7.3*. Available at http://www.cityjournal.org/html/7_3_urbanities-new_class.html.

Caplan, Cora. 2000. "Introduction: Millennial Class." *PMLA 115.1* (January): 9–20.

Felski, Rita. 2000. "*Nothing to Declare*: Identity, Shame, and the Lower Middle Class." *PMLA 115.1* (January): 33–45. Available at http://www.engl.virginia.edu/ritafelski.

Freeman, Elizabeth. 2002. *The Wedding Complex: Forms of Belonging in Modern American Culture*. Durham, NC: Duke University Press.

Gamson, Joshua. 1998. *Freaks Talk Back: Tabloid Talk Shows and Sexual Nonconformity*. Chicago: University of Chicago Press.

Gross, Larry. 2001. *Up from Invisibility: Lesbians, Gay Men, and the Media in America*. New York: Columbia University Press.

Hemphill, Essex. 1995. " '*In Living Color*': Toms, Coons, Mammies, Faggots, and Bucks." In *Out in Culture: Gay, Lesbian and Queer Essays on Popular Culture*, 389–402. Ed. Alexander Doty & Corey K. Creekmur. Durham, NC: Duke University Press.

Henderson, Lisa. 1999. "Simple Pleasures: Lesbian Community and *Go Fish*." *Signs: Journal of Women in Culture & Society 25.1* (Autumn): 37–64.

Ingraham, Chrys. 1999. *White Weddings: Romancing Heterosexuality in Popular Culture*. New York: Routledge.

Kipnis, Laura. 1999. "*Disgust and Desire*: *Hustler* Magazine." In *Bound and Gagged: Pornography and the Politics of Fantasy in America*, 122–160. Durham, NC: Duke University Press.

Lotz, Amanda D. 2004. "Textual (Im)possibilities in the U.S. Post-network Era: Negotiating Production and Promotion Processes on Lifetime's *Any Day Now*." *Critical Studies in Media Communication 21.1* (March): 22–43.

McElya, Micki. 2001. "*Trashing the Presidency*: Race, Class and the Clinton/Lewinsky Affair." In *Our Monica, Ourselves: The Clinton Affair and the National Interest*, 156–174. Ed. Lauren Berlant & Lisa Duggan. New York: New York University Press.

Ortner, Sherry B. 2003. *New Jersey Dreaming: Capital, Culture, and the Class of '58*. Durham, NC: Duke University Press.

Rubin, Gayle S. 1993. "*Thinking Sex*: Notes For a Radical Theory of the Politics of Sexuality." In *The Lesbian & Gay Studies Reader*, 3–44. Ed. Henry Abelove, Michele Aine Barale, & David M. Halperin. New York: Routledge.

Stallybrass, Peter, and Allon White. 1986. *The Politics and Poetics of Transgression*. Ithaca, NY: Cornell University Press.

Woods, James D. 1993. *The Corporate Closet: The Professional Lives of Gay Men in America*. New York: Free Press.

Talking Gay

TODD MUNDT

I have been thinking off and on for the past year about how queers talk about being gay or lesbian, bisexual, or transgender and how that conversation occurs in the media. Lesbian and gay political culture is at a crossroads. Three developments mark the first wave of a massive change that will sweep over U.S. culture in the next ten years. First is the unprecedented interest that mainstream media lavish on LGBT characters and plotlines. Second is the development of alternative niche streams of content designed especially for the LGBT audience—from *OutQ* on Sirius Satellite Radio to the DirecTV pay-per-view channel devoted to gay and lesbian films to the much-talked about new gay channel, Logo, that Viacom plans to launch. The third development is a coming cultural and political change, which is not fully realized yet, and may not be for some time.

At least three contexts require juggling: how queers are using media resources we have, how media represent us to ourselves and the rest of America, and media's role in advancing or hindering the cause of gay rights. Columnists and speakers have declared this a new gay era on mainstream television and radio. When it comes to certain individual programs, queers have made inroads. *Will & Grace* remains a phenomenon, and its success ensures there will be spin-offs. The networks have tried developing other gay sitcoms to copy the winning *Will & Grace* formula. So far, they have not succeeded, and the only consistently gay programming to enjoy success on prime-time television has been reality shows like *Boy Meets Boy* and *Queer Eye for the Straight Guy*.

Most media content makes gays and lesbians the butt of jokes and reinforces stereotypes. Some think these programs will have a deleterious effect on perceptions of gays and lesbians, but I think their effect is somewhat mixed. Jack on *Will & Grace* may be a highly stereotypical rendering of a gay man, but he serves at least two purposes that are not easy to dismiss. He provides a nonthreatening way for many millions of Americans to get a taste of gay life, however artificial. He is also manna from heaven for many thousands of gay men who thirst to see representations of themselves on television, even ones as crudely constructed as Jack.

A couple years ago, I interviewed the author of a book about the growth of the African American presence on television over the last fifty years (Bogle 2002). He sketched those first African American television roles this way: Blacks are the butt of jokes, the characterizations are rudely drawn caricatures laden with distasteful stereotypes. But that rather ignoble beginning leads to slightly better sitcom roles, then to early dramatic roles, and gradually toward a fuller acceptance of African Americans in serious and significant dramatic roles.

This process is not over yet, but everyone can see how television has struggled and achieved some success in presenting real, flesh-and-blood, African American characters. This progression will probably repeat itself with gay and lesbian characters, and the stereotypes certainly will not suffice for long. Already, there is a hunger for more carefully developed dramatic roles for gays and lesbians, the majority of them on the pay channels, away from some of the pressures of audience and advertising.

HBO and Showtime took more risks with *Queer As Folk, Six Feet Under,* and the lesbian drama *The L Word. The L Word* had such a large audience that Showtime renewed it for a second season after just two or three shows. These shows either are not in the mainstream or, in the case of *Six Feet Under,* reside at the upscale edge of the mainstream market. For a long time to come, that edge will be where to find much of the better content. The other home for serious dramatic and real portrayals of our lives will be PBS.

PBS needs to develop more significant content for the LGBT audience. Public television and the independent producers who serve as the source of much of its best content are best positioned to present a complex, nuanced view of lesbian and gay life in America. They need to encourage producers to search the American landscape for the personal stories of LGBT brothers and sisters. The stories can be alternately serious and entertaining, heartbreaking and joyous, but must be boldly produced and presented. To do this, PBS will have to grow a spine. The network will have to present programs of the highest standard to its audience and then prepare to defend those programs, should they come under attack, from a position of strength.

Here is the strength of PBS: The media landscape has been completely transformed in the last decade. The corporate conglomerates now own most of commercial broadcasting in the country. Who remains? Public broadcasters are the last

locally owned and locally managed media organizations. They are also the stations most closely connected to their communities and most free of the concerns over ratings and advertising, which have produced the bland sameness of commercial broadcasting. PBS has yet to embrace this reality fully and fearlessly. If it can do so, the network will secure a rightful place as the unifying force in American culture. It will be the hub of the American conversation about vital social, cultural, and political issues. That conversation will include the issues queers care about most.

It sounds like I'm making a pitch for queers to support your local PBS station—and I am. Here's why: NBC, Bravo, and MTV are producing gay-themed content because it's cool, it attracts an audience, and it sells—for now. The moment it doesn't, *Will & Grace* and all those other shows will disappear. Only one over-the-air network is not based on the premise of delivering viewers' eyes to a group of advertisers: PBS. Its mission is, ideally, to serve viewers. A reformed, rejuvenated PBS with a renewed purpose has the potential to produce the most significant program service for the LGBT community. The transgender community's best hope is PBS.

The content that exists on the mainstream or near mainstream channels is vital. It serves a purpose of showing stylized versions of our queer selves. Its most important work is in providing a view of gay and lesbian life—yes, with all its exaggerations—to the straight world. It is not going to serve fully the needs of those who want to know more about lesbian and gay history or LGBT heroes, but it will provide a subtle socialization and normalization, which lays the groundwork for some of the political battles to come.

A second stream of developments in media is the appearance of channels that speak directly to members of the lesbian, gay, bisexual, and transgender community. *OutQ* has the dubious distinction of being located on the smaller of the two satellite radio services—Sirius, a distant second to XM. But *OutQ* also streams on the web, just as the older, now-defunct *GayBC* did. John McMullen, the one responsible for *GayBC*, is the mastermind of *OutQ*. Michelangelo Signorile has a daily talk show in the afternoon and is doing some great work. He is a solid interviewer with a surprisingly strong point of view. *OutQ* has potential, and Sirius may deserve a second look as a show of support for its decision to serve the relatively underserved queer niche.

The plans for Outlet are uncertain. Viacom has shown some interest in reaching the queer market, and the gay-friendliness of networks like MTV, Showtime, and Sundance Channel is a good sign. Outlet should devote some of its time to telling queer history. Too many of us are blissfully ignorant of our lesbian and gay history and heroes. Gay media should help to correct this deficiency. The network should take seriously its role as a forum for a variety of political views. Just as MTV and Tabitha Soren energized the youth vote in the 1990s, queer television needs to energize LGBT voters to be aware of the most important issues and a variety of viewpoints.

The kinds of gay-themed shows airing on television and radio may have a long-term impact on the political issues that so many lesbians and gays consider important. The representations stand alongside events that have created a paradigm shift in this conversation. The June 2003 Supreme Court ruling in *Lawrence v. Texas* focused the discussion on issues of equality and the eventual debate over gay marriage. In November of that same year, the Massachusetts Supreme Judicial Court ruled same-sex marriage legal. Issues like equality for gays and lesbians, workplace discrimination, and even marriage are more often now framed using the ideas of equal protection and fairness, and that shift is going to have a long-term impact on how straight, white, relatively conservative, middle America views us.

I could say that media played a leading role in the reframing of this debate, but I don't really think that's true. The news is a weird animal. It pretends or tries to be objective, but that is nearly impossible. So what readers get is a bunch of conservative liberals, who try to bury our queer stories deep within the paper. Or we get schizophrenic coverage, cheering our fight for equality one moment and expressing deep concerns about the same issue the next.

At moments, the planets align, and something truly amazing happens. We experience earth-shattering events in our queer history, but they remain a sleeper for some of us. In February 2004, Gavin Newsome, the mayor of San Francisco, asked the city clerks to remove all references to gender on marriage licenses. On February 13, 2004, the front page of the on-line *Washington Post* carried the picture of Phyllis Lyon and Del Martin, a lesbian couple together for fifty years, who married in a hasty ceremony the day before. The article said that about eighty gay couples had rushed to City Hall to get married. As I read the article, I thought, "Well, there's a stunt that's probably going to backfire," and clicked to the next story. That day, hundreds of couples flocked to City Hall, where they stood in line, got marriage licenses, and promptly tied the knot. Saturday, the city started asking them to take a number. The story continued to grow through the weekend.

A few weeks later at a news conference, Chicago Mayor Richard Daley said of gay marriage,

> A lot of people are opposed to it. So be it. But again, you have to point out the strength of that community—they're doctors, they're lawyers, they're journalists, they're politicians, they're someone's son or daughter, they're someone's mother or father.
>
> They're parents, and I have been with them. They've adopted children. They have wonderful children. To me, we have to understand this is part and parcel of our families and our extended families.
>
> We have to understand what the gay couples have been saying: They love each other, just as much as anyone else. They believe that the benefits they don't have, they should have. And so I have a very open mind on it. (quoted in Steph Smith, "Chicago Mayor Supports Gay Marriage," *365Gay.com*, 18 February 2004, http://www.365gay.com/)

At that moment, my hair stood on end. This was big, really big. At that moment, all the pieces came together: Significant members of the straight community were showing support for gays and lesbians and for what many of us consider to be the ultimate right. Until then, I did not fully understand the power of images to shape the debate: first the photo of Phyllis and Del in San Francisco, getting married, then the newspaper and television reports showing male couples their thirties holding children, waiting to exercise their right to marriage. Ordinary-looking individuals of all ages standing together in pairs, shedding tears as they celebrated a rite that others take for granted, was a powerful image.

Conservatives continued their shrill harangue about the harm that it would do America. But the media coverage—the video of those couples, their pictures in the papers—caused a subtle rephrasing of the issue. The Christian Right wanted to talk about how allowing gays and lesbians to wed would harm the institution of marriage. The pictures forced a different question to straight, somewhat homophobic, America. Those pictures asked, "How does allowing these people to marry hurt you?" The question has forced many Americans to reconsider their opposition to gay marriage, a hugely important step that happened because of the power of media.

With a few notable exceptions, the media are friends to the queer community, but there is plenty of room for improvement. Mainstream news media need to make their coverage better in at least one important way: by presenting multiple viewpoints on marriage from within the queer community, including those who don't want marriage. NPR News has done a particularly good job of seeking out queer individuals from across the spectrum on the marriage issue. Airing a multiplicity of viewpoints does the issue a good public service and helps the rest of the world understand the complexity of viewpoints inside the community.

Queers need to support filmmakers and producers and journalists among our community, so that they can produce the content that gets noticed in the mainstream media, so they can succeed in telling our story.

The queer community has to be quicker on our feet, responding in the media when opposing forces attack. The Human Rights Campaign (HRC) and other organizations are getting better at rapid response when conservative Republicans or the Christian Right spread inaccuracies or hate. When they level charges against us, the queer community has to be ready to hit back.

Part of setting an agenda for how the media should cover queer issues involves striving to present more of our lives, striving to present our concerns more widely to mainstream media, by increasing the kinds of channels we use not only to talk to each other about these important issues, but also to reach out to mainstream media. Five hundred channels offer the opportunity not merely for five hundred showings of *Friends* but also for programs and services that meet our needs. Why not? When multichannel television allows, at a low cost, the transmission of multiple

streams, why not have three or four gay television channels? Public television and other television stations are moving in this direction right now.

This is the sort of discussion queers need to have among ourselves as we find new ways to express ourselves to each other and to straight America. The process is a part of strengthening our community bonds and increasing the respect we need to have for our own community.

REFERENCE

Bogle, Donald. 2002. *Primetime Blues: African Americans on Network Television*. New York: Farrar, Straus & Giroux.

Part IV
Queers in Cyberspace

Queer on Line

STEVE JONES

The year 2004 was something of a milestone for the internet. October 2004 marked ten years since Tim Berners-Lee, the inventor of the web, founded the World Wide Web Consortium. It was fifteen years since Berners-Lee proposed the hypertext system that became the web. It was forty years since Paul Baran laid out the idea of packet-switching networks, thereby laying the foundation for internet infrastructure. How much has the internet changed since then? Enormously, and in particular between 1994 and 2004.

Research on the social consequences of the internet has also changed a great deal. The last ten years or so have produced a veritable flood of research on internet social aspects. Before the mid-1990s, when considerable research focused on the effects of computer-mediated communication (CMC), it was common to find studies of its impact on productivity in the workplace but uncommon to find much—with some notable exceptions, such as the work of Ron Rice (Rice 1984; Williams, Rice & Rogers 1988)—about social support. Now there are reports and studies of on-line communities, interest groups, mailing lists, chat rooms, web sites, social networks, and numerous other on-line social phenomena. There are internet research institutes at a few universities and a full-blown Internet Studies Ph.D. program at Curtin University in Australia.

Despite increasing scholarly output across numerous disciplines that takes aim at internet consequences and influences, precious little scholarship has anything

to do with sex, sexuality, and sexual identities on line. While working on the *Virtual Culture* anthology (Jones 1997), I could find only one person studying queers on line, David Shaw, who was then a doctoral student at the University of Colorado. David began his fine essay with a quote from Roland Barthes, and then wrote,

> If, as Barthes illustrates, love is most readily understood in the physical absence of the lover, then perhaps the best way to understand communication lies in the uncharted territories of cyberspace where men sit alone at their keyboards producing and inscribing themselves within interactive texts of homosexual desire and need. (Shaw 1997, 133)

David interviewed a dozen or so gay men who used an internet chat room. So, yes, there are queers in cyberspace. Scholars know that. But beyond knowing that, we know little else. In fact, we cannot even be certain that they "sit alone at their keyboards." We do know that teenagers, in particular, use the internet for health information, especially related to sex education and sexual health. In a 2001 report (Lenhart, Rainie & Lewis 2001), the Pew Internet and American Life Project found that 40 percent of teenage girls and 26 percent of teenage boys who use the internet look for health information. As one girl, age fifteen, noted in a focus group for that study, "Health and body issues is the topic that sticks out in my mind when it comes to sensitive subjects that can be researched on line." Or, as another girl said, "It's less weird and cheaper than going to a doctor to ask."

Part of the reason so little empirical evidence exists about queers on line may be the difficulty of studying matters of sex and sexuality on the internet. Quite often, when someone learns that I work with the Pew Internet and American Life Project, the first question asked is what we have learned about on-line porn. Sex and porn are almost unavoidable on line, and the public wants to know how prevalent it really is and what to do about it. In truth, in our research, we have learned just about nothing about porn on line. Our primary research method is the telephone survey. Random digit dialing around the country and asking interviewees about their use of internet for porn is not likely to yield many useful or trustworthy results. Even asking questions about sexuality would cause many, if not most, of our respondents to hang up on us.

Trying to use the internet for such research would be even more difficult. First, there would be the spam filters that would no doubt block e-mail messages we would send to invite participants, unless we cleverly disguised words like *sex* to a degree that we could never be sure whether the questions asked what we would like to know. But the more important problem with using the internet for the research would be the difficulty of overcoming respondents' fears. Given numerous news stories about on-line sexual predators caught in law enforcement stings, would anyone trust us? And should we trust those who would trust us? (And would we get in trouble ourselves?)

Of course, researchers have managed to study other harmful, dangerous, or illicit behaviors, such as drug use, often with good results. Why should the internet be more difficult? In part, the problem springs from the never-ending alarms that technology companies sound and the media report, making the internet out to be untrustworthy. Were the public to heed all the dire warnings about the internet, ranging across what it could do to our computers, to our credit ratings, to our bank accounts, and even to ourselves, we would have quit using the internet by now, if we had the temerity to begin using it in the first place. But that is not the prime source of the difficulty, because, after all, most users seem to trust others on line—to a point. The primary reason is that gaining trust on line is difficult beyond the initial, basic level first established. An internet user is a curious and contradictory mix of low alert and high suspicion, willing to part with all sorts of personal information but dubious about the identity of most other users on line.

David Phillips's essay offers insight into trust and identity. His ideas can help teach more about what it means to be queer on line, not only in the sense of the visual and textual representation of queer identity, but also in relation to the traces that on-line activities create and leave. I am convinced of the need to think further about the connections he draws between performance and context, because, at least at present, I would argue that the internet is largely about performance and context. If one were to replace the word *identity* with the word *performance* in the numerous theoretical interventions into on-line life, the result would leave agency foregrounded in ways that, thus far, internet studies have overlooked.

What is urgent, however, is that the ideas Phillips sets forth be put into practice in scholarship. The next iteration of Internet Protocol, IPv6, is to include unique identifiers in every device and every message, in every packet, transmitted and received. Router-level control of internet connections promises more forceful and stringent limits on access to the internet. In short, internet infrastructure is changing. The implications for surveillance are staggering, of course, but more so are the implications for performance and context and for scholarship.

The internet is still in flux, in many ways, and its history is unwritten. Gay and lesbian communities (and individuals within those) played key roles in the development of elements of CMC that users today take for granted. Little historical work about the internet has been undertaken, and now is the time to begin interviewing, while many of those involved in its initial development are still alive and willing to discuss, recollect, and reminisce. It is important to approach internet history from a critical standpoint. Like the hypertext links that provide the base for the web, the multiple histories of the internet are not linear but connect and reconnect in interesting ways within and outside the on-line realm. Rather than lumping together the groups on the Whole Earth 'Lectronic Link (Well), to cite an easy example, one could tease out the histories of individual groups and note the connections between

them. That might reveal something about the multiple dimensions of group and self-identity and about the roles the gay and lesbian communities played in relation to and within other communities in the early days of the internet.

The connections between on-line identity and life off line are where one must go, I believe, to understand to the consequences of the internet for social interaction. Han Lee does just that (Chapter 12, pp. 243–260), integrating race and ethnicity into an understanding of queer identity on line. Lee notes that queer communities "played a vital role in the early transformation of internet technology into sociable media" (p. 244) and provides a sterling example of how to interrogate identity—queer, on line, and racial—to provide a valuable understanding of the seemingly contradictory fluidity and fixity of identity and social relations.

Perhaps at no time in one's life is identity more fluid than during youth (particularly adolescence), and yet it is also a time when one may feel trapped, that one's identity is forever fixed and unchanging. One of the most important factors in adolescent development must be the media, at least when it comes to matters of identity, for, through the media, young persons learn about and discover the plethora of identities in the world. For most youths in the West today, the concept of the media is impossible to imagine without the internet, and it is just as hard for them to imagine a world without the internet. The pervasive invisibility of homosexuality, about which Larry Gross writes, is now bisected by a visibility in media and cultural products, as he notes, complicated by the availability of ready communication with and among homosexual members of across cultures, backgrounds, and ethnicities.

But I suspect that, as Gross writes, "most young lesbian, gay, bisexual, and transgender youths still find themselves isolated and vulnerable" (see Chapter 13, pp. 261–278), no matter how much the internet can give them a space to be themselves, because to do so truly would be to integrate their identity into everyday life and not sequester it for use only during on-line communication, to trade in effect a figurative closet for a virtual one. The virtuality that makes the internet a playground for role games, gender bending, and other types of experimentation also hints at the fluidity of identity off line and likely makes it difficult for the young to understand that identity can be integrated. No matter how provocative and downright fun it may be to consider virtual disembodiment, cyborg theory, or William Gibson's ideas about cyberspace, humans do not so easily disassemble into bodies and projections, experiences and expressions, or words and bodies.

That caveat does not rule out positive outcomes. Gross notes a sense of community belonging and social support, as well as the creation of a community safe enough that many youths feel comfortable coming "out on line before doing so in so-called real life." But it is also clear from Gross's essay that internet use does not ameliorate everything. And so I return to David Shaw's poignant image of the physically absent lover, in "the uncharted territories of cyberspace," sitting alone at the keyboard

"producing and inscribing" the self "within interactive texts of homosexual desire and need" (Shaw 1997, 145). What transpires on line researchers can observe and may try to understand, but what occurs at the keyboard we still do not know, and we know next to nothing about the connections between what occurs on line and what occurs in other aspects of life. As a result, we know a little about queers on line, and we know even less about what it means to be queer on line. But as the essays in this section show, perhaps now we have begun to learn.

REFERENCES

Jones, Steve, ed. 1997. *Virtual Culture: Identity and Communication in Cybersociety*. Thousand Oaks, CA: Sage.

Lenhart, Amanda, Lee Rainie, and Oliver Lewis. 2001. "Teenage Life Online: The Rise of the Instant-Message Generation and the Internet's Impact on Friendships and Family Relationships." Pew Internet and American Life Project. Available at http://www.pewinternet.org/pdfs/PIP_Teens_Report.pdf. Accessed 5 February 2006.

Rice, Ronald E., ed. 1984. *The New Media: Communication, Research, and Technology*. Beverly Hills, CA: Sage.

Shaw, David. 1997. "Gay Men and Computer Communication." In *Virtual Culture: Identity and Communication in Cybersociety*, 133–145. Ed. Steve Jones. Thousand Oaks, CA: Sage.

Williams, Frederick, Ronald E. Rice, and Everett M. Rogers. 1988. *Research Methods and the New Media*. New York: Free Press.

Privacy, Surveillance, or Visibility

New Information Environments in the Light of Queer Theory

DAVID J. PHILLIPS

Surveillance studies can offer queer studies an understanding of the infrastructures mediating new forms of identity practices. Queer studies can offer surveillance studies a theoretical perspective on the social consequences of those practices. Together, they offer a framework for the analysis of infrastructures of identity and visibility. Research should focus on how infrastructures permit individuals to claim an identity within a social context and how they enable subcultures to generate knowledge. Not restricted to techniques, analysis should include the institutional adoption of techniques, to expose, demystify, and appropriate the mechanisms that produce social truth.

Increasingly, daily life is identified and monitored. One's movements, transactions, and communications translate into data, become commodities, and are analyzed. Many scholars and activists see the rise of these practices as a ground shift in social relations and social power. Yet there remains, especially in the United States, a schism between scholarly understanding of the shift and its articulation with political or legal responses. Scholarship tends to focus on the paradigm of surveillance to understand the implications of new practices of information processing, whereas law and policy tend to focus on the paradigm of privacy. The chasm remains because scholars have been unable to find in surveillance theory the ethical or political doctrines that would replace privacy doctrines.

Meanwhile scholars of gay and lesbian studies and queer theory have reached a pause of their own. Much of their work has attended to the public representation

of gay and lesbian lives and the construction of the social reality for gays and lesbians as types of persons. That scholarship has yet to embark on a full investigation of how the creation, administration, and use of databases containing personal information represent private gay and lesbian lives.

Surveillance theory, queer theory, and gay and lesbian studies have much to offer each other. Surveillance theory can learn from queer theory and gay and lesbian studies the politics and practices of visibility. Queer theorists can learn from surveillance studies the political economy of surveillance infrastructures. This chapter seeks to redress the situation, by bringing the theories together. It first outlines the theoretical common ground of surveillance and queer studies. It then suggests gaps and lacunae in each and shows how the other can fill those gaps. Finally, it sketches an approach to the social studies of information environments that melds the two fields, contributing a political response to new information practices by offering a framework for analyzing infrastructures of identity and visibility.

COMMON GROUND

Queer theory and surveillance theory share a fundamental interest in the power of categorization, typification, and naming. Drawing on Foucault, especially the *History of Sexuality, An Introduction* (1990), queer theory looks at how discursive processes make sexuality and sexual categories into stable objects of study (Halperin 1995). It examines how "the categories through which one sees" determine "what will and will not constitute an intelligible life" and how "the naturalized knowledge of gender operates as a preemptive and violent circumscription of reality" (Butler 1999, xxii–xxiii). "The aim is to reveal not only the indeterminacy, contingency, malleability, and often oppressive nature of taken-for-granted concepts" and categories "but also the subtle ways" that "the hidden power relations behind these categories depend crucially on" how "they are gendered and sexualized" (Knopp & Brown 2003, 409–410). Surveillance theory also sees Foucault as a primary author, through the seminal text, *Discipline and Punish* (1979). Surveillance theory takes as its central concern the systems and organizations "used to sort and sift populations, to categorize and to classify, to enhance the life chances of some and to retard those of others" (Lyon 2001, 4; see also Gandy 1993). Both theories examine the implications that endure when social processes normalize, categorize, and typify. Cross-fertilization has not yet grown among scholars of these disciplines.

A sketch of queer studies must treat together the work of historians and sociologists of gay and lesbian life with the work of queer studies scholars. Not all the authors included here would claim a queer theoretical perspective, but their work in some way addresses the representation of gay and lesbian persons, the social recognition of gays

and lesbians as types of persons, and the integration of those representations into structures of economic and political power.

Their research has focused primarily on public, mass-mediated images. Histories of gay images in radio, television, film, Broadway theater, print and broadcast advertising, and glossy magazines first appeared in the 1980s and have continued to track and critique the changing text and context of those images (Russo 1981; Capsuto 2000; Gross 2001; Walters 2001; Sender 2001). The 1990s saw an upsurge of interest in gay visibility and social life on the streets and in baths, bars, neighborhoods, and regions (Chauncey 1994; Leap 1999; Ingram, Bouthillette & Retter 1997; Bell & Valentine 1995). These scholars have paid attention to how gay and lesbian representations and identities articulate with the processes of capital, especially the complex and contradictory effects of being recognized, constituted, and normalized as a market (e.g., D'Emilio 1983; Sender 2001; Chasin 2000; Binnie 1995).

As it moved into new media, especially on-line interactions, queer theory has been slower to study issues of political economy. Queer theory (and other) responses to cyberspace tend to focus on peer-to-peer visibility, the pleasures, possibilities, and politics of disembodied presence and identity and the cyborg (Haraway 1991; Stone 1995). The studies tended at first to approach the media used to create on-line identities as a given, ignoring the social, economic, and political forces that constitute the media themselves. Despite changes, queer theory approaches still ignore one of the fundamental ways that new media constitute gay and lesbian identity, the process of panoptic surveillance—technologies, practices, and economies of individual identification, monitoring, datafication, analysis, and response, all of which create and position social groups. Some scholars move in this direction—Lee Badgett (2001) through a critique of the methods and uses of demography and John Campbell (2003) through a comparison of the communities that gay portals offer their users and the market segments that they offer their advertisers.

To understand the discursive creation of usable categories, queer theory must recognize and evaluate not only public discourse in the mass media and physical presence but also the sub-rosa discourse of databases. Here, surveillance scholars have already laid the theoretical and empirical groundwork. Much of surveillance theory sees the role information technologies play in constructing social visibility through the lens of Foucault's metaphor of the panopticon (Foucault 1979). He bases the metaphor on a prison design of Jeremy Bentham. The panoptic prison consisted of an outer circle of illuminated individual cells, visible to an observer in a darkened central tower. The invisible observer could watch the actions of each individual, compare and analyze the prisoners as a group, and respond to each specifically. Individual punishments or reward efficiently managed the entire prison population. Foucault extrapolated a panoptic ideal from this structure. Panoptic surveillance

observes each member of the population, recording of the individual's activities and then collating the observations. Together, the observations produce statistical norms. When applied to the subjected individuals, the norms categorize and perhaps guide action upon each member.

Panoptic surveillance follows a four-stage process: individuation, observation, analysis, and response. During individuation, the technical and social means established to distinguish individuals give each member of the population a unique and persistent identifier. For example, licenses or passports contain biometric identifiers first developed and embedded and then verified during social interactions. Under observation, the data models developed become idealized, formal representations of the salient features the type of entity reveals. The stage establishes a one-to-one correspondence between each member of the population and a particular data record. Observation encodes and records the salient features of each entity within the data record. Analysis subjects the accumulated records to statistical tests to discover norms, identify outliers, and create types of persons. Finally, the response phase applies the knowledge created to the population. Action upon individuals varies according to the particular type assigned to them. The surveillance authority alters the social context for all the individuals to better suit its own needs. The surveillance process may modify itself to better identify, represent, and study new phenomena.

Through the analytic phase, surveillance produces disciplines—regulated fields of knowledge and expertise. Through the response phase, it produces discipline—conformity to the norm. Surveillance creates individuals and types of individuals. It "compares, differentiates, hierarchizes, homogenizes, excludes. In short, it *normalizes*" (Foucault 1979, 163).

The panoptic metaphor can enhance the understanding of personal information systems that operate every day, usually silently and without notice, in computer-mediated communication systems. A paradigmatic example, the *Wall Street Journal* on line, uses cookies to *identify* unique individual users (placing an identifier on each user's machine) and then to *monitor* and *track* their traversal of the site (compiling a history of each user's activities across browser sessions on the site). The analysis uses the *statistics* gathered to place each user in one of eight *categories* (car buffs, consumer techies, engaged investors, health enthusiasts, the leisure-minded, mutual-fund aficionados, opinion leaders, or travel seekers). The category then becomes the *knowledge guiding the treatment of each individual*, serving different advertisements to members of different classes. Nat Ives described the process in "On-line Profiling, Separating the Car Buff from the Travel Seeker, Is a New Tool to Lure Advertisers," for the *New York Times* (16 June 2003, C-10). Queer theory should move toward precise sociotechnical analysis of particular media systems.

Surveillance studies stumble at two important points. The first is a focus on privacy. As a legal principle, privacy has exerted the most leverage on how regulatory

agencies respond to the collection and use of personal information. Even when theorists accept privacy on contingency as an organizing principle (Gandy 1993) or reject it outright in favor of social sorting and discrimination (Lyon 2001), surveillance studies seem to labor in the gloom of inevitable domination. Surveillance theory has yet to embrace fully the queer theory aspiration to "not just a safe zone for queer sex but the changed possibilities of identity, intelligibility, publics, culture, and sex" (Berlant & Warner 1998, 548).

The second is a tendency to accept readily the *pan-* of panopticism. Individuals do not live in prisons; there is no overarching plan. The surveillance process distributes across many institutional settings, each with its cultural history and operational objectives. Institutions and their surveillance practices interact in myriad ways, by exchanging data and research, by submitting to laws and regulatory regimes, by relying on distinct practices, techniques, and ideologies, and by pursuing their interests, sometimes allied, sometimes opposed, and sometimes at cross purposes. A fairly simple grammar describes a complex system. Surveillance exists in an ecology of identity and information.

Every stage of the surveillance process opens itself to social contention (Agre 1994). Within this complex contest lie possibilities for institutions and practices of visibility that are not panoptic. Individuals and groups have qualities and degrees of control over the processes of identification, tracking, analysis, and response. The potential structures of visibility might produce knowledge that does not domineer or oppress. Instead, the known population itself may deploy information to make sense of the world. The resulting alternative perspectives may maintain subcultural identity or articulate that identity with the social order. The alternatives highlight the contrasts between imposed and chosen visibility, between knowing oneself and being known, between claiming and being ascribed an identity. Each structure distributes differently the power to understand, live, and create the social world. Understanding the processes and resources of identity, community, visibility, and presence is the realm of gay, lesbian, and queer studies, and surveillance theory can look there for inspiration and guidance.

BRINGING IT TOGETHER

From gay, lesbian, and queer studies, research should import historical and theoretical understanding of the resources for, rewards of, and dangers to identity. At the same time, it should import understanding of the laws, economics, and technologies of panoptic information management from surveillance studies. When analyzing particular configurations of identification, tracking, analysis, and response, research should look at how the legal, technical, and economic structures girding

these systems interact to help produce transgressive identities and regenerative places and communities. A central question is what opportunities a discursive formation can create for counter practices (Halperin 1995). Some answers emerge from five types of understanding: performativity, self-reflexiveness, idealization, adaptability, and regeneration.

To study transgressive, contingent identities requires an understanding of performativity. Individuals perform their identities. They do so to serve certain ideals, to adjust to certain contexts, and to use certain resources (Goffman 1959; Butler 1998). Surveillance research can analyze how infrastructures distribute these resources and look for points vulnerable to strategic manipulation.

Second, studies also require an understanding of self-reflexivity. Dancers rehearse before a mirror; actors rely on the director to let them know what plays well. All performances are self-reflexive. In information environments, performances translate into data impressions, records of attributes and activities representing the salient features. Making those records available facilitates reflexive performance. For example, Nguyen and Mynatt (2002) propose *privacy mirrors*, interfaces that enable users to monitor the data impression they are exhibiting to others.

Knowledge of representational practice leads in the right direction, but subcultures also need the means to influence, engage, and counter these practices. That is, scholars need to develop technological and institutional ways to produce malleable and contingent data records. Studies must identify the moments and the processes that legitimate certain data values. For example, when and how can one assert *trans* (or, for that matter, *N/A*) as a gender identity? What automated, mechanized, or institutionalized roadblocks prevent one from claiming marriage to others?

Third, studies require an awareness of how data traces transform into ideal types. "Heterosexuality is always in the process of imitating and approximating its own phantasm idealization of itself—and failing," writes Judith Butler (1998, 1520). To extend her observation, all self-conscious social performance tends to approximate a phantasmal ideal, and that phantasm becomes reified as it guides social activity. For example, in current surveillance practice, marketers classify neighborhoods by demographic type and then target them for particular advertisements, reinforcing the very consumption patterns that constituted the type in the first place. Likewise, airport security forces analyze travel patterns for norms and then subject those deviating from the norm to greater scrutiny. Those scrutinized learn to conform to the ideal, so that they can get through the airport quickly.

The social issue here is not whether the idealizations are untrue or inaccurate but whether they are useful. Once used, they pattern social relations. As the character Eliza Doolittle says in *Pygmalion*, "The difference between a lady and a flower girl is not how she behaves, but how she is treated" (Shaw 1951, 99).

Currently, these processes of idealization remain obfuscated and mystified. Laws require, for example, that insurers and lenders reveal only the data elements used to generate their decision on whether and at what rate to lend or insure. They are under no obligation to disclose the algorithms they use to transform the data into particular categorical identities. Surveillance researchers and queer theorists can attempt to state theories of ethics and social power that extend the legal regimes beyond privacy interests into issues of social discrimination. Queer theorists can evaluate classification practices and identify options for drag, that is, for creative appropriation that resignifies identity categories and makes them theatrical (Halperin 1995, 48).

Fourth, studies require an understanding of the ability to adapt performance to context. Identities are not unary. Individuals change roles as they change social contexts. The ability to match performance to context is a measure of social power. Information infrastructures mediate power by enabling individuals' awareness of contexts and by allowing them to segregate their identities into appropriate contexts.

An information environment might define context as the scope of an individual's visibility, that is, the presence of aware others. Laws that may or may not require notice of information collection practices mediate knowledge of the context. Technologies and standards also mediate by signaling the presence of others, such as sending notice when a web site attempts to set a cookie.

The scope of one's unique identifier partly mediates the segregation of contexts. Records of activities referenced by a social security number may contribute to the construction of a single identity or main performance. Separate pseudonyms referenced in the records are parts of different performances. Using a pseudonym allows an actor in an informational environment to hone her performance to match her audience. For example, protocols such as the Freedom suite permitted users to establish more than one unlinkable pseudonym—say, WorkerJoe, FuckBuddyJoe, and CitizenJoe. Joe would choose among the pseudonyms for each internet session, so that, although web sites might track his activities, they could not link his work performance to his political performance (Phillips 2002; Goldberg & Shostack 1999).

The surveillance literature undertheorizes this type of identity management, but queer theory can provide enrichment with explorations of the situated politics of identity, with historical understanding of the costs and benefits of coming out as a specific type in a specific context. For its part, surveillance and privacy literature offers rich empirical data on how identification practices become institutional, on the structural forces determining when actors must establish a link between their bodies and a particular set of data records.

Finally, studies require an understanding of regenerative places and communities. Individuals do not create performances and identities in isolation. A community creates meaning by defining what each gesture, image, and symbol signifies. One never lives in a single, monolithic community of meaning. Instead, each person

interprets social contexts using frames of meaning inherited from many sources: shared experiences within and across generations, particular quirks of parents, deeply ingrained religious or ideological orthodoxies, and so forth. Frames of meaning provide an understanding of the world. They influence concepts of the true, the right, and the good. They justify laws and inform behavior as a person decides why and how to go on in the world. Because they are enduring influences on the shape of social practices, they become hotly contested. Surveillance infrastructures mediate the contests by establishing public and private regions and topologies of communication within those regions. Again, queer studies can help guide surveillance theory in its attempt to do political analysis of the mediating infrastructures.

Surveillance theory can look particularly to the history of gay and lesbian subcultures in urban environments. Cities have offered and continue to offer the comforts of anonymity and community (Rothenberg 1995). The practices that subcultures construct to manage that dialectic can be illuminating. George Chauncey describes how, in early twentieth-century New York City, gay individuals developed "tactics that allowed them to identify and communicate with each other without alerting hostile outsiders to what they were doing. Such tactics kept them hidden from the dominant culture, but not from one another." In part, the tactics involved "constructing a gay map of the city," which "had to consider the maps devised by other, sometimes hostile, groups" (1994, 187–189).

Information environments can and should facilitate ways to generate and sustain subculture, that is, to produce social knowledge within and for the benefit of self-identified groups. This involves two essential criteria, group distinction and public space.

Symbolic exchange and meaning creation occur within groups, and so the individual actors need some means of determining whether other actors are group members. The policing of in-group–out-group distinctions is a fundamental process of group identity formation. Group distinction is never concrete; it is always contested. Under what circumstances do gay men and lesbians share a useful categorical link, and when do their interests and identities diverge? One criterion to assess information environments is the way they mediate this contest. How do they model and make operational the relations based on trust? Consider SecureId, a management tool that allows users to segregate their personal information into facets of identity (boyd 2002). Before gaining access to a facet, the visitor must answer a question to prove in-group membership. SecureId mimics, in part, the social signaling work of fashion and speech codes and uses those cultural codes to limit or extend social visibility and interpersonal trust.

The second criterion for subcultural knowledge production is the availability of a public environment from which, and with which, to make meaning. In Chauncey's example, gay men used the public environment, the same space dominant cultural groups populated

and used, but they created their own maps of that environment, their own meaning. Research might evaluate information infrastructures by how they make environments public and how they facilitate the construction of alternative maps or meanings.

Public environments are texts amenable to analysis, and, as texts, they may be open or closed. Open texts lend themselves to interpretations in ways that closed texts do not. Public parks are open; frontier checkpoints are not. Department store windows are also open. Their displays and windows lend themselves to chatting up strangers, as well as checking out wares, unlike, say, mail-order catalogues. Data environments, too, may be open or closed. Proprietary protocols and software may close them—if the data come in a format readable only by a Windows product, then Microsoft chooses the parameters for manipulating the data. Contracts and licenses limiting the legitimate uses of data may also close data environments. Privacy laws and intellectual property laws do likewise. The collection, storage, and dissemination of information are rife with legal, political, and ethical issues. Good theoretical work on the ethics and the economics of commodifying behavior could serve surveillance, as well as queer, studies. Further and better study should examine the processes of privately capturing, storing, and analyzing public behavior. The design process must incorporate legal philosophies, such as extending privacy protection to public actions (Nissenbaum 1998). The point is to establish not public or private activities or places per se but some standards of equitable access to the raw material individuals and communities use to order the world.

Access to a public text, however, is not sufficient for subcultures to produce knowledge. In information environments, knowledge production generally occurs through statistical analysis of data. To facilitate subcultural knowledge, information environments must also incorporate a variety of analytic engines. These engines are the conceptual models and algorithms each user employs to interpret data according to her own goals or those of her community of users. The same space must be available for different meanings.

Within information environments, statistical analysis of data often intervenes to create sense. Research can assess information infrastructures according to how well they facilitate equity not only externally, providing access to the raw material individuals and communities use to make sense of the world, but also internally, analyzing the statistical drivers that forge knowledge from the data. In design terms, equity translates into a structure that can link shared public space (data) with private place-making drivers. The drivers are the conceptual models and algorithms each user employs to interpret data according to her own design goals or those of her community of users. For example, collaborative filtering techniques that enable privacy also allow actors to determine which of their actions to make available for modeling and to decide whom to give access to those models (Canny 2002). Techniques may facilitate in-group, rather than panoptic, knowledge production.

The following examples, one that supports subcultural knowledge production and another that does not, illustrate the distinction between open and closed information environments. In a downtown district, shoppers walk through with wireless-enabled personal digital assistants (PDAs). The PDAs are constantly emitting identifying signals. Networked stationary sensors placed throughout the district receive the signals. The network triangulates the signals to calculate each individual's location, then correlates the location with a database of the person's preferences and history, and finally serves information appropriate to that person. Such an environment does not support a subculture in its knowledge production.

By contrast, in the design of Place Lab (Hong et al. 2003), stationary transmitters throughout the district constantly emit signals that each PDA receives and triangulates. The PDA calculates its own location, and the user can then refer to local information and guides after downloading. Any subculture may publish a guide. Place Lab offers more room for individuals to negotiate their environment anonymously and through their chosen cultural lens. When studying the genesis of surveillance environments, scholars should look to the particular moments when one paradigm, rather than the other, becomes dominant.

ILLUMINATION

Surveillance studies and gay, lesbian, and queer studies have blind spots that the other can illuminate. In particular, surveillance studies can offer queer studies an understanding of the legal, technical, and economic infrastructures mediating new forms of identity practices. Gay, lesbian, and queer studies can offer surveillance studies a new historical and theoretical perspective on the social consequences of those practices. Together, they offer a framework for the political analysis of infrastructures of identity and visibility.

The framework would focus research on how infrastructures permit individuals to claim a social identity in a social context. Research would also attend to the constructing of data models and identity categories, as well as the processes of choosing identifiers and making contexts visible. The framework suggests that studies analyze infrastructures according to how much they enable the subcultural generation of knowledge, form and maintain subgroups, provide a common space, and afford the means to generate and disseminate knowledge about and within that space. The analysis should not restrict itself to the techniques of information management, but should instead expand to the institutional adoption of particular techniques—the constellations of social pressures constraining and enabling certain forms of visibility and certain forms of representation and knowledge. The goal of this analysis is to expose, demystify, and appropriate the political economic mechanisms of the production of social truth.

REFERENCES

Agre, Philip. 1994. "Surveillance and Capture: Two Models of Privacy." *The Information Society 10*.2 (April–June): 101–127.

Badgett, M. V. Lee. 2001. *Money, Myths, and Change: The Economic Lives of Lesbians & Gay Men.* Chicago: University of Chicago Press.

Bell, David, and Gill Valentine, eds. 1995. *Mapping Desire: Geographies of Sexualities.* London: Routledge.

Berlant, Lauren, and Michael Warner. 1998. "Sex in Public." *Critical Inquiry 24* (Winter): 547–566.

Binnie, Jon. 1995. "Trading Places: Consumption, Sexuality, and the Production of Queer Space." In *Mapping Desire: Geographies of Sexualities*, 182–199. Ed. David Bell & Gill Valentine. London: Routledge.

boyd, danah. 2002. "Faceted Id/entity: Managing Representation in a Digital World." Unpublished Master's Thesis, Media Arts and Sciences, Massachusetts Institute of Technology.

Butler, Judith. 1998. "Imitation and Gender Insubordination." In *The Critical Tradition: Classic Texts and Contemporary Trends*, 1514–1525. 2nd ed. Ed. David H. Richter. New York: Bedford-St. Martin's.

———. 1999. *Gender Trouble.* 2nd ed. London: Routledge.

Campbell, John. 2003. "Outing Planet Out." Paper delivered at the Fourth Annual Conference of the Association of Internet Researchers, Toronto, Canada, October.

Canny, John. 2002. "Collaborative Filtering with Privacy via Factor Analysis." Paper delivered at the SIGIR 01 Conference, Tampere, Finland, August.

Capsuto, Steven. 2000. *Alternate Channels: The Uncensored Story of Gay & Lesbian Images on Radio and Television.* New York: Ballantine Books.

Chasin, Alexandra. 2000. *Selling Out: The Gay and Lesbian Movement Goes to Market.* New York: Palgrave.

Chauncey, George. 1994. *Gay New York: Gender, Urban Culture, and the Making of the Gay Male World, 1890–1940.* New York: Basic Books.

D'Emilio, John. 1983. "Capitalism and Gay Identity." In *Powers of Desire: The Politics of Sexuality*, 100–113. Ed. Ann Snitow, Christine Stansell & Sharon Thompson. New York: Monthly Review.

Foucault, Michel. 1979. *Discipline and Punish.* New York: Vintage.

———. 1990. *History of Sexuality: Volume I: An Introduction.* Trans. R. Hurley. New York: Vintage.

Gandy, Oscar H. 1993. *The Panoptic Sort.* Boulder: Westview.

Goffman, Ervin. 1959. *The Presentation of Self in Everyday Life.* New York: Doubleday.

Goldberg, Ian, and Adam Shostack. 2001. "Freedom 1.0 Architecture and Protocols." Adam Shostack's Homepage. Available at http://www.homeport.org/~adam/zeroknowledgewhitepapers/arch-tech.pdf. Accessed 2 January 2006.

Gross, Larry. 2001. *Up from Invisibility: Lesbians, Gay Men, and the Media in America.* New York: Columbia University Press.

Halperin, David M. 1995. *Saint Foucault: Towards a Gay Iconography.* New York: Oxford University Press.

Haraway, Donna J. 1991. *Simians, Cyborgs, and Women.* New York: Routledge.

Hong, Jason, Gaetano Boriello, James A. Landay, David W. McDonald, Bill N. Schilit & J. Doug Tygar. 2003. "Privacy and Security in the Location-Enhanced World Wide Web." Workshop on Ubicomp Communities: Privacy as Boundary Negotiation, Ubicomp 2003, Seattle, October.

Ingram, Gordon Brent, Anne-Marie Bouthillette & Yolanda Retter, eds. 1997. *Queers in Space: Communities/Public Spaces/Sites of Resistance.* Seattle: Bay Press.

Knopp, Larry, and Michael Brown. 2003. "Queer Diffusions." *Environment and Planning D: Society and Space 21*.4 (August): 409–424.

Leap, William, ed. 1999. *Public Sex/Gay Space*. New York: Columbia University Press.

Lyon, David. 2001. *Surveillance Society: Monitoring Everyday Life*. Buckingham: Open University Press.

Nguyen, David H., and Elizabeth D. Mynatt. 2002. "Privacy Mirrors: Understanding and Shaping Socio-technical Ubiquitous Computing Systems." Georgia Institute of Technology Technical Report GIT-GVU-02-16. Available at ftp://ftp.cc.gatech.edu/pub/gvu/tr/2002/02–16.pdf. Accessed 21 September 2003.

Nissenbaum, Helen. 1998. "Protecting Privacy in an Information Age: The Problem of Privacy in Public." *Law and Philosophy 17* (June): 559–596.

Phillips, David J. 2002. "Negotiating the Digital Closet: Online Pseudonyms and the Politics of Sexual Identity." *Information, Communication, and Society 5*.3 (September): 406–424.

Rothenberg, Tamar. 1995. " 'And She Told Two Friends': Lesbians Creating Urban Social Space." In *Mapping Desire: Geographies of Sexualities*, 165–181. Ed. David Bell & Gill Valentine. London: Routledge.

Russo, Vito. 1981. *The Celluloid Closet*. New York: Harper & Row.

Sender, Katherine. 2001. "Gay Readers, Consumers, and a Dominant Gay Habitus: 25 Years of the *Advocate* Magazine." *Journal of Communication 51*.1 (March): 73–99.

Shaw, Bernard. 1951. *Pygmalion*. Baltimore: Penguin Books.

Stone, Allucquere Rosanne. 1995. *The War of Desire and Technology at the Close of the Mechanical Age*. Cambridge: MIT Press.

Walters, Suzanna Danuta. 2001. *All the Rage: The Story of Gay Visibility in America*. Chicago: University of Chicago Press.

Queering Race in Cyberspace

HAN N. LEE

What happens to race when it gets placed within a social space of communication technology where the immediate corporeal body is absent? How does race get represented as a form of sexuality in queer context on line? This essay examines race in on-line personal advertisements for men seeking men at a popular LGBT portal site, Gay.com, and finds that race is unstable, shifting conceptual metaphors incoherently across the boundaries of nonwhite, place, body, and culture, and that race is interwoven with sexuality. Critical scrutiny of this social phenomenon shows that race can be queered.

In some versions of identity produced in the name of queer theory, sexuality becomes the primary figure of mobility and crossing, leaving race relatively stable (Martin 1994). Some scholars argue, however, that queer theory fails if it does not take seriously how race and ethnicity intersect with sexuality (Reid-Pharr 2002; Somerville 2000). There is no universally coherent politics of queer subjectivity. In fact, the concept *queer* emerged in response to the scientific discourse of homosexuality, by extension, and heterosexuality as identities (Foucault 1978; D'Emilio 1983). The discourse has firm roots in Western, especially American, cultural traditions such as medical science, capitalism, and slavery (Somerville 2000). At stake in the current literature of queer theory is the need to expose the unconscious assumption that all queers transhistorically experience exactly the same forms of oppression and that they must resist the oppression in more or less the same manner.

The reverse of this warning could also be true. A grand narrative of race in separation from sexuality or across all sexualities needs scrutinizing for its underlying assumptions. Race happens with sexuality, but scholarship has separated out race and sexuality and examined them in isolation. In general, lesbian and gay studies has had a tendency to subordinate questions of race to analyses of sexuality. Separating categories of gender, race, and sexuality preoccupied the scholars establishing the field of lesbian and gay studies. Much scholarship on race has minimized the role of sexuality, particularly homosexuality (Somerville 2000). In response to this gap in the literature, this essay aims to examine the intersection of race with sexuality, in particular gay sexuality, and to destabilize the concept of race in cyberspace, which has generally remained stable in the scholarship on sexuality (Martin 1994).

Cyberspace fits the particular goals of the essay because cyberspace is ultimately queer. First, it is queer in its origin. Gay, lesbian, bisexual, transgender, and queer communities played a vital role in the early transformation of internet technology into sociable media (Ellis 2004). Second, cyberspace is queer in the sense that it highlights the performance of identity. Cyberspace puts into question the authenticity of fixed, stable identity. Racial passing, virtual cross-dressing, tiny sex, identity tourism, role-play, Turing test, and cyborg are just few phenomena referring to the identity crisis that one encounters in the age of information and communication technologies. As one sits at her computer keyboard, she splits herself into at least two personae, one mediated through the computer and another that experiences the virtual self through the corporeal body and senses. The two selves are highly interwoven in the postmodern condition, which increasingly subverts the distinction between the human and the technology (or virtual self) that mediates human communication (Haraway 1991; Lyotard 1979; Turkle 1995; Markham 1998). With this shift, the modernist tradition is in jeopardy. Improvisations and queer subjectivities have become inevitable means of survival in highly technological society.

To queer race in cyberspace, the title of this essay, is to illustrate how cyberculture studies, critical race theory, and queer theory can come together to critically interpret a social phenomenon of identity. In particular, the word *queering* serves at least two purposes in this essay. First, it highlights the idea that race intertwines with sexuality in social spaces for queers' romance, or in particular for gay men's. Instead of attempting to focus on race alone and to hold sexuality separate, I examine how race occurs *in sexual politics* (such as cybersex, on-line romance, and the like). Second, the word *queering* highlights how supposedly disembodied internet communication *destabilizes* race. Scholars have argued that race is unstable and shifting in social life generally (Yanow 2003; Ignatiev 1995). I illustrate how race is indeed unstable, incoherently shifting from one to another conceptual metaphor in a new social communicative environment, or *cyber-queer* space (Wakeford 1997). By analyzing this performance of sexual and racial identities in on-line personal advertisements, I queer race.

RACE IN CRISIS

Race is a troubling concept in U.S. discourse. Since the demise of biological approaches, race has "not been afforded explicit theoretical primacy" (Omi & Winant 1994, 12) without a clear conception of race itself. From an everyday, popular perspective, race is anchored in a person's body. The sociology of race once shared such a naïve biological paradigm but now has moved to a more critical social constructivist paradigm. The new paradigm argues that no absolute physiological characteristics exist, either as genotypes and phenotypes, which can neatly map out the entire human population into racial categories. Instead, race is a relatively new human (that is, social) invention (Yanow 2003; Roediger 2005; Hudson 1996). With this understanding, a better sociology of race can emerge, but the phrase *social construct*, ironically, often serves as an end point rather than a starting place to examine the concept of race (Smaje 1997; Society of the Study of Symbolic Interaction 2005). The pitfall may be that scholars casually use the phrase *social construct of race* without any specific meanings:

> Too often, the analysis of race begins and ends with its dismissal as a social construct. Race as social construct becomes a master trope, sociology's own construction of what race is about. Yet the discipline is substantially founded on the notion that *all* forms of sociality are constructs, particular relations inscribed in the world from the universe of possible relations. Simply making this point with reference to race or ethnicity does not, however, constitute a theory of them. (Smaje 1997, 308)

Meanwhile, the effort to move away from the biological to the social construction paradigm of race, if not made critically, creates a dichotomous

> tension between the physical body as a material representation of racial identity with particular social and political effects and the body as a rhetorical construct situated in social processes [that] either leaves the physical body as the essentialized center of attention or completely erases the body. (Warren 2003, 1)

Throwing the concept of ethnicity onto the table complicates the tension even more. Some scholars make sharp distinctions between race and ethnicity, but often with a confusing emphasis that assumes the body is what makes them separate. They define *race* as an identity that "signifies and symbolizes social conflicts and interests by referring to different types of human bodies" (Omi & Winant 1994, 55), but *ethnicity* refers to something else based on language, religion, culture, and the like (Nagel 2001). Other scholars casually or interchangeably "use *race* and *ethnicity* in their commonsense meanings, corresponding respectively to the *physical traits* and *cultural traits* taken to characterize different groups and demarcate between and among them" (Yanow 2003, 163). With the confusion over race and ethnicity, the

challenge is to weave the tissue of the body into an understanding of race and ethnicity in a theoretically grounded way.

STUDYING RACE IN DISEMBODIED SOCIAL SPACE

In the transition of the sociology of race from the biological paradigm to social constructivism, the physical body is the central dilemma. The new theory of race rejects, but cannot completely leave out, that embodiment. A study of race in supposedly disembodied social space, however, can provide interesting empirical cases useful for identifying the meanings of race beyond the corporeal body. Cyberspace is one such space, where a kind of architecture inscribes and reconfigures the body (McDonough 1999; Kolko 1999) through the representations the inhabitants make of that space and the interactions with other inhabitants. Among many social arenas of cyberspace, the discourse of race is perhaps richest in on-line personal advertisements (Lester & Goggin 1999), especially those of gay men, which describe the race of self and Other more explicitly than do ads for any other sexuality (Phua & Kaufman 2003).

Popular and mainstream on-line dating sites for men seeking men, such as Match.com and Yahoo! Personals, censor what the ad placers write in their profiles. A personal ad containing the phrase, "I want to join the Klan," along with racist remarks, for instance, would provide a rich example of white-other power dynamics for research, but Match.com would likely never approve or publish the ad. In search of a site for study on race and sexuality in cyberspace, I looked instead for other on-line dating sites with less restriction from the top. Also I looked for a racially diverse site, instead of one devoted to a single racial group (such as AsianAvenue.com), which would allow me to examine racial formations or racial meanings in a broader perspective. These criteria suggested that I examine Gay.com, which has a large, racially diverse population of personal advertisements along with less censorship.

In 2003 at the beginning of this study, Gay.com had more than 4 million registered users. Since then, the number of members and their personal ads almost doubled, reaching 7 million in 2007 at the time of writing of this essay. The enormous number of personal advertisements presents a challenge. Unlike scanning the columns of personal ads in newspapers or magazines, viewing Gay.com personals is through a search function. One searches for ads by using menus or typing in keywords. One can search for potential dates by the sex or gender of the desired partners, by the desired age range, by the zip code, by the proximity in miles, as well as by such details as the HIV status or fetishes. The site then generates a list of personal advertisements that meet the selected criteria. However, the search engine gives access not to every ad fitting those parameters but to a selection. If one leaves all

menus blank except for Man Seeking Man, for example, the search engine generates only about 250 ads, a much smaller number than the many millions it should provide. Systematic random sampling is difficult to conduct.

The site does, however, have options for identifying a target group of personal advertisers. Besides the personal ad feature, the Gay.com portal provides chat services to the site visitors. The site organizes chat rooms by geography and topics. Some topic-based chat rooms of Gay.com relate to race or ethnicity, such as the Asian, Hispanic/Latino/Mexican, Jewish, Men of Color, Muslim, and Native American rooms. These chat rooms permitted a preliminary examination of the patrons' personal advertisements. Because the patrons get together under the theme of race for discussions, cybersex, friendship, and so forth, they would likely discuss their race or the race of the desired partners in their personal ads. Using track bots (software programs that keep logs of the patrons who enter certain chat rooms), I generated a list of the patrons, which then yielded a corpus of about six hundred personal ads. After a preliminary analysis of those ads, I generated keywords and used the search engine to find personals related by theme.

One immediate observation from this preliminary analysis was that the site forces users to represent race as ethnicity. The typical U.S.-Census-like racial categories appear on the site: African/African American/Black, Asian/Pacific Islander, Latina/Latino, Middle Eastern/North African, Native/Aboriginal, White/European, Mixed/Multi, and Other. But these come under the heading My Ethnicity, not under race. In Waters's (1990) *symbolic ethnicity*, ethnic identity is celebratory for whites, serving a person's racial identity but leaving unacknowledged the effects of race on interaction and on power differences in society. Instead of the popular ethnic categories (such as Italian American or Polish American), Gay.com lists the actual racial categories as ethnicity, being a slightly different version of Waters's *symbolic ethnicity* yet still representing a person's race as a celebratory ethnicity. This tendency of naming race as ethnicity prevails in other dating sites as well. The Match.com profile management page, titled, "New to Match.com? Join for free," for instance, has almost the same racial categories with these instructions: "Which ethnicities describe you the best? When limiting yourself to labels just won't do, share some more about your ethnic background" (Match.com 2005).

Incorporating racial and ethnic category labels into the on-line menu contrasts with scholars' earlier observations about race in cyberculture studies (Kolko 2000; Nakamura 1995; Silver 2000). Previous studies compared gender and race in text-based multi-user domains (MUDs) and MUD object orienteds (MOOs), finding race often omitted from the architecture of cyberspace. In those social spaces, race is "not even on the menu," although gender is (Nakamura 1995, 183). Internet spaces rarely ask users to identify a race when creating profiles (for e-mail, on-line banking, electronic job applications, and the like). Asking a person's race is generally awkward,

if not racist, within the prevailing U.S. cultural tendency toward colorblindness (Omi & Winant 1994), but on-line personal ads deliberately request race in the fore-front of sexual intimacy, on the menu as celebratory ethnicity and as date seeker's personal choices.

Using these loosely defined conceptions of race and ethnicity (and ethnicity as race), I analyzed images and texts inductively to generate themes on the meanings of race grounded in the data of cyber-queer personal advertisements. In similar studies in different social contexts, Omi and Winant (1994) identify three dimen-sions of race and racial dynamics from their historical survey of theories—*ethnicity, class,* and *nation*—and Yanow (2003) suggests *color, place,* and *culture* for the shifting concept of race in the U.S. Census in history. In my analysis of Gay.com personal ads, four themes emerged: race as *nonwhite,* race as *place,* race as *body,* and race as *culture.*

In what follows, I use pseudonyms for on-line user names or *handles* to protect the confidentiality of ad placers, even though on-line personal advertisements are public. I created pseudonyms close to the original handles in some cases, when the quality of the name was crucial for presenting the analysis. My references to the users reflect the users' own indications of race on line, letting stand their claim to be a per-son of a certain race. Some ad placers do not specify their race but may evoke it through other references. I paid close attention to such *racial mapping* (Kang 2003). The process of racial mapping constitutes the themes of this study. The first theme is race as nonwhite.

RACE AS NONWHITE

Not all, but many advertisers failed to see the white race as *a* race. For instance, chi-whitefratboy312 says, "Ethnicity: I'm just plain old American," implying that his whiteness is so "plain" that it does not have any racial/ethnic characteristics. In his ad, he represents whiteness as a default attribute for the concept of American and the term *American* alone is enough to constitute him as white. The users pendude 802 and CyberBigApple construct their personal ads in the same manner, regarding whiteness and its invisible default characteristic in the concept *American* (or a nor-mative human being). A self-identified white pendude802 says for his race, "Ethnicity: American mutt or nothing," associating his whiteness with "nothing." Another white ad placer CyberBigApple says, "Ethnicity: Where's 'American' on this list," implying that his whiteness is equated with American or that all races, in par-ticular white, should be clumped into the category of American. In those ads, the analogy is that *whiteness is not racial.*

The failure to acknowledge white as a race appeared not only from self-identified white advertisers, but also from or in reference to self-identified nonwhite

advertisers. The personal ads of bimedboi, dclawman72, and hotthaiguy212 construct the white default identity from the opposite end. A white user bimedboi says, "I really like ethnic men (but not to the exclusion of whites)." In his ad, whites are not included in the category *ethnic* (that is, "not to the exclusion of whites"). A black user dclawman72's ad reads: "I am a person of color. It is very important to me that I can share the experience with my guy. So, I am usually interested in people who are like me. No Whites, please," excluding whites from all other races that have attributes such as the "color." Being Asian is ethnic and exotic, according to a self-identified Thai user hotthaiguy212 who says in his ad, "Hot sexy ethnic Asian man looking 4 the same exotic guy." That is, being Asian is *deviant from the default white characteristics*. In the ads of bimedboi, dclawman72, and hotthaiguy212, the embedded analogy is that *being nonwhite is being racial*.

Sometimes the absence of any description of race in cyberspace is a way to be invisibly white because of the perception that whites dominate cyberspace (Nakamura 1995). In the Gay.com personals, the architecture pushes this cultural tendency. When an ad placer does not post his picture, his personal ad has a default picture: a white man's face and shirtless body with the phrase, "No Photo Uploaded." In other words, the site equates the absence of a description of user's race with the normal default human being, an invisibly white man.

Finding whiteness represented as excluded from race is not new. It is one of the key themes in *whiteness studies*, which aims to expose how white domination sustains and reproduces itself through invisibility. Through the lack of identity, white persons perceive their whiteness not as race but as the invisible human norm:

> Whites as a privileged group take their white identity as the norm and the standard by which other groups are measured, and this identity is therefore invisible, even to the extent that many whites do not consciously think about the profound affect being white has on their everyday lives. (Martin et al. 1996, 28)

The internet, as a medium of communication, adds a twist: When users change their race on line, they may enjoy a form of *identity tourism* (Nakamura 1995; 2002). In such a case, whose ideas about race in on-line personal ads then prevail? The race that the users perform and represent on line, or the race that the users live behind the screen? Regardless of the answer, whiteness was represented as the invisible norm in my analysis of the personal ads.

Whiteness studies claims that white persons are reluctant to identify themselves as white, because examining the meanings of whiteness would make them confront their privileged place in the racist system. Another twist to this previous claim by whiteness studies is that, in the Gay.com personals, many advertisers *deliberately* identify their race as white. The medium and the intimate romantic context may account for this difference between the real-life avoidance of the label *white* and the

deliberate incorporation of white identity into on-line personal ads. Intimate romantic relationships privilege and encourage the advertising of race (Johnson 1994). In the absence of the corporeal body for others to read the user's racial markers, the first priority for an individual may be to clarify his race and to gain as quickly as possible the status as a privileged white man. Or perhaps the interface of Gay.com encourages white advertisers to identify their race, because, to be discoverable in a search, they first must be reduced to clickable categories.

The representations of white identity—although deliberately disclosed—seem to have meanings different from the identities of other racial minorities. In the Gay.com personals, the white race appears as a race of its own, apart from social consequences or categories for other races. This finding still supports the early claim of whiteness studies. The white user bimedboi illustrates this point that the white race is an identity a person may emphasize (or perhaps must include) with a privileged status that transcends all discriminatory social consequences for other racialized beings. His ad reads: "I'm 6', 180 lbs, dark blonde hair, muscular, gray eyes . . . I really like ethnic men (but not to the exclusion of whites)." The irony is that, although he devotes some texts to emphasize his white body (e.g., "dark blonde hair," "gray eyes"), bimedboi still fails to see himself as a person of race and excludes his invisible whiteness from the category of ethnicity (e.g., "ethnic men (but not to the exclusion of whites)").

RACE AS PLACE

Asians on Gay.com tend to indicate where they are from or where their ancestors are from, mostly as one particular foreign country (such as India, Thailand, or China). The ad from user gamrp2nd reads, "Ethnicity: South Asian and yes India is in ASIA," and the ad from user pepperdude reads, "I'm Taiwanese from Taiwan. NOT Chinese. I'm looking to date another Taiwanese." In their self-presentations, the *place of origin* ties closely to their race and ethnicity. Some other Asian ad placers deliberately state their place of birth as the United States, emphasizing an American identity. The ad from user transpark reads, "Ethnicity: I'm not an FOB [fresh off the boat]. don't ask me where in Asia I am from. Yes I was fu*@#!? born in the U.S." The *place of origin* and the *place of birth* can show a conflict between Asian identity, presumed nonwhite, and American identity, presumed white. This finding, that Asian Americans fight for their American identity in everyday life, does not seem surprising. Asian Americans have historically faced discrimination and Othering as foreign and exotic or, at best, stereotyped as the model minority (Haney-Lopez 1996; Lowe 1996). My analysis of the ads found that the more Asian Americans emphasized their assimilation into the mainstream (white) American society, the

more they highlighted their Asian or Other identity along the racial white-other binary. To argue for American identity, they had first to present and agree with the premise that they appear *non-American* in everyday life. That need and their demands for American identity themselves confirmed the oppressive idea of *America as white by default*.

Some Asian advertisers tie their racial and ethnic identities closely to where they grew up or where they live now. The *place of living* serves as a racial identifier in such cases. A self-identified Taiwanese American, deltaflyer, for instance, writes in a personal ad,

> I was born in Taiwan, raised in Southern California (not be grouped with those from Central or Northern California! ;-p), and moved east to Chicago for university and then staying for work. Although I am of the 0th generation here in the states, I did grow up in a 90% white community. (Ya, riiggghhht? A 90% white community in So Cal? It's true. . . . I'm not joking!) And as a result, I've been pretty much "labeled" as an "ABC" . . . American-Born Chinese. (My parents are probably not all that thrilled about it. =)

In his ad, deltaflyer argues that changing location has moved his racial identity from Taiwanese to American-born Chinese, a hybrid of Taiwanese and white. In his analogy, deltaflyer is Taiwanese by *place of birth*. His Taiwanese identity was not meaningful from the beginning but became so only after he moved to the United States and lived in the community where his racial identity was compared to whites spatially. By having grown up among whites, he claims that he has moved away from his Taiwanese identity, even to his parents' disappointment. *Living and growing up in a certain place* so closely ties to racial identity that, in deltaflyer's analogy, although it may not surpass the *place of origin* (Taiwan or China), it produces a hybrid (American-born Chinese). He suggests that certain places come packaged with racial expectations (such as Southern California) and link race and place tightly together.

The personal ads of Asian Americans and Asians who identify themselves as racial hybrids exemplify a "racial project" or "interpretation, representation, or explanation of racial dynamics, and an effort to reorganize and redistribute resources along particular racial lines" (Omi & Winant 1994, 54). The reader of these ads may label the ad placer *non-American* by skin color (or body), but the rhetoric in the ads suggests meanings of race "unfixed and subject to outcomes of struggle" (Gilroy 1987, 24). The struggle is about the exclusion of Asian Americans from mainstream American identity.

White advertisers often list multiple places in Europe, instead of one particular country, illustrating how they assimilated into mainstream America. Terms such as *half* or *quarter* pepper their ads, as if racial identity could somehow follow a *mathematical* formula (such as, "I'm 1/2 German 1/4 Italian and Others" in powerlift74's ad). Unlike Asian American ads, white advertisers use racial place or history not necessarily to

specify a nation but to generalize a symbolic sense of a European origin. Imprecise location terms, such as *Scandinavian* or *European descendent*, appear rather than country names (such as India, Thailand, or China). The fuzzy connection to an old country provides the historical backdrop and cultural space for the construction of white identity, or "a yearning for usable past" (Blauner 1994, 27).

Some advertisers use pictures to associate themselves with a place. For instance, fly_guy 212 posted a picture from his childhood with a script underneath reading, "a picture of me and my family in the Philippines." His My Ethnicity label is Asian, but the picture signals his connection to the Philippines, whether he is originally from there or he was merely visiting. Other advertisers who seek persons of a particular race post pictures of themselves in places where they can use them as icebreakers or points of reference. For instance, a self-identified white advertiser avartar36 had several pictures of himself taken during his trip to India. (His on-line handle derives from the Sanskrit word for manifestation, a Hindu religious concept now commonly used in cyberspace to indicate any graphic representation of self.) The pictures show him in a casual outfit (such as a T-shirt, short cargo pants, and sandals) at temples, before statues of Hindu gods, and at an Indian village. He writes: "I enjoy traveling. There is no place on earth that I would not visit. I recently took a trip to India and it would be great to date a guy who could travel with or possibly even introduce me to his family there." Even without specifying that he wishes to date an Indian man, avartar36 constructs "a guy" as Indian through spatial association (a *place of vacation*) or lineage (*family*).

Pictures of a place do not suggest the same meanings for whites as for persons of color. Unlike the picture of fly_guy 212, that of avartar 36 is more like a white man exercising identity tourism in a postcolonial fashion (Nakamura 2000). He might try out Indian culture for fun but only as a person who could return to his white privileges at any time.

RACE AS BODY

Jerry Kang (2003) argues that the racial mapping process in face-to-face contexts generally follows two steps: first, gathering data (such as skin color and facial features), mostly phenotype based, from individuals through the senses and, second, placing the individuals cognitively into racial categories (such as Asian, black, and white). The process may reverse in some on-line personal ads, which have no data on the physical body at all except a few categories (such as the terms *white* or *black*). Personal ads that have no other racial descriptions but a statement such as "white man seeking the same," may start with the category *white* (because it comes first) and later attach racial bodies and meanings to the disclosed racial category.

Describing physical characteristics from scratch in on-line personal ads seems to resemble most the racial mapping process and the interaction with someone new in face-to-face contexts. The descriptions may reflect advertisers' efforts to restore quickly the bodily presence or to bring the off-line physical flesh into the disembodied on-line space (Bryne 2003). Issues of embodiment in virtual space have been a key theme in cyberculture studies (such as Nakamura 1995; 2002; Stone 1991; Campbell 2004). David Shaw (1997) notes in his study of gay internet relay chats (IRCs) that, although users find appealing the "physical absence of the other . . . , all of the men actively transgress the bounds of bodilessness through the exchange of GIFs, photographs, phone calls, and ultimately in the face-to-face" (143–144).

Advertisers include photos that disclose their own facial and bodily features (or someone else's as their own) for identity tourism and cybersex. On-line personal ads commonly contain phrases such as "no pic, no chat" or "if you don't have a pic, don't even bother." Gay.com and other on-line dating sites encourage ad placers to post photos of their faces, which can contain racial markers. Even with photos present, advertisers also describe their bodies *in text*, despite the fact that their posted photos already present the information in the descriptions, including racialized details about their eye and hair colors.

RACE AS CULTURE

Five dimensions of the personal ads represent the theme of race as culture: language, food, celebrity, religion and myth, and cultural practice.

Race as Language

Some ad writers use non-English languages to describe themselves. For instance, there appeared several personal ads entirely composed in Spanish. Some ads use non-English greeting expressions that Americans commonly understand, such as Hello! in Spanish (*Qué pasa?*) or Japanese (*Kónnichi wa*) or Hawaiian (*Aloha*). Such a use of languages invokes images of racial identities. Regarding this phenomenon, Sarah Bryne (2003) notes that advertisers who seek interracial partners may use particular language to establish credibility with the racial group being sought.

Some advertisers, mostly whites exclusively seeking Asian men, exercise their white privilege as default American through language. They use their knowledge of English to highlight racial differences, assuming that Asians and even Asian Americans are foreign and not native speakers of English. For instance, the personal ad of a self-claimed white advertiser steadfast who says to his potential Asian dates,

"GWM [gay white man] seeking GAM [gay Asian men] . . . I will help you learn english," operates within the cultural stereotype and eroticization of Asian Americans as new immigrants.

Specific terms, such as *DL* (Down Low) for gay or bisexual black men, appear in personal ads especially among (or associated with) particular racial groups. For instance, some black gay men's ads use the term *brother* to refer to other black men. A self-identified black advertiser named detroitguy64 says in his personal ad, "6'0, 180 lbs, athletic black guy looking for his brother." Users rarely, if ever, place personal ads on Gay.com to find missing family members. In the context of seeking new romantic relationships, the term *brother* points to black racial identity, rather than to a particular family relation.

The Gay.com interface includes a menu for advertisers to mark the languages they know. As part of the process for creating a personal ad, users encounter a question about languages, including English. Many of the ads, not surprisingly, list the languages advertisers can speak. In the absence of other racial markers, such as pictures or labels, indicating a language of competency can invoke the ad placer's racial identity. For instance, a personal ad with no picture or mention of race might say that the advertiser speaks Russian. When no other racial description is present, revealing the knowledge of the Russian language constitutes the ad placer as white. Even without racial terms or images, scholars argue, on-line users constitute others as, or assume them to be, white (Nakamura 1995; Nakamura 2002; Steinfirst & Moran 1989). I would refine that claim by adding that, in on-line dating, users are assumed to be white *if* their personal ads are in *English* or *any white-dominant language*.

Race as Food

Some personal advertisers use culinary metaphors to refer to particular races. Users seeking romantic relations with particular races employ terms such as *rice* and *banana* for Asians, *bean* for Latinos, *potato* and *cream* for whites, and *chocolate* and *coffee* for blacks.

Some of these terms may suggest stereotypes about the racial groups' food consumption or culinary practices. For instance, a self-identified Asian advertiser chelseastud says in his personal ad that he is a "GAM looking for rice queens [men who are exclusively attracted to Asian males]" and another self-identified Asian advertiser peace_revision says, "Other vices: Indonesian fried noodles. You like? Hah, hah," referring themselves as "rice" and "fried noodles." In the case of the personal ad by a self-identified white user SFsolomio, the ad placer excludes Chinese or Asian men from his dating pool by saying, "I don't date fortune cookies."

Other culinary terms may suggest similarities between the foods and the phenotypes of a particular race. For instance, a self-identified white advertiser Atlntahunk72

says, "I'm only attracted to chocolates [black men] with a huge rod as the 'real' black man should have," associating chocolate with the darker skin color of black men. Some of the images may seem cute or playful, such as calling black men "sweet chocolates," but they have a racist dimension. Ultimately, food is for consumption and, once eaten, has "no remaining existence separate from what it provides to the consumer" (Owens 2004, 227). In the culinary metaphor, race serves only to satisfy a consumer's hunger and desire.

Queen, a derogatory term based on stereotypes of femininity, refers to a gay man when used by itself. In my observation, this term often appeared along with food metaphors, such as *rice queens* for (usually white) men exclusively seeking Asian men or *potato queens* for (usually Asian) men exclusively seeking white men, similar to other scholars' earlier finding (Ayres 1999).

Race as Celebrity

Some advertisers use celebrity pictures to signal their racial identity. An advertiser named blkdomtop posted a picture of black celebrity Will Smith and also identified himself as a black man. He followed the norm of posting a picture in on-line personal ads but instead chose a picture of Will Smith for reasons that come clear in his ad:

> Black DL [Down Low] guy looking to get to meet other straight acting guys. Sorry I am very discreet so I can't post my picture here. But I'm VGL [very good looking]. I've been told several times that I look like Will Smith. (blkdomtop [black dominant top])

Even without detailed descriptions of his race (other than the term *black*), he does signify his race by posting a picture with an identifiable race and by borrowing the celebrity's well-known images as his own racialized description.

Race as Religion and Myth

Religious themes and references, overt and latent, made in some personal advertisements, invoke ad placers' racial identities. Greek mythologies are popular among white advertisers to emphasize their hypermasculinity and muscular sexuality, for instance, in the self-identified white advertiser's on-line handle "HotGreekAdonis." Christian references appear in other ads. For instance, a self-identified white user dand1329 plays on the wording of the biblical story of Adam and Eve in Genesis and says, "Adam seeks Steve," signaling the white (perhaps Israeli) identity of himself and his desired partner. Some advertisers, such as teki, whose ad reads, "Religion: Hindu,"

signal their race by associating themselves with the religion that aligns with a particular racial group (e.g., Hinduism for Indians, Shinto for Japanese).

Race as Cultural Practice

Some white advertisers distinguish themselves within white identity by associating themselves with particular ethnicities, such as Italian Americans (Bryne 2003), Irish Americans, or Polish Americans. For instance, Italian American ad placers may emphasize their relatively darker features compared to other whites, along with other cultural characteristics such as passion (a common cultural stereotype for Italians). A self-identified Italian American advertiser, NYCItalian_30, writes, "Looking for guys with hot passion for life? Search no more! I have dark Italian features that can melt you down and know how to enjoy life with passion (It is all in my Italian gene)." The ad claims the Italian gene is suitable for love-making "that can melt you down." Meanwhile, the analogy in the ad may perpetuate the reverse stereotype, coupling the race and the cultural characteristic: The practice of enjoying life with passion makes the advertiser a *real Italian*.

Celebrating a holiday associated with certain racial groups is another way to signify a person's race. A self-identified white advertiser, wehoMahoney, writes about his identity by referring to the holiday of the Irish national saint:

> I find values in my family and my self. My family is very important to me. My favorite holidays are Christmas and Thanksgiving when I can spend sometime with my family. Oh! Plus St. Patrick's day.

Horoscopes are a popular theme in on-line personal ads, which can sometimes signify a person's race. For instance, a self-identified Asian advertiser LAtiger23 states in his ad that, instead of the signs popular in mainstream U.S. culture (such as Aries, Taurus, Gemini), he follows the lunar zodiac signs: "I'm a tiger. Well at least by zodiac signs, but you never know I may be as well in bed. *evil grins* And tiger makes me 31 not 43," highlighting his Asian identity.

A final theme for *race as cultural practice* is beardom, a gay culture dominated by "white, upper-middle class, white-collar professionals" (Suresha 1997, 45). The stereotypical bear look is an "all-natural, rural, even woodsy" man with "full beards" in "countrified versions of the Seventies clone's garb" (Locke 1997, 126). Then, beardom excludes some other races, such as Asian men who have smooth, rather than hirsute, bodies (Ayres 1999). To indicate an association with bear culture, some ad placers post the bear pride flag, which has horizontal stripes in brown to black colors and a bear paw print at the top left corner. A personal ad with the bear flag or the statement that the ad writer is a bear or attends bear events may constitute him as a white man.

QUEERING RACE

The intertwining of race/ethnicity and gay male desire documented and analyzed in this chapter has pointed to four themes of the race concept in the on-line personal advertisements of Gay.com. These four themes do not aim to encompass all aspects of race across sexuality and communication. Such a goal would go directly against the understanding of race, a negotiated, unstable, historical, sexual, and *queer* identity. Instead, I aimed to illustrate how race happens in the particular context of queer sexuality and to destabilize the concept of race by identifying some metaphors that shift incoherently in gay on-line personals. A question may arise: If race still happens on line even with the absence of corporeal body and if race gains its meanings through multiple metaphors which may be dramatically different from one another (e.g., body, place, culture, nonwhite), what do these phenomena say about the concept of race? In my analysis, the best answer to this question seems: Race is queer.

Upon this finding that race is queer, some other themes may emerge. First, my analysis found body included as one of the metaphors for race, and I argue against the dichotomous tension between the body as a material representation and the body as a purely rhetorical construct (Warren 2003). Scholars must avoid falling into this false dichotomy and instead accept the body as just one metaphor, among many other possible metaphors, of the race concept. (Other themes, such as race as surname, as music, or as income level, did not appear strongly in the Gay.com personals, but I suspect they do appear in other social contexts.) Such a framework opens up possibilities for queering or destabilizing race.

Second, the cultural tendency in the United States is to avoid overt mention of race or phenotypic difference (such as colorblindness) among individuals, but, in gay male sexual discourse, race comes to the forefront. In this setting, race must not be a taboo but instead an object of critical discussion, to interrogate the unacknowledged power underneath that social phenomenon. Unfortunately, the way on-line gay male personal ads make race relevant, according to my observations, is not through critical discourse but through a series of *cybertypes*, in which "users perform stereotyped versions of the *Oriental* that perpetuate old mythologies about racial difference" (Nakamura 2002, xv).

Third, race comes to the forefront through multiple metaphors and sometimes its representation may be redundant. For instance, a self-identified white advertiser signals his race through the on-line handle Gwminweho (gay white man in West Hollywood), through the pictures of his white phenotypic face and body, through the race menu selection ("Ethnicity: White/European, Good Irish lad"), and through a personal statement that reads: "Hello. I am a nice GWM . . . 5'11'', 160 lbs, blue eyes, and blond hair." In face-to-face communication, the corporeal body already present signals a person's race, and redundant mentions would generally be

awkward. However, such redundancy is common in on-line personal ads, even when pictures of the person's body are present.

Interpretations regarding this phenomenon may vary. Perhaps advertisers are simply borrowing the culture of personal ads from old media technologies, such as newspapers or magazines, where advertisers had to write out their race in text. Even though advertisers acknowledge the pictures are available in on-line personal ads, they may simply bring in the culture of old media or feel compelled to inscribe race into the text of their ads despite the different setting within the new medium. Or perhaps advertisers simply follow through the overlapping menus without noticing that the means (such as pictures and racial categories) for conveying racial information are redundant. Or perhaps advertisers feel an urge to disclose their race repeatedly to increase their chances of appearing in date seekers' search results, which rely mainly on those categories and clickable boxes for access.

For representations of race, repetitive disclosures may suggest that the interface for presenting advertisers' racial information is poor and inefficient, rather than concise and effective. Or the repetitions could suggest that race, rather than a mere piece of information, is a social ritual that comes without much literal information but with rich social *meanings*. James Carey's (1989) notion of *communication as culture* may be useful here. He criticizes the transmission model of communication and argues that a ritual model of communication can better explain the sharing of ideas and beliefs in social relations. The focus in the ritual model becomes the *meanings* in communication.

If the redundancy of racial disclosure is a sharing process in social relations, then race ceases to be mere information about advertisers. Advertisers do not simply bring their race from off line to fill the void of missing information in cyberspace. They instead discursively and repeatedly construct race, which gains meanings through sharing of and participation in a social ritual that the new medium enables. The ritual practice of race has particular meanings for advertisers' identities (or for whom they seek or do not seek), situated in their social relations with others and, by extension, with the social world. The ritual of race does not happen alone but as a sexualized identity in on-line dating.

REFERENCES

Ayres, Tony. 1999. "China Doll: The Experience of Being a Gay Chinese Australian." *Journal of Homosexuality* 36.3/4 (Autumn/Winter): 87–97.

Blauner, Bob. 1994. "Talking Past Each Other: Black and White Languages of Race." In *Race and Ethnic Conflict*, 30–40. Ed. Fred L. Pincus & Howard J. Ehrlich. Boulder, Co: Westview Press.

Bryne, Sarah. R. 2003. *Constructing Racialized Identities in the Search for Intimate Relationships: An Analysis of Personal Advertisements, 1974–2002.* Unpublished Doctoral Thesis, University of Cincinnati.

Campbell, John E. 2004. *Getting It on Online*. New York: Haworth Press.

Carey, James. 1989. *Communication as Culture*. Boston: Unwin & Hyman.

D'Emilio, John. 1983. "Capitalism and Gay Identity." In *Lesbian & Gay Studies Reader*, 467–476. Ed. Henry Abelove, Michele A. Barale & David M. Halperin. New York: Routledge.

Ellis, Alan L. 2004. "The Development of the World Wide Web and the Lesbian, Gay, Bisexual, Transgender, and Queer Communities." Paper presented at the Media Queered Colloquium, Queers in Cyberspace, University of Illinois at Chicago, 20 February.

Foucault, Michel. 1978. *The History of Sexuality: Volume I: An Introduction*. Trans. R. Hurley. Harmondsworth, UK: Penguin.

Gilroy, Paul. 1987. *"There Ain't No Black in the Union Jack": The Cultural Politics of Race and Nation*. Chicago: University of Chicago Press.

Haney-Lopez, Ian F. 1996. *White by Law: The Legal Construction of Race*. New York: New York University Press.

Haraway, Donna J. 1991. *Simians, Cyborgs, and Women*. New York: Routledge.

Hudson, Nicholas. 1996. "From Nation to Race: The Origin of Racial Classification in Eighteenth Century Thought." *Eighteenth-Century Studies 29*.3 (Spring): 247–264.

Ignatiev, Noel. 1995. *How the Irish Became White*. New York: Routledge.

Johnson, John W. 1994. "Racial Steering in the Romantic Marketplace." *Harvard Law Review 107*.4 (February): 877–894.

Kang, Jerry. 2003. "Cyber-race." In *AsianAmerica.Net*, 37–68. Ed. Rachel C. Lee & Sau-ling C. Wong. New York: Routledge.

Kolko, Beth E. 1999. "Representing Bodies in Virtual Space: The Rhetoric of Avatar Design." *The Information Society 15*.3: 177–186.

———. 2000. "Erasing @race: Going White in the (Inter)face." In *Race in Cyberspace*, 213–232. Ed. Beth E. Kolko, Lisa Nakamura & Gilbert B. Rodman. New York: Routledge.

Lester, Neal A., and Maureen D. Goggin. 1999. " 'Extra! Extra! Read All About It!' Constructions of Heterosexual Black Male Identities in the Personals." *Social Identities 5*.4 (December): 441–468.

Locke, Philip. 1997. "Male Images in the Gay Mass Media and Bear-Oriented Magazines: Analysis and Contrast." In *The Bear Book: Readings in the History and Evolution of a Gay Male Subculture*, 103–140. Ed. Les Wright. New York: Haworth Press.

Lowe, Lisa. 1996. *Immigrant Act: On Asian-American Cultural Politics*. Durham, NC: Duke University Press.

Lyotard, Jean-François P. 1979. *The Postmodern Condition: A Report on Knowledge*. Minneapolis: University of Minnesota Press.

Markham, Annette N. 1998. *Life Online: Researching Real Experience in Virtual Space*. Walnut Creek: Altamira Press.

Martin, Biddy. 1994. "Sexuality without Gender and Other Queer Utopias." *Diacritics 24*.2/3 (Summer/ Autumn) : 104–121.

Martin, Judith N., Robert L. Kritzek, Thomas K. Nakayama, and Lisa Bradford. 1996. "What Do White People Want to Be Called?: A Study of Self-labels for White Americans." In *Whiteness: The Communicating of Social Identity*, 27–50. Ed. Thomas K. Nakayama & Judith N. Martin. Thousand Oaks, CA: Sage.

Match.com. 2005. New to Match.com? Join for free. Available at http://www.match.com/profile/ myprofile.aspx?sect=3. Accessed 26 January 2007.

McDonough, Jerome P. 1999. "Designer Selves: Construction of Technologically Mediated Identity within Graphical, Multiuser Virtual Environments." *Journal of the American Society for Information Science 50*.10 (July): 855–869.

Nagel, Joane. 2001. "Racial, Ethnic, and National Boundaries: Sexual Intersections and Symbolic Interactions." *Symbolic Interaction 24*.2 (Fall): 123–139.

Nakamura, Lisa. 1995. "Race in/for Cyberspace: Identity Tourism and Racial Passing on the Internet." *Works and Days* Nos. 25/26 *13*.1&2: 181–193.

———. 2000. " 'Where Do You Want to Go Today?': Cybernetic Tourism, the Internet, and Transnationality." In *Race in Cyberspace*, 15–26. Ed. Beth E. Kolko, Lisa Nakamura, & Gilbert B. Rodman. New York: Routledge.

———. 2002. *Cybertypes*. New York: Routledge.

Omi, Michael, and Howard Winant. 1994. *Racial Formation in the United States from the 1960s to the 1990s*, 2nd ed. New York: Routledge.

Owens, Erica. 2004. "Race, Sexual Attractiveness, and Internet Personal Advertisements." In *Net.seXXX: Readings on Sex, Pornography, and the Internet*, 217–234. Ed. Dennis D. Waskul. New York: Peter Lang.

Phua, Voon C., and Gayle Kaufman. 2003. "The Crossroad of Race and Sexuality." *Journal of Family Issues 24*.8 (November): 981–994.

Reid-Pharr, Robert. 2002. "Extending Queer Theory to Race and Ethnicity." *Chronicle of Higher Education 48*.49 (16 August): 7–9.

Roediger, David R. 2005. *Working toward Whiteness: How America's Immigrants Became White*. New York: Basic Books.

Shaw, David F. 1997. "Gay Men and Computer Communication: A Discourse of Sex and Identity in Cyberspace." In *Virtual Culture*, 133–145. Ed. Steven G. Jones. Thousand Oaks, CA: Sage.

Silver, David. 2000. "Margins in the Wires: Looking for Race, Gender, and Sexuality in the Blacksburg Electronic Village." In *Race in Cyberspace*, 133–150. Ed. Beth E. Kolko, Lisa Nakamura & Gilbert B. Rodman. New York: Routledge.

Smaje, Chris. 1997. "Not Just a Social Construct: Theorizing Race and Ethnicity." *Sociology 31*.2 (May): 307–327.

Society for the Study of Symbolic Interaction. 2005. SSSITalk Archives. Available at http://venus.soci.niu.edu/~archives/SSSITALK/dec05/0920.html. Accessed 26 January 2007.

Somerville, Siobhan B. 2000. *Queering the Color Line: Race and the Invention of Homosexuality in American Culture*. Durham, NC: Duke University Press.

Steinfirst, Susan, and Barbara B. Moran. 1989. "The New Mating Game: Matchmaking via the Personal Columns in the 1980's." *Journal of Popular Culture 22*.4 (Spring): 129–139.

Stone, Allucquére R. 1991. "Will the Real Body Please Stand Up?: Boundary Stories about Virtual Cultures." In *Cyberspace: First Steps*, 81–118. Ed. Michael L. Benedikt. Cambridge: MIT Press.

Suresha, Ron. 1997. "Bear Roots." In *The Bear Book: Readings in the History and Evolution of a Gay Male Subculture*, 41–49. Ed. Les Wright. New York: Haworth Press.

Turkle, Sherry. 1995. *Life on the Screen: Identity in the Age of the Internet*. New York: Simon & Schuster.

Wakeford, Nina. 1997. "Cyberqueer." In *Lesbian & Gay Studies: A Critical Introduction*, 21–38. Ed. Andy Medhurst & Sally Munt. London: Cassell.

Warren, John T. 2003. *Performing Purity: Whiteness, Pedagogy, and the Reconstitution of Power*. New York: Peter Lang.

Waters, Mary C. 1990. *Ethnic Options*. Berkeley: University of California Press.

Yanow, Dvora. 2003. *Constructing "Race" and "Ethnicity" in America: Category-Making in Public Policy and Administration*. New York: M. E. Sharpe.

Gideon, Who Will Be Twenty-five in the Year 2012

Growing Up Gay Today

LARRY GROSS

Ways of thinking about queerness have been based on the experiences of pervasive invisibility and isolation. What do we say about growing up with common news and entertainment presence and with the opportunities for exploration and contact offered by the internet? Queer kids today are growing up in a culture that acknowledges queerness and does so by attempting to integrate it into the commercialized array of cultural products, niche-marketed demographic slices, and voting blocks. But most kids are still experiencing isolation and vulnerability in enemy territory, and, for them, media images, for all their problems, are far from trivial psychic and cultural resources.

This is one of those half-empty–half-full stories. It is not the worst of times, and it is certainly not the best of times, but the story that interests me here is one of remarkable progress as well as often depressing challenges. In the 1976 film by Alain Tanner (written with John Berger), *Jonah Who Will Be 25 in the Year 2000* (*Jonas—Qui Aura 25 Ans en l'An 2000*), a character notes wistfully that "men wish history would move as fast as time." History rarely grants that wish, but the past half century has witnessed a transformation in the circumstances for gays in the United States, and much of the rest of world, that would have been unimaginable at the middle of the twentieth century.

THAT WAS THEN

A half century ago, homosexuality was still the love that dared not speak its name: It was a crime throughout the United States. In the fervor of the cold war that gripped the country, homosexuals became targets along with Communists and were officially defined as mentally ill by the medical establishment. Newspapers and magazines referred to homosexuals only in the context of police arrests or political purges, as in a July 2, 1953, Los Angeles *Herald Express* headline: "State Department Fires 531 perverts, Security Risks" (Alwood 1996, 24). Hollywood operated under the Motion Picture Production Code, which prohibited the presentation of lesbian or gay characters and ensured that any implied homosexual characters would be villains or victims.

Throughout the 1950s and into the 1960s, the homophile movement, as it then called itself, expanded and deepened the self-awareness of lesbians and gays as a distinct, self-conscious, and embattled minority. The movement was born behind a veil of pseudonyms and secrecy at the height of the cold war, and its members, defined as criminal, mentally ill, and immoral, attempted to effect social change by persuading experts—mostly progressive psychologists and liberal clergy—to speak on their behalf. With the advent of television, brave activists appeared on the new medium, using pseudonyms, but this did not protect them from being recognized and promptly fired.

By the early 1960s, movement leaders emerged, inspired by the civil rights movement to proclaim that Gay is good! They began taking their struggle to the streets, demonstrating in front of government buildings, demanding an end to laws that criminalized gays and promoted discrimination and harassment.

The Stonewall riots in June 1969 harvested a crop planted by a decade of political and social turmoil. The new movement was founded on the importance of coming out as a *public*, as well as an individual, act. The open avowal of one's sexual identity, whether at work, at school, at home, or before television cameras, symbolized shedding the self-hatred that gay men and women had internalized. To come out of the closet expressed the quintessential fusion of the personal and the political that the radicalism of the late 1960s exalted.

> The most momentous act in the life of any lesbian or gay person is when they proclaim their gayness—to self, to other, to community. Whilst men and women have been coming out for over a hundred years, it is only since 1970 that the stories have gone very public. (Plummer 1995, 82)

The experience of coming out is at the center of the story that concerns me here, the experience of coming to terms with an identity unlike what everyone—parents, peers, preachers, and teachers, even oneself—expects or welcomes. All too often, even today, to quote Andrew Hodges and David Hutter, we learn to loathe homosexuality

before it becomes necessary to acknowledge our own (1974). In the early part of the twentieth century, and even in the first decade or so following Stonewall, young men and women came to this realization in an environment of pervasive public and private invisibility. The occasional encounter with a queer image or actual person would likely be greeted with undisguised hostility. Around 1972, when he was ten, Aaron Fricke's mother warned him that a man might ask him up to his house, and, "If I went, terrible things would happen to me. The man might cut me up into little pieces. When I asked her why someone would do this to me, she paused and said, 'Because they are what you call homosexuals.' She had no idea what impact that admonishment would have on me" (1981, 17–18). Fricke had, by that age, begun to consider that he might be gay, but now he knew he was, "in the eyes of my mother and many others, something more vile."

The early gay liberation moment of the 1970s broke through the wall of silence so eloquently captured by Adrienne Rich:

> Whatever is unnamed, undepicted in images, whatever is omitted from biography, censored in collections of letters, whatever is misnamed as something else, made difficult-to-come-by, whatever is buried in the memory by the collapse of meaning under an inadequate or lying language—this will become, not merely unspoken, but unspeakable. (1979, 199)

In the 1970s, the unspoken began to be spoken, as coming out stories flooded out. Julia Penelope Stanley and Susan Wolfe's collection, *The Coming Out Stories* (1980) was representative of the new genre: forty women (or, as they mostly wrote, wimmin) telling their stories of lies, secrets, oppression, and liberation. These were mostly stories of growing up queer in earlier decades. C. J. Martin's opening is representative:

> The day I accepted my label I still didn't know the word lesbian. The label I accepted was homosexual. Still, I had problems with even that since what little I could find in the literature that was available to me in 1950 was about men or about women in prison. Since neither of those categories included me—I was alone in my affliction—so horribly deviant there were no others like me. (1980, 56)

Growing up gay meant coming to terms with a stigmatized sexuality while living in an environment of public invisibility. Although broadcast media increasingly dominated U.S. society, with television well ensconced in the nation's living rooms and rapidly overshadowing other forms of public culture, the tube—or, for that matter, the pages of newspapers or the movies—rarely showed lesbians and gay men. Usually ignored altogether, we appeared, if at all, in roles that supported the so-called natural order. Gay persons made it on stage, in the roles generally offered to minority groups, as villains or victims. In unfriendly shows, queers were a threat to be contained; in friendly ones, we sparked surprise that someone apparently *normal* could be— gasp!—gay and offered the *real* characters the opportunity to demonstrate tolerance. The familiar stereotypes were always present, if only implicitly so in gay characters

depicted with antistereotypic care, drawing attention to the absence of the expected attributes and setting up the surprise or joke. Richard Dyer has pointed out that, "What is wrong about these stereotypes is not that they are inaccurate." They are, after all, often more than a little accurate, at least for some gay persons, some of the time. Dyer continued, "What we should be attacking in stereotypes is the attempt of heterosexual society to define us for ourselves, in terms that inevitably fall short of the 'ideal' of heterosexual society (taken to be the norm of being human), and to pass this definition off as necessary and natural" (1984, 31). Sexual minorities are not, of course, unique in this regard—one could say the same for most media images of minorities. But our general invisibility makes us especially vulnerable to the power of media images (Gross 2001).

Despite the rapid advances the gay liberation movement won in the 1970s—advances real enough to spur a fervent backlash (headlined in the mid-1970s by Anita Bryant) that continues in the present—most queer teens were only dimly aware of the changes being advocated and even achieved, mostly in a few large cities. The daily experience of queer youths remained one of public invisibility and private isolation.

"I'M SCARED TO DEATH"

As late as the early 1990s, the responses of audiences to a soap opera story thread illustrated the reality of this experience. In the summer of 1992, the daytime serial *One Life To Live* (*OLTL*) began what was at the time the longest and most complex television narrative ever to deal with a lesbian or gay character. When Billy Douglas, a high school star athlete and class president, confides to his best friend and to his minister that he is gay, he sets off a series of plot twists that differ from the usual soap opera complications by exposing homophobia and AIDS phobia, offering the characters—and the audience—an opportunity to address topics that daytime serials, along with the rest of U.S. mass media, preferred to ignore.

Ryan Phillippe, in his first professional role, played Billy Douglas and found himself at the center of media and audience attention. He received an unusually large amount of mail even for a good-looking young soap opera actor (see Gross 1996). Even more unusual, many of the hundreds of letters he received during his months appearing on *OLTL* came from young men, most of whom identified themselves as gay. In one interview Phillippe reported getting two thousand letters, adding that "a good 45 percent" were from homosexual teenagers" (Mallinger 1993, 14). Among the most frequent expressions were those of isolation from family and friends and desperation:

> My favorite scene was when Billy told Joey that he was gay. I like this so much because it was like a scene from life. Ever since this storyline began I have not been able to think of anything else, but what's going to happen next. . . . I feel the same way your character does about my parents finding out. I'm scared to death about that happening, because my family

doesn't like gay people. I just don't want my family to hate me or be embarrassed or ashamed of me. I'm writing this letter to you because I think you can relate to what I'm talking about. Ryan, I would like to know if we can become pen pals. (Mallinger 1993, 5–7)

I'm 19 years old and I live in XX, Colorado, and I'm gay. This is the first time I have ever told someone that. . . . Some of my closest friends say prejudiced things about gays and it hurts me very deeply because I am pretty sure they would have nothing to do with me if they knew about me. I hope that you aren't like that in real life; I'm pretty sure that you aren't but one never really knows. . . . If it's alright with you maybe we could write each other every so often? I would really like that!! (Gross 1996, 381)

I begin this letter by being blunt and upfront. I am a 22 year old homosexual male. . . . Life has been so hard for me. I've tried suicide, I was threatened with expulsion from my high school, I ran away and I was nearly stabbed by some people at my college. Storyline may be fiction, but mine was not—it was an ugly reality. I write this letter in hopes I can get help and need any advice you can give me. Ever since I was 13, I've been scared and alone. (Gross 1996, 371)

It is not difficult to imagine that an African American, Asian American, or Latino actor would get letters from teenagers who identify with and appreciate their representation of an underrepresented group on the public media stage. It is inconceivable that they would receive letters like the ones quoted above, let alone similar letters from adults:

Your performance has been "right on." I am a happily married, successful father of two teenagers (one, your age, equally good looking as you). . . . You see, I lived the character you are playing, and still live it, although in the "closet." I've never been a victim of homophobia, because no one knows I'm a life-long, born-that-way homosexual, comfortable with who I am, but not comfortable with living as a gay person. Still your character has created an empathy in me, because I can relate so well to your character. You are doing a service to millions of people, whether you know it or not, just by bringing the subject to a mass audience. Keep up the good work. Sorry, I can't sign this letter.

THIS IS NOW

Over the past three decades, the circumstances facing queer youths have changed radically. Thanks in part to AIDS—if the expression of thanks isn't too obscene—gays have overcome many of the last vestiges of public invisibility. Today, few can remain unaware of the existence of lesbians and gays, and the young grow up reading words and seeing images that previous generations never encountered. In the final years of the twentieth century, lesbian, gay, bisexual, and transgender persons entered the ranks of the culture's permanent cast of characters, even though rarely cast in leading roles and almost never permitted to express physical affection. We can expect to show up as the subject of news stories, even some that do not presume that our existence is controversial or that simple equality is a special right (although

the current same-sex marriage struggle guarantees a flood of these stories for the future). In a further demonstration that gays have emerged onto the American landscape, we are receiving the ultimate recognition that this country can bestow: being included in advertising. Gay and lesbian Americans now classify as a certifiable market niche, one well-heeled enough to warrant targeted ads, some of them winking at us over the heads of straight audiences.

Those growing up queer at the turn of the new century are facing new circumstances, good and bad, as well as the familiar challenges of the past. In their 1993 study of gay youths in Chicago, *Children of Horizons*, Gilbert Herdt and Andrew Boxer defined four age cohorts of gay persons in twentieth-century America. Their first cohort comprised those coming of age after World War I, and their fourth cohort came of age in the era of AIDS, since the early 1980s. Unlike previous cohorts, this fourth cohort includes a "great majority (who) come of age self-identifying as gay or lesbian, and expecting not only to live their lives openly, but to tell all their family and friends, and their employers, of their desires and lifestyles" (1993, 12). A decade later, a fifth cohort has clearly emerged, a generation of queer youths who have come of age in the era of media visibility and of the internet. Much remains the same, but much has changed.

Ways of thinking about queerness based on the experiences of pervasive invisibility need reconsidering to comprehend the experiences of today's and tomorrow's kids. They are growing up in a culture that acknowledges queerness by attempting to integrate it into the commercialized array of cultural products, niche-marketed demographic slices, and political voting blocks. Most lesbigay (pre-queer) theorizing presupposed invisibility and rare stereotypic representations as a limiting and distorting condition of growing up. What can theory say now about growing up with reasonably common news and entertainment presence and with the opportunities for exploration and contact offered by the internet?

One option is to deny the meaningfulness of identity and theorize the problem away. The 1990s were also the era of what British social scientists Paul Flowers and Katie Burston call the "metropolitan blossoming of both queer theory and queer politics" (2001, 61). After studying young gay men in Northern England, they point out that the theories "shatter and fragment the apparent unity of ideas of gay identity," but, in interviews, "these working class men all articulate a distinct and familiar coming-out story." The story is one of isolation, vulnerability, and deception, followed, if they are lucky, by self-disclosure, self-acceptance, and connection to a community.

Today's stories start at a younger age. Savin-Williams summarizes a body of research on the stages of the coming out process conducted over more than two decades and concludes that ages when these "developmental milestones are reached . . . have been steadily declining from the 1970s to current cohorts of youths . . . awareness

of same-sex attractions has dropped from the onset of junior high school to an average of third grade" (1998, 16). Savin-Williams attributes this declining age of self-definition to the "recent visibility of homosexuality in the macro culture (such as in the media), the reality of a very vocal and extensive gay and lesbian culture, and the presence of homosexuality in their immediate social world" (122).

Coming out earlier is hardly a guarantee of smooth passage. Most kids still find themselves growing up in enemy territory, in a country where heterosexuality is the love that needn't speak its name, because it's taken for granted, and where *gay* is a term of abuse to rival *faggot* or *queer*. But, unlike the experience of most kids in the past, kids today have ways to fight back, and public schools have become battle grounds of new civil rights struggles.

A young man named Jamie Nabozny made news in 1996 when he successfully sued a Wisconsin school district for failing to stop the antigay abuse he suffered for years. Other pupils realized Nabozny was gay when he was in the seventh grade. In later years, a classmate pushed him to the floor and simulated raping him as other pupils watched. Another time, one boy knocked him into a urinal while another urinated on him. When he sought help from the principal, he was told, "Boys will be boys." During another assault, ten students surrounded Nabozny while a student wearing boots repeatedly kicked him in the stomach. Nabozny attempted suicide several times, and, like many gay teenagers in similar situations, he dropped out of high school. But Jamie Nabozny also fought back in federal court and won. The school district agreed to a $900,000 settlement. "That case opened the floodgates to lawsuits—and, perhaps more important, to *threats* of lawsuits—from other gay students who said their complaints about harassment had been ignored. School officials saw the potential for liability" (Jones 1999, n.p.).

Organization has been more common than lawsuits. Supportive organizations emerged within schools, starting with the 1984 founding of Project Ten in a Los Angeles high school, and grew slowly for the next decade. In the aftermath of Matthew Shepard's death, the number of gay-straight alliances (GSAs), as most of these groups are named, rose dramatically, reaching about 750 nationwide by 2001 (Platt 2001). The clubs often meet resistance from school officials, but they have an effective weapon, courtesy of the religious Right. In 1984, to force public schools to permit Bible study clubs, Senator Orrin Hatch spearheaded the passage of the federal Equal Access Act, which makes it illegal for a school to ban some extracurricular clubs if it allows others. After refusing to permit a GSA to meet at a public high school in 1995, the Salt Lake City Board of Education had to ban all extracurricular clubs. Salt Lake City stuck by its principles—sacrificed the interests of all students to deny gay students the right to a club—before finally relenting in 2000. In other localities as well, the Equal Access Act has served to open school doors to GSAs (Platt 2001; Barovick 2001).

QUEER TEENS AS DEMOGRAPHIC NICHE

The changing circumstances of gays in the 1990s led predictably to the emergence of media products not only produced by gays themselves—the case since the start of the gay liberation movement (then called the homophile movement) in the 1950s—but also targeted at segments not previously addressed so directly. Notable among these are gay youths, whom the media, wary of the accusation of recruiting or seducing the innocent, have avoided as customers and subjects.

Founded in 1996 for gay male teens, a San Francisco–based magazine, *XY*, by 2002 boasted, "We sell over 60,000 copies per issue and have more than 200,000 readers from all over the world. Our average reader age is 22, according to our last reader survey, and *XY* is officially targeted toward 12–29-yo [year-old] young gay men." The twenty-four-year-old editor told the *San Francisco Chronicle*, "I don't think there's a magazine in the country that means more to its readers. I say that because we're dealing specifically with a demographic of gay teenagers who are not living in L.A. or New York, or some place where being gay is accepted. There's really no other forum for them to read about that experience" (Aidin Vaziri, "A Voice for Gay Teens," 13 June 1999, 34). The magazine's price—$7.95 per issue and $29 for a six-issue subscription, in 2002—might be a deterrent to many in the magazine's target audiences.

If steep prices and prying parents limit the success of magazine publishing for lesbian and gay teens, the internet offers them readier access and greater privacy (those without access to computers and the internet are also less likely to have the money for a subscription to *XY*). The web site for *XY*, in fact, offers much more than enticements to subscribe to the magazine or to buy back issues or such tempting merchandise as "glamorous laminated cardboard containers to neatly store your *XY* issues . . . only $12" or a $5 *XY* bumper sticker.

The section called Bois contains personal profiles—called *peeps*—submitted by young men after they register with their name, e-mail address, and age (the site pledges to maintain complete privacy). In August 2002, there were 13,559 profiles listed on the site; by March 2004, there were 92,440, many of them including the registrant's photograph. Scanning through the lists, one can specify location and limit to profiles with pictures. The listings are far from evenly distributed across the United States and elsewhere. The numbers are often impressive, as is the geographical dispersion. Alabama listed 637 peeps, thirty-five with photos; Montana had 127 (sixty-three photos), but Los Angeles boasted 2284, 1461 with pictures Outside the United States, the patterns are probably predictable, with Toronto offering 565 peeps (358 photos), London 251 (138 photos), and Australia 408 listings (182 with photos). Leaving the English-speaking world the numbers fall off, as would be expected. There are 123 listed in Germany (64 with pictures), 35 in France

(12 photos, and some of these would appear to be older than the target age), 24 in Japan (15 photos) and only 12 in China (3 pictures). There is no lesbian equivalent of *XY*, but the most successful lesbian magazine, *Curve*, includes on its web site extensive personals listings, with and without photographs, that specify ages beginning at eighteen and going up to ninety. In the section called Community, discussions appear under many group and topic headings, including Baby Dykes—Youth Hangout.

Sites run by magazines are only the tip of the internet iceberg, when it comes to opportunities to post personal ads and engage in conversation. Despite a slant toward the interests of those old enough to get into bars and spend more money, the major gay web sites appear to be accessible to gay teens. PlanetOut, the largest commercial gay site, boasts more than 350,000 personal ads from individuals that seem to range in age from fifteen to the early sixties and is likely to attract the attention of many teenagers looking for information, connections, and, for many, no doubt, sex. There are, in addition, sites specifically developed for gay youths, such as OutProud, *Oasis*, Blair, and Mogenic (located in Sydney), that combine support, counseling, and information with news and links to other sites oriented to youths (Addison & Comstock 1998).

GROWING UP GAY IN CYBERSPACE

In contrast to the world of earlier decades, youths grow up reading words and seeing images that previous generations never encountered, and few can remain unaware of the existence of lesbians and gays. Despite the dramatic increase in the public visibility of gays found in nearly all domains of public culture, most lesbian, gay, bisexual, and transgender youths still find themselves isolated and vulnerable. The formal curricula of schools or society's informal curriculum, the mass media, do not reflect their experiences and concerns. For these teenagers, the internet is a godsend, and thousands are using computer networks to declare their homosexuality, meet, and seek support from other gay youths.

"Does anyone else feel like you're the only gay guy on the planet, or at least in Arlington, Texas?" When seventeen-year-old Ryan Matthew posted that question on AOL in 1995, he received more than one hundred supportive e-mail messages (Trip Gabriel, "Some On-line Discoveries Give Gay Youths a Path to Themselves," *New York Times*, 2 July 1995, 1). The stories that fly through the ether make all too clear that the internet can be a lifesaver for many queer teens trapped in enemy territory:

> JohnTeen Ø (John Erwin's AOL name) is a new kind of gay kid, a 16 year old not only out, but already at home in the on-line convergence of activists that Tom Rielly, the co-founder of Digital Queers, calls the "Queer Global Village." Just 10 years ago, most queer teens hid

behind a self-imposed don't-ask-don't-tell policy until they shipped out to Oberlin or San Francisco, but the Net has given even closeted kids a place to conspire. Though the Erwins' house is in an unincorporated area of Santa Clara County in California, with goats and lamas foraging in the backyard, John's access to AOL's gay and lesbian forum enables him to follow dispatches from queer activists worldwide, hone his writing, flirt, try on disposable identities, and battle bigots—all from his home screen. (Silberman 1994, n.p.)

Kali is an 18-year-old lesbian at a university in Colorado. Her name means *fierce* in Swahili. Growing up in California, Kali was the leader of a young women's chapter of the Church of Jesus Christ of Latter-day Saints. She was also the Girl Saved by E-mail, whose story ran last spring on CNN. After mood swings plummeted her into a profound depression, Kali—like too many gay teens—considered suicide. Her access to GayNet at school gave her a place to air those feelings, and a phone call from someone she knew on line saved her life. Kali is now a regular contributor to Sappho, a women's board she most appreciates because there she is accepted as an equal. "They forgive me for being young," Kali laughs, "though women come out later than guys, so there aren't a lot of teen lesbians. But it's a high of connection. We joke that we're posting to 500 of our closest friends." (Silberman 1994, n.p.)

Jay won't be going to his senior prom. He doesn't make out in his high school corridor the way other guys do with their girlfriends. He doesn't receive the kind of safe-sex education at school that he feels he should. He can never fully relax when he's speaking. He worries that he'll let something slip, that the kids at his Long Island high school will catch on. He'd rather not spend his days at school being beaten up and called a faggot. It's not like that on the internet. "It's hard having always to watch what you say," said Jay, which is not his real name. "It's like having a filter that you turn on when you're at school. You have to be real careful you don't say what you're thinking or look at a certain person the wrong way. But when I'm around friends or on the Net, the filter comes off." For many teenagers, the internet is a fascinating, exciting source of information and communication. For gay teenagers like Jay, 17, it's a lifeline. The moment the modem stops screeching and the connection is made to the Net, the world of a gay teenager on Long Island can change dramatically. The fear of being beaten up and the long roads and intolerant views that separate teens lose their impact. (Matthew McAllester, "What a Difference a Modem Makes," *Newsday*, 28 January 1997, B-4)

Jeffrey knew of no homosexuals in his high school or in his small town in the heart of the South. He prayed that his errant feelings were a phase. But as the truth gradually settled over him, he told me last summer during a phone conversation punctuated by nervous visits to his bedroom door to make sure no family member was listening in, he became suicidal. "I'm a Christian—I'm like, how could God possibly do this to me?" he said. He called a crisis line for gay teenagers, where a counselor suggested he attend a gay support group in a city an hour and a half away. But being 15, he was too young to drive and afraid to enlist his parents' help in what would surely seem a bizarre and suspicious errand. It was around this time that Jeffrey first typed the words *gay* and *teen* into a search engine on the computer he'd gotten a few months before and was staggered to find himself aswirl in a teeming online gay world, replete with resource centers, articles, advice columns, personals, chat rooms, message boards, porn sites and—most crucially—thousands of closeted and anxious kids like himself. That discovery changed his life. (Egan 2000, n.p.)

Without unfettered access to the internet at Multnomah County Public Library, sixteen-year-old Emmalyn Rood testified Tuesday, she might not have found courage to tell her mother she was gay. "I was able to become so much more comfortable with myself," Rood told a special three-judge panel weighing the constitutionality of the Children's Internet Protection Act. "I basically found people I could talk to. I didn't have anybody I could talk to in real life." In the summer of 1999, Rood was a freshman at Portland's Wilson High School confused about her sexual identity but eager to learn. Today, she is attending a Massachusetts college and is a determined plaintiff in a lawsuit aimed at scuttling the new federal law, which she said would have hindered her search. (Jim Barnett, "Gay Teen Testifies against Law on Internet," *The Oregonian*, 27 March 2002, E-1)

Similar accounts abound, not only in the United States but also in many other parts of the world. Sometimes, as in the case of Israeli gay teenagers interviewed by Lilach Nir (1998), on-line discussions offered them contact and confirmation unavailable to them in their real (so-called) environments of smaller cities, rural villages, and kibbutzim. One of the clichés of computer-mediated communication is that one can hide one's true identity, so "that nobody knows you're 15 and live in Montana and are gay" (Gabriel, *New York Times*, 2 July 1995, 1). It is also true, as Nir's informants told her, that in their internet relay chat (IRC) conversations they "are unmasking the covers they are forced to wear in the straight daily lives" (Nir 1998, 11).

BEYOND THE ANECDOTES

The stories recounted above, and others readily found in news accounts, may seem exceptional or extreme instances. A body of more representative data is growing on the role the internet plays in the lives of queer kids. In September and October of 2000, two of the largest web sites serving lesbian, gay, bisexual, and transgender youths, OutProud and *Oasis* magazine, conducted an on-line survey. OutProud is an arm of the National Coalition for Gay, Lesbian, Bisexual, and Transgender Youth, founded in 1993 to provide advocacy, information, resources, and support to in-the-closet and openly queer teens through America Online and the internet. *Oasis* magazine has published on line since December 1995. OutProud director Chris Kryzan authored the survey, and the two sponsoring sites advertised it, along with other web sites oriented to youths and, as it turned out, two sites devoted to gay and lesbian erotica. Some 7,884 respondents completed the survey, of whom 6,872, aged twenty-five or younger, constituted the primary sample.

The survey permitted respondents of any age to complete the form, discouraging older respondents from presenting themselves as younger to participate. Obviously, respondent age, like anything else queried over the internet, is subject to falsification, but there seems little reason to imagine that many would spend an average of thirty minutes pretending to be something they're not. Nearly 60 percent of those beginning

the survey completed it. As the researchers discovered midway, slightly more than half of the respondents (and 60 percent of the males) entered the survey site from an erotic stories site targeted at gay males, but no systematic differences among respondents corresponded to the point of entry. The pattern does tell something about the importance of erotic content sites for gay youths, who aren't likely to find similar erotic material in mainstream media. Pornography is central to the appeal of the internet and is often the only source available for queer youths to get the sort of sexual imagery and information widely available in the media for heterosexual youths.

The respondents clearly do not constitute a probability sample, and, from them, one cannot generalize about queer youths. Studies can never obtain such a sample for gays, who remain largely hidden from the survey researcher's sampling frames. The size and diversity of the group do offer insights into the lives of some queer youths and their relationships to the new communications technologies that came into the world as they were being born. Most (77 percent) of the respondents were from the United States, with the next largest numbers from Canada (8 percent), the United Kingdom (5 percent), and Australia (4 percent); seventy-two other countries contributed fewer than 1 percent each. Few differences followed from geographical origin, suggesting that many of those responding from other countries might not have been of local origin (such as children of diplomats or overseas businessmen).

The Australian Research Centre in Sex, Health, and Society conducted a somewhat similar, more qualitative survey (Hillier, Kurdas & Horsley 2001). The sample of respondents included 5,310 males, 1,412 females, and 150 individuals who identified as transgender. The median age of the respondents was 18 (the mode was 17); the median age reported for realizing that they were gay was 13; and the median age of accepting that fact was 15. There were significant correlations between their reported position on the Kinsey scale (from 0, completely heterosexual, to 6, completely homosexual) and the age of becoming aware of their sexuality (-0.06) and the age of accepting their sexuality (-0.20). The more strongly they identify as gay, the earlier they recognized and accepted their sexual orientation (these correlations are controlling for gender). Of course, causality may run in either direction.

As might be expected, this is a group of youths familiar with the internet: Nearly half of those sixteen and under and two thirds of those twenty and older had been on line for at least three years, and fewer than 10 percent had been on line less than one year. More than 90 percent of respondents reported going on line at least once a day; nearly half said several times per day. About 50 percent reported spending more than two hours on line each day. The usage figures reported in the survey put these youths well above the average of 9.8 hours per week found in the 2001 UCLA Internet Report, *Surveying the Digital Future* (2003).

The most frequent activities on line included looking at specific sites, 28 percent (males cited this more than females—presumably, this includes the erotica site

that linked so many respondents to the survey); chatting, 24 percent; and e-mail, 20 percent (more females than males cited these two) (see the OutProud/*Oasis* 2000 survey described on p. 271). Unspecified surfing absorbed 20 percent; reading message boards, 2 percent. Downloading music, the Recording Industry Association of America (RIAA) would be relieved to learn, only accounted for 5 percent of reported time.

Given the makeup of this sample, one would expect their on-line experiences to relate to their sexuality. Two-thirds of the respondents said that being on line helped them accept their sexual orientation; 35 percent said that being on line was crucial to this acceptance. Not surprisingly, many said they came out on line before doing so in so-called real life—this was much more the case for males (57 percent) than for females (38 percent) and more for those who had spent more time on line.

Connections on line sometimes lead to real life meetings. About half of the respondents report such meetings, and 12 percent of the males (but only 4 percent of the females) said they met someone off line to have sex. About a quarter of males and females met someone "with the hope that we might become more than friends." Overall, a quarter of the respondents said that they met those they've dated on line. It is good to know that 83 percent report having enough knowledge of sexually transmitted diseases (STDs) to follow safer sex practices. Nearly a third cite the internet as their primary source for this information.

Queer youths often feel isolated and rarely have access to a supportive queer community in their vicinity. Sixty percent of the respondents said they did not feel as though they were part of the gay, lesbian, bisexual, and transgender community, but 52 percent said they felt a sense of community with those they've met on line. Mass media, even minority media, do not necessarily provide a great deal of contact and support for these youths. Only 47 percent have bought a gay or lesbian magazine, and only two of these, the *Advocate*, the largest U.S. gay magazine, and *XY*, for young gay males, reach as many as a fifth of the sample. Even fewer report familiarity with *Oasis*, the longest running on-line magazine for queer youths.

A frequent concern about their isolation is that queer youths are vulnerable to suicide, and the rate of attempted and completed suicides commonly reported is high in the group. Among the on-line survey respondents, 40 percent of females and 25 percent of males reported thinking seriously about suicide sometimes or often, and 30 percent of females and 17 percent of males said they had tried to kill themselves (the median age for these attempts was fourteen). For queer teens, the internet can often be a lifeline: 32 percent of the females and 23 percent of the males say they've gone on line when feeling suicidal, so that they would have someone understanding to talk to. Among those who report frequent suicidal thoughts, 53 percent of the females and 57 percent of the males say they've gone on line for this reason.

GIDEON WHO WILL BE TWENTY-FIVE IN THE YEAR 2012

In late 2000, the twelve-year-old son of a colleague of mine told his mother that he is gay. Gideon told his mother that he had known this since he was around six years old and that he was telling her now because he wanted to see the American version of *Queer as Folk*, then about to debut on the subscription cable channel Showtime.

While American viewers were wondering when Will from the television show *Will & Grace* would get a date, let alone get laid, Channel 4 in Britain made television history in 1999 with something completely different. *Queer as Folk* centered on three gay men in Manchester who spend most of their non-working hours in the bars of the trendy Manchester gay neighborhood. The three men include two twenty-nine-year-olds—Stuart, a sexy, heartless Don Juan who says he wants to "die shagging," and Vince, his shy best friend, hopelessly yearning to shag Stuart—and Nathan, a golden-haired fifteen-year-old bursting out of the closet. In the first episode, Nathan is picked up (or vice versa) by Stuart and then introduced to rimming and anal sex.

At least as much as the explicit sex, the novelty of *Queer as Folk* for mainstream media was the dramatic lens focused on the gay characters and their world, with only token straight characters and no effort to explain things to, or wink at, the audience. "Most of the gay drama we've had on British television has dealt with big statements: victimization, the political agenda, AIDS," Gub Neal, the head of drama for Channel 4, said to the *New York Times*. "But this group of characters doesn't think they're victims at all. They're not even aware that they're a minority. They simply exist and say, 'Hey, we don't have to make any apologies, and we're not going away.' The series has given us a chance to simply reveal gay life, to some extent, in its ordinariness" (Sarah Lyall, "Three Gay Guys on British TV: What's The Fuss?" *New York Times*, 15 April 1999, E-1).

It didn't take long for the series to attract attention in Hollywood, and Showtime began to produce an American version, set in Pittsburgh. "I thought this show was unique," said Jerry Offsay, Showtime president of programming (Bernard Weinraub, "A Controversial British Series Seduces Showtime," *New York Times*, 14 May 2000, sec. 2, 36). "I had never seen characters like these on television. The characters were unapologetic, they lived their lives the way they wanted to. There were great twists and turns and reverses in the storytelling. This show will be as edgy as any television series has ever been in America." Edginess has its limits. Unlike the British Nathan, who is fifteen, in the American version the youth, named Justin, will be nearly eighteen. "The boy is on the cusp of being the legal age," said Tony Jonas, one of the executive producers of the series. "The idea is, kids who are seniors in high school are being sexual. We can't deny that. It's the reality."

High school seniors are being sexual, and their sexuality is at the center of the peculiarly American fertility ritual known as the senior prom. The prom, officially defined as a celebration of young love and coming of age, is for many teens a painful reminder of social hierarchy and exclusion. For queer teens, even more than most, the high school prom is likely to be an occasion for suffering rather than joy, and most queer adults probably look back on their high school prom—if they went at all—as a low point of their high school years. But there are exceptions.

In 1981, Aaron Fricke went to federal court to force his high school to permit him to bring a male date to his senior prom. The court case, and the prom, drew national attention, and, in subsequent years, many lesbian, gay, bisexual, and transgender youths have braved parental, peer, and official disapproval to participate in their preferred fashion in this rite of passage.

In bigger cities across the country, there are special proms for queer teens: In May 2003, Denver held its tenth Queer Prom in a local college student union. "Most of the kids who attend the prom come from the Denver area, but we see people from all over the region—Wyoming, Utah, Montana," says Julie Voyles, director of youth services at Rainbow Alley. "We're the biggest GLBT youth group in the Western states, and for a lot of the rural youth we're it" (Lesley Kennedy, "Queer Prom Night: Alternative Dance a Haven for Gay Students," *Rocky Mountain News*, 19 May 2003, 3-D). Other teens follow in Aaron Fricke's footsteps, although they rarely need to go to court these days. Some of them even run for prom queen or king, and, sometimes, they succeed. Seventeen-year-old Catherine Balta wanted to be prom queen of Lincoln High School in Omaha, because, if her fellow Lincoln High seniors elected her prom queen, it would prove she was accepted. If an out lesbian could be prom queen, Balta said, "I just felt it would be something that would be cool for everybody" ("Prom Tiara Is More Than a Crown," *Omaha World Herald*, 6 June 2003, 1-B), and elected she was, wearing a mismatched tuxedo with a red fedora over her short hair. Brenda Melton, president of the American School Counselor Association told *Newsweek*/MSNBC that "it has become almost commonplace in urban and suburban areas for a student to bring a date of the same sex to the prom—and that in most schools, it's really no big deal" (Scelfo 2003, n.p.).

After Gideon's mother told me about his coming out, and the reason for it, I offered to tape *Queer as Folk* for him, and I then passed on copies of the program.

The final episode of the first season—the series turned the British eight-episode series into an open-ended soap opera now beginning its fourth season—climaxed at Justin's high school prom. The creators of the program, Ron Cowen and Daniel Lipman—two gay men who are life as well as work partners—gave their fictional eighteen-year-old a prom that would fulfill every queer high school boy's dream fantasy. Having gone to the prom with his straight female best friend, Daphne, Justin is surprised when thirty-year-old Brian appears, gorgeous in a tuxedo. The

crowd clears a space in the center of the floor, the band begins to play "Save the Last Dance for Me," and spotlights shine down on the couple as they twirl and spin, ending in an extended romantic kiss. Then, in the parking garage, a high school bully comes up behind and hits Justin in the head with a tire iron. Brian knocks the bully out and cradles Justin in his arms. The season ends with Brian sitting in a hospital corridor, holding a bloodied silk scarf.

Here, in an effective nutshell, is the situation of queers in America today. We are able to live our lives openly and fully to a degree unimaginable a few decades ago, and, at the same time, we are targets for gay bashing, whether in high school parking lots or by Republican and Democratic politicians who wish to deny us full equality as citizens. History may not move as fast as time, but I trust that Gideon will live in a freer world by the time he reaches twenty-five.

REFERENCES

Addison, Joanne, and Michelle Comstock. 1998. "Virtually Out: The Emergence of a Lesbian, Bisexual, and Gay Youth Cyberculture." In *Generations of Youth*, 367–378. Ed. Joe Austin & Michael Willard. New York: New York University Press.

Alwood, Ed. 1996. *Straight News: Gays, Lesbians, and the News Media.* New York: Columbia University Press.

Barovick, Harriet. 2001. "Fear of a Gay School." *Time*, 21 February, 52. Available at http://home.earthlink.net/~scoey/Pride23.html.

Dyer, Richard. 1984. "Stereotyping." In *Gays and Film*, 27–39. Rev. ed. Ed. Richard Dyer. London: British Film Institute.

Egan, Jennifer. 2000. "Lonely Gay Teen Seeking Same." *New York Times Magazine*, 10 December, 110–117, 128–133. Available at http://www.nytimes.com/library/magazine/home/20001210mag online.html.

Flowers, Paul, and Katie Burston. 2001. " 'I Was Terrified of Being Different': Exploring Gay Men's Accounts of Growing up in a Heterosexist Society." *Journal of Adolescence 24*.1 (February): 51–65.

Fricke, Aaron. 1981. *Reflections of a Rock Lobster: A Story about Growing up Gay.* Boston: Alyson.

Gross, Larry. 1996. "You're the First Person I've Ever Told: Letters to a Fictional Gay Teen." In *Taking Liberties: Gay Male Essays on Politics, Culture, and Art*, 369–386. Ed. Michael Bronski. New York: Kasak Books.

———. 2001. *Up from Invisibility: Lesbians, Gay Men & the Media in America.* New York: Columbia University Press.

Herdt, Gilbert, and Andrew Boxer. 1993. *Children of Horizons: How Gay & Lesbian Teens Are Leading a New Way out of the Closet.* Boston: Beacon Press.

Hillier, Lynne, Chyloe Kurdas, and Philomena Horsley. 2001. " 'It's Just Easier': The Internet as a Safety-net for Same Sex Attracted Young People." Australian Centre for Research in Sex, Health and Society, La Trobe University, Melbourne, Commonwealth Department of Health & Aged Care. Available at http://www.latrobe.edu.au/ssay/pdfs/internetreport.pdf.

Hodges, Andrew, and David Hutter. 1974. *With Downcast Gays: Aspects of Homosexual Self-Oppression.* London: Pomegranate Press. Reprinted in Gross, Larry, and James Woods. 1999. *The Columbia Reader on Gay Men & Lesbians in Media, Society & Politics.* 551–561. New York: Columbia University Press. Available at http://www.outgay.co.uk/intro.html.

Jones, Rebecca. 1999. " 'I Don't Feel Safe Here Anymore': Your Duty to Protect Gay Kids from Harassment." *American School Board Journal 20*.11 (November): 26–31. Available at http://www.asbj.com/199911/1199coverstory.html.

Mallinger, M. Scott. 1993. "I'm Not a Homosexual, but I Play One on TV." *Au Courant* (Philadelphia) *11*.19 (22 March): 11–17.

Martin, C. J. 1980. "Diary of a Queer Housewife." In *The Coming Out Stories*, 56–64. Ed. Julia Penelope Stanley & Susan J. Wolfe. Watertown, MA: Persephone Press.

Nir, Lilach. 1998. "A Site of Their Own: Gay Teenagers' Involvement Patterns in IRC and Newsgroups." Paper delivered at the International Communication Association annual convention, Jerusalem, July.

Platt, Leah. 2001. "Not Your Father's High School Club." *American Prospect 12*.1 (January): [on line] Available at http://www.prospect.org/print/V12/1/platt-l.html.

Plummer, Ken. 1995. *Sexual Stories: Power, Change and Social Worlds.* London: Routledge.

Rich, Adrienne. 1979. "It Is the Lesbian in Us." In *On Lies, Secrets, and Silence*, 199–202. New York: Norton. (Orig. pub. 1976.)

Savin-Williams, Ritch. 1998. ". . . And Then I Became Gay." New York: Routledge.

Scelfo, Julie. 2003. "Out at the Prom." *Newsweek* [web exclusive], 19 August. Available at http://msnbc.msn.com/id/3068938/.

Silberman, Steve. 1994. "We're Teen, We're Queer, and We've Got E-Mail." *Wired 1*.8 (December): 1–3. Available at http://www.wired.com/wired/archive/2.11/gay.teen_pr.html.

Stanley, Julia Penelope, and Susan J. Wolfe. 1980. *The Coming Out Stories.* Watertown, MA: Persephone Press.

UCLA Internet Report. 2003. *Surveying the Digital Future.* Los Angeles: UCLA Center for Communication Policy. Available at http://www.digitalcenter.org/pdf/InternetReportYearThree.pdf.

Contributors

James Allan completed doctoral work in communication at the University of Massachusetts, Amherst, and works at York University, Toronto. He has studied Montreal gay club culture, Canadian queer cinema, and the politics of the Chelsea gym queen. This chapter comes from a larger project, "Fast Friends and Queer Couples: Relationships between Gay Men and Straight Women in North American Popular Culture, 1959–2000," with support from the Gay & Lesbian Alliance Against Defamation Dissertation Fellowship.

Edward Alwood received a Ph.D. in mass communication from the University of North Carolina at Chapel Hill. The *New York Times* named his *Straight News: Gays, Lesbians, and the News Media* a notable book of 1996. In fourteen years of broadcasting, he became a news correspondent at WTTG-TV in Washington, D.C., and at CNN. He is an associate professor of journalism at Quinnipiac University, Hamden, Connecticut.

Tracy Baim is a Chicago native and chronicler of its queer communities since 1984. Recognized in journalism for "Go Home, Faggots" and other editorials, she won awards from the NOW Chicago Chapter, Dignity, Human Rights Campaign Fund, NLGJA, and Community Media Workshop. She helped found the Chicago Gay and Lesbian Chamber of Commerce and served as board co-vice-chair for Gay Games VII. The Chicago Gay and Lesbian Hall of Fame inducted her in 1994.

Kevin G. Barnhurst (Ph.D., University of Amsterdam) is head of the Department of Communication, University of Illinois at Chicago (UIC). He has studied

the homoerotic images of Lewis Hine and queer representations on NPR. He served on the Center for the Study of Media and Society board and on campus diversity committees at Syracuse and UIC. He teaches media theory, political and visual studies, and qualitative research methods. He thanks James Owens for research assistance.

John D'Emilio studies sexuality, social movements, and post-1945 U.S. history. He is author of *Sexual Politics, Sexual Communities* (Chicago), a history of gay liberation before Stonewall, and coauthor with Estelle Freedman of *Intimate Matters* (Chicago), which the U.S. Supreme Court quoted in the decision striking down sodomy laws. His biography of civil rights activist Bayard Rustin, *Lost Prophet* (Free Press), was a finalist for the National Book Award and a *New York Times* Notable Book.

Jason DeRose is a news correspondent and weekend host for Chicago Public Radio and contributes regularly to National Public Radio. His beat includes religion, ethics, and spirituality, as well as the media during election years. He worked for NPR stations in Seattle, Minneapolis, and Tampa and at the network headquarters in Washington, D.C. He is a graduate of St. Olaf College in Minnesota and holds a master's degree from the University of Chicago Divinity School.

Vincent Doyle (Ph.D., Communication, University of Massachusetts, Amherst, 2005) is Mellon Postdoctoral Fellow in Humanities and Media and Cultural Studies at Macalester College, St. Paul, Minnesota. He also holds a Fellowship in the Sexuality Research Program of the Social Science Research Council (2000), which sponsored his participation in Media Queered.

Larry Gross, director of the Annenberg School of Communication, University of Southern California, is author of *Up from Invisibility: Lesbians, Gay Men, and the Media in America* (Columbia) and *Contested Closets: The Politics and Ethics of Outing* (Minnesota) and co-editor of *The Columbia Reader on Lesbians and Gay Men in Media, Society and Politics* (Columbia).

Bruce Henderson (Ph.D., Northwestern University; Ph.D., University of Illinois at Chicago) is professor of speech communication and coordinator of culture and communication, Ithaca College. He supervises performance studies and formerly chaired his department. He is coauthor, with Carol Simpson Stern, of *Performance: Texts and Contexts* (Longman) and does research on performance, disability studies, gay studies, children's literature, and modern poetry and fiction. He wishes to thank the volume editor and Daryl J. Bem for invaluable assistance.

Lisa Henderson is associate professor of communication at the University of Massachusetts, Amherst, where she teaches media and cultural studies. She is the author of numerous essays on cultural production and of a book in progress titled, *Love and Money: Queers, Class, Cultural Production.* Thanks to Kevin Barnhurst, Lauren Berlant, Lynn Comella, Vincent Doyle, Scott Tucker, and Leola Johnson, to

colleagues in the Conjunctures workshop, and to faculty and student audiences at Keene State College, Smith College, and the Chicago and Urbana-Champaign campuses of the University of Illinois for their responses to earlier versions of this essay.

Jaime Hovey has taught English and Gender and Women's Studies at Rutgers University, the University of Miami, and the University of Illinois at Chicago. She publishes on British and U.S. modernist lesbian writers, and her book, *A Thousand Words: Portraiture, Style, and Queer Modernism* (Ohio State University Press, 2006), explores relationships between fin de siècle visual culture, Anglo-U.S. and French literary modernisms, and queer identity.

Gavin Jack (Ph.D., Heriot-Watt University, UK, 2000) is reader in culture and consumption at the University of Leicester, United Kingdom. He has research interests in how communication and cultural identity articulate with consumption. His research on male sex work is recent, but his imagination on the subject has a longer history.

Steve Jones (Ph.D., University of Illinois at Urbana-Champaign), a professor of communication at the University of Illinois at Chicago, has been using the internet since 1979, when he coauthored educational materials on the PLATO system. A social historian of communication technology, his books, including *CyberSociety* (Sage), versions 1 and 2.0, have won critical acclaim and international media attention. He cofounded the Association of Internet Researchers, coedits the journal, *New Media & Society*, and is Senior Research Fellow at the Pew Internet and American Life Project.

Deborah Kadin has worked as a print journalist for twenty years, primarily in the Chicago region, as a freelance writer for the *Chicago Tribune* in the near suburb Oak Park, and as a full-time staff member with the *Daily Herald* in the far west suburb of DuPage County. She has also served as president of the Chicago Chapter for the National Lesbian and Gay Journalists Association (NLGJA).

Amit Kama (Ph.D., Tel Aviv University, 2001) teaches in the Communication Department at the Academic College of Emek Yezreel, Israel. He is author of *The Newspaper and the Closet: Israeli Gay Men's Communication Patterns* (in Hebrew). The research reported here derives from his dissertation written under the guidance of Professor Dafna Lemish. He wishes to express deep gratitude and appreciation for her academic and moral contributions.

Laura Kipnis, a cultural critic and former video artist, is a professor at Northwestern University. Her books include *The Female Thing: Dirt, Sex, Envy, Vulnerability* (Pantheon), *Against Love: A Polemic* (Pantheon), and *Bound and Gagged: Pornography and the Politics of Fantasy in America* (Grove Press). The Guggenheim and Rockefeller Foundations and the National Endowment for the Arts, among others, have given her awards. She has taught at the Universities of Michigan and Wisconsin–Madison and at the School of the Art Institute of Chicago.

Han N. Lee studies at the Department of Communication, University of Massachusetts at Amherst, focusing on qualitative inquiry, social aspects of communication technologies, and queer identity formations in rural environments. This essay grew from a master's thesis in the Department of Communication, University of Illinois at Chicago. He wishes to thank the faculty and staff of both institutions for their guidance and for their responses to earlier versions of this essay.

Deirdre McCloskey is an economist and economic historian who, around 1980, got interested in the rhetoric of persuasion. She is the author of *Crossing: A Memoir* (Chicago) and plans an upcoming book to bring speech into economics, because, she says, "An economy is not merely a matter of language, but a great deal of it takes place on lips and pages."

Ellen Meyers, deputy director of intergovernmental affairs, Office of Illinois Secretary of State, is the highest-ranking open lesbian in the executive branch of Illinois state government. She served several terms chairing the board of the rights group Equality Illinois. Among her other awards, the Chicago Gay and Lesbian Hall of Fame inducted her in 2001, and she was a National Endowment for the Arts fellow. She holds degrees from Lawrence University and Columbia College, Chicago.

Marguerite Moritz (Ph.D., Northwestern, 1991) is a professor at the University of Colorado. She writes on media portrayals of gays and produces independent documentaries. She was the writer for *Scout's Honor*, on antigay Boy Scouts of America policies, which won the audience award for best documentary at the Sundance Film Festival in 2001.

Todd Mundt is director of content and media at Iowa Public Radio and host of *Assignment Iowa* on Iowa Public Television. NPR syndicated *The Todd Mundt Show*, a daily interview program, from 1998 to 2003. He cohosted PBS national coverage of the Millennium in 2000 and has narrated documentaries and hosted specials and live productions for Iowa Public Television. He began his radio career at age fourteen and first entered public broadcasting at eighteen.

David J. Phillips is associate professor of information studies at the University of Toronto. He studies sociotechnical infrastructures of identity, visibility, and representation. He is the author of "Negotiating the Digital Closet: On-line Pseudonyms and the Politics of Sexual Identity," published in the journal *Information, Communication, and Society* (2002).

Katherine Sender is assistant professor at the Annenberg School for Communication, University of Pennsylvania. Her work on LGBT media and marketing produced this essay and the book, *Business, Not Politics: The Making of the Gay Market* (Columbia University Press, 2004).

Studs Terkel is the Peabody Award–winning former host on WFMT radio Chicago, the Pulitzer Prize–winning author of *Hope Dies Last: Keeping the Faith in Difficult Times* (New Press), and the author of many other books. He was born May 16, 1912.

Index